SACRED SPACES

THE AWE-INSPIRING ARCHITECTURE OF
CHURCHES AND CATHEDRALS

BY GUILLAUME DE LAUBIER WITH TEXT BY JACQUES BOSSER

ABRAMS · NEW YORK

Copyright © 2018 Éditions de la Martinière, La Martinière Groupe, Paris
English translation copyright © 2018 Abrams

Heritage credits: P. 73–76: F.L.C. / Adagp, Paris, 2018

Published simultaneously in French as *Les Plus Belles Églises d'Europe* by Éditions de La Martinière

FRENCH EDITION
Graphic Design and Layout: Éléonore Gerbier
Research: Laurence Alvado

ABRAMS EDITION
Editor: Laura Dozier
Designer: Shawn Dahl, dahlimama inc
Production Manager: Denise LaCongo

Library of Congress Control Number: 2017956864

ISBN: 978-1-4197-2806-8

Printed and bound in Slovenia
10 9 8 7 6 5 4 3 2 1

Abrams books are available at special discounts when purchased in quantity for premiums and promotions as well as fundraising or educational use. Special editions can also be created to specification. For details, contact specialsales@abramsbooks.com or the address below.

Abrams® is a registered trademark of Harry N. Abrams, Inc.

ABRAMS The Art of Books
195 Broadway, New York, NY 10007
abramsbooks.com

CONTENTS

4 Introduction

8 St. Peter's Basilica ROME ▫ VATICAN

18 Papal Basilica of Santa Maria Maggiore ROME ▫ VATICAN

24 Cappella Palatina PALERMO ▫ ITALY

30 San Maurizio al Monastero Maggiore MILAN ▫ ITALY

36 Church of the Gesù PALERMO ▫ ITALY

42 Cappella Sansevero NAPLES ▫ ITALY

46 Le Thoronet Abbey LE THORONET ▫ FRANCE

52 Notre-Dame Cathedral PARIS ▫ FRANCE

60 Chartres Cathedral CHARTRES ▫ FRANCE

66 The Royal Chapel of Versailles VERSAILLES ▫ FRANCE

72 Couvent Sainte-Marie de la Tourette ÉVEUX ▫ FRANCE

78 Mosque-Cathedral of Córdoba CÓRDOBA ▫ SPAIN

86 Santa Maria de León Cathedral LEÓN ▫ SPAIN

92 Seville Cathedral SEVILLE ▫ SPAIN

98 Basilica de la Sagrada Família BARCELONA ▫ SPAIN

106 Igreja de São Francisco PORTO ▫ PORTUGAL

114 Jerónimos Monastery LISBON ▫ PORTUGAL

120 Igreja da Misericórdia CHAVES ▫ PORTUGAL

124 Ulm Minster ULM ▫ GERMANY

130 Ottobeuren Abbey OTTOBEUREN ▫ GERMANY

138 Asamkirche MUNICH ▫ GERMANY

146 St. Moritz Church AUGSBURG ▫ GERMANY

152 Church of St. Leopold VIENNA ▫ AUSTRIA

158 Chapel of St. Mary of the Angels MONTE TAMARO ▫ SWITZERLAND

164 Ely Cathedral ELY ▫ UNITED KINGDOM

170 Wells Cathedral WELLS ▫ UNITED KINGDOM

178 King's College Chapel CAMBRIDGE ▫ UNITED KINGDOM

184 St. Paul's Cathedral LONDON ▫ UNITED KINGDOM

190 St. Michael the Archangel Church BINAROWA ▫ POLAND

196 Churches of Peace JAWOR AND ŚWIDNICA ▫ POLAND

204 Churches of Moldavia ARBORE, MOLDOVITA, AND SUCEVITA ▫ ROMANIA

214 Sedlec Ossuary KUTNÁ HORA ▫ CZECH REPUBLIC

220 Saint-Sophia Cathedral KIEV ▫ UKRAINE

228 Stave Churches BORGUND, HEDDAL, AND UVDAL ▫ NORWAY

238 Afterword

240 Acknowledgments

INTRODUCTION

It is certainly a challenge to select only forty-some remarkable churches from among the tens of thousands of houses of worship that have been a central feature of European cities and have shaped their history for centuries.

To a certain extent, our main theme was the expansion of Christianity across Europe after emperors Constantine I (280–337) and Licinius (d. 325) legalized Christianity in the Edict of Milan in 313. That allowed us the freedom to broadly outline a panorama of the architectural and aesthetic history of the churches of Europe, from early Christianity to the twenty-first century, and from Rome to the eastern reaches of Europe and Scandinavia, including France, the Iberian Peninsula, Germany, and England. We have presented major Catholic, Orthodox, and protestant architectural masterpieces, and have revealed little-known sanctuaries, such as the chapel by Mario Botta nestled in the mountains of Ticino or the St. Moritz Church in Augsburg, a Baroque sanctuary transformed into a place for retreat and prayer and wonderfully adapted to the contemporary faithful.

Although the practice of Christianity is on the wane throughout Europe, it seems to be gaining in intensity—perhaps in terms of authenticity—what it loses in numbers. Paradoxically, churches of a certain architectural and decorative quality have historically received few visitors. But our perspective has changed over the years. In the nineteenth century, the famous Baedeker travel guides recommended visiting notable churches, but their readers were more likely to be religious, attending mass or other services on a regular basis. Their viewpoint was therefore different from that of the contemporary tourist, who may be neither a practitioner nor a believer of any religion.

Today, the Notre-Dame Cathedral in Paris welcomes more than thirteen million visitors a year! It has become difficult, if not impossible, to find the opportunity to reflect in historically significant churches. Even at St. Peter's Basilica in Rome, one cannot pray in peace, except for in the Chapel of the Most Holy Sacrament, and even there it is difficult. Cathedrals, abbey churches, and Romanesque chapels are on the circuit of must-see attractions, on par with fine art museums, historic neighborhoods, and even amusement parks. Visitors walk through, look around, and take a lot of pictures, and while many understand less and less about the architectural symbolism and iconography of the paintings and sculptures, most are filled with wonder before they leave. They are to be thanked: their sincere interest has saved many masterpieces of religious architecture from neglect and dereliction. Congregational practice, faith, and the support of parish communities have been practically replaced by public grants, business sponsorship, and tourists who are passionate about cultural history. In the eyes of many, the church has lost its original role as a place of worship, but it has been given another one: that of witness to history, culture, and art. For many, that is the function and utility of being added to UNESCO's World Heritage List.

For a long time, places of worship were on the forefront of architectural creation. When civil society was still building massive castles, the church was inventing

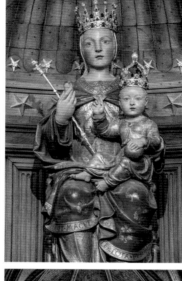

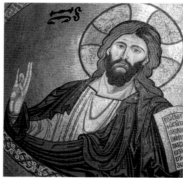
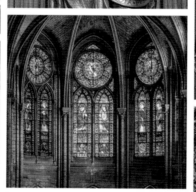
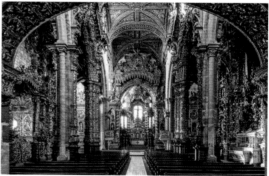
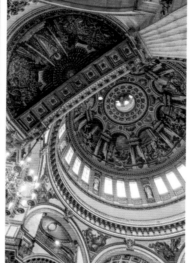

elaborate Gothic vaults and enormous stained glass windows that magnified the changing light of seasons. Later, the Counter-Reformation launched the Baroque style, which would dominate art throughout the seventeenth century, and support the greatest painters and architects, including Bernini, Rubens, and Caravaggio, providing them with the opportunity to execute the masterpieces we know. Where would great European art be without the enormous contribution of churches? From the eleventh century to the nineteenth century, the construction of places of worship was one of the main engines of artistic activity, in terms of both creativity and commissioning.

The history of these public monuments is also the story of the human obsession with power, the affirmation of clerical authority, the display of urban wealth, and the competition between cities and pilgrimage sites. It incorporates an incredibly concentrated history of Christianity, ideas, techniques, class conflict, war, pretension and pride, eschatological fear, dreams of forgiveness, redemption, and the hope of finally being admitted into paradise.

The church, like history, is not reducible to the splendid stained glass windows of Chartres Cathedral in France, the incredible altarpieces made of gilded wood at São Francisco in Portugal, or the wild technical feats of the vault at King's College Chapel in England. Our modern viewpoint, influenced by atheism and materialism, too often overlooks the astonishing collective and social adventures that inspired these magnificent places. Construction on cathedrals often lasted for centuries. Successive generations were moved to fulfill a duty, to do everything possible, including financing the project and incurring debt, to allow the new sanctuary to be built for the glory of God.

Can we even imagine the existence of an enormous and dangerous work site in the heart of a city for two or three hundred years? Can we imagine vaults, walls, and spires collapsing? Or the frequent fires that necessitated starting over from scratch a century later?

First and foremost, all churches, and in particular the most beautiful ones in Europe, are an act of faith. This is, again, often difficult for us to perceive and understand—for a singular act to be so pure, absolute, and shared by all. Robert Aron, in *Ce que je crois*, wrote in 1955: "I don't know if I believe in God. But thanks to the history that surrounds me, one thing I am certain of is that I believe in those who throughout the ages and in all places believed in Him." And it is that very feeling that often seizes the men and women who enter a church today, whether it is a chapel tucked in the English countryside or the gigantic nave of a Spanish cathedral. Those daring architectures, those exhilarating frescoes, those humble or majestic sculptures all speak of the same, profound belief guiding the hand of builders and artists; it is the belief shared by congregants who found peace and refuge there. Each of these churches is, strictly speaking, a prayer that united all men and all women of all social classes together. And amid so much beauty, we are filled with emotion in thinking about the faithful millions who have come to these places over centuries to pray, plead, and make manifest their infinite belief in that which gave their life meaning: the existence of God. Each of these churches is a temple not only to the greatest glory of the Christian God but also to the memory of the countless men and women who believed, and a beacon to those who continue to live lives enriched by faith.

ST. PETER'S BASILICA

ROME ▫ VATICAN

One of the largest basilicas in the world was designed not only to welcome pilgrims and the faithful but also to amplify the image of the Catholic Church. It's easy to feel lost in the vast nave, which measures some 614 feet (187 m) long and 151 feet (46 m) high, its proportions at once otherworldly and harmonious. The nave expands sharply into the gigantic arms of the transept (arms of the cross shape), which is enhanced by two opposing chapels. Even though Romans were accustomed to the Empire's architectural extravagance, they marveled at the elevation of the cupola and especially at the astonishing luxury and style of such an incredible display of artistic treasures, which culminates in an explosion of golds and light in the Cathedra Petri, Peter's throne. A Christian visitor might spare a thought for the humble tomb of Peter, the poor fisherman buried beneath the thousands of tons of stone, marble, and bronze, beneath the ostentatious tombs, paintings, and sculptures celebrating the glory and triumph of the church Christ entrusted to him.

As it did for most major houses of worship, construction of St. Peter's lasted decades. However, in the long history of sacred architecture, we do not know of any other project that has been as disorganized, as poorly managed, and as great a victim of wavering and disinterested developers, of viciously competitive and greedy architects, and of creative financing as St. Peter's. Between 1506, when the first stone was laid, and the construction of the square in 1667, the papacy underwent the sack of Rome, in 1527; religious wars; battles to expand Italian territories; and the launch of Counter-Reformation policies as a means to reassert the Catholic Church's spiritual power.

At the beginning of the sixteenth century, pilgrims still gathered in the basilica, which had been erected as early as 324 A.D. at the foot of Vatican Hill by the first

PAGE 9: St. Peter's, seen here from the Tiber River, was built at the foot of Vatican Hill. Roman Emperor Constantine I (c. 280–337) built his basilica starting in 324 on this site. ‡ PAGES 10 AND 11: In the transept, the architectural play of light and the three-dimensional perspectives are largely as Michelangelo envisioned them.

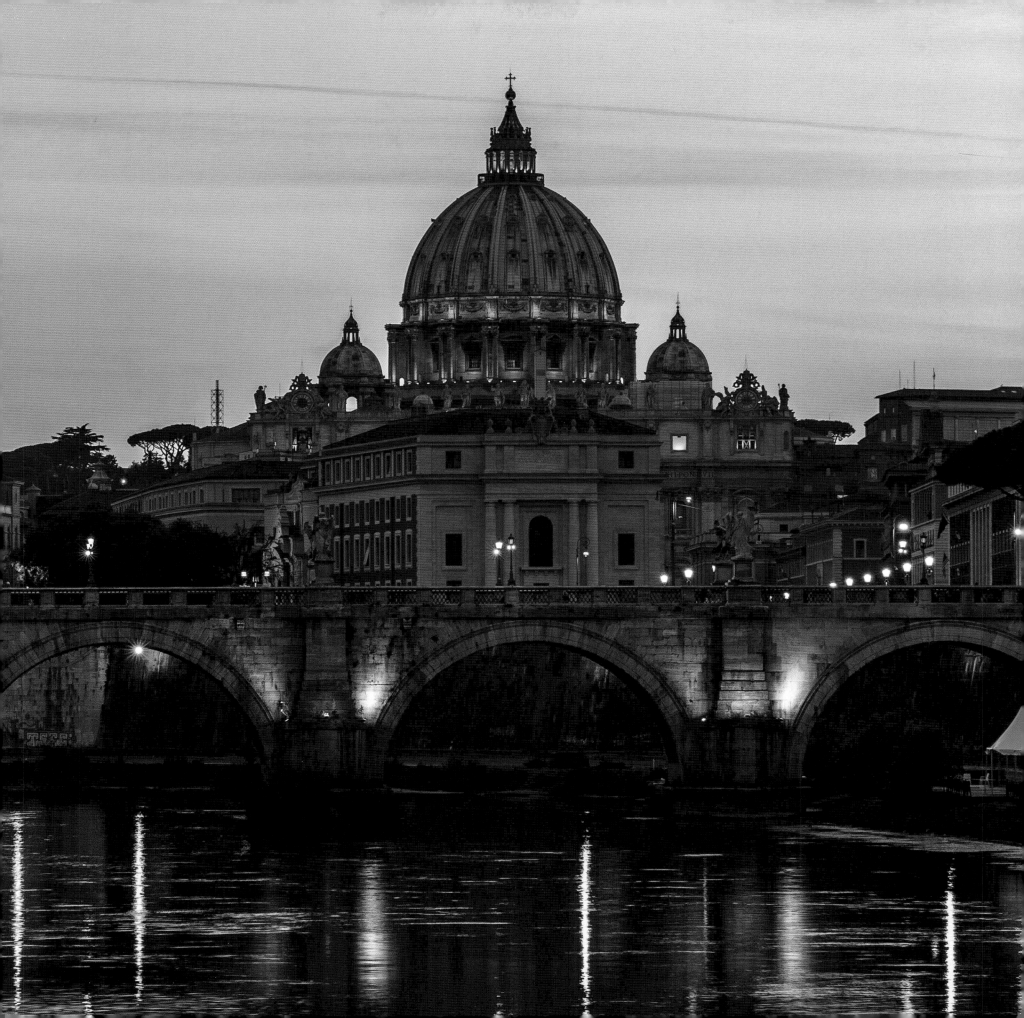

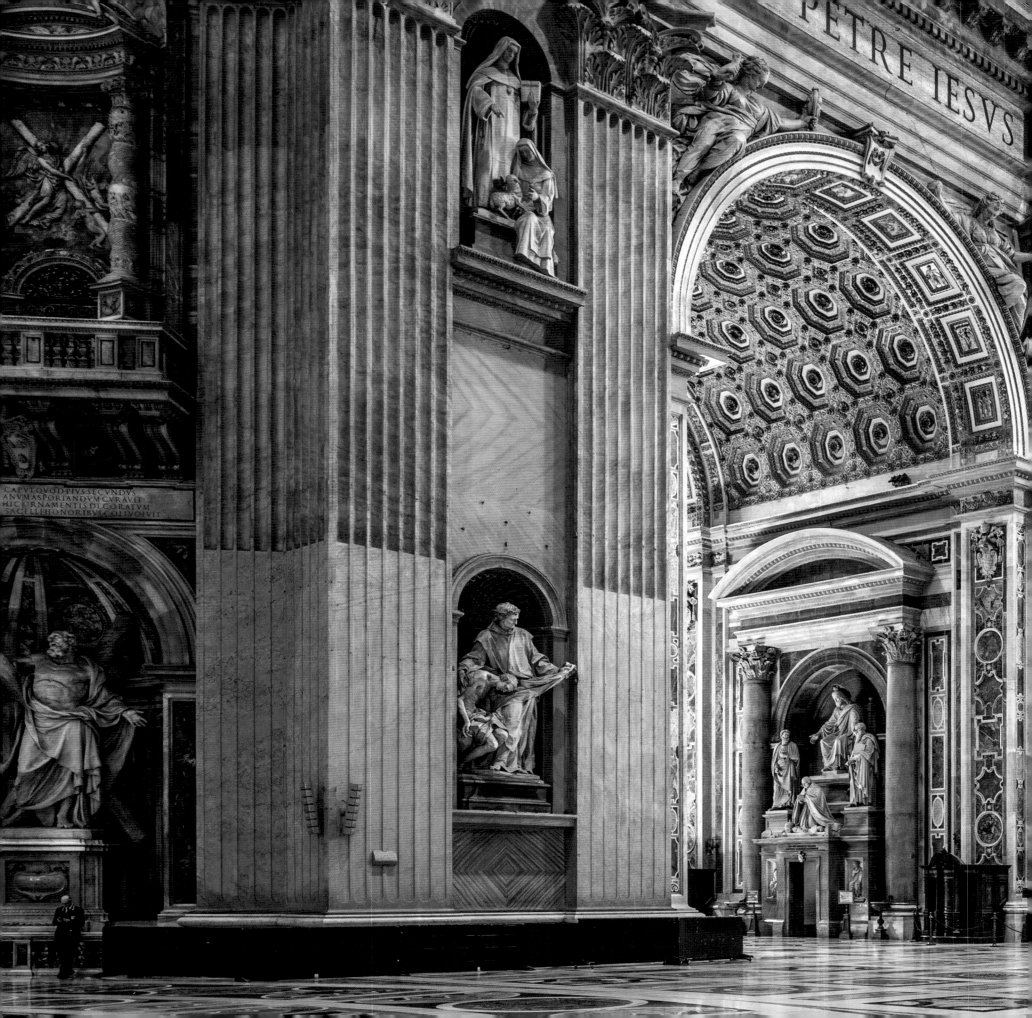

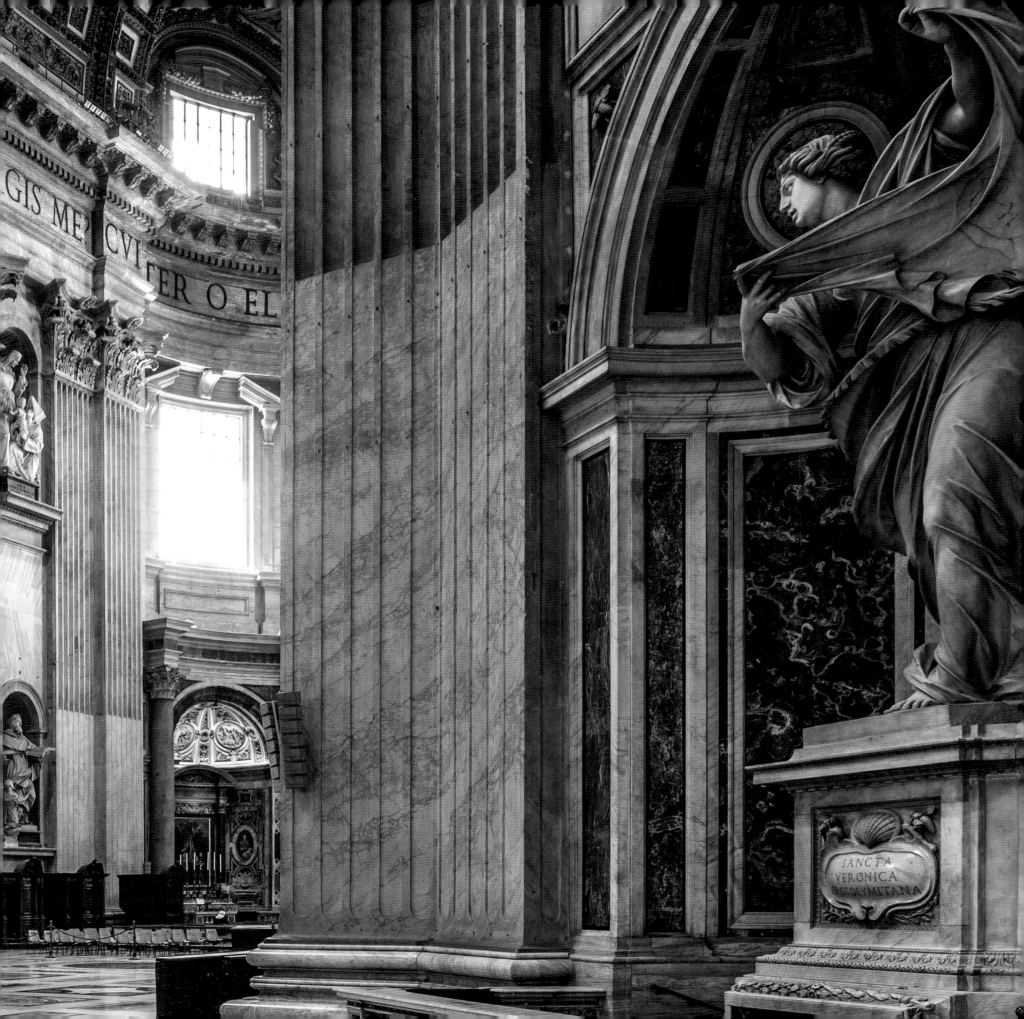

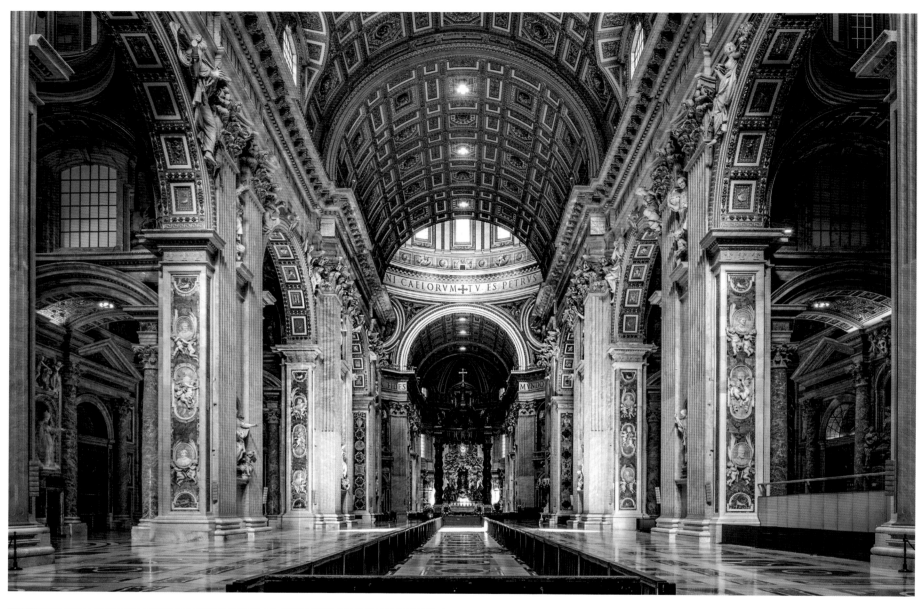

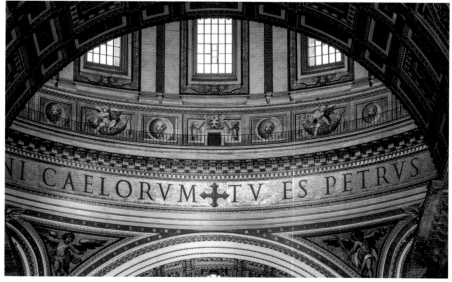

Christian Roman emperor, Constantine (c. 280–337). The church was built outside city walls at the site of St. Peter's martyrdom and tomb, and of the Circus of Caligula and Nero. It had a basilica and a vast atrium, but it was on the brink of ruin. As early as 1450, Pope Nicholas V (1397–1455) began consulting with architects; then Pope Julius II (1433–1513) decided to demolish the old buildings and build the largest church in the world, which took more than a century. Eighteen popes participated in the enormous project. It was financed by all of Europe and also by the selling of indulgences—payment to the church that purchased the exemption of punishment for certain sins, a controversial practice that was a catalyst for the Protestant Reformation.

Nicholas V had called upon the architect Bernardo Rossellino (1409–1464), but Rossellino's plans for a vast "traditional" basilica, with a dome and cupolas, excited no one. The seven pontiffs who followed showed no interest in the project; it was Julius II, the "warrior pope," who again turned attention to it. Of the plans proposed by Rossellino, Giuliano da Sangallo (1445–1516), and Donato Bramante (1444–1514), Julius II chose Bramante's, which

was a basilica in the shape of a Greek cross, topped by a giant dome flanked by four enormous piers. After the death of Bramante, Pope Leo X (1513–1521) charged Sangallo, Fra Giovanni Giocondo (1433–1515), and Raphael (1483–1520) with continuing the construction of St. Peter's. Raphael proposed a sanctuary in the shape of a Latin cross but died shortly thereafter. With funds lacking and indecision prevailing, Giuliano's nephew Antonio da Sangallo, the Younger (1484–1546), proposed a large, tiered structure topped by a massive dome and accompanied by two gigantic towers. Disappointed by the plan, Pope Paul III (1534–1549), an aesthete, asked Michelangelo (1475–1564) to take over the architecture after Sangallo the Younger's death. The Renaissance genius would work without remuneration on the massive project until the end of his life. To Michelangelo, architecture was the sculpture of matter and light. He returned to the Greek cross and began work on the choir. When Michelangelo died, he left behind the choir, part of the transept, the very beginnings of the dome, and the high bay windows he had reintroduced to lighten the immense volume. Decoration had not yet begun. The outside of the choir, with its powerful geometry, gives an idea of what Michelangelo's St. Peter's might have looked like. Two architects succeeded him: Pirro Ligorio (1512/1513–1583), who was quickly dismissed, and the very classic Giacomo Barozzi da Vignola (1507–1573), who accomplished little. In 1573, Giacomo della Porta (1532–1602) was named head architect, but it was not until the arrival of Pope Sixtus V (1585–1590) that construction resumed in earnest. The dome was built at astounding speed, although not without controversy. It seems that Michelangelo had wanted a hemispheric form, whereas, for technical reasons, della Porta preferred an ovoid dome.

PAGE 12 TOP: The nave, by Carlo Maderno (1556–1629), was designed to create a feeling of expansion as one approaches the altar beneath a barrel vault representing the sky. ✠ PAGE 12 BOTTOM LEFT AND RIGHT: An inscription in gold mosaics runs along the cupola and the nave. Beneath the cupola is written: "You are Peter, and on this rock, I will build my church. I will give you the keys of the kingdom of heaven." (Matt. 16:18–19) ✠ PAGE 14: The extraordinary baldachin with twisting bronze columns. ✠ PAGE 15: Statue of St. Elijah (1727) by Agostino Cornacchini (1686–1754).

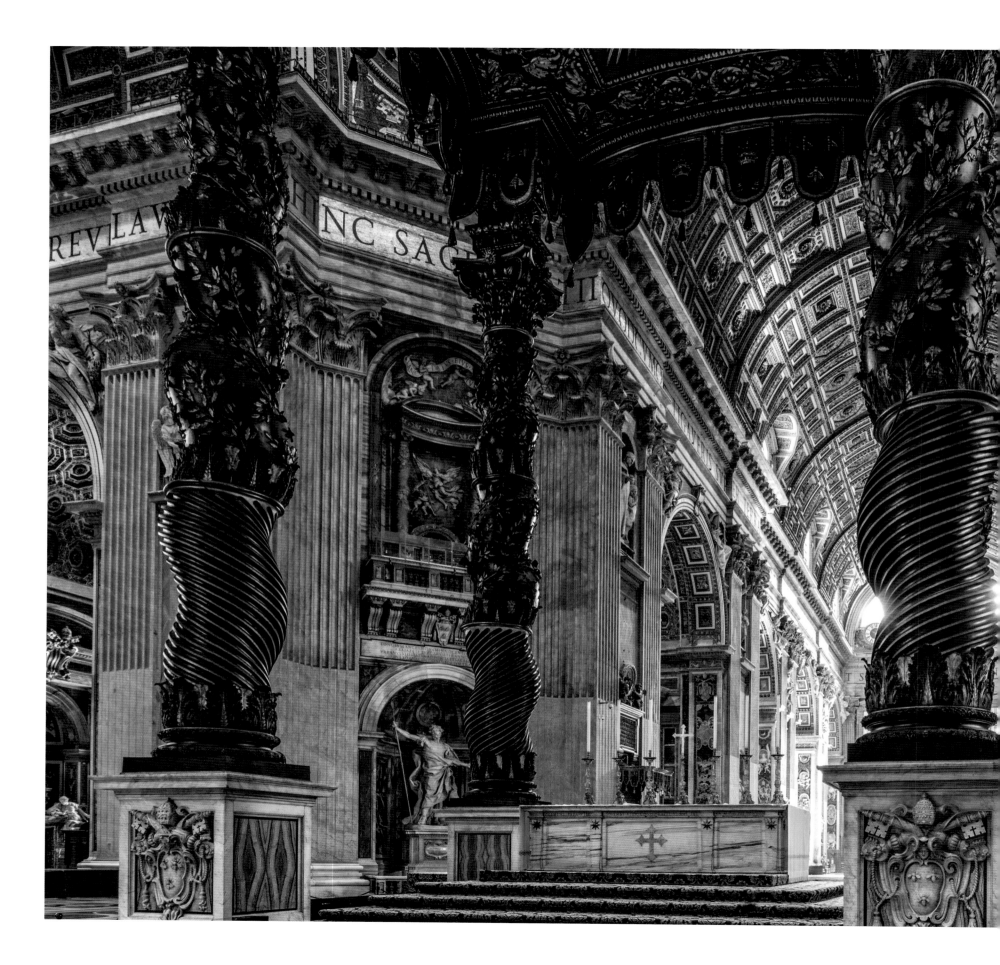

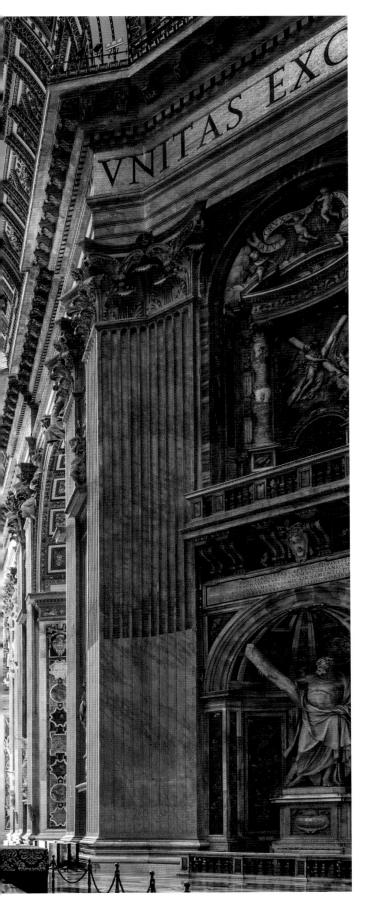

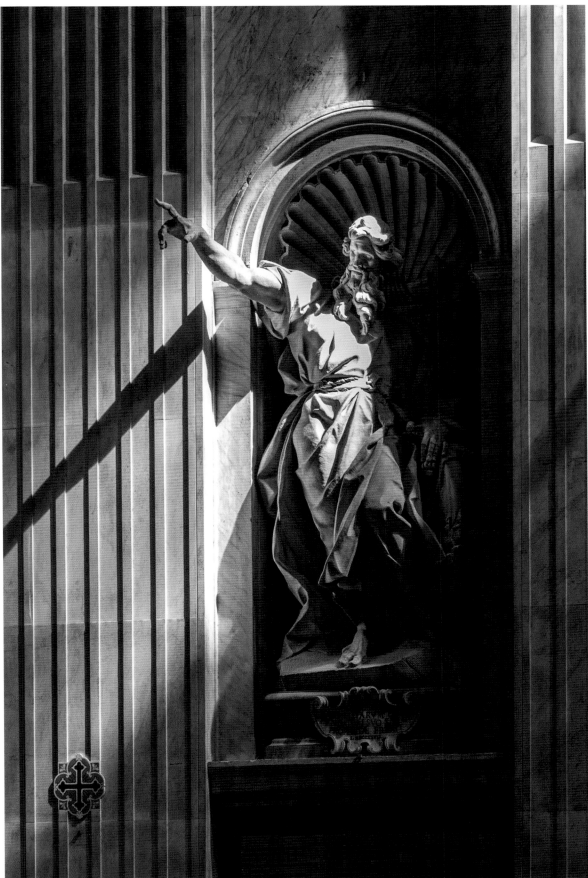

The ovoid proved to be a fortunate aesthetic choice. His partner on the project, Domenico Fontana (1543–1607), moved the obelisk from the site of the Circus of Caligula to the center of the square in front of St. Peter's, which, at that time, was not only lacking a facade but was also masked by disparate former constructions.

With the pontificate of Paul V (1605–1621), the project accelerated, but the new basilica repeatedly came up against the separation wall built in 1538 to protect the part of the old Constantinian basilica that was still in use. The perilous demolition began again in 1606 to the great displeasure of conservators, who managed to impose their opinion: lengthen Michelangelo's nave to cover and protect the former sacred site of the old basilica. Thus, the Latin cross was adopted again, as it was deemed to be more Christian. The pope appointed a new architect, the Italian Carlo Maderno (1556–1629), to carry out the extension. Although it forever distorted Michelangelo's plan, this extension would lead to the St. Peter's we know today. A slight shift in the axis (to align with the obelisk) and the somewhat narrower nave with two aisles explain why the space feels like it opens up as one approaches the transept. The facade remained a problem. Maderno added a heavy attic story or top story that lent it a slightly compacted and even unfinished look. And the broad facade was meant to accommodate two bell towers at its ends, which never materialized. The architect made up for it with the portico, or vestibule, which is irrefutably grand.

Maderno's retirement marked the end of the early Roman Baroque period. The beginning of the seventeenth century's great Baroque style was exemplified by Gian Lorenzo Bernini (1598–1680), named architect of St. Peter's in 1626. Three years earlier, he had started by building the astounding baldachin (a canopy placed over an altar or tomb), which measures ninety-five feet (29 m) high. Its four bronze Solomonic columns were greatly debated and their construction entailed odd deaths and labor strikes. He added a majestic loggia (balcony) to each of the cupola's four columns and attempted to add bell towers to Maderno's facade, which almost collapsed due to the unstable ground below. The bell tower plans were abandoned in 1641. He also added Urban VIII's (1623–1644) tomb (with skeleton) and designed the marble bas-relief decor for most of the columns of the nave and the Cathedra Petri, a sculpted gilt bronze casing which holds a modest wooden throne thought to be St. Peter's. Our contemporary view of the basilica's interior decor owes everything to Bernini's interventions and undeniable genius.

In 1657, work began on the elliptical colonnade that surrounds the oval plaza as well as on its obelisk and two fountains. With those additions, whose magnitude and geometric perfection are unrivaled, Bernini integrated the basilica into the surrounding urban plan while isolating it from the growing number of buildings that continue to assail it. Despite the trials and pitfalls of the basilica's conception and construction, Bernini turned St. Peter's of Rome into one of the absolute masterpieces of Western art.

PAGE 17 *TOP LEFT*: Bernini's (1598–1680) Baroque masterpiece, the famous Cathedra Petri (1666). It includes a throne assumed to have belonged to St. Peter. ✚ PAGE 17 *BOTTOM LEFT*: View of the 597-foot (182-m) nave, toward the facade. With its 247,570 square feet (23,000 sq. m), St. Peter's is one of the largest churches in the world. ✚ PAGE 17 *RIGHT*: The ninety-five-foot (29-m) baldachin weighs sixty tons. Underneath, in the crypt, is the tomb of St. Peter.

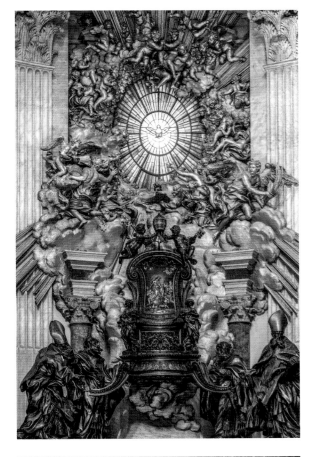

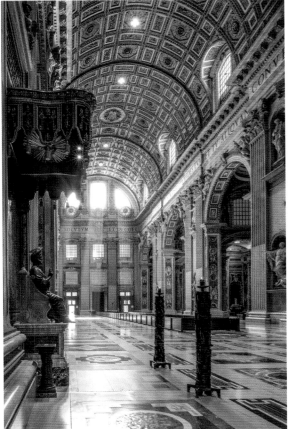

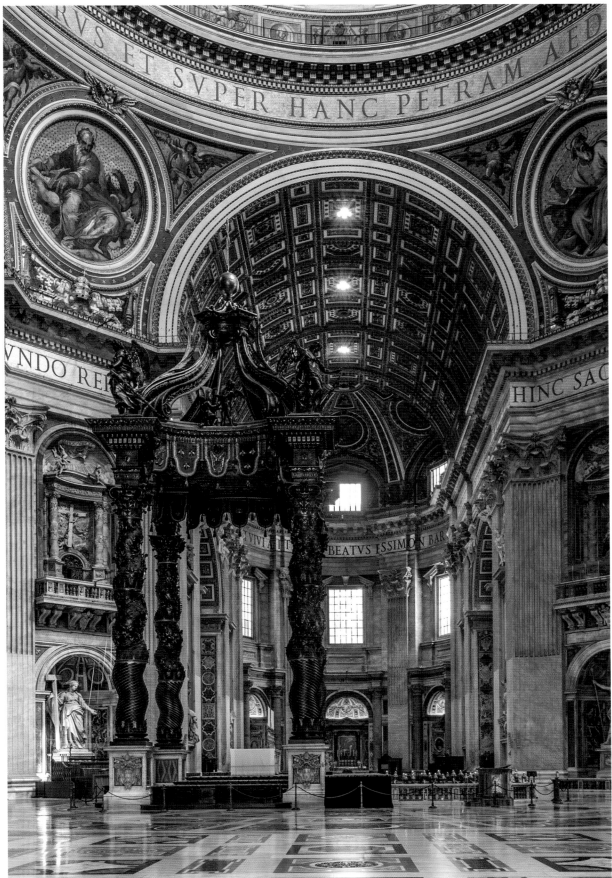

PAPAL BASILICA OF SANTA MARIA MAGGIORE

ROME ▫ VATICAN

During the fourth century, the Catholic Church readily invested in the miraculous. For instance, the Virgin Mary was said to have appeared in a dream simultaneously before Pope Liberius (352–366) and a rich patrician, Giovanni. It is said that she asked them to build her a shrine at a site that she would indicate by way of a miracle. The following day, on August 5, snow fell on Esquiline Hill, an unlikely occurrence for the season. The pope then traveled there and used a stick to trace the plan for a church, which Giovanni financed. However, it is Sixtus III (432–440) we should thank for the present-day basilica, which was built at the same site and dedicated to the Virgin Mary right after the Council of Ephesus, in 431, proclaimed that Mary was the Theotokos (Mother of God).

Santa Maria Maggiore is the only early Christian church in Rome to have retained its original plan, despite multiple modifications over the centuries. In the eighteenth century, it was entrenched among enormous buildings, making it look like a Baroque palace. The gigantic and well-proportioned nave is separated from the aisles by a row of massive columns, some of which are Roman replacements. A continuous entablature (horizontal molding) connects them, and eleven of the original twenty-one windows open above it. The extraordinary wood coffered ceiling, by the Sangallo brothers, dates from the very end of the fifteenth century. Its gilded decor is said to have been executed using the first boatload of gold brought from Peru to Spain, a portion of which was offered to the pope by Ferdinand II (1452–1516), also known as Ferdinand the Catholic. The vast mosaic carpet on the floor, made by members of the Cosmati family in the thirteenth century, is a marvelously powerful and intricate example of the Cosmatesque style that would spread through southern

PAGE 19: Santa Maria Maggiore is one of the four papal basilicas of Rome, along with St. Peter's, St. John Lateran, and St. Paul Outside-the-Walls. The ceiling (late fifteenth century), designed by Giuliano da Sangallo the Elder (1453–1534), is said to have been gilded using gold from Peru.

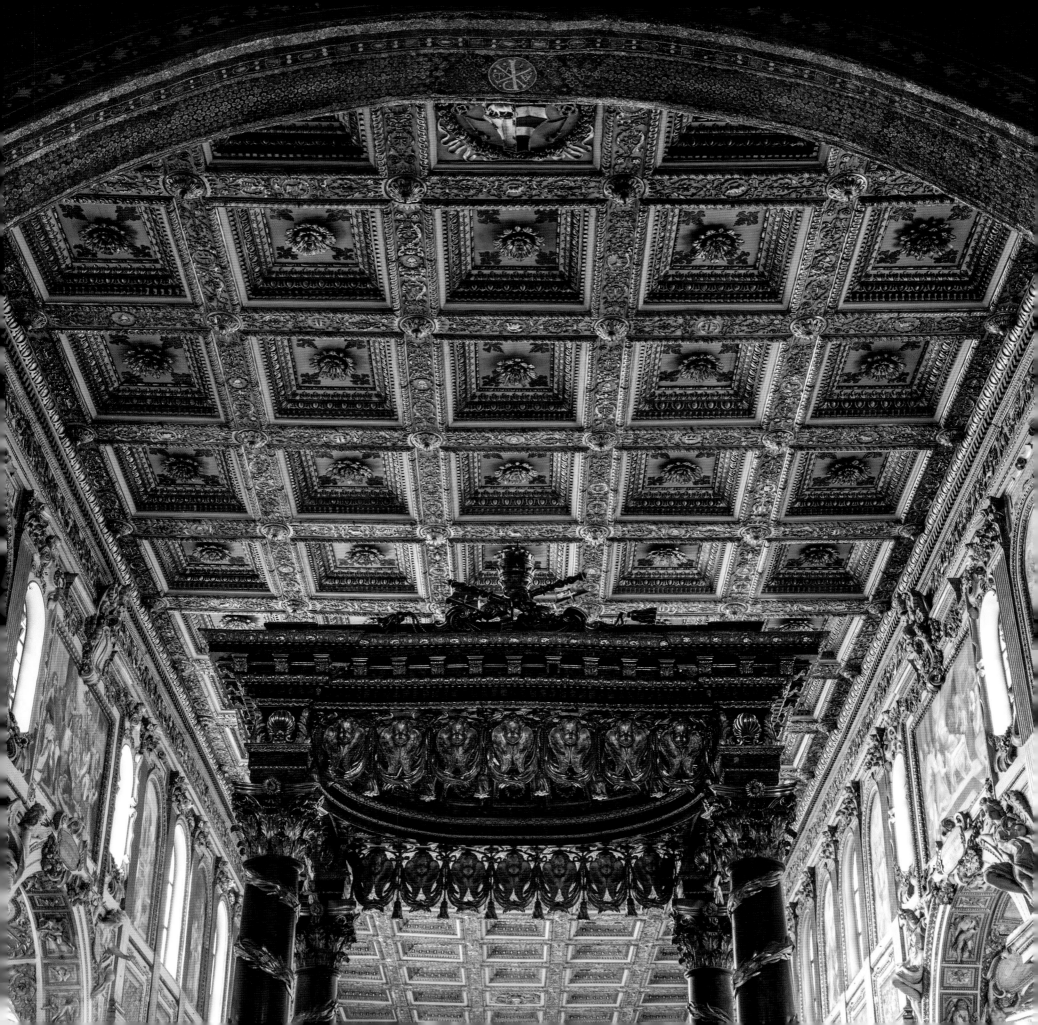

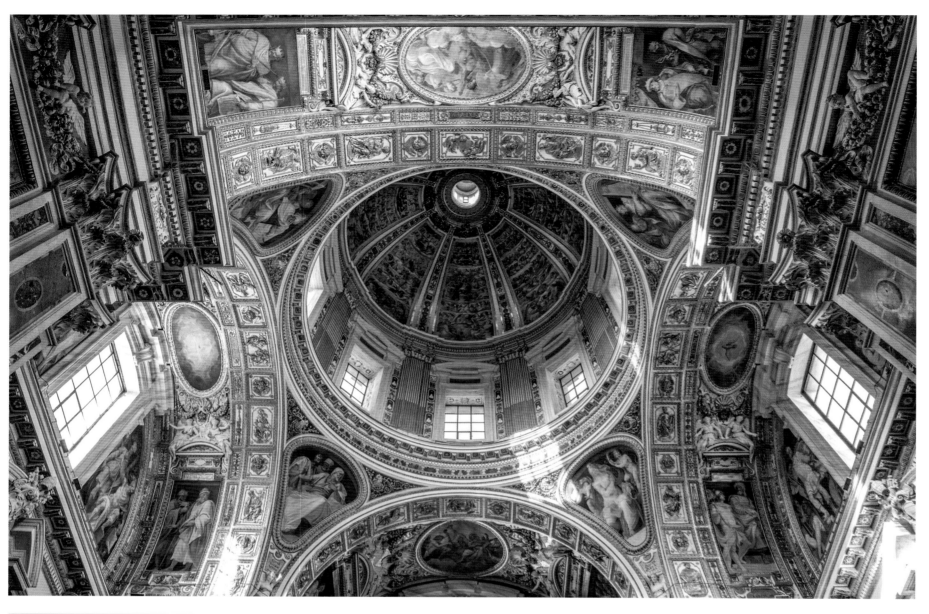

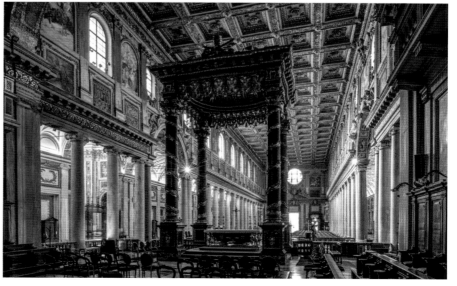

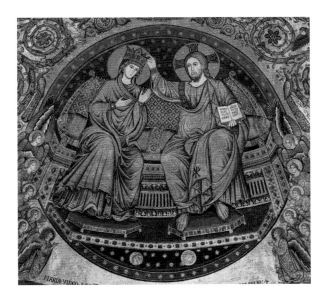

Europe. On the walls, rich iconography on the themes of Christ's genealogy and the affirmation of his divinity is expressed in twenty-seven mosaic panels that bear traces of Byzantine influence (originally, there were forty-two). They date from the fifth century. In the thirteenth-century apse (semicircular or polygonal end of an aisle), the life of the Virgin Mary is recounted and celebrated, again in mosaics, between the curls of two entwined acanthus trees.

PAGE 20 *TOP*: Cupola of the Sistine Chapel, built by Sixtus V (1585–1590) at the end of the sixteenth century to house his tomb, the tomb of his family, and that of Pius V (1566–1572). ╬ PAGE 20 *BOTTOM LEFT*: The baptistery chapel with baptismal fonts (1825) by Giuseppe Valadier (1762–1839). ╬ PAGE 20 *BOTTOM RIGHT*: The elegant baldachin with porphyry columns is the work of Ferdinando Fuga (1699–1781). Underneath, one of the first crèches in the history of the church. ╬ PAGE 21 *LEFT TO RIGHT*: In the apse, the mosaic of the *Coronation of the Virgin* (circa 1296), by Jacopo Torriti, and a detail of the two giant acanthus trees around the scene.

At the foot of the altar is a small crypt, or confession, built by Virginio Vespignani (1808–1882), the nineteenth-century architect to the popes; in it is a crystal urn containing relics of Christ's crib.

Such luxury at the gates of the city—it was one of four Roman papal basilicas—could only draw the attention of the popes of the Counter-Reformation, for whom respect of heritage, whether ancient or Early Christian, was not a chief concern. Three new chapels were added around the nave: the Sistine, Pauline, and Sforza. Sixtus V (1585–1590), the sixteenth-century pope who is known for his lasting influence on the Eternal City through his numerous urban planning projects, deemed the site worthy of receiving his and his family's tombs. He asked Domenico Fontana (see St. Peter's basilica page 16) to build the enormous and luxurious Sistine Chapel, even though it meant demolishing another chapel and interrupting the nave's entablature. At the beginning of the seventeenth century, Paul V (1605–1621) had his family chapel, known as the Pauline

PAPAL BASILICA OF SANTA MARIA MAGGIORE

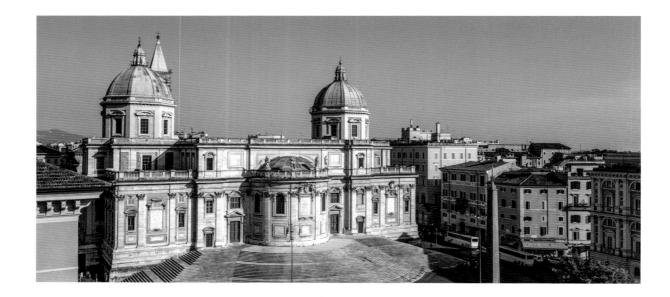

as well as his tomb, built across from Sixtus V's. Designed by the architect Flaminio Ponzio (1560–1613), the chapel was adorned with rare marble and precious stones. The adjacent Sforza Chapel was based on drawings by Michelangelo, but built after his death. Modest in execution, it represents the Renaissance genius's final stage in the evolution toward architectural abstraction.

The outside of the Papal Basilica of Santa Maria Maggiore is equally fascinating. The original basilica is surrounded by palatial buildings dating from the eighteenth century that incorporate the former structure, chapels, courtyards, an indoor garden, a college, offices, halls, large staircases, and even the highest campanile (bell tower) in Rome, which dates from 1375. The sanctuary is the only one in Rome to have two squares: one in back, around the apse with an Egyptian obelisk at its center; and one at the foot of the eighteenth-century facade, enlivened by the Column of Peace. The marble column is topped by a statue of the Virgin and was erected in the center of the

square on the order of Paul V in 1614. The palatial facade was built on top of the former facade, by Ferdinando Fuga (1699–1781), and elegantly connects the buildings. It left room for a loggia for papal benedictions while protecting the mosaics on the former facade; it also exhibits the formal brilliance of five arcades beneath three other arcades, and the play between arched and triangular pediments.

Every year, on August 5, to commemorate the "Miracle of the Snow," a shower of white petals falls from the ceiling onto the faithful gathered in prayer, continuing to bear witness to the Church of Rome's very ancient history.

PAGE 22: In the back, the basilica's second square, by Carlo Rainaldi (1611–1691). ‡ PAGE 23 *TOP LEFT*: The basilica is enclosed within a series of courtyards, buildings, and passages. ‡ PAGE 23 *BOTTOM LEFT*: Detail of the luxurious marble mosaic floor, by the Cosmati family (thirteenth century). ‡ PAGE 23 *RIGHT*: In the Pauline Chapel, the statue of Pope Clement VIII (1592–1605), by Silla Longhi (1569–1622).

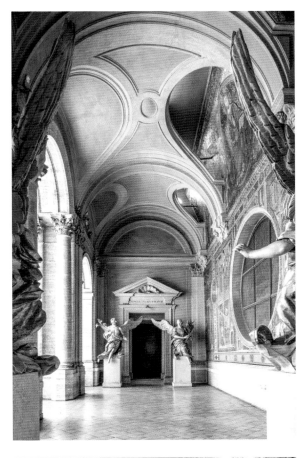

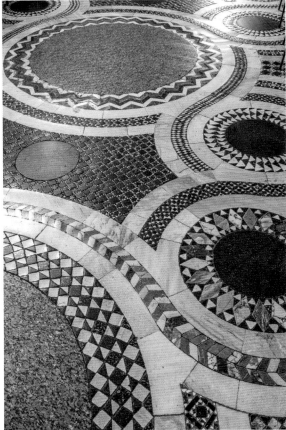

CAPPELLA PALATINA

PALERMO ▫ ITALY

At the heart of the enormous Norman palace that has dominated the city for almost one thousand years, a wide staircase with red marble steps, polished by time, leads to the main floor, which surrounds a courtyard bordered by a succession of arches. A sculpted doorway, almost modest in style, opens onto one of the most sumptuous vestiges of the Hauteville dynasty. The early Hauteville brothers were from a family of minor Norman nobility. After the death of their father, Tancred of Sicily, they conquered a large portion of southern Italy and Sicily. The brothers' eruption onto the stage of history stoked conflicts between the three major forces of the Mediterranean region at the time: the Byzantine Empire, the Arabs, and the Roman Catholic Church, which continued to be preoccupied with secular authority. For a time, the alliance between the Normans and the church was a means of limiting Byzantine and Arabic influence in southern Italy and Sicily.

In 1132, Roger II (1095–1154), self-declared king of Sicily, launched construction of a new chapel in the former Arabian palace he was renovating. The project lasted eight years. A ruthless warlord and a shrewd politician, he was also cultured and interested in the arts. He even corresponded with Bernard de Clairvaux (1090–1153) and Suger (1081–1151), the French abbot. Roger II understood that tolerance might allow him to better establish his power over a Sicily that was still Arabic-speaking and Muslim.

PAGE 25: The majestic Christ Pantocrator (ruler of all) in the apse, in mosaic, is attributed to twelfth-century Byzantine craftsmen. ‡ PAGE 26 *TOP LEFT*: Half-dome of the left lateral chapel. The mosaic depicts John the Baptist. ‡ PAGE 26 *BOTTOM LEFT*: A mosaic depicting the baptism of Christ. ‡ PAGE 26 *RIGHT*: The cupola surmounting the main altar is also decorated with a Christ Pantocrator and is illuminated by nine bay windows. ‡ PAGE 27: All the walls and arches are covered in mosaics representing the saints and fathers of the church.

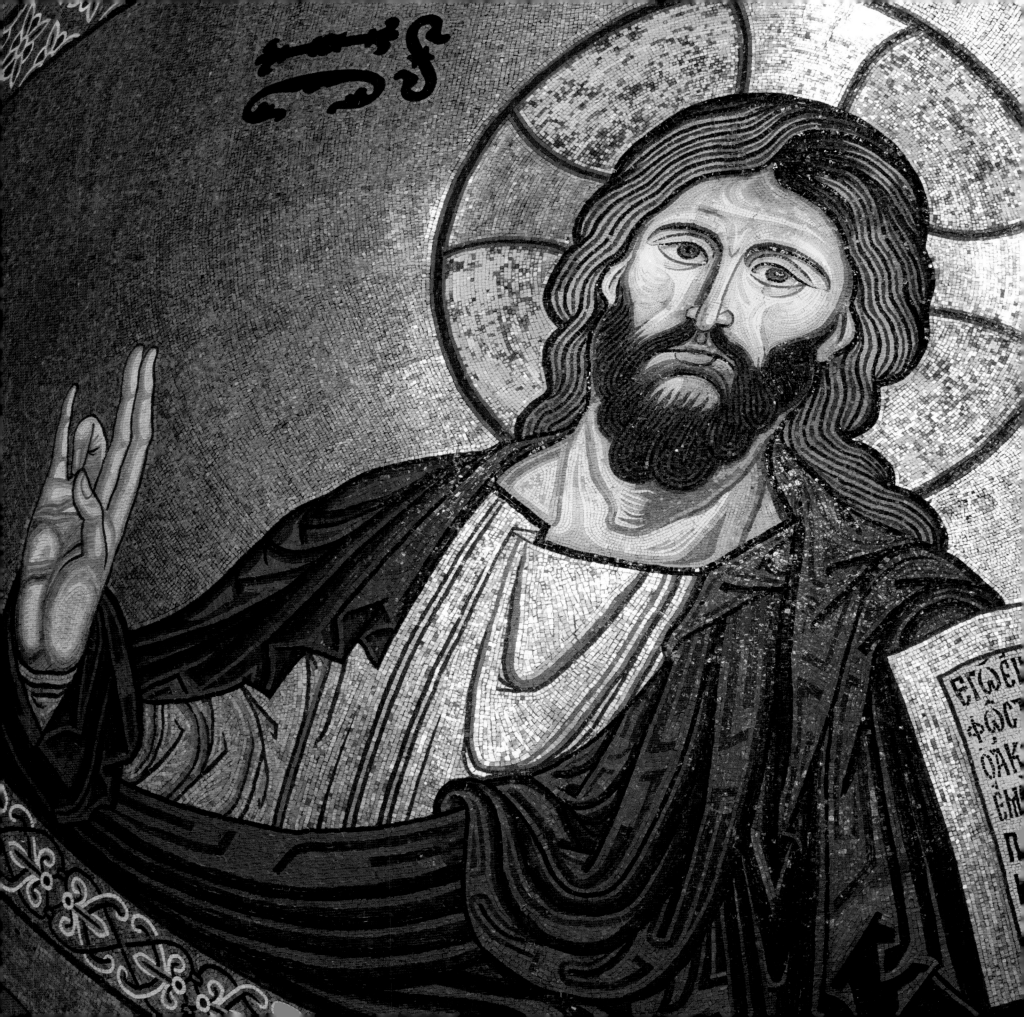

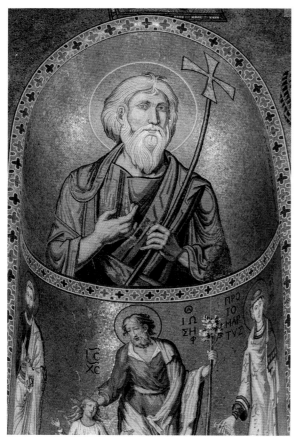

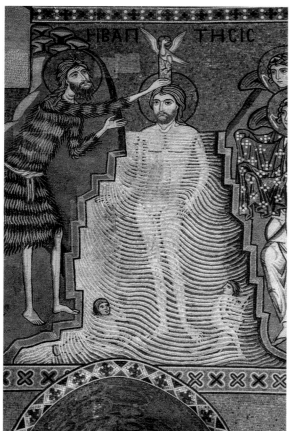

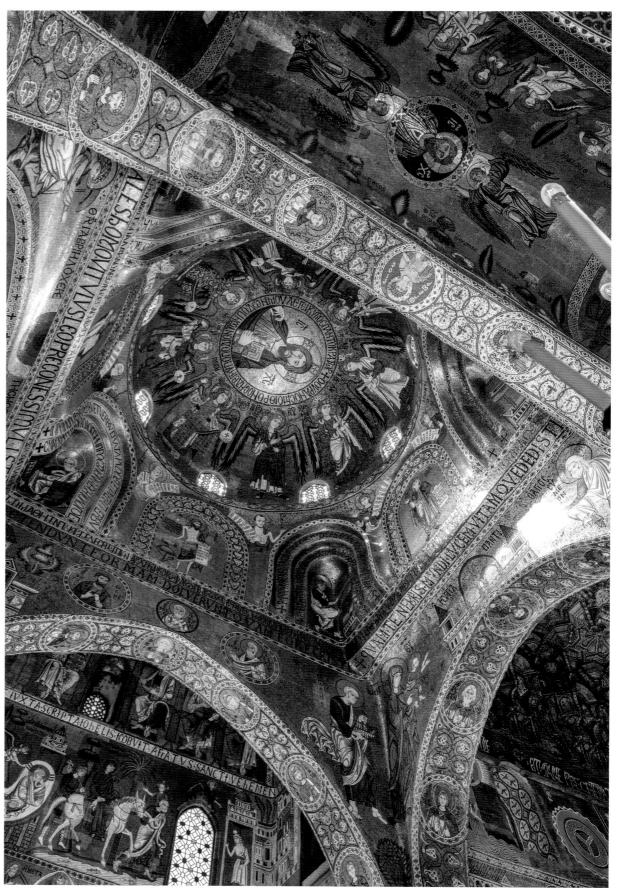

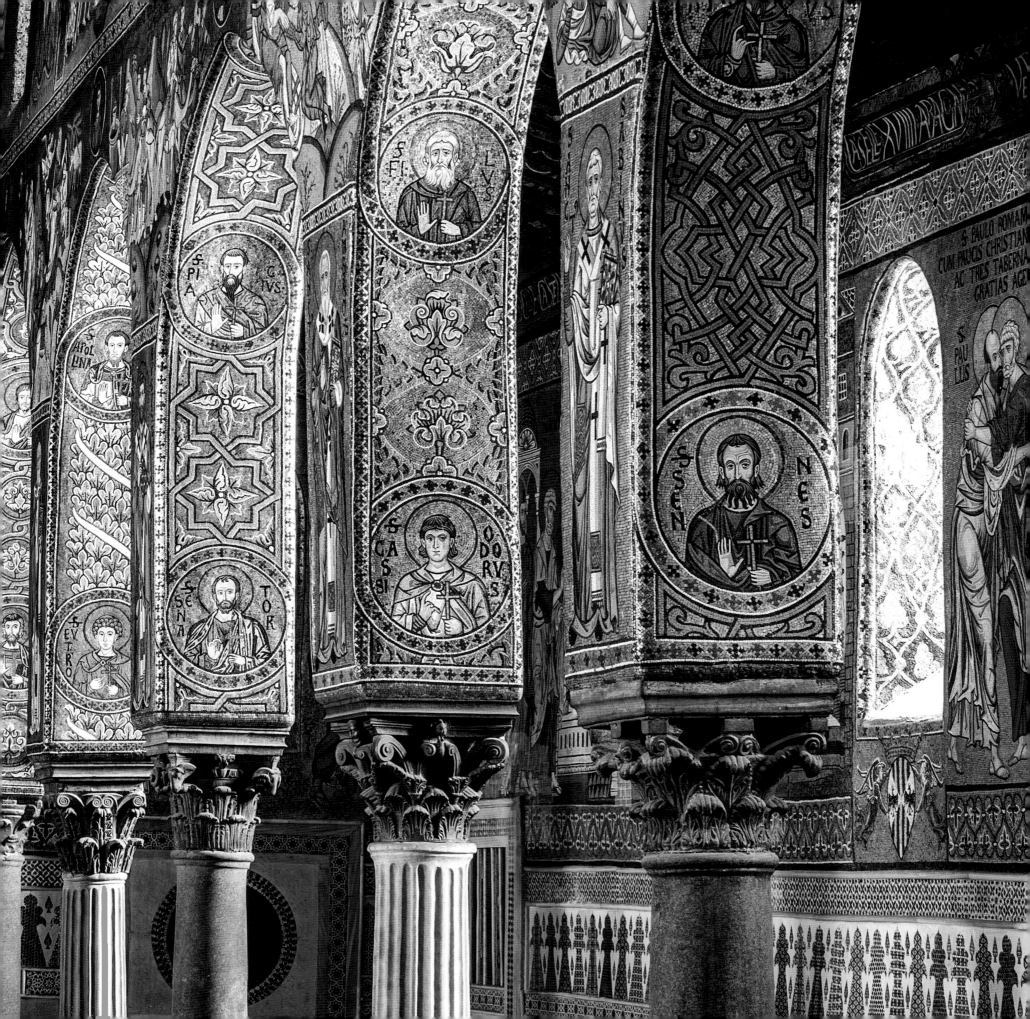

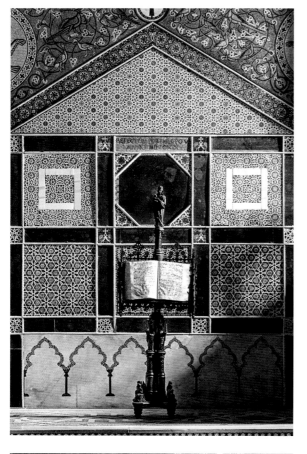

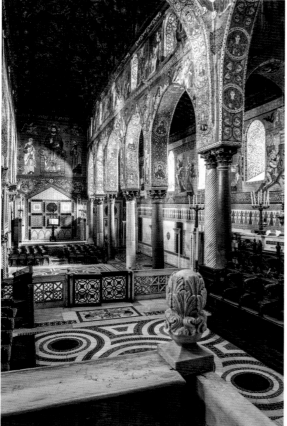

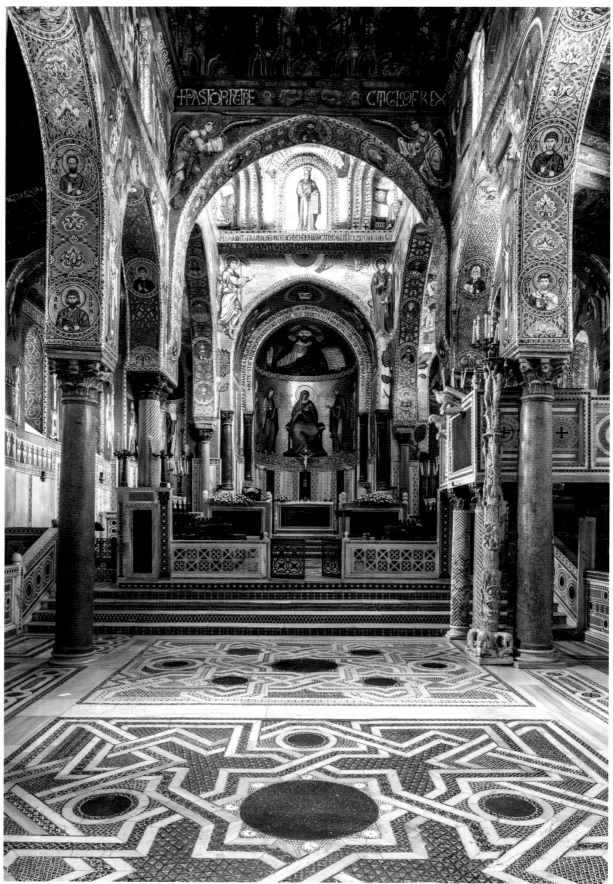

CAPPELLA PALATINA

To a certain extent, the Cappella Palatina (Palatine Chapel) illustrates that political, religious, and cultural approach. Relatively small in size, it presents itself as a sumptuous architectural object. Enclosed, it has been hidden from both the outside and the inside of the palace since the Spanish renovations during the sixteenth century.

Sicilian Norman in style, its very simple plan is only slightly different from that of a basilica: a main nave occupies almost the entire space, two lateral naves serve mostly as corridors, and a raised choir culminates in an apse and two apse chapels. Its visual impact therefore is not tied to its architecture so much as to its amazing mosaics, which, somewhat Byzantine in style, line the inside of the cupola, the apses, and the walls above the marble panels. They vividly depict scenes from the Old and New Testaments. The floor, which a twelfth-century monk-philosopher compared to "a meadow in the springtime . . . unassailable and eternal," is a stunning composition of rare and luminous inlaid marble in the opus sectile technique.

Gold abounds, particularly in the cupola and the barrel vaults. The gold was intended to reflect light from the few windows, but especially from chandeliers and oil lamps.

The most astounding element is the gilded ceiling, which is Arabic in style. A coffered ceiling composed of eight-pointed stars lines the nave and is echoed along the walls by a row and a half of *muqarnas* (stalactic-like decoration). That "sky," which contemporaries compared to a "meadow," expresses an iconography that is Islamic in spirit. It is filled with colorful representations of birds, plants, people, and small scenes against gold backgrounds, which are accompanied by kufic inscriptions used to summon divine blessings. The meaning of such Islamic decor has been greatly debated, although the fact that it was illegible from the floor has not been acknowledged. One can reasonably conclude that it was nothing more than a symbolic gesture on the part of Roger II toward the artists and Muslim community in his new kingdom, especially because some of the mosaics illustrate Christian proselytism and because the cupola includes a marvelous Byzantine Christ Pantocrator, affirming the universality of the Christian religion.

The chapel of the Norman palace in all its extraordinary luxury—with its decorative program, complex iconography, and gold—served as a political message and, to a certain extent, continues to do so. More than just visiting a church, visitors today feel they are witnessing the miraculous preservation of a forgotten era, evidence of a mysterious culture and religion that has traveled across time.

PAGE 28 *TOP LEFT*: The back of the chapel. The geometric composition in marble mosaics was in all likelihood executed by Arab craftsmen. ☩ PAGE 28 *BOTTOM LEFT*: The nave, as seen from the altar. In the back, Christ between St. Peter and St. Paul. ☩ PAGE 28 *RIGHT*: The nave, between the Cosmatesque mosaic floor, which symbolizes the earth, and the gilded ceiling with inscriptions, which symbolizes the sky.

SAN MAURIZIO AL MONASTERO MAGGIORE

MILAN ▫ ITALY

In 1499, life in Milan continued undisturbed, even though the Lombard capital had fallen to the French fifteen years earlier. And so the monks of the Monastero Maggiore, the huge Benedictine monastery reserved for daughters of the upper aristocracy, decided to build a new church to replace the previous one, which dated from the Carolingian period and was in poor condition. The convent buildings were partially constructed on what remained of the city ramparts and the ruins of the Roman circus. The project was entrusted to Gian Giacomo Dolcebuono (1445–1504), a sculptor and architect from Ticino, who contributed to the construction of the Milan Cathedral and the Certosa di Pavia, a monastery in Lombardy.

The exterior architecture is relatively plain: a simple facade in the Renaissance style that is adjoined to the convent. Composed of a modest entrance, three arched windows, an oculus, and a curved pediment, the three-story facade is punctuated with projecting cornices and fluted columns.

The interior architecture is more original, in part because this convent church was open to the public. The unique nave is divided down its length by a wall separating the section meant for congregants from the one reserved for priests and nuns. There is room at the top of the partition (*tramezzo*) for sound to pass over. For a century, a

PAGE 31: Christ on the cross, from the early Renaissance, installed on the choir tribune in the hall of the nuns. ‡ PAGE 32: The *aula* (hall) is decorated with frescoes, most of them by Antonio Campi (1524–1587) and Bernardino Luini (c. 1485–1532), a peer of Leonardo da Vinci (1452–1519). ‡ PAGE 33: Passage beneath the tribune. The vaults attributed to Vincenzo Foppa (1427–1515) represent the Eternal Father in front of a star-filled sky.

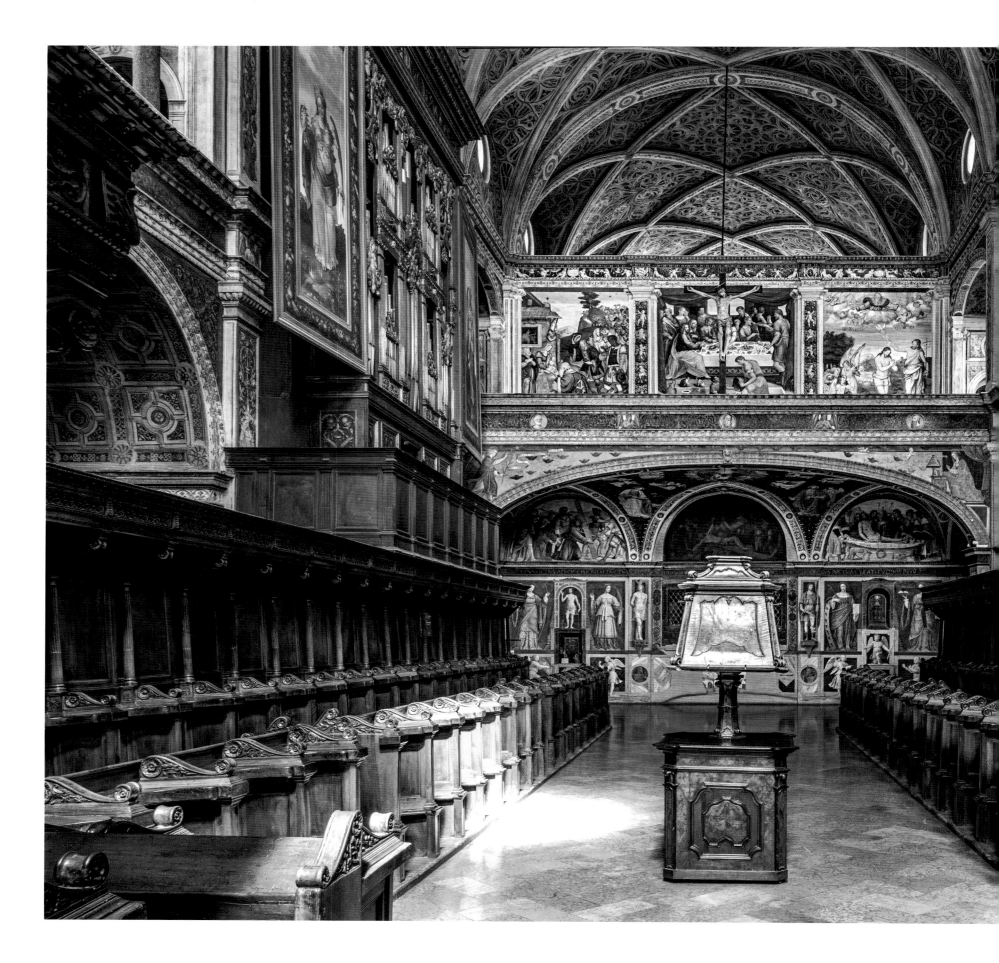

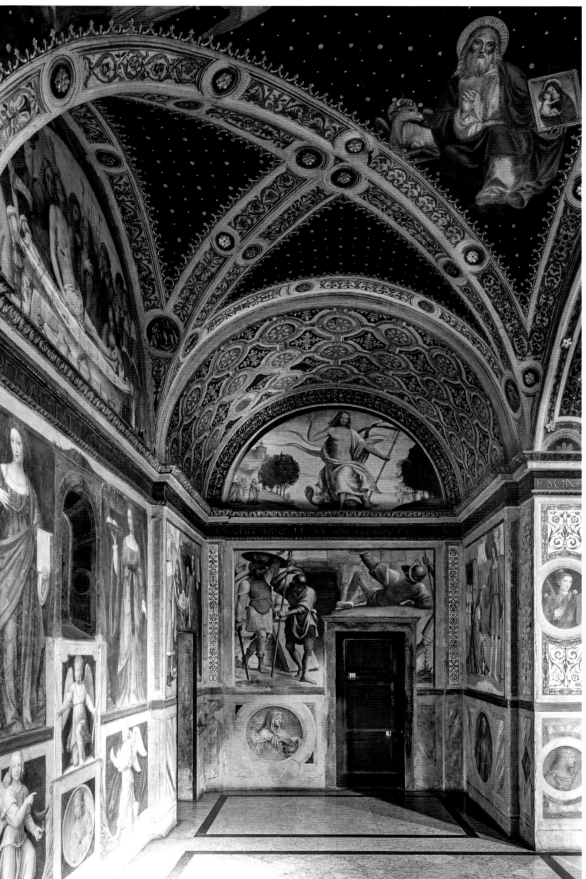

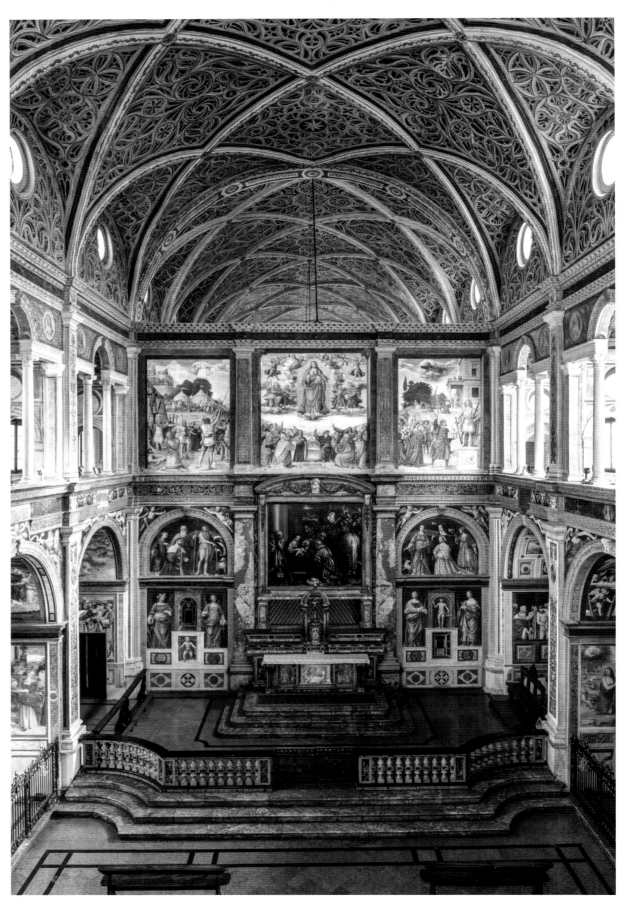

grate above the altar on the public side allowed nuns to have a partial view of the outside world. The archbishop Charles Borromeo (1538–1584) had it removed at the end of the sixteenth century, after which there remained only a small window to allow nuns to receive communion.

Both sides of the nave have a gallery floor, the *matroneum*, reserved for women. On these gallery floors, a row of very elegant Palladian arches look out onto the nave, mirroring the shape of the windows to the outside.

No architectural description can capture the extraordinary visual shock that an enthusiast of Renaissance painting experiences upon entering the nave. All the walls, in their entirety, including the vault, the ceilings, the entablatures, the portals, the pilasters, and the partition, are covered in frescoes and decorations by the great painters of the late Lombardy Renaissance, influenced by Leonardo da Vinci (1452–1519); Bernardino Luini

PAGE 34 *TOP LEFT*: St. Catherine of Alexandria, attributed to Bernardino Luini. ✝ PAGE 34 *BOTTOM LEFT*: Noah's Ark, attributed to Aurelio Luini (1530–1593), Bernardino's son. ✝ PAGE 34 *RIGHT*: The *aula* for congregants. Its ribbed vaults have trompe-l'oeil tracery. The altar decorated with the painting *The Adoration of the Magi* by Antonio Campi (1578) sits in front of the wall that separates the hall for congregants and the hall for the nuns.

(1485–1532), with his serene, always classical style; Luini's sons, Giovan Pietro, Aurelio (1530–1593), and Evangelista; Giovanni Antonio Boltraffio (1467–1516); and Bernardo Zenale (1464–1526). Recent restoration has given light, delicate color, and depth back to the frescoes, which had been soiled over the centuries by smoke from candles and incense, pollution, humidity, and salt. Because of the variety of artists, sizes, and scenes—from Noah's Ark to the Crucifixion—and because of the various compositions and their incorporation into the architecture, the Church of San Maurizio today is one of the most astounding museums of religious painting from the Renaissance.

San Maurizio al Monastero Maggiore has had a turbulent life, falling victim to political threats, the passage of time, and the pressures of real estate. The convent, which was secularized in 1798 (again under French occupation), was transformed into barracks, into a school for young girls, and into a military hospital. It was partially demolished to make room for apartment buildings and may have been bombed in World War II before becoming the Civic Archaeological Museum of Milan. That the church has survived is a miracle, but it was deconsecrated. Fully restored between 1997 and 2015, it has become one of Milan's main tourist attractions and was recently nicknamed the "Sistine Chapel of Milan," a moniker that does not do justice to its unique character.

CHURCH OF THE GESÙ

PALERMO ▫ ITALY

Located in the historic district of Albergheria, the Church of the Gesù, also known by locals as Casa Professa, attests to two historical developments: the rise of the Jesuits, who arrived in Sicily as early as 1546, and the growth in Sicilian prosperity during the seventeenth century, which unleashed social upheavals. The aristocracy, which had been rural, emigrated toward cities and built expensive and lavish residences that allowed its members, particularly those in Palermo, to lead lives of luxury similar to ones in other European capitals. The new Jesuit church enthusiastically competed in the fevered race toward such opulence and ostentation; for the new religious order, nothing was too beautiful when it came to glorifying Christ.

Ignatius of Loyola (1491–1556), who had founded the Jesuit order in 1534 in Paris, was a protégé of the Spanish viceroy of Sicily. The viceroy welcomed the Jesuit priests who founded a college in his capital, and the institution grew quickly. The church that was entrusted to it soon proved too small. In 1564, the Jesuits began construction on a new ecclesiastical complex, which was completed in 1577, with aisles added shortly thereafter. An architect in the order, Father Tommaso Blandino (1585–1628), who designed the cupola (small, often dome-like structure on the top of a building) and the apse, oversaw another expansion in 1606. The church we see today was severely damaged by Allied bombing in 1943, which caused the turquoise cupola to collapse, ravaging the inside. After a long and extensive restoration, the site has regained its splendor, save for certain frescoes and paintings, which for the most part are modern.

The facade follows the standards of Jesuit Baroque architectural norms of the time. Sober in design, the pediments of its three portals are surmounted by statues, and the crowned upper tympanum (decorative wall over the entrance) bears the IHS Christogram—a Greek monogram

PAGE 37: The ornate decoration attests to the masterful skills of the local and Neapolitan artists who worked on the project for close to two hundred years.

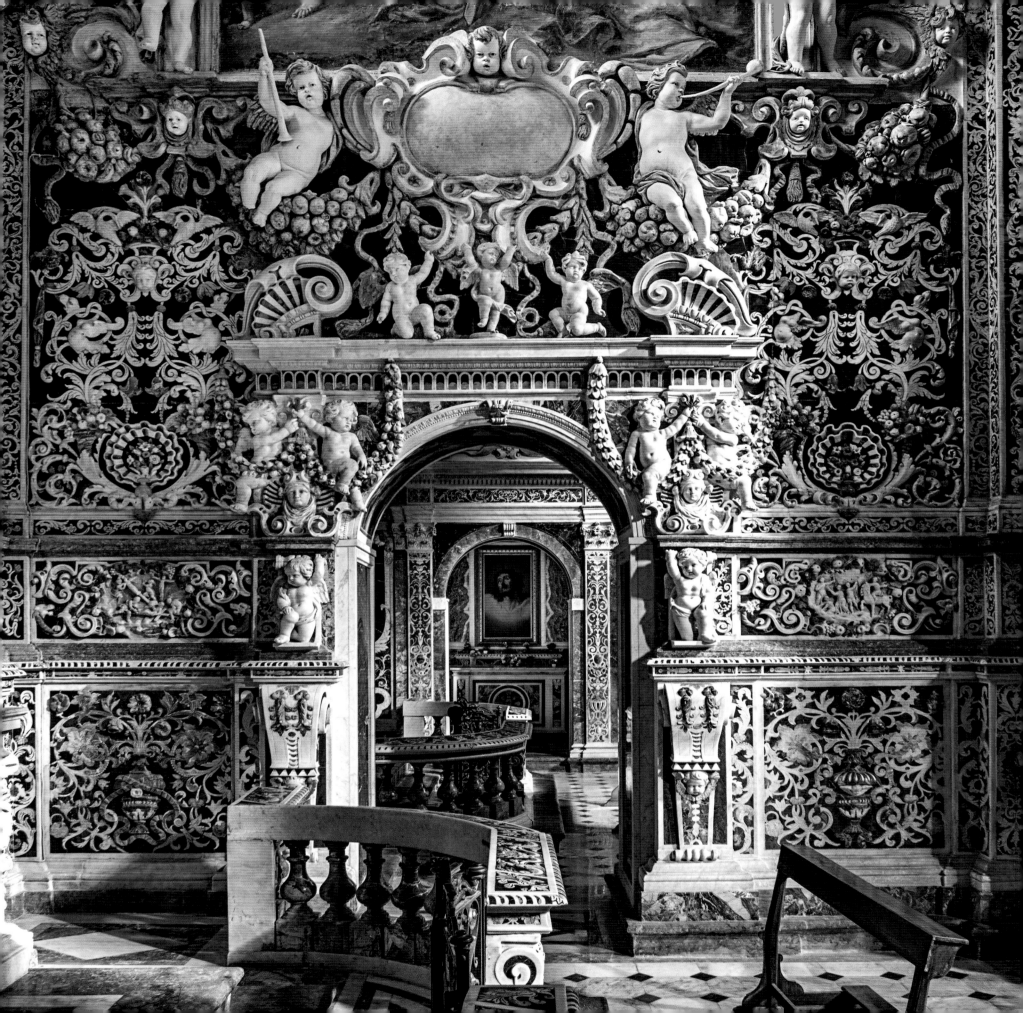

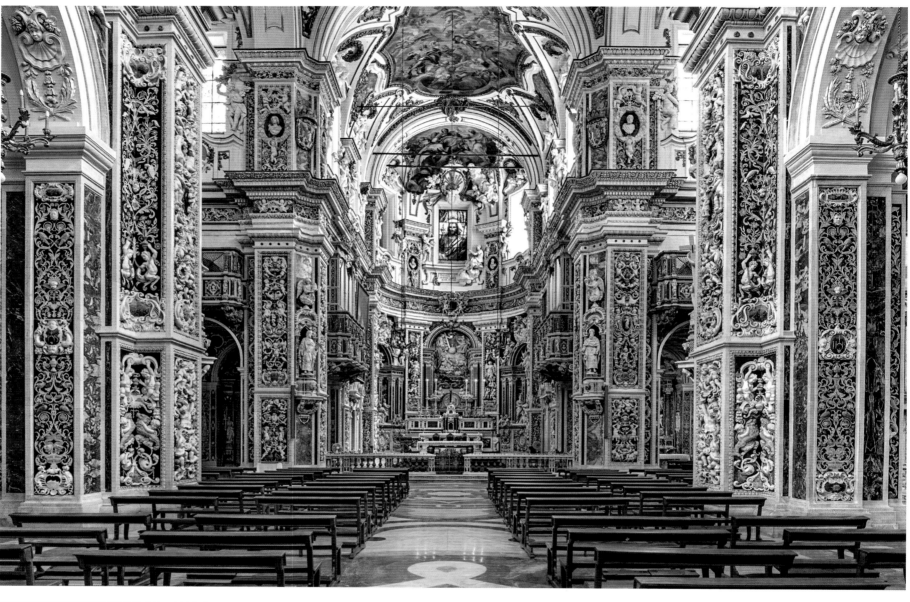

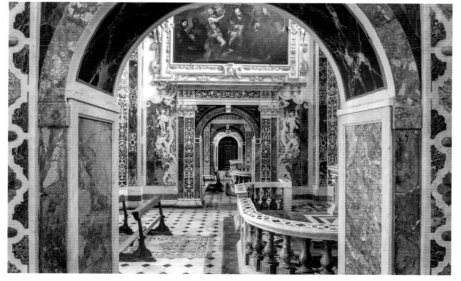

or abbreviation of Jesus Christ. As a whole, the building is exceptionally sophisticated, especially in comparison with its modest neighborhood.

Wealth, extravagance, ostentation, virtuosity, excess, detail, and drama: words cannot do justice to the inside, but there is one word that does not apply—restraint.

PAGE 38 *TOP*: The nave culminates in the presbytery, the area around the altar, which is dominated by a vibrantly colored stained glass window depicting Christ. ‡ PAGE 38 *BOTTOM LEFT*: Passage between the apse chapel and the apse. ‡ PAGE 38 *BOTTOM RIGHT*: Apse decoration, *Achimelec and King David*, by Gioacchino Vitagliano (1669–1739). ‡ PAGE 39 *LEFT*: Marble *mischi* (inlay) decorates the space. There are many motifs, and hundreds of putti—representations of small, often winged cherubs or infants. ‡ PAGE 39 *RIGHT*: Infinite variations on both traditional and modern motifs can be seen in the marble decoration throughout the space.

The Church of the Gesù, as well as the churches of St. Catherine and the Immaculate Conception, all three in Palermo, are indeed among the highlights of effervescent Baroque decor in Sicily, rivaling Naples.

A number of artists of great talent were called upon to adorn the floors, ceilings, walls, pillars, chapels, and altars. The project continued until 1767 and resumed in 1805, when the Jesuits returned after forty years in exile.

Donald Garstang, the American art historian, describes the church's decor as "unleashed fancy." According to the classic formula, painters, sculptors, and especially marquetry craftsmen left not one inch untouched. Sicilians had become masters in *marmi mischi e tramischi*, a technique incorporating marble marquetry, colored stones, and elements of sculpted white marble. The highly skilled artists and craftsmen of Sicily made use of the abundant presence of colored marble on the large island. The Church

of the Gesù is thus a genuine catalog of the color and formal possibilities of that original approach. Renowned painters from the period, such as Vito d'Anna (1718–1769), were also involved, as were sculptors such as Gioacchino Vitagliano (1669–1739), Ignazio Marabitti (1719–1797), and Giacomo Serpotta (1656–1732), one of the virtuosos of Sicilian stuccowork.

The iconography, developed by the Jesuits over a long period, presents a biblical narrative revolving around the celebration of the glory of Jesus and the Virgin Mary. A contemporary visitor might nevertheless wonder about the meaning of the many fat-bottomed and chubby-cheeked putti (cherubs), who seem to mischievously tumble down the walls, fight viciously, and tenderly intertwine; the charming ephebes (youths of military age), who seem rather removed from any reflection of Christ; and the handful

of very realistic peasants. The elaborate Baroque decorations are intended to arouse feelings of religious ardor and exaltation, and these feelings are only amplified by this delightful population constructed of marble and stucco. In its history and decor, the Church of the Gesù draws on fantasy in the face of tragedy and on dream in the face of reality, in a fashion that is typical of marvelous Sicily.

PAGE 40 *LEFT*: Detail of twisting columns with garlands of white marble. ‡ **PAGE 40** *RIGHT*: While the doors are made of wood, their frames were an opportunity for marble sculptors to express their creativity. ‡ **PAGE 41** *TOP LEFT*: One of two organ chambers, which face each other in the choir. ‡ **PAGE 41** *BOTTOM LEFT*: Passage beneath the organ chamber, rebuilt in 1954. ‡ **PAGE 41** *RIGHT*: The floors (rebuilt after the bombings in 1943) are in marble marquetry and echo classic geometric motifs in a greatly enlarged format.

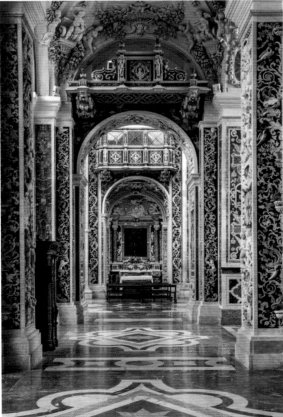

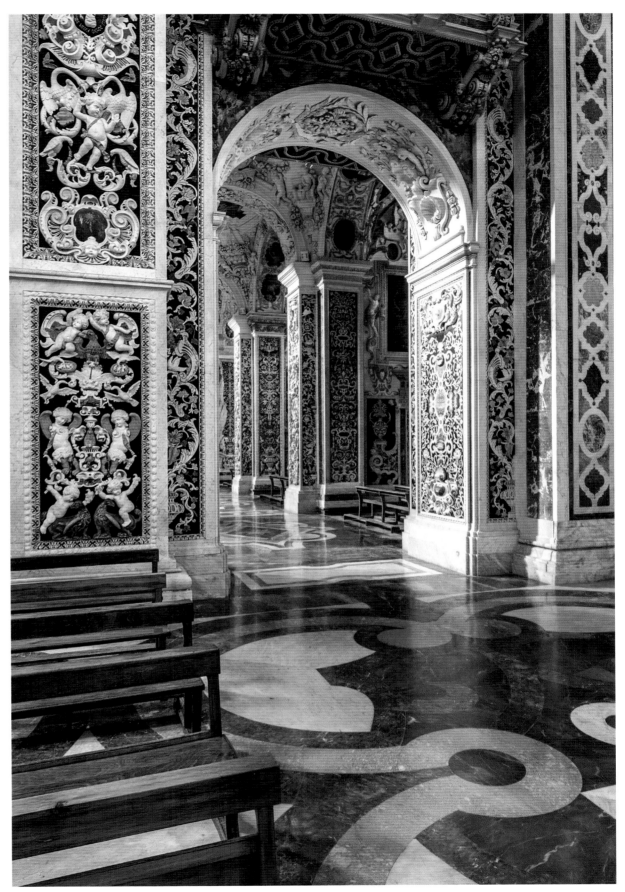

CAPPELLA SANSEVERO

NAPLES · ITALY

Raimondo di Sangro (1710–1771), the seventh prince of Sansevero and Castelgrande, and Peer of Spain, was one of the most mysterious members of a certain European intellectual elite during the eighteenth century. The group was drawn to freemasonry, esotericism, philosophy, languages, scientific experiments, technology, alchemy, and the arts. Di Sangro was at times considered to be a magician and was later described as a "Neapolitan Faust." Accused of heresy, he only narrowly avoided excommunication. It was in the basement of the Palazzo di Sangro, in the center of Naples, that he conducted his mysterious experiments and notably created his famous "anatomical machines," mummified corpses (possibly of servants) whose circulatory system could be observed. He invented various hydrostatic machines and pyrotechnic methods and was fascinated by subjects as diverse as typography and mechanics.

Around 1590, a modest chapel had been built in his palace. It commemorated the Madonna's appearance before a prisoner who was later found innocent.

Considering the usual practices of the local legal system, the ruling was seen as a miracle. The building, which was expanded and transformed into the Sangro family mausoleum in the seventeenth century, was entirely redesigned and redecorated by di Sangro starting in the 1740s. The prince was rich and sought forgiveness for his theological errors. He hoped to impress the newly arrived Bourbons in Naples—to make a bella figura—but couldn't help but incorporate multiple symbols referencing earthly passions and alchemy into the artwork that decorated his luxurious jewel, a masterpiece of late-Baroque art in southern Italy. As a patron of the arts, he was extraordinarily precise in his demands and closely monitored projects, even if it meant having his artists make constant corrections. It

PAGE 43: Titled *The Glory of Paradise* (1749), the chapel ceiling, a triumph of the late Baroque period, is by Francesco Maria Russo. Its colors are thought to have been prepared by a patron of the church, Raimondo di Sangro, seventh prince of Sansevero (1710–1771). They still look beautiful after two and a half centuries, without restoration.

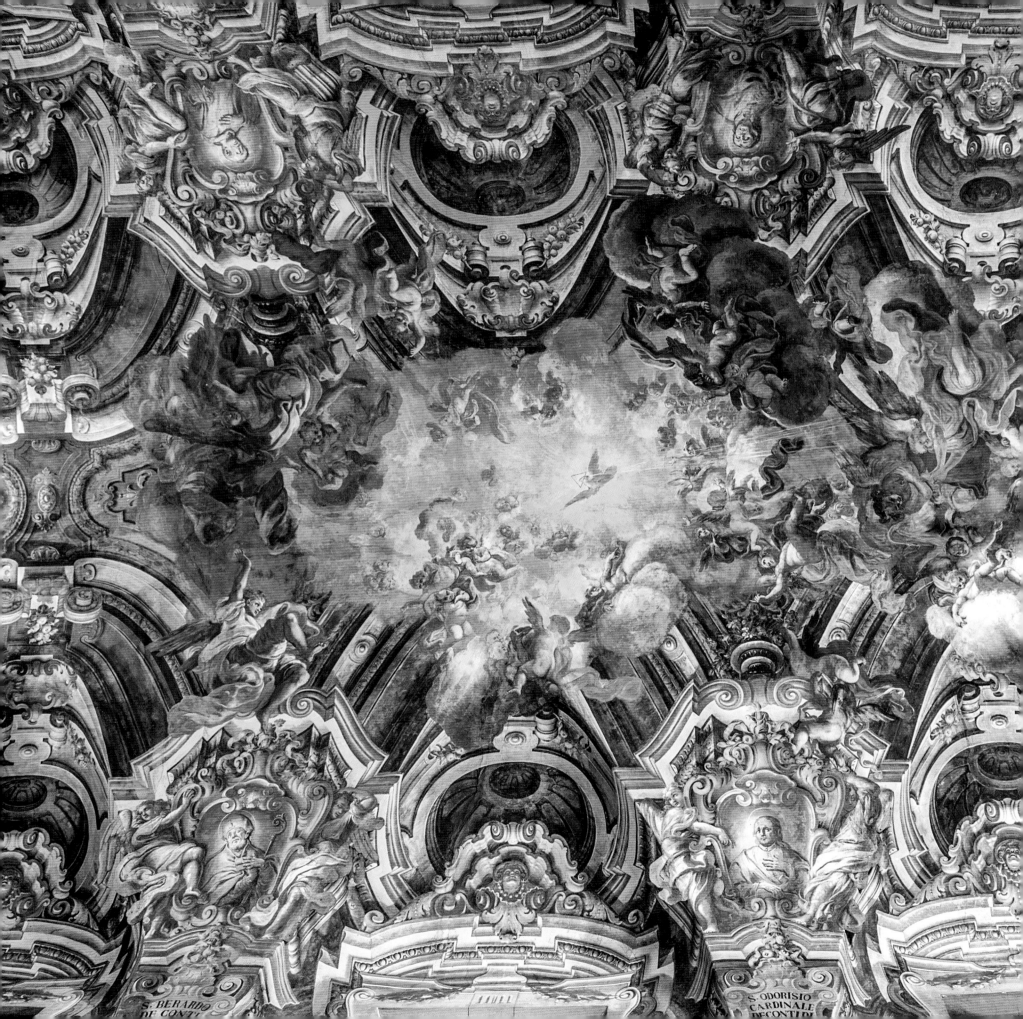

S. BERARDO
DE CONTI

S. ODORISIO
CARDINALE
DE CONTI

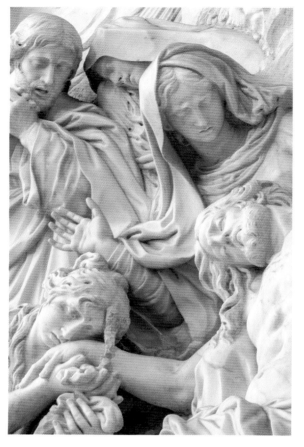

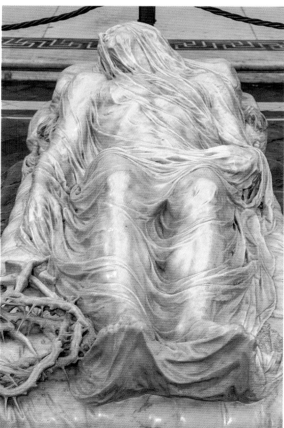

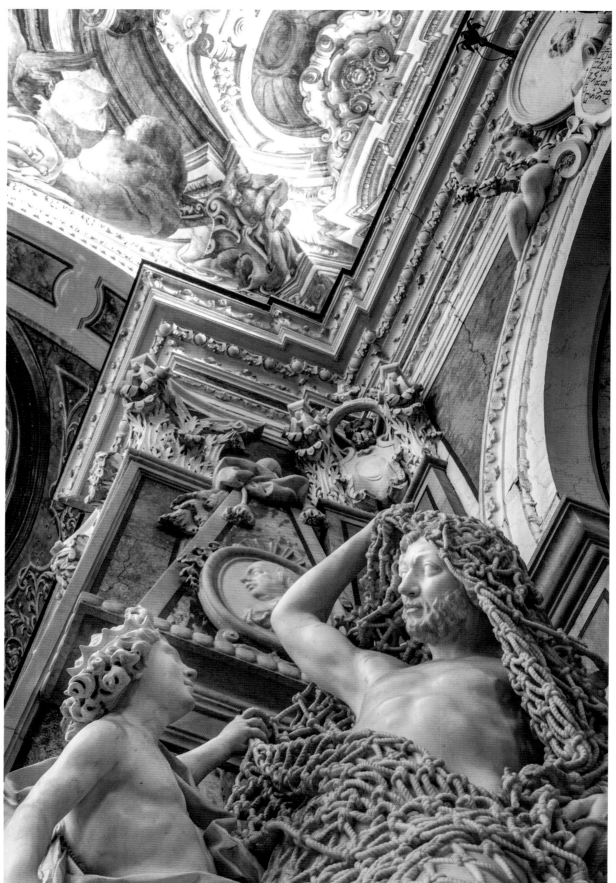

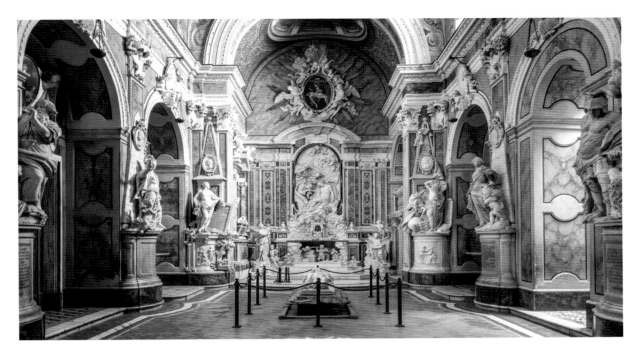

should be noted that the same artists were employed by the king of Naples for the Royal Palace of Caserta.

The chapel, which is still very popular among Neapolitans and tourists, is striking for its chromatic and aesthetic unity, despite the fact that some of the seventeenth-century sculptures have been restored. The floor is a labyrinth of marble, and the ceiling, dating from 1749 and depicting the glory of heaven, was executed using paint that the prince invented and manufactured. Despite its age, it has retained its freshness.

Aside from funerary monuments, certain charming symbolic sculptures, such as the *Sweetness of the Marital Yoke*, and inventive works in stucco, the decor's main focus is a central recumbent statue. To create the sculpture, Sansevero called upon the renowned Venetian sculptor Antonio Corradini (1668–1752), the artist behind the famous *La Pudicizia* (Modesty) at the Ca' Rezzonico in Venice and the *Veiled Woman* housed at the Louvre.

Corradini accepted the project but died and was replaced by the young, brilliant Neapolitan Giuseppe Sanmartino (1720–1793). His *Veiled Christ* is a marble figure covered in a shroud that divulges more than veils his anatomy and reveals the suffering of the broken body.

The prince ultimately fell victim to his bold chemical experiments and was buried in one of the eight side chapels surrounded by members of his family. Beneath those bodies, in the crypt, remain two of his sinister "anatomical machines"; one raises an arm, as if bidding life farewell.

PAGE 44 *TOP LEFT*: Detail of the large altar, *The Deposition*, by Francesco Celebrano (1729–1814). ✝ PAGE 44 *BOTTOM LEFT*: *The Veiled Christ*, the masterpiece conceived by the Venetian Antonio Corradini (1688–1752) but executed by Giuseppe Sanmartino (1720–1793). ✝ **PAGE 44** *RIGHT*: In the foreground, *Disillusion*, with its delicate net made of marble, by Francesco Queirolo (1704–1762). ✝ PAGE 45: View of the ochre and white nave.

LE THORONET ABBEY

LE THORONET ▫ FRANCE

Today, thousands of men and women across the world abide by the Rule, a document written around 540 by Benedict of Nursia (480–547), the hermit and founder of the Monte Cassino monastery and the patron saint of monasticism, of Europe, and of civil engineers. His precepts were a discipline intended for anyone who wanted to become closer to God. Transforming each abbey into a "school in the service of the Lord," the Rule reacted against monastic decadence. Following an imperial decree pronounced by Louis the Pious (778–840), it was adopted by most European abbeys.

It was in the twelfth century that the powerful Cîteaux Abbey in Burgundy decided to found three new facilities, "the three sisters of Provence": the abbeys of Silvacane, Sénanque, and Le Thoronet. In 1136, monks were sent on a mission into the far reaches of a forested valley, to build Le Thoronet. The architect Fernand Pouillon (1912–1986), in his book *Les pierres sauvages*, would marvelously recount their adventures.

The abbey would never be rich. It housed a maximum of about twenty monks; during the French Revolution, there were no more than four or five. As early as the middle of the fourteenth century, it would fall into disrepair, the buildings suffering from neglect and land erosion. A Benedictine historian from the eighteenth century, Edmond Martène (1654–1739), nevertheless called the abbey "one of the Order's most beautiful." Abandoned, it

PAGE 47: The abbey was originally founded in Floriéges in 1136 by an order of Benedictine monks, who then moved and rebuilt in a small valley in Thoronet in 1156. The abbey's construction lasted from 1160 to 1230, and it began to fall into disrepair at the start of the fifteenth century. In the power and purity of its architecture, it remains one of the archetypes of the Cistercian style. Le Thoronet would be one of the first churches to be registered as a historic monument, in 1840. In the half-dome of the apse (a welcome infringement of Cistercian principles), there is nothing more than a wooden cross next to a modest sculpture that forms a unique altar, its circle a reminder of divine perfection.

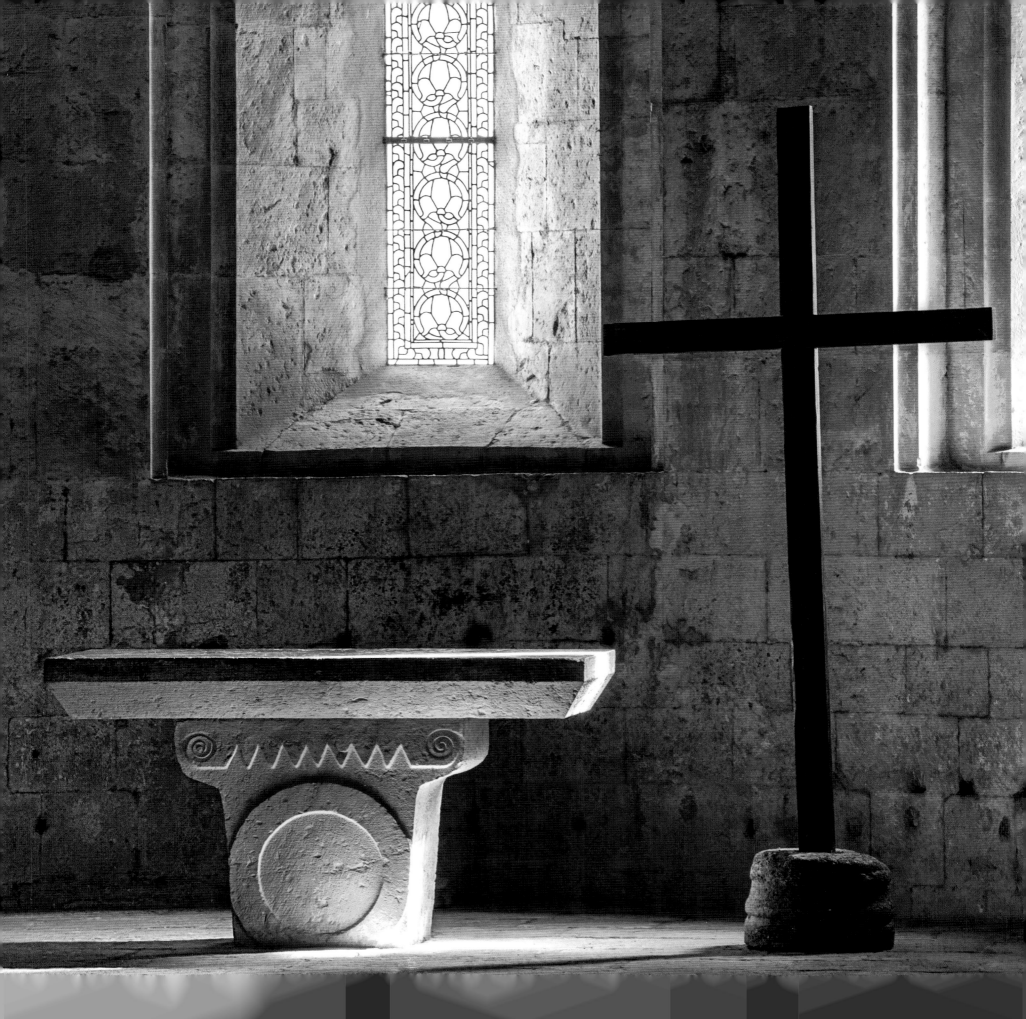

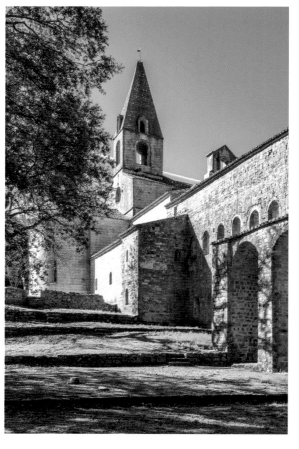

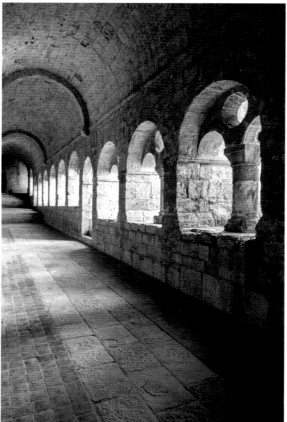

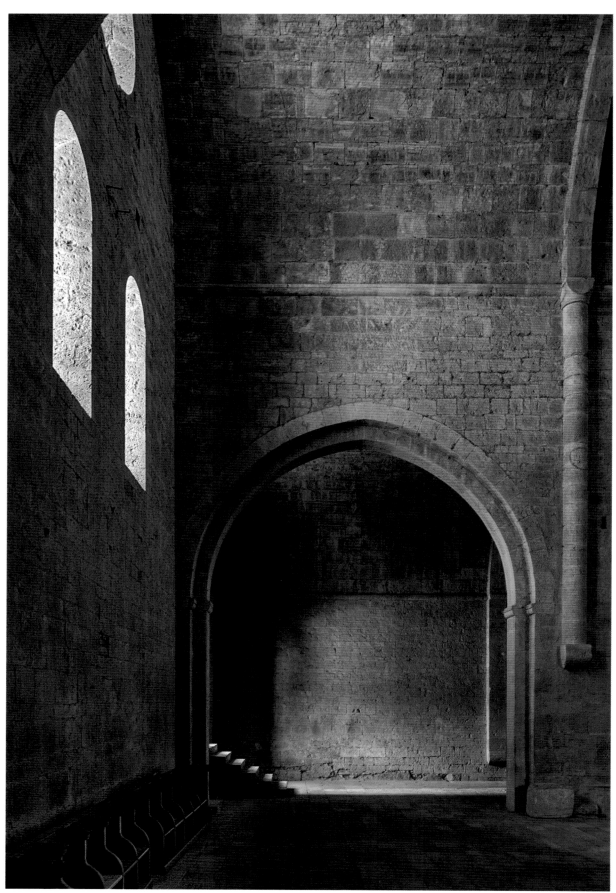

would later be saved in 1840 when it came to the attention of Prosper Mérimée (1803–1870), the first inspector-general of historical monuments, and today welcomes more than one hundred thousand visitors annually.

Le Thoronet has fascinated many architects, from its savior Henry Révoil (1822–1900) to John Pawson (b. 1949) (see St. Moritz Church, page 146) and Le Corbusier, who intriguingly remarked: "Light and shadows are the amplifiers of this architecture of truth, quiet and strength." Relatively small in size, it presents such a concentration of Romanesque style that it has become one of its archetypes.

The abbey is a microcosm of the image of the city of God. Its builders were seeking not to isolate it but rather to protect it, for times were violent. It was intended to be functional, protective, and plain, the opposite of the

PAGE 48 TOP LEFT: Built on sloping and unstable ground, the abbey has had several structural problems. ✠ PAGE 48 BOTTOM LEFT: View of the cloister with double arcade and oculi. ✠ PAGE 48 RIGHT: Access to the church through a small, almost hidden door. ✠ PAGE 50: The nave. PAGE 51 TOP LEFT: Minimalist capitals. PAGE 51 BOTTOM LEFT: Bay of the chapter house. ✠ PAGE 51 RIGHT: Lateral chapel with traces of a Baroque fresco.

Gothic church. Through the trade and commerce of forest clearing and farming, it engaged with the outside world. Only later would monks concentrate on intellectual activities and meditation. Le Thoronet's abbey church was an instrument for spiritually and materially conquering an isolated, dangerous region, and where monks simply came together to pray: "For where two or three are gathered in my name, there am I among them" (Matthew 18:20).

Le Thoronet is simple in construction, an exercise in pure geometry. It contains no technical feats. It is about the balance of volumes, the perfection of proportion, the presence of stone, and the action of light, which pierces the darkness through a limited number of carefully placed windows. There is no decoration to distract a person from prayer, no excessively sculpted capitals (only a small fountain with running water). Nothing better expresses the manifest power of the utilitarian and pure Romanesque form than the double arcade around the cloister, with its simple oculus piercing the tympanums. Le Thoronet is a masterpiece of minimalism, executed well before the term existed. The play of shadow and light. Rock that is almost rough. The patina of time. Eternal beauty in the service of God.

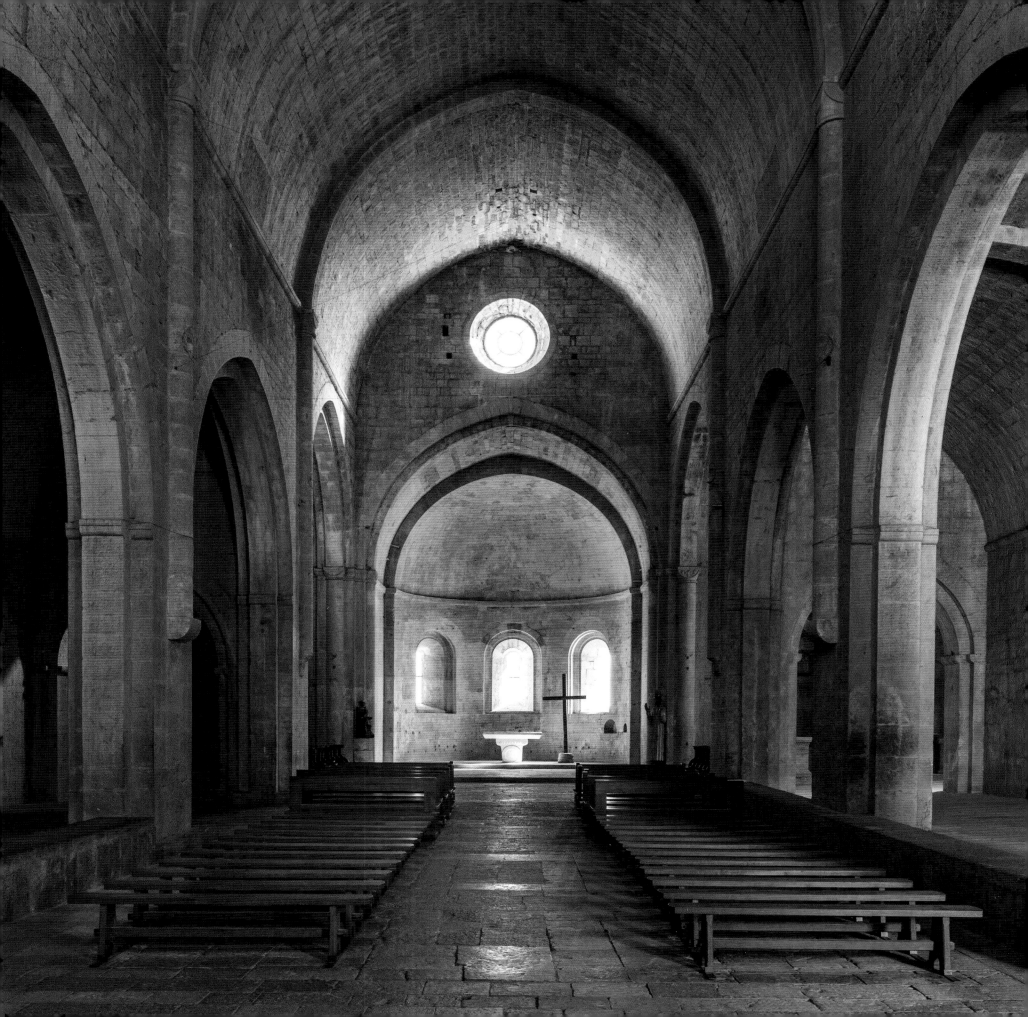

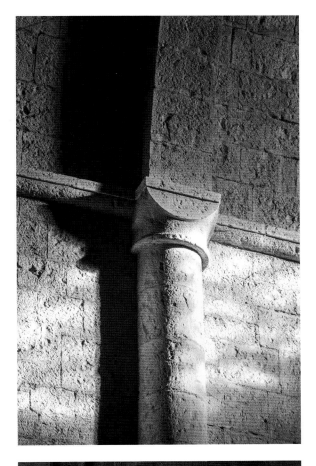

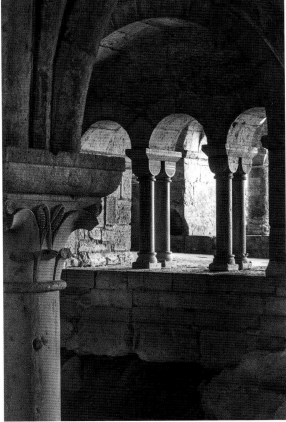

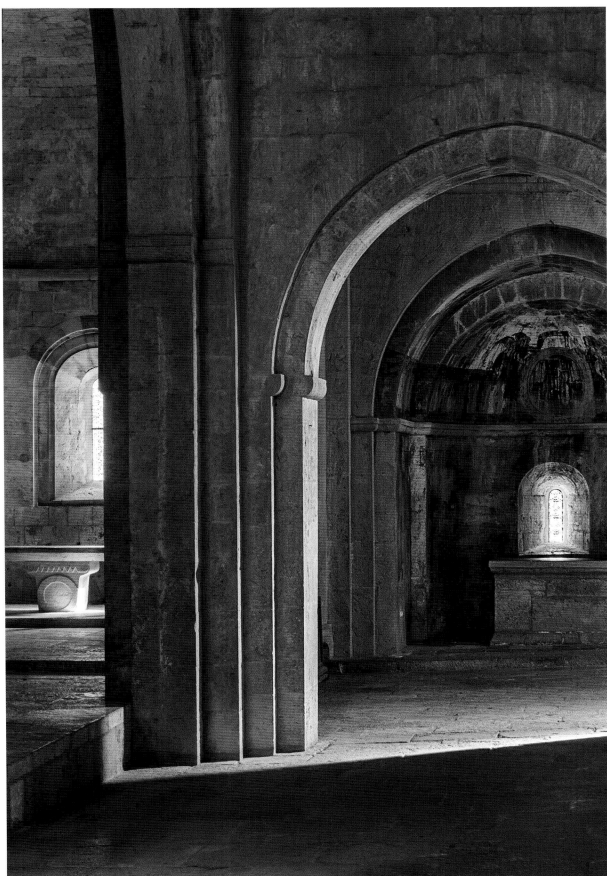

NOTRE-DAME CATHEDRAL

PARIS ▫ FRANCE

The stuff of one hundred and fifty years' worth of postcards, appearing in every English-language romantic comedy set in Paris, Notre-Dame is visited by thirteen million tourists every year and has become the archetype of the Gothic cathedral the world over. Paris is delighted and art historians smile discretely. To be sure, what we see today is not what any Parisian saw between the twelfth and nineteenth centuries, from the time construction started to the cathedral's restoration in 1864. The astounding monument of implacable symmetry—each facade statue, every gargoyle in its proper place—and the staggering apse of architectural virtuosity owe a great deal to the vision of a brilliant architect and theoretician who led the cathedral's restoration, Eugène-Emmanuel Viollet-le-Duc (1814–1879).

Viollet-le-Duc championed two conflicting positions: "Each part added, no matter the era, must, in principle, be preserved, reinforced, and restored in accordance with its own style, and with religious discretion, in complete abnegation of all personal opinion." Yet, his practice reflected his famous adage: "To restore a building is not to maintain it, to repair, or rebuild it; it is to restore it in a complete state that may never have existed at any given time." Indeed, he unified Notre-Dame by fully re-creating its interior and exterior decor, particularly its sculptures, eliminating the seventeenth- and eighteenth-century additions, building a spire rising 315 feet (96 m), transforming the roofs into terraces, reconstructing the two large rose windows to the west and the north, restoring the tympanum depicting the Last Judgment, rebuilding the flying buttresses, adding an outside sacristy in the Troubadour style where the old archbishop's palace had once stood, and redesigning the square.

Notre-Dame, which took more than one hundred seventy years to finish, became a model for Christendom as a

PAGE 53: Stained glass in the choir's upper bays. ✠ PAGE 54 *LEFT*: The choir with double ambulatory illuminated by bay windows on two levels. The high altar, designed by Eugène-Emmanuel Viollet-le-Duc (1814–1879), is surrounded by statues of Louis XIII (1601–1643), by Guillaume Coustou the Elder (1677–1746), and of Louis XIV (1638–1715), by Antoine Coysevox (1640–1720). ✠ PAGE 54 *TOP RIGHT*: Bust and reliquary of St. Denis (1657). ✠ PAGE 54 *BOTTOM RIGHT*: Stained glass in the clerestory of the south rose window, depicting the prophets. ✠ PAGE 55: Virgin and Child sculpture from the fourteenth century, known as both the *Notre-Dame de Paris* or the *Virgin of Paris*.

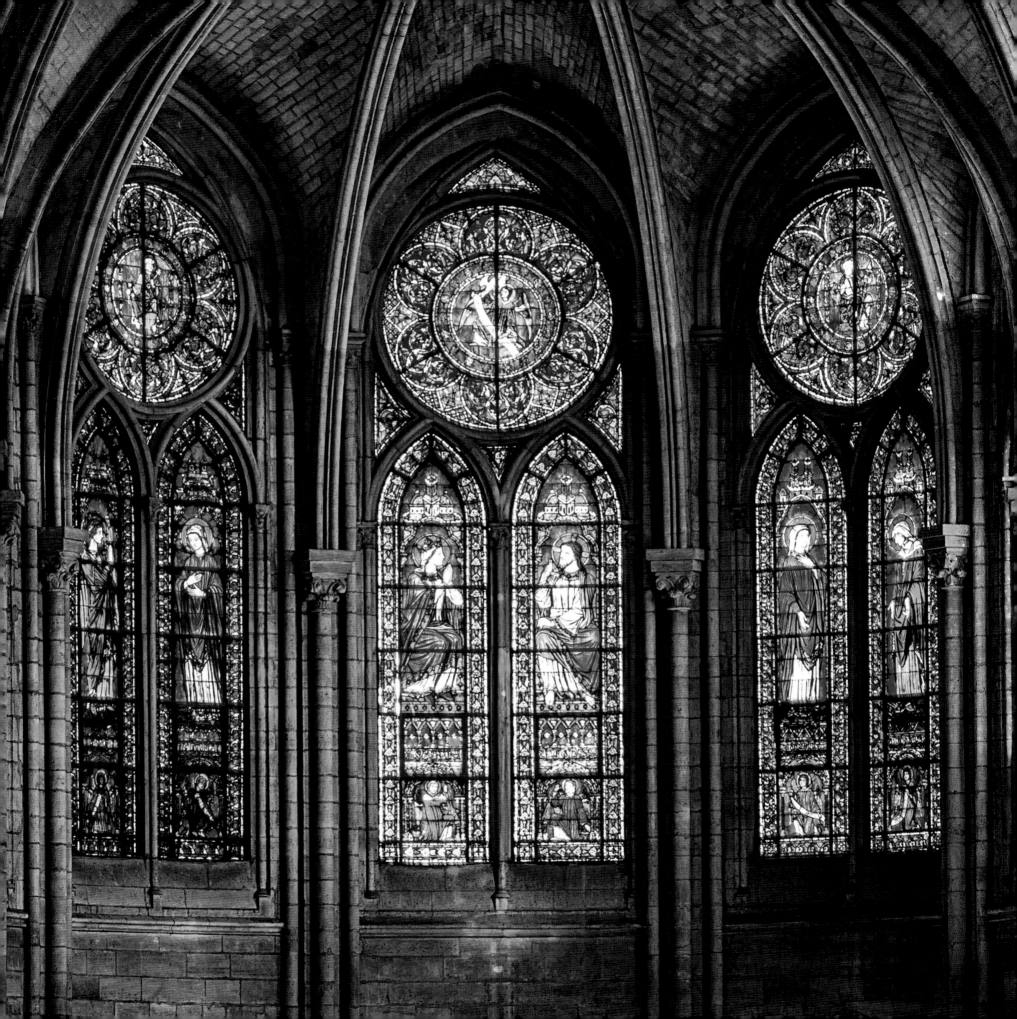

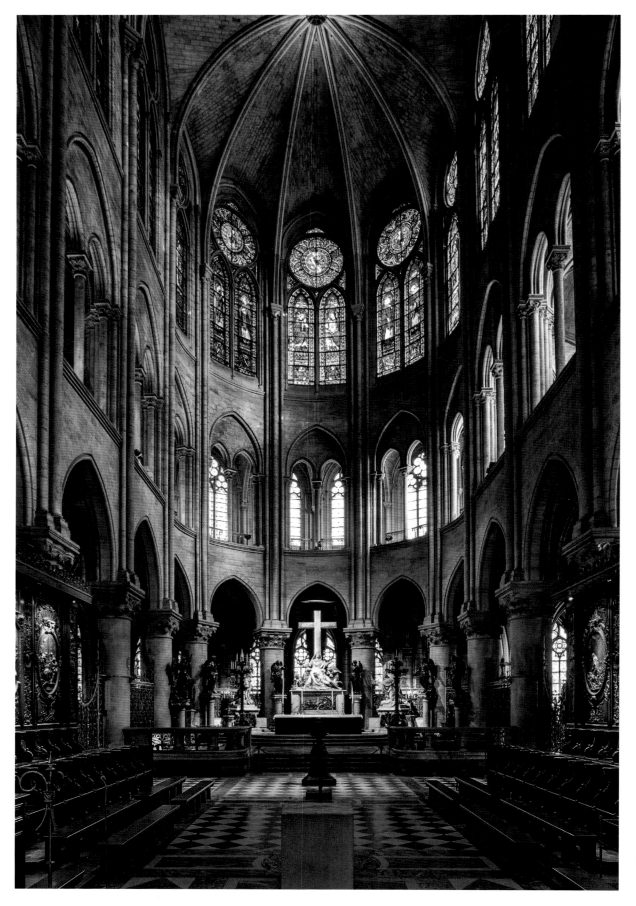

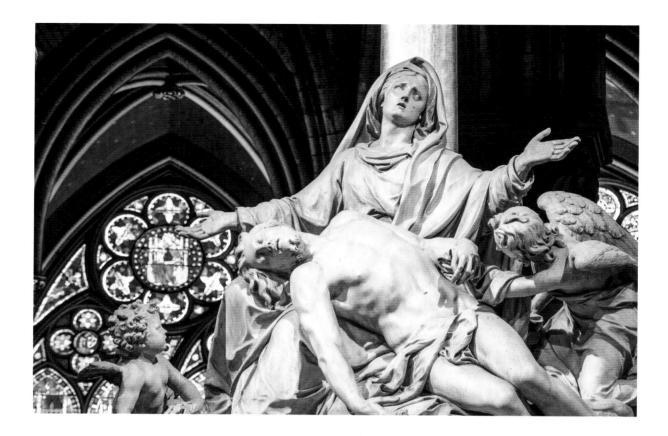

whole. Both the largest religious building in Europe (before Amiens Cathedral, in France) and also the richest, it acted as a church and perhaps even a Roman basilica. The project was launched by Maurice de Sully (1120–1196), then the bishop of Paris, who had the ear of both the pope and King Louis VII (1120–1180). He conceived of the cathedral and its square and proposed clearing neighboring buildings and connecting the church and the archbishop's palace via a double gallery.

The floor plan was slightly skewed and based on the assumed proportions of Solomon's Temple (the center area is based on those of Noah's Ark). It was not until the thirteenth century that the arms of the transept were given their definitive length. At the same time, new bay windows were opened and a system to drain rainwater via the flying buttresses was developed.

This large vessel of stone and light, atop its marvelous site and bearing all its statues, almost immediately became the symbol of religion's close ties with secular power. Every major royal event—engagements, weddings, funerals, victories, receptions, and birthdays—took place there. By the eighteenth century, the inside had been adapted to host

PAGE 56: The famous marble *Pietà* by Nicolas Coustou (1658–1733), behind the high altar. ✝ PAGE 57 *TOP LEFT*: The *Pietà* seen from the back of the apse. The work is in the French grand manner, inspired in part by Bernini (1598–1680), whose work Coustou studied during his time in Rome. ✝ PAGE 57 *BOTTOM LEFT*: The cylindrical pillars in the nave, dating from the end of the twelfth century. ✝ PAGE 57 *RIGHT*: View of the great nave, measuring almost two hundred feet (60 m) in length and more than one hundred feet (33 m) in height, including the triforium above.

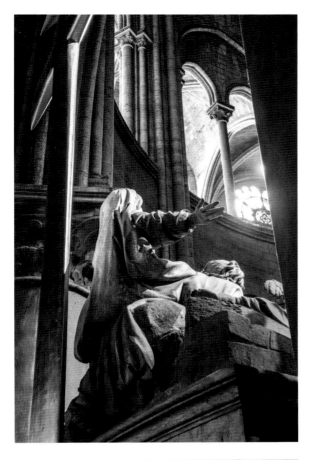

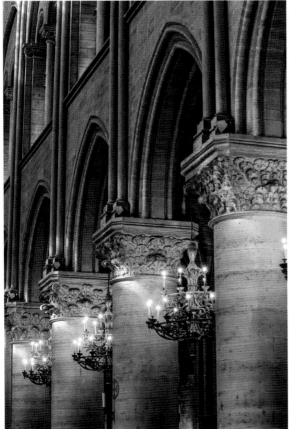

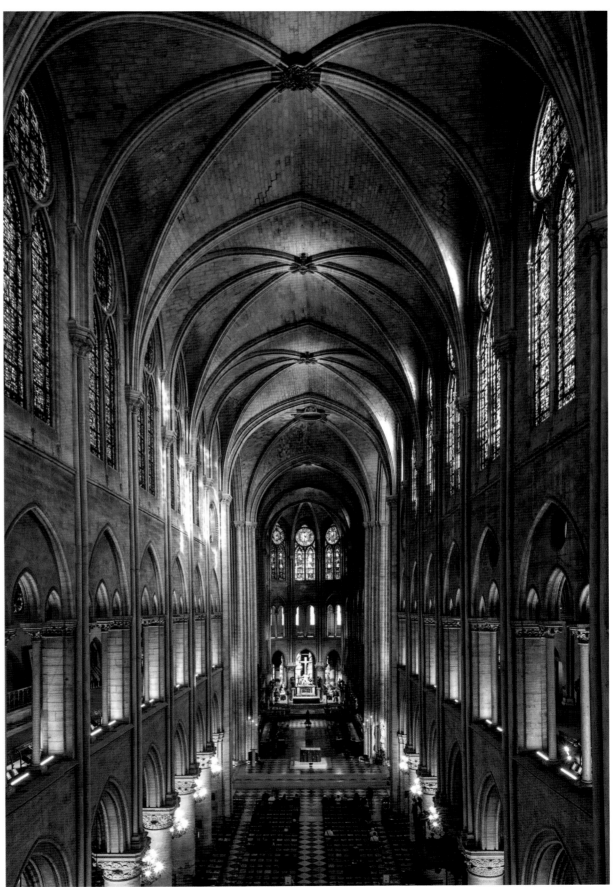

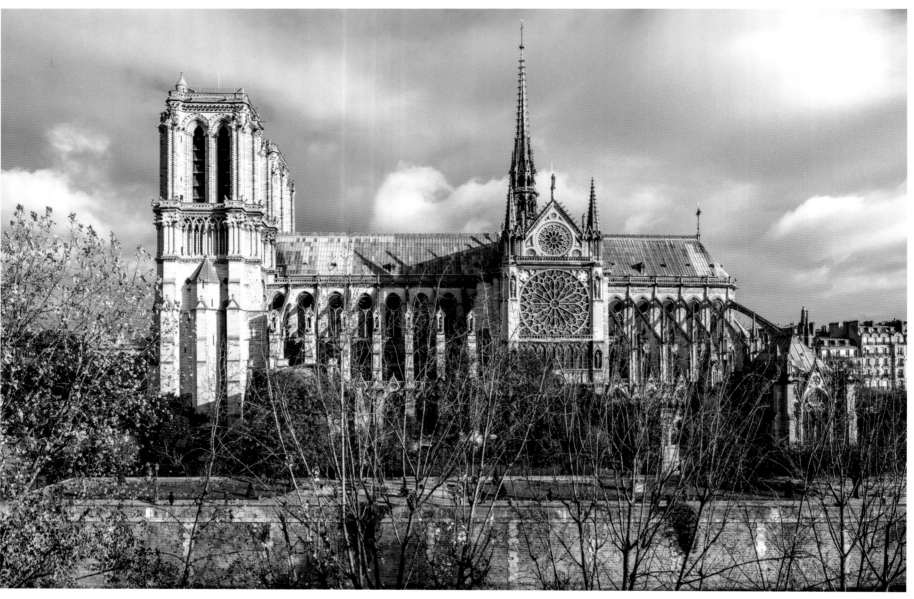

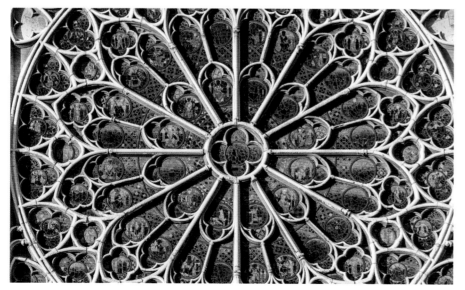

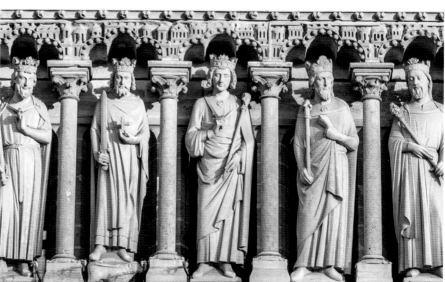

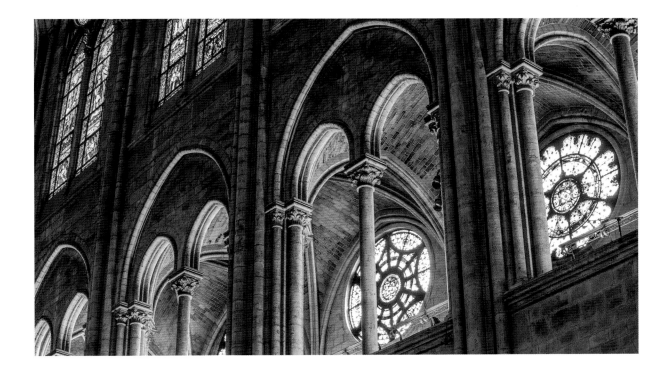

these festivities. For instance, in 1771, the architect Jacques-Germain Soufflot (1713–1780) even destroyed a part of the intricately carved Last Judgment tympanum in order to enlarge the central portal on the Western facade, so that processions with the royal dais and canopies could pass through. Given this close link with the monarchy, it made sense that the limestone statues of the kings of Judah, seen by a Parisian

PAGE 58 *TOP*: Notre-Dame Cathedral and its spire, designed by Viollet-le-Duc and made from seven hundred and fifty tons of oak and lead. It replaced the previous spire, removed in 1786. ‡ PAGE 58 *BOTTOM LEFT*: The south rose window (1260), by Jean de Chelles (1200–1270) and Pierre de Montreuil (1200–1267), was a gift from Louis IX (1214–1270), known as St. Louis. ‡ PAGE 58 *BOTTOM RIGHT*: The Gallery of Kings above the portal of the Last Judgment. These statues of the twenty-eight kings and church fathers were replaced in the mid-nineteenth century. ‡ PAGE 59: View of the triforium. Its depth limits the light reaching the nave.

mob as symbols of French royalty, were decapitated during the revolution, their heads hurled away and found only by chance in 1977.

The cathedral was saved by Viollet-le-Duc and later restored, particularly its filthy facades, which required a two-fold refurbishment. Isolated on an island invaded by unattractive public buildings during the Second Empire, Notre-Dame is no longer the heart of Paris Victor Hugo praised in his 1831 novel, *The Hunchback of Notre-Dame*. But is it still a place for contemplation? Might a modern-day poet still find the enlightenment of faith, like Paul Claudel (1868–1955) did more than a century ago? While that seems somewhat unlikely, recent renovations on the Île de la Cité should better accommodate the throngs of tourists visiting its square, and as the never-ending stream of visitors suggests, Notre-Dame Cathedral will certainly survive and continue to be one of the most significant symbols of France and the Christian faith.

CHARTRES CATHEDRAL

CHARTRES ▫ FRANCE

St. Bernard of Clairvaux (1090–1153), a great reformer of the church in the twelfth century, offered the following criticism of religious buildings of his time: "I say nothing of the enormous height, extravagant length and unnecessary width of the churches, of their costly polishings and curious paintings which catch the worshipper's eye and dry up his devotion." Clearly, the Cathedral Chapter of Chartres did not heed his words when it decided to build a new cathedral. The city at the time was an influential center of scholastic study, and its sanctuary contained the Veil of the Virgin said to have been worn by the Virgin Mary when she gave birth to Jesus Christ. The relic, perhaps a gift to Charlemagne (742–814) from Irene (752–803), the Byzantine empress, was the devotional object of a Marian congregation that attracted many pilgrims. They needed to be welcomed properly.

The new building succeeded a Carolingian cathedral that was destroyed by the Vikings in 858 and a second cathedral destroyed in a fire in 1020. Rebuilt by Bishop Fulbert of Chartres (960–1028), this second cathedral burned again in 1134, was partly rebuilt, and then went down in flames a third time in 1194, along with much of the city.

It was a rich city: King Philip Augustus (1165–1223) offered to help pay for the new cathedral, Richard Coeur de Lion (1157–1199) authorized the collection of funds in England, the chapter relinquished its income for a time, and all of aristocratic and religious Europe contributed to the financing of the new building.

The project, which was launched on top of old foundations and the enormous crypt for pilgrims, took only twenty-six years to complete, which explains its

PAGE 61: Although the stained glass of the south rose window was restored and cleaned, this part of the cathedral retains its patina and is reminiscent of a "warm darkness" (Joris-Karl Huysmans [1848–1907]).

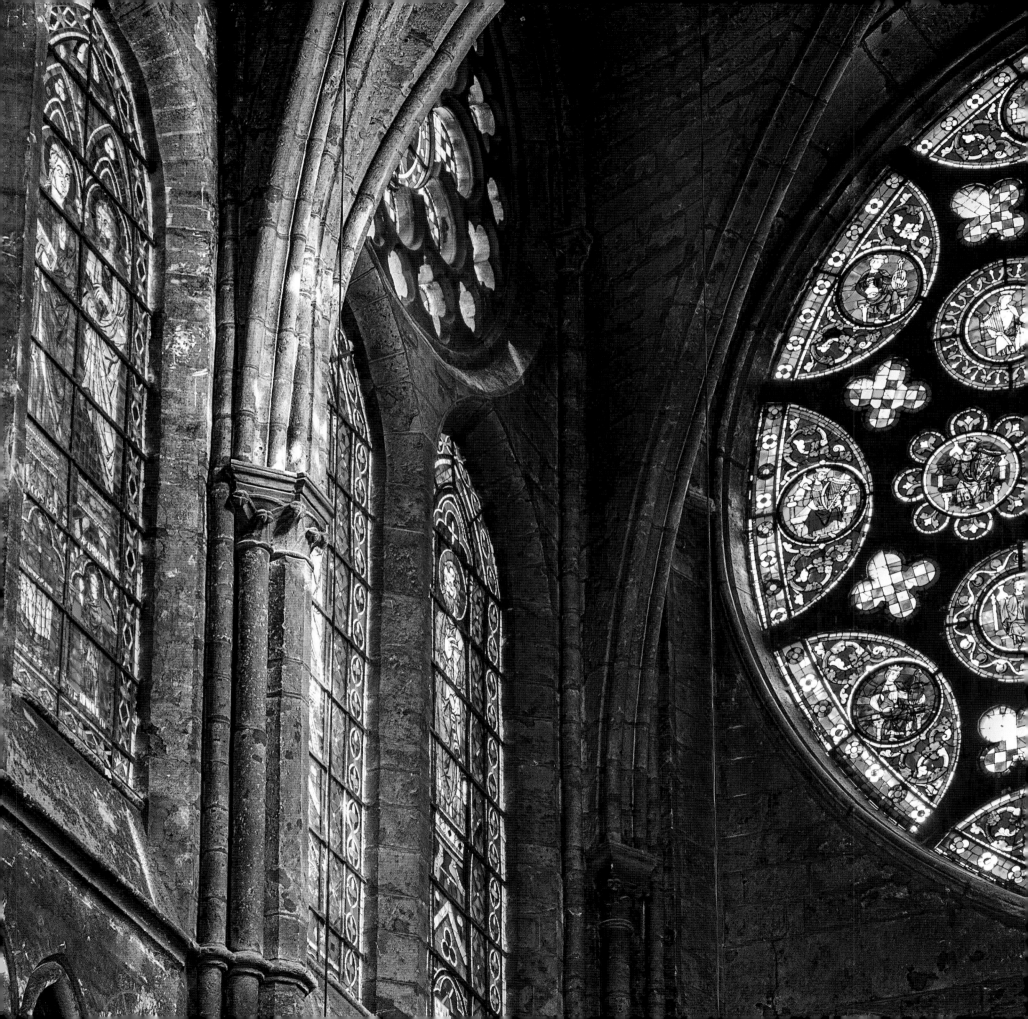

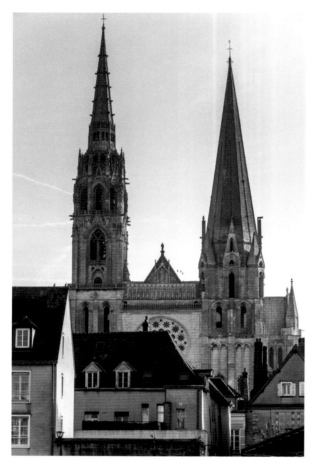

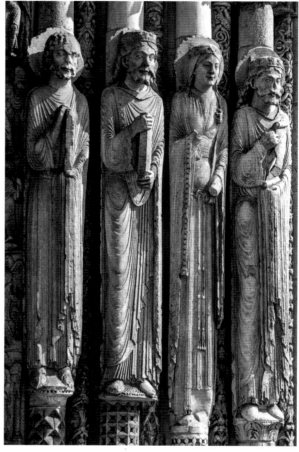

architectural unity. The Royal Portal and towers of the main facade are older, however, as they are from the previous cathedrals on the site. King Louis IX (1214–1270), the sainted king of France, furnished a rood screen (partition between the chancel and the nave), and at the start of the fourteenth century, the enormous chapel of St. Piatus was added; starting in 1417, the particularly opulent Vendôme Chapel was built. The Renaissance bell tower built on the north spire dates from 1513. Major renovations were carried out in the eighteenth century: the rood screen was demolished and the decor modernized, supervised by

Victor Louis (1731–1800), the architect of Bordeaux's Grand Théâtre. Further renovations were executed after a fire damaged the roof in the middle of the nineteenth century.

PAGE 62 *LEFT:* The cathedral still dominates the heart of the city. ✝ PAGE 62 *RIGHT:* Statue columns of the Royal Portal (built from 1145–1155). ✝ PAGE 63 *TOP LEFT:* The south rose window (c. 1224). In the middle, Jesus sits on an emerald throne, surrounded by angels and symbols of the evangelists. ✝ PAGE 63 *BOTTOM LEFT:* Staircase leading to the chapel of St. Piatus (d. 286) in the back of the choir. ✝ PAGE 63 *RIGHT:* View of the nave. At left is the large organ, which has been restored several times.

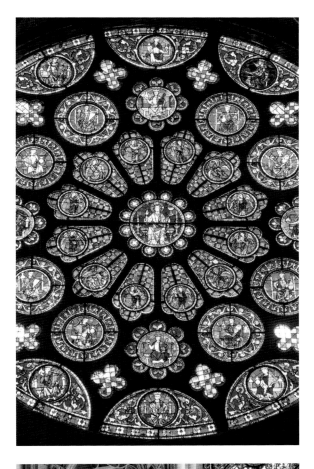

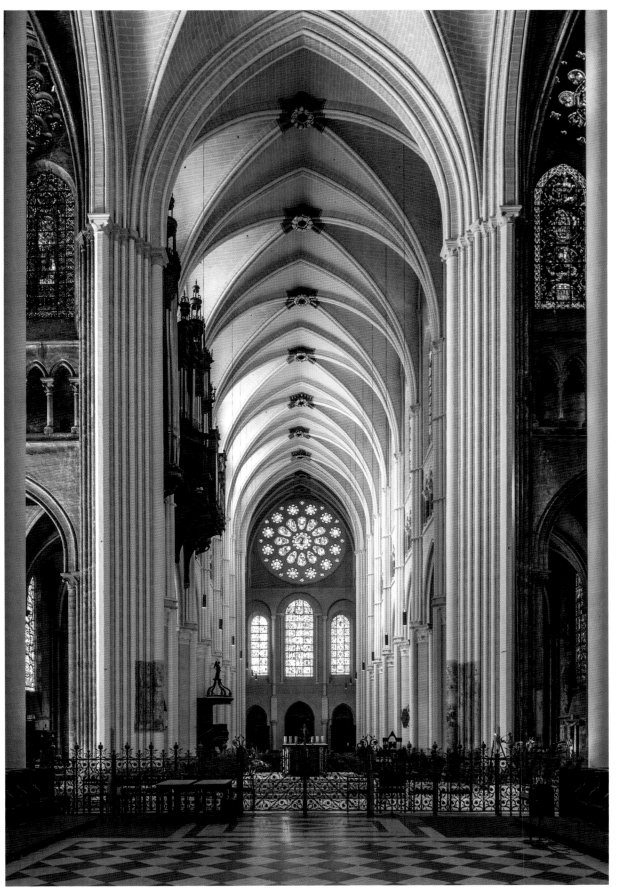

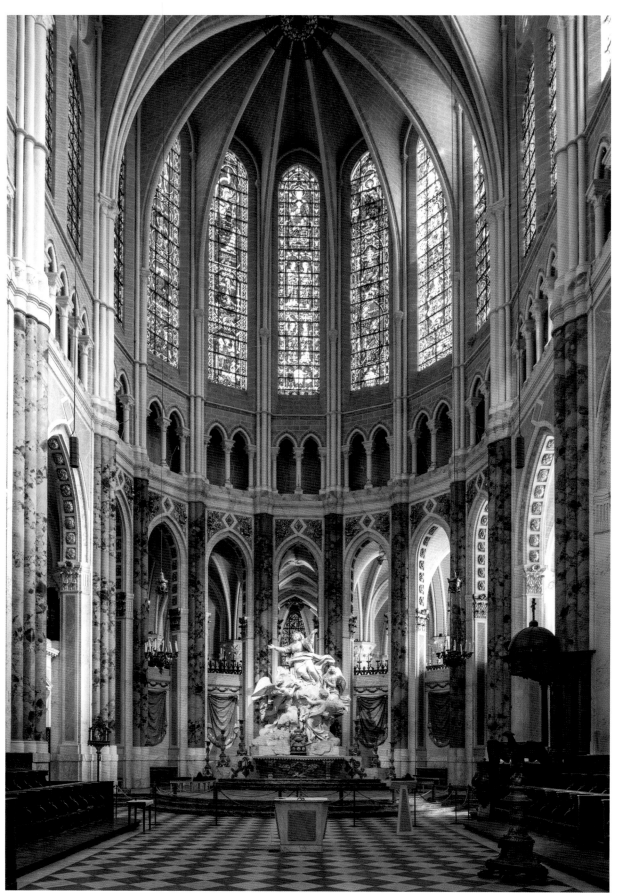

CHARTRES CATHEDRAL

Chartres benefited from architectural innovations that emulated German cathedrals. It was in this building, in fact, that a ribbed vault with tighter, rectangular webs was installed to facilitate the opening of enormous bays in the walls, replacing the classic sexpartite Gothic vault. The tribunes (upper stories which open onto the nave or choir) were eliminated and the triforium (gallery above the arches, choir, and transepts) reduced to accentuate the effect of pillars disappearing into the heavens. For us, those buttresses and double flying buttresses point to a brilliant, intuitive knowledge about weight distribution. From certain angles, they are true cascades of stone.

Very early on, Chartres became famous for its stained glass windows, donated by rich families and city guilds. The medieval cathedral is an ode to light. While the Romanesque style is defined by material, energy determines the Gothic style: the energy of captured strength, of heavenly height, and of light, dispensed by enormous openings. Light is an essential Christian theme, expounded on in countless texts, hymns, and artifacts based on the word of Christ—"I am the light of the world" (John 8:12)—and adopted by Neoplatonism, which embraced the sun as generator of ideas. With about 27,000 square feet (2,500 sq. m) of windows dating for the most part from the twelfth and thirteenth centuries, Chartres has more stained glass than any Gothic cathedral. Most of it is still in good condition, despite the revolution, wars, and chemical deterioration.

Since 2009, the cathedral has been undergoing a bold restoration. The dark and romantic building that some readers may have known—that enchanted cavern, what novelist Joris-Karl Huysmans (1848–1907) called that "warm darkness," where the eye was drawn only to the stained glass windows sparkling with precious stones—no longer exists. Restorers have chosen to bring back the original colors from the twelfth through eighteenth centuries. Centuries of grime and hasty white washing have been removed, inch by inch, to reveal the original light ochre color. The faux marble decoration on the choir pillars has also been restored. The restoration has entirely changed the look of the architecture, its decor, and also its stained glass windows. The latter were dismantled, cleaned, and protected against chemical erosion; the famous and dark "Chartres blue," in fact a kind of soiling, has become a full palette of luminous blues. It is an expensive undertaking, but in the twenty-first century, a restored Chartres allows us to better understand the feelings a humble believer may have had centuries ago upon entering the unique and exhilarating site, a luminous image of the city of God.

PAGE 64 *TOP LEFT*: Detail of the high altar's enclosure (early sixteenth century). It would take two centuries to complete the sculptures. ‡ PAGE 64 *BOTTOM LEFT*: *Notre-Dame du Pilier* (1507), once venerated by pilgrims at the entrance of the cathedral. Today it can be found in the ambulatory. ‡ PAGE 64 *RIGHT*: The choir after restoration. The stone was cleaned, and the stained glass and faux marble on the pillars was restored. It took twenty years of work to reveal the sanctuary as conceived by its builders. The high altar is by the sculptor Charles-Antoine Bridan (1730–1805).

THE ROYAL CHAPEL OF VERSAILLES

VERSAILLES □ FRANCE

Oddly enough, the architect Louis Le Vau (1612–1670) did not include a monumental house of worship in his plans for Europe's largest palace. Around 1665, there was only a small two-story chapel measuring some 270 square feet (25 sq. m). It could be reached directly from the king's apartments, an essential trait of a palatine chapel. In 1669, another sanctuary, two times the size, was built, and it included a gallery that could be accessed from the second floor. In 1672, it was decided that the chapel should be moved closer to the Old Wing, on the south side of the palace; hence, a new project and a third iteration in fifteen years. It would not be until the late 1680s that Louis XIV (1638–1715) resolved to build a chapel worthy of his palace. Construction was turbulent, with changes in plans and financial obstacles. Work only really began in 1689 and would take twenty-one years.

These hesitations nevertheless opened the way for one of the purest masterpieces of the French Baroque period. The Royal Chapel, which dazzles visitors with its splendor and sublime austerity, is essentially the work of one of France's greatest architects, Jules Hardouin-Mansart (1646–1708), even though construction was completed by Robert de Cotte (1656–1735).

PAGE 67: Work on the marble and gilded bronze high altar began in 1708. The angel by the sculptor Corneille van Clève (1645–1732), is accompanied by a child angel. They top the altarpiece, which is also in gilded bronze.

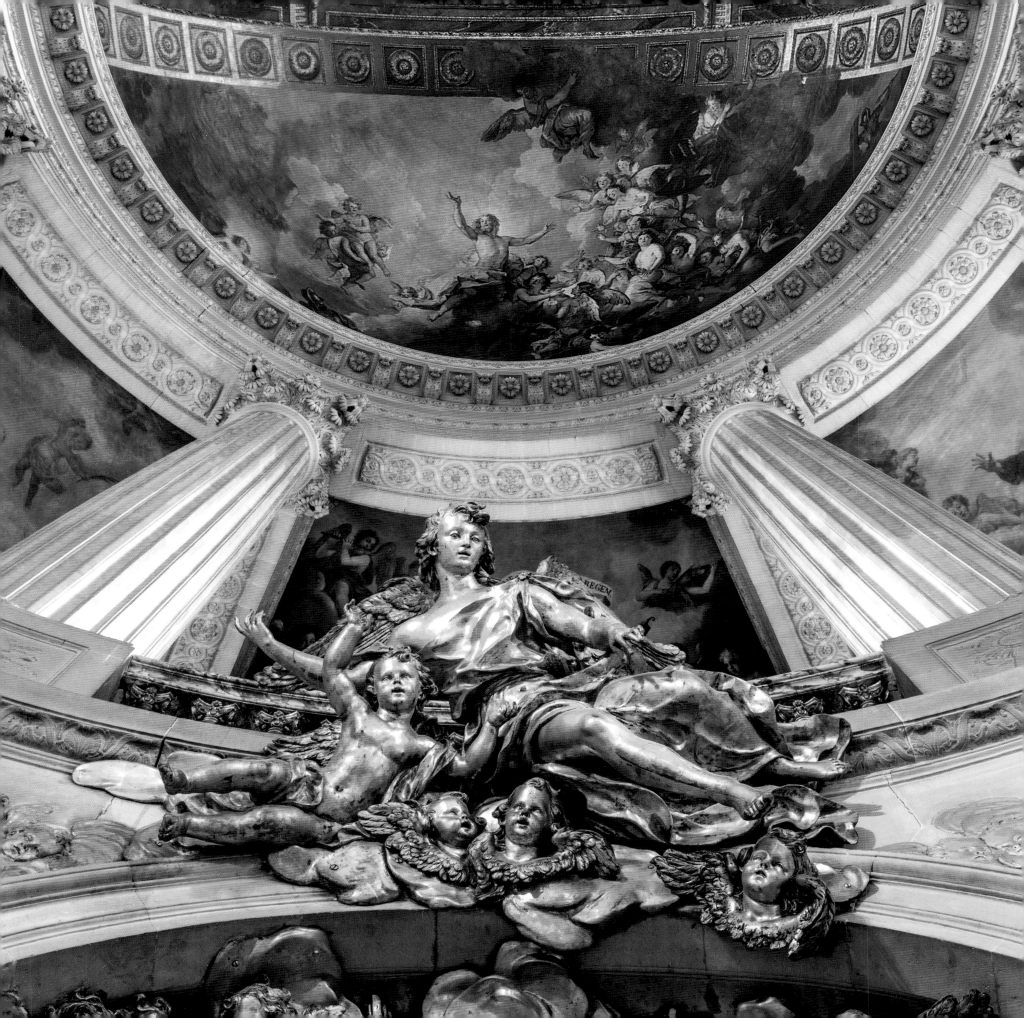

The challenge was to create a monument within another monument while satisfying the requirement that the chapel be easily accessible from the king's apartments without disturbing circulation through the north wing. Moreover, the king and the architect wanted it to be visible as such, which complicated the determination of its height with regard to the chateau and its flat rooftops. Finally, because the chapel was somehow "attached" to the royal building, it could not have a facade per se. Hardouin-Mansart found a solution for each issue but not without considerably modifying his design. For example, at first the sanctuary was integrated into the new north wing, but then it was moved to its current location. The architect also seriously considered building a high dome, small in diameter, which would have certainly been unfortunate for the vision of the palace as a whole. He ultimately chose a classic roof, which he would raise three times, topping it with a large lantern measuring some forty feet (12 m) high. The lantern was removed in 1765.

The chapel was the final project undertaken in Versailles by Louis the Great; it proceeded slowly and rather chaotically at first and cost a fortune. The monarch avidly monitored it, even though Madame de Maintenon (1635–1719), the king's second wife, disapproved of the enormous expense. The best craftsmen—masons, stone carvers, sculptors, painters, gilders, artisans of mosaics and marble marquetry, organ makers, and roofers—were recruited to execute the project, with contracts sometimes passed down from father to son.

Past the peristyles (colonnades surrounding an open space) on the ground floor and the second floor, which serve as a kind of interior facade, the visitor stands before an enormous space made of pale stone, a single unit inundated with light. It leads to an apse (reminiscent of the Sainte-Chapelle, in Paris) with a gilded high altar dominated in a rather astonishing manner by the organ.

The opulence of the decor, including the vast carpet of inlaid marble on the floor and the ceilings painted by Charles de La Fosse (1636–1716), Antoine Coypel (1661–1722), and Jean Jouvenet (1644–1717) contributed to the pursuit of a "total work of art," before the term *Gesamtkunstwerk* was coined. French art historian André Chastel (1912–1990) remarked, "The staggering play of medallions and celestial views rival all the glories of Italy."

Less obvious than the lavishness of the decor, and an aspect that often goes unnoticed by contemporary visitors is the extraordinarily rich and codified universe expressed in allegories and symbols, found on the stone reliefs, ceilings, and more. Such decoration was the subject of long discussion between the church, the king, the architect, and the court, and clearly Cesare Ripa's (1560–1622) renowned rules regarding religious iconology served as inspiration.

The exterior, although not very visible, was of equal concern. The art of French decorative sculpture was applied to the sophisticated ornamentation, the friezes, the skylight frames, the lead statues on the roof, and the

PAGE 68 *LEFT*: The great ceiling by Antoine Coypel (1661–1722), *God the Father in Glory* (1708–1710). It is not a fresco but rather is painted in oil. ✝ PAGE 68 *TOP RIGHT*: Detail of *Pentecost* by Jean Jouvenet (1644–1717), above the king's tribune. ✝ PAGE 68 *BOTTOM RIGHT*: *The Apotheosis of Saint Peter* by Bon Boullogne (1649–1717). The apotheoses of each one of the twelve apostles that fill the small vaults of the tribune were entrusted to the brothers Bon Boullogne and Louis Boullogne the Younger.

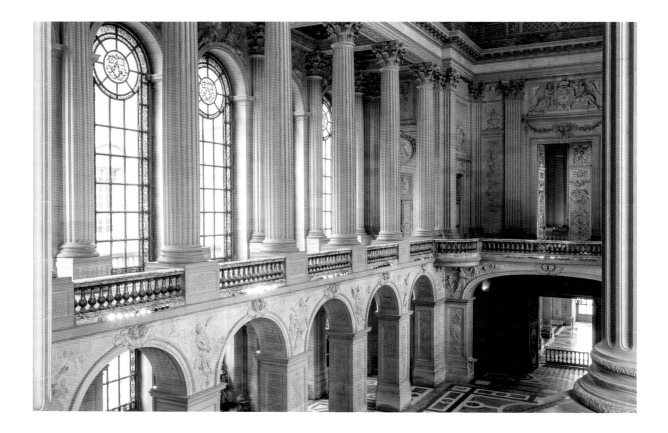

twenty-eight statues of the apostles and church fathers on the balustrade, which is now being restored.

The chapel is more an act of faith than a simple place of worship. It structures a face-to-face encounter between God and the king, each at one end of the building, with the king, it should be noted, in a superior position. In 1710, Madame de Maintenon said: "Magnificence responds more to the piety of the king than to our present state." The chapel reflects that lingering Gallican vision of a king appointed by God but master of his kingdom. Thus, on the ceiling one sees Charlemagne offering God a fleur-de-lys, symbol of the French monarchy, and on the censers (pot in which incense is burned) a painted fleur-de-lys. The royal chapel advanced Louis XIV's grand project of promoting royal power through art and architecture. A masterpiece within the masterpiece that is Versailles, the Royal Chapel is its climax.

PAGE 70: The king's tribune, facing the altar, on the other end of the chapel. ✠ PAGE 71 TOP: View of the nave, the altar, the organ, and the apse vault decorated with the *Resurrection of Christ* (1710) by Charles de La Fosse (1636–1716). ✠ PAGE 71 BOTTOM LEFT: The organ (1710), designed by Philippe Bertrand (1663–1724). It is, unusually, located above the altar. ✠ PAGE 71 BOTTOM RIGHT: The floor (1708) in Portor marble, Languedoc rouge marble, and Campan Grand Mélange marble.

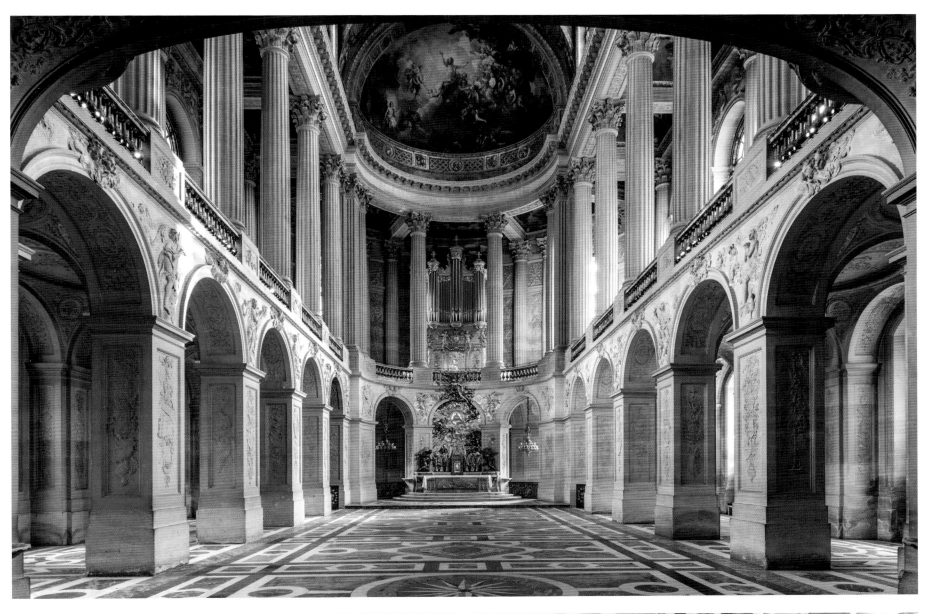

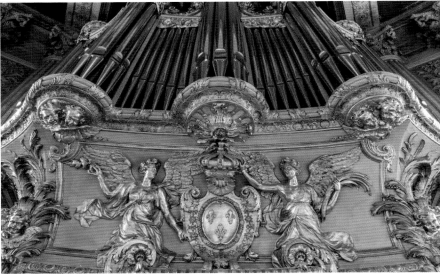

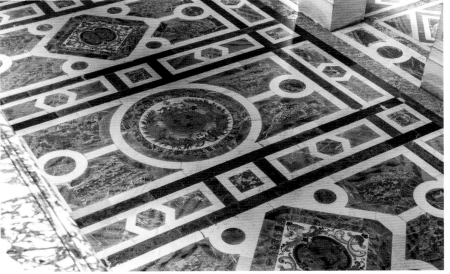

COUVENT SAINTE-MARIE DE LA TOURETTE

ÉVEUX ▫ FRANCE

The Dominican convent of La Tourette and its church occupy a special place in the history of twentieth-century architecture. The masterpiece was a challenge to build and is sometimes described in contradictory terms by critics—as a seminal example of brutalism and a key work in the oeuvre of Le Corbusier (1887–1965), one of Modernism's most important architects. Though La Tourette is disorienting and difficult to digest at first, its intelligent complexity, its architectural purity, and its spiritual grandeur will eventually impress every visitor.

The project owes a great deal to the Dominican friar Marie-Alain Couturier (1897–1954), who significantly revived sacred art in France and also steered the development of Notre Dame du Haut, the chapel in Ronchamp. For the intellectual and artist that he was, twentieth-century religious art, which had not evolved from the pseudo-Romanesque and the pseudo-Gothic, remained a "disgrace," and an "offense to God." Over the course of his life, through his publication *L'Art sacré* (The Sacred Art), he fought to convince the church to draw upon artists of its time. He befriended Le Corbusier, then a controversial figure, and, in 1953, was able to persuade the Dominicans to call upon him.

What followed were seven trying years marked by the limited involvement of the very busy architect, managerial disorganization, financial difficulties of the sponsors, delays, and poor workmanship. In fact, Le Corbusier entrusted much of the work to the architect and musician

PAGE 73: There are seven altars for monks on various levels in the crypt illuminated by three cylindrical skylights that Le Corbursier (1887–1965) called "light cannons." ‡ PAGE 74 AND 75 TOP: The nave with horizontal slits that let in light. In the back, the organ is built into the wall. ‡ PAGE 75 BOTTOM LEFT: Entrance to the sacristy. ‡ PAGE 75 BOTTOM RIGHT: Entrance to the chapel.

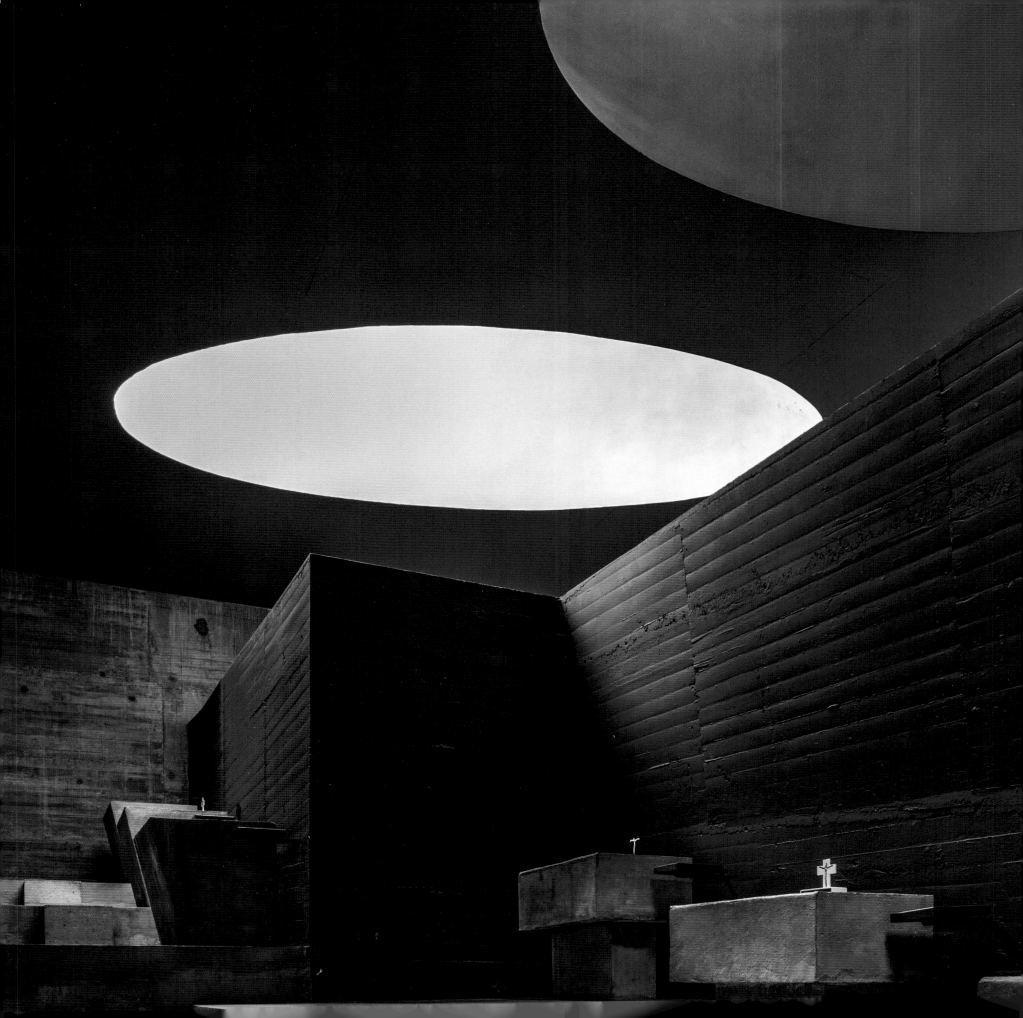

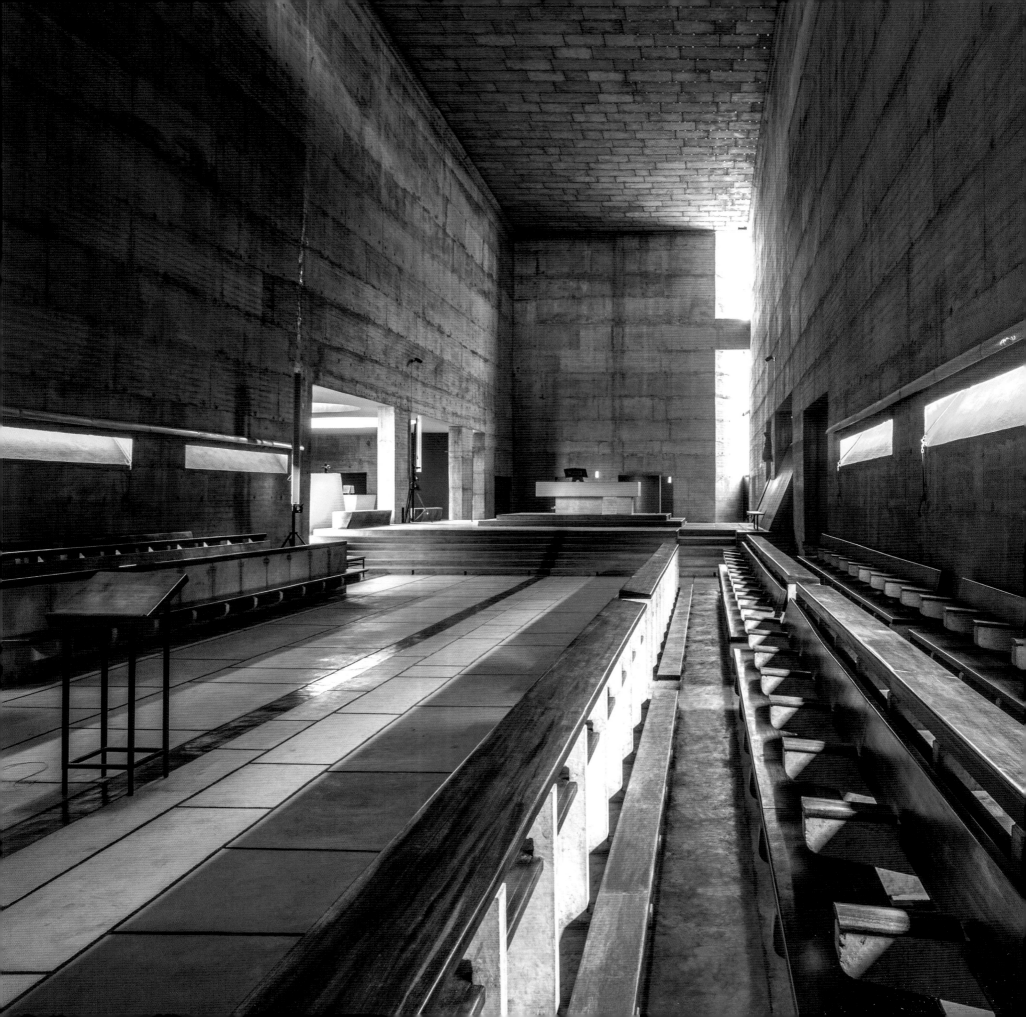

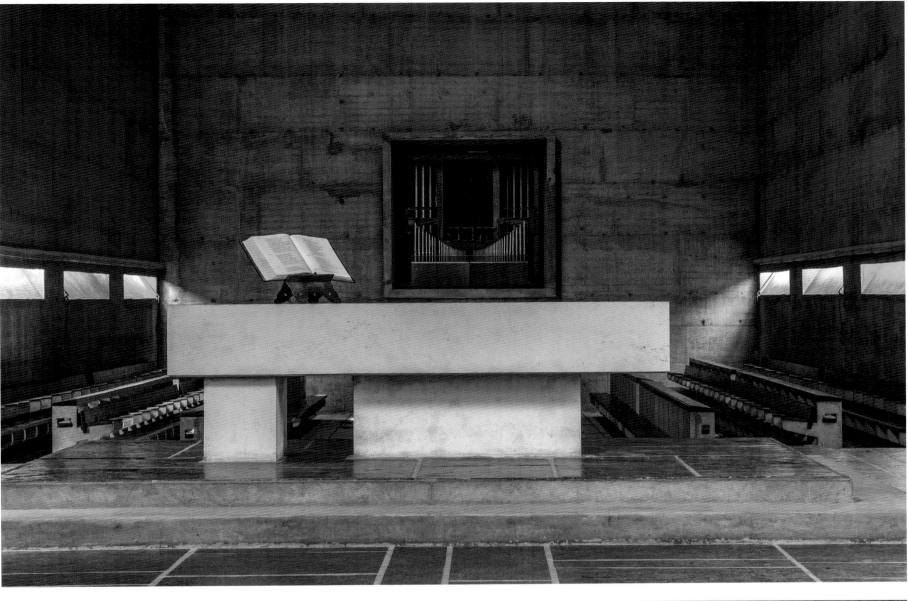

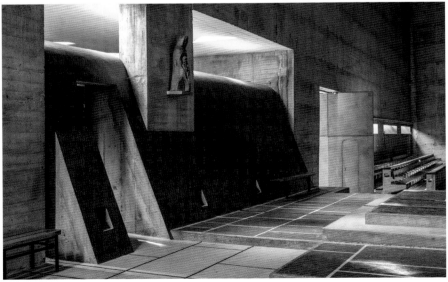

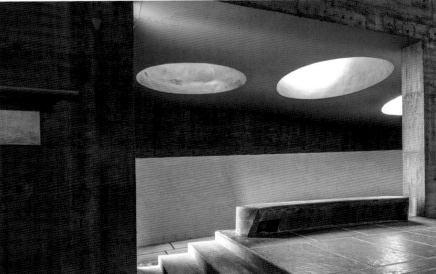

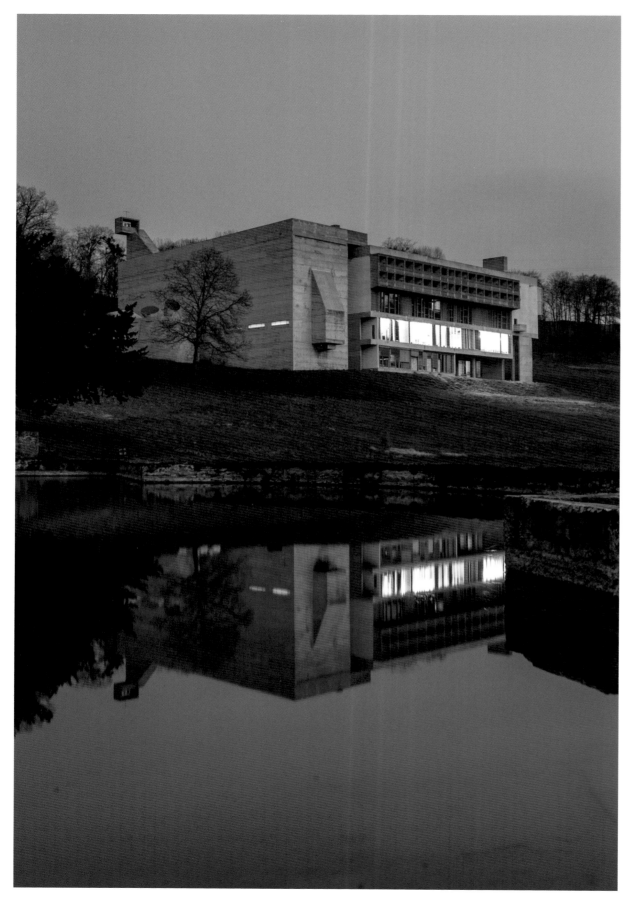

COUVENT SAINTE-MARIE DE LA TOURETTE

Iannis Xenakis (1922–2001) and his associate, André Wogenscky (1916–2004). Money problems quickly led to significant modifications: a story was eliminated; techniques and materials that were too expensive were tabled and finishes were neglected. Construction lasted six years and the convent did not truly open until 1960, and even then it was not finished. Over time, the Dominican community transformed the site into a cultural center. Seven years of major restoration was completed in 2013, and in 2016, it was classified as a UNESCO World Heritage Site. Today, having ceased to be a monastery, the site is home to exhibitions, seminars, meetings, retreats, and thousands of visitors.

How do La Tourette and its church appear today? One is struck first by its imposing materiality on the rustic and wooded site. A simple parallelepiped rectangle planted on a hillside, the church is connected to a U-shaped structure, propped up on a forest of stilts that supports the rest of the monastery and surrounds a central courtyard. The crypt, an organic form, springs out from the solid, plain north facade of the church, looking like a kind of ear. The three exterior facades of the U-shape are pierced with the balconies of the one hundred individual rooms, which served as cells for the monks. The balconies overhang walls of windows in the lower floors, formed in some places by an undulating rhythm of panels, and at others, by wide windows opening onto the landscape, offering expansive views from the library, refectory, and offices.

The concrete is raw, gray, and neutral, and is either solid or penetrated by light, which spills through clear or colored glass. Narrow slits illuminate corridors and spaces throughout, cylindrical skylights that Le Corbusier called "cannons" flood the crypt with shafts of light. The pentagonal windows that Le Corbusier called his "machine guns" of light punctuate the darkness of the sacristy, and concrete sculptural elements known as "flowers" obscure the view out of the windows in the corridors while reflecting light. Against this rigorous framework emerge other strange architectural objects: the oratory with its pyramidal roof, the precariously perched bell tower, the box-like shape that houses the organ, which protrudes from the church's west exterior wall, an amorphous mass of concrete placed in a passageway, an unusual entrance to the grass-covered roof. And the list goes on.

The interior is austere, humble, and dignified, reminiscent of the first truly Romanesque abbeys like Le Thoronet (see page 46), which Le Corbusier admired. A long ramp descends to the church, which has an unexpectedly lofty nave. There is no decoration, save for a few strips of white and colored light. Here, Le Corbusier spoke of "visual acoustics," an odd term that makes sense when one enters this naked space. The walls disappear; light falls on the white stone block of the altar and travels between the tops of the walls and ceiling or meets at the corner where two walls converge; word, song, and music have a mesmerizing presence. Amid absolute austerity, amid such abstraction, nothing material seems to matter save for what is essential, which is spiritual intensity. Le Corbusier, an atheist, made the following comment when he met with the monks of La Tourette in 1960: "When a work reaches its maximum level of intensity, proportion, quality of execution, and perfection, a phenomenon of ineffable space occurs: the places radiate, physically they radiate. They become what I call "ineffable space."

PAGE 76 LEFT: View of the convent on the hill, at the center of a very large property in L'Arbresle. ‡ PAGE 76 TOP RIGHT: The distinctive tower with cantilevered bell chamber, designed by Le Corbusier and Iannis Xenakis (1922–2001). ‡ PAGE 76 BOTTOM RIGHT: These balconies off the rooms that were designed to be monks' cells overlook the interior courtyard.

MOSQUE-CATHEDRAL OF CÓRDOBA

CÓRDOBA ▫ SPAIN

Added to UNESCO's World Heritage List in 1984, the monumental complex that is the hypostyle Mosque-Cathedral of Córdoba is an admirable testament to four centuries of Arab-Muslim presence in Spain. In its grandiose manner, it illustrates the fusion of five cultures: Roman, Visigothic, Islamic, Jewish, and the Catholic Spanish and Portuguese kingdoms.

It was in 711 that the governor of Tangier arrived at Algeciras with seven hundred men, most of them Berbers. For once, it was not a pillage but a conquest. The southern Visigothic kingdom fell, and in 712, so did the northern one; in 719, the Arab government settled in Córdoba. The Basilica of St. Vincent of Lérins, built on an ancient temple to Janus, was then partially transformed into a mosque.

In 755, 'Abd al-Rahmān I, who carried on the lineage of the Umayyads ousted from Damascus by the Abbasids, found refuge in Andalusia, took power, and in a few years formed a mighty kingdom, the intellectual and artistic influence of which would leave a lasting mark on the entire Iberian peninsula.

The emir wanted a mosque for his capital that would rival those in Damascus. He tore down St. Vincent and constructed a building that would be expanded by his successors between 821 and 852, again around 929, and finally again starting in 961. The initial goal was achieved: Córdoba had the second-largest mosque in the known world outside of Mecca.

PAGE 79: Strange effects of light play among the hundreds of tiered arched pillars that surround the cathedral.

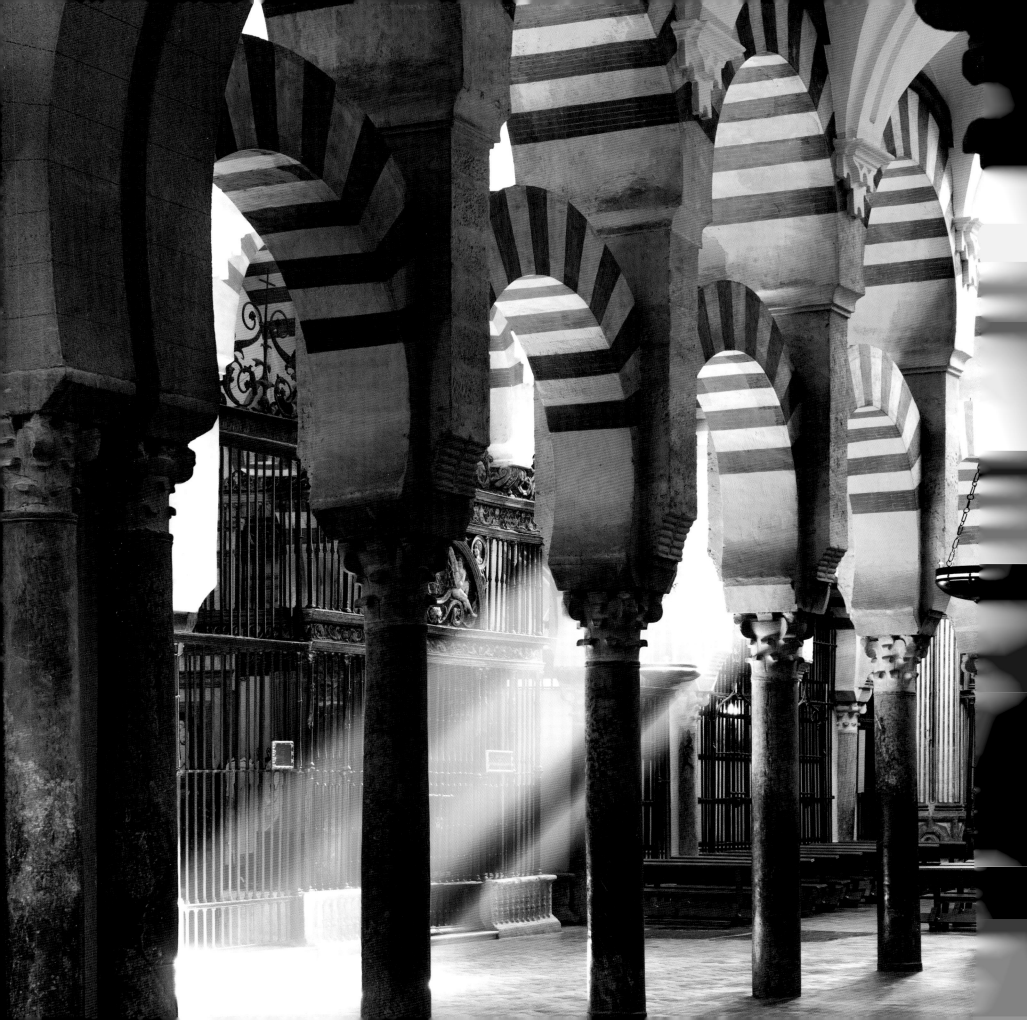

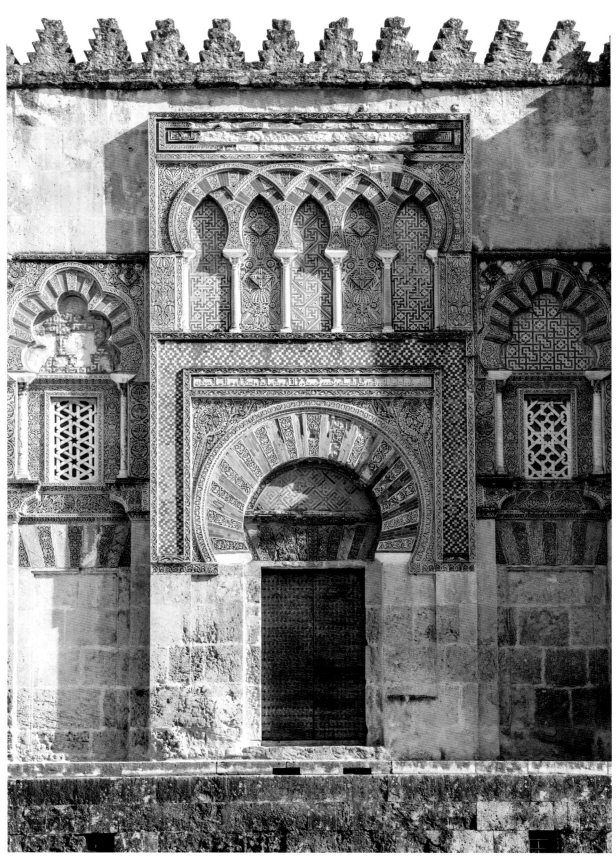

MOSQUE-CATHEDRAL OF CÓRDOBA

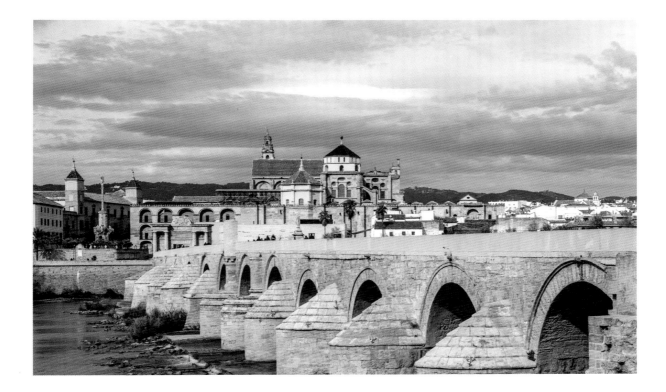

Théophile Gautier (1811–1872), in an account published in 1842 by the *Revue des Deux Mondes*, described his vision of Córdoba in the following way: "The mosque-cathedral rises above the ramparts and roofs of the city more like a citadel than a temple, with its high walls denticulated with Islamic crenels battlements, and a heavy Catholic dome squatting on its eastern platform." Indeed, the mosque gives the impression of being an enclosed, almost fortified building. None of the thirteen doors are monumental; rather, their plain decor and subtle reliefs announce the endlessly repeating architectural motif inside.

The inside not only comes as a surprise but amazes. If a visitor is accustomed to the feeling of Gothic verticality, here the eye will get lost in the indistinct and infinite horizontality; there is no point of convergence, because the *mihrab*, or prayer niche, was moved off center when the site was expanded. One almost feels disoriented when crossing these unique and mysterious grounds, which were once bathed in the low light of oil lamps reflecting off the shiny floor. The severe repetition of the two-tiered arched pillars was intended to lead believers into a visual trance; there was nothing to focus on but the shimmering mosaics of the slightly larger mihrab at the back of the nave.

PAGE 80 *TOP AND BOTTOM LEFT*: The mosque's vast courtyard planted with orange trees. It is dominated by the minaret, which was built in the seventeenth century. ‡ PAGE 80 *RIGHT*: Door of St. Stephen (eighth and ninth century), which served as a model for the twelve others. ‡ PAGE 81: View of the mosque from the other side of the Guadalquivir River. The enormous cathedral built in the sixteenth century emerges from it.

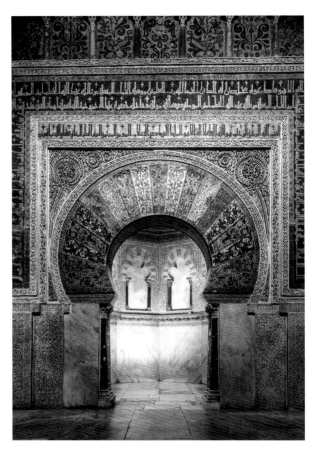

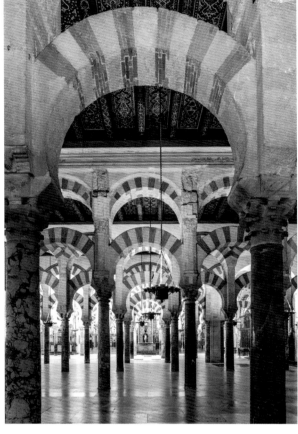

Córdoba is a lesson in experimental architecture before the year one thousand. Techniques were still primitive and carried risk, given that, in the tenth century, a massive lateral wall had to be built to support the structure. In the vast rectangle measuring more than 250,000 square feet (23,400 sq. m), there are no less than nineteen naves and 856 columns made of, according to Gautier, "rare marble, porphyry, jasper, green and violet breccia, and other precious materials; some are even ancient." They bear horseshoe arches, which support semicircular arches in an alternating pattern of stone and red brick. In the *maqsura,* an area reserved for the emir to pray, the multifoil arches intersect with massive blooms of ornamental

stone. And in a small heptagonal recess, a mihrab roofed with a single block of white marble is carved in the form of a shell. The golden mosaics on its walls, along with the craftsmen capable of installing them, were a gift from a Byzantine emperor in 965.

PAGE 82 *LEFT:* The mihrab with a Moorish arch and decorated with lavish gold Byzantine mosaics. ‡ PAGE 82 *RIGHT:* More than eight hundred and fifty columns support two-toned horseshoe arches. ‡ PAGE 83: The mihrab, after its transformation from a niche into a small room with a shell cupola. It is supported by a complex and elegant play of arches. Extraordinarily rich and inventive mosaics adorn it.

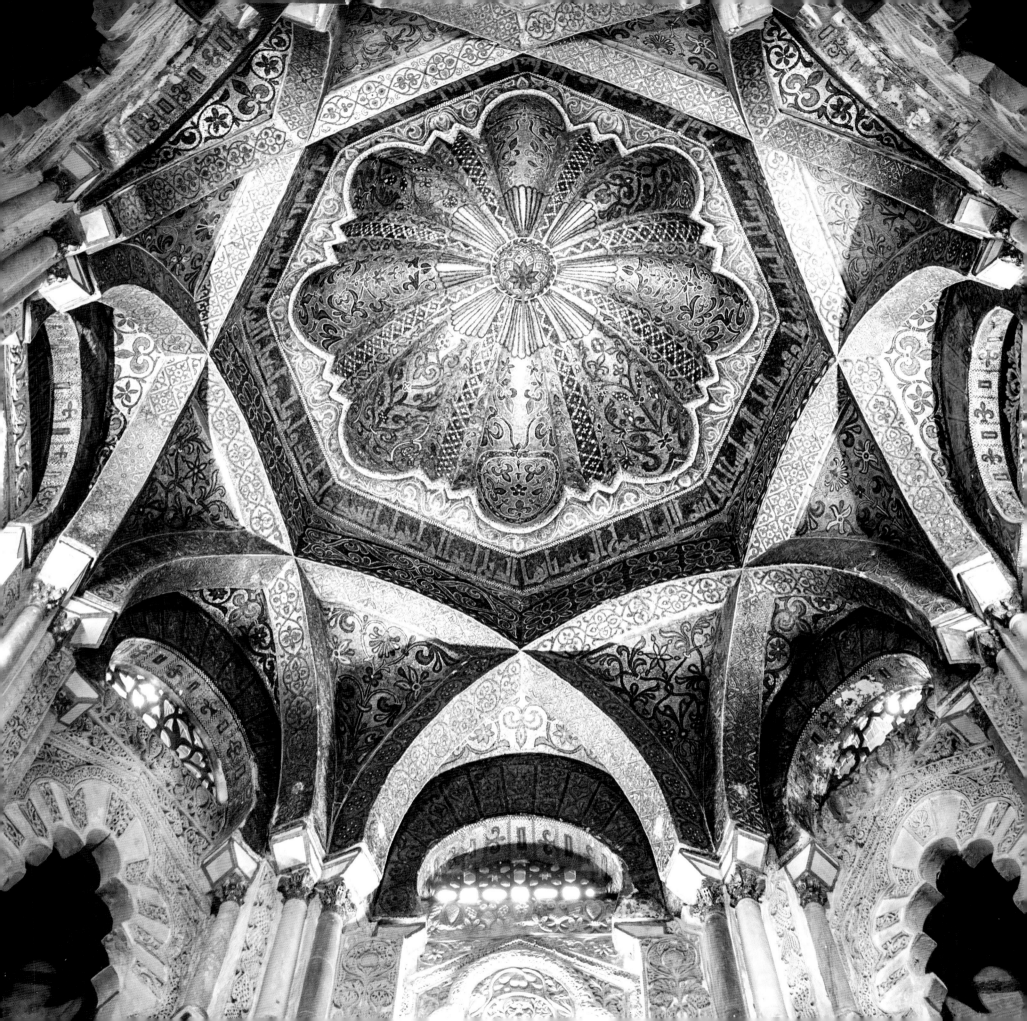

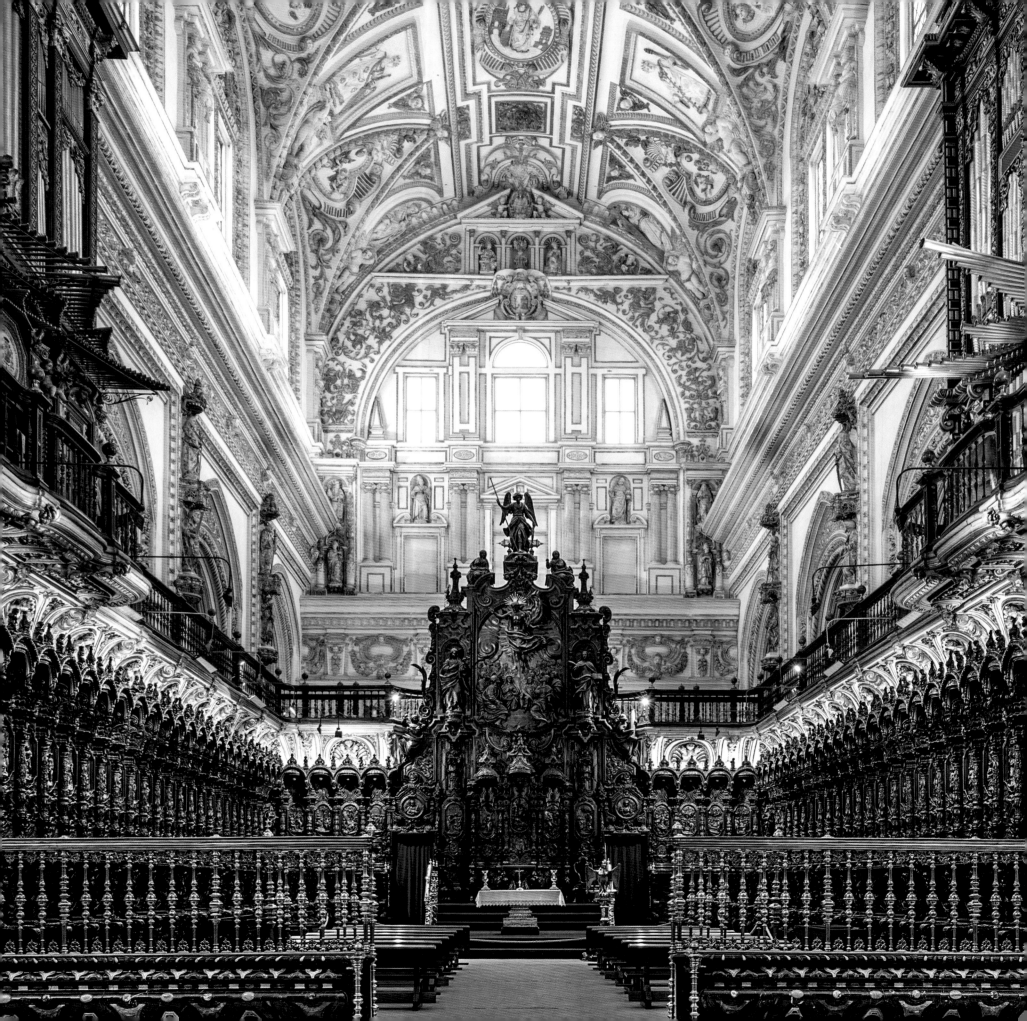

In 1236, Ferdinand III (1201?–1252) seized control of Córdoba, and purification rituals were performed at the mosque before it was transformed into a royal chapel. It would not be until the end of the Reconquista and the beginning of the sixteenth century that Bishop Alonso Manrique (1471–1538) was able to insert a cathedral at the very center of the mosque. A curious idea and a strange object, in the Renaissance style, it clashes with the mosque's serenity. When Charles V (1500–1558) visited it, he regretted allowing the construction and issued this stinging criticism: "You have destroyed something unique to build something commonplace."

PAGE 84: The cathedral choir and stalls in the Gothic, Renaissance, and Mannerist styles. Work began on these elements in 1523. The architects, Hernán Ruiz the Elder (c. 1475–1547) and Hernán Ruiz the Younger (1514–1569), were assigned the difficult task of integrating the classic and majestic cathedral, with nave, transept, and choir, into the immense hypostyle mosque. ‡ PAGE 85 *LEFT*: The back entrance to the choir, facing the mosque. ‡ PAGE 85 *RIGHT*: *Nuestra Señora de la Concepción* (*Our Lady of the Conception*, c. 1680) by Pedro de Mena (1628–1688), which is the altar statue in the red marble chapel of the same name, located at one of the mosque entrances.

SANTA MARIA DE LEÓN CATHEDRAL

LEÓN ▫ SPAIN

We usually consider places of worship to be finished architectural objects that have existed for centuries and will survive for many more. The Santa Maria de León Cathedral is an example of the opposite. It is with us today only because of a series of major interventions to save it, the first beginning right after construction was completed. Excellent architects and other somewhat incompetent ones would take the helm one after another.

The initial problem was its foundations. In 1205, it seemed normal and economical to build the new cathedral on the same site previously occupied by a Roman temple, baths, a church, and a palace. Such an accumulation on top of embankments and mortar foundations eroded by time and humidity could in no way provide a solid base for a new structure, and the mediocre quality of the stones chosen only increased the risk of collapse. The first problems emerged during construction. Legend has it that an evil mole destroyed at night what masons had built during the day. A poor animal was then captured and its skin exhibited above a door, but two centuries later, the skin was discovered to belong to a turtle. Around 1350, shortly after construction was completed, worrisome cracks appeared.

PAGE 87: The thin choir vaults and the dimensions of the stained glass partly explain the turbulent history of the cathedral's architecture. ‡ PAGE 88: Stained glass, mostly from the thirteenth and fifteenth centuries. León is often compared to Chartres Cathedral. ‡ PAGE 89 *TOP LEFT*: Statue of an evangelist (sixteenth century), part of the Renaissance rood screen by Juan de Badajoz the Younger (1495–1554). ‡ PAGE 89 *BOTTOM LEFT*: Sunset on the two Gothic towers (thirteenth century), some 213 and 223 feet (65 and 68 m) in height. ‡ PAGE 89 *RIGHT*: The choir, enclosed with gates from the fifteenth century. The stained glass of the cathedral fills almost thirteen thousand square feet (1,800 sq. m).

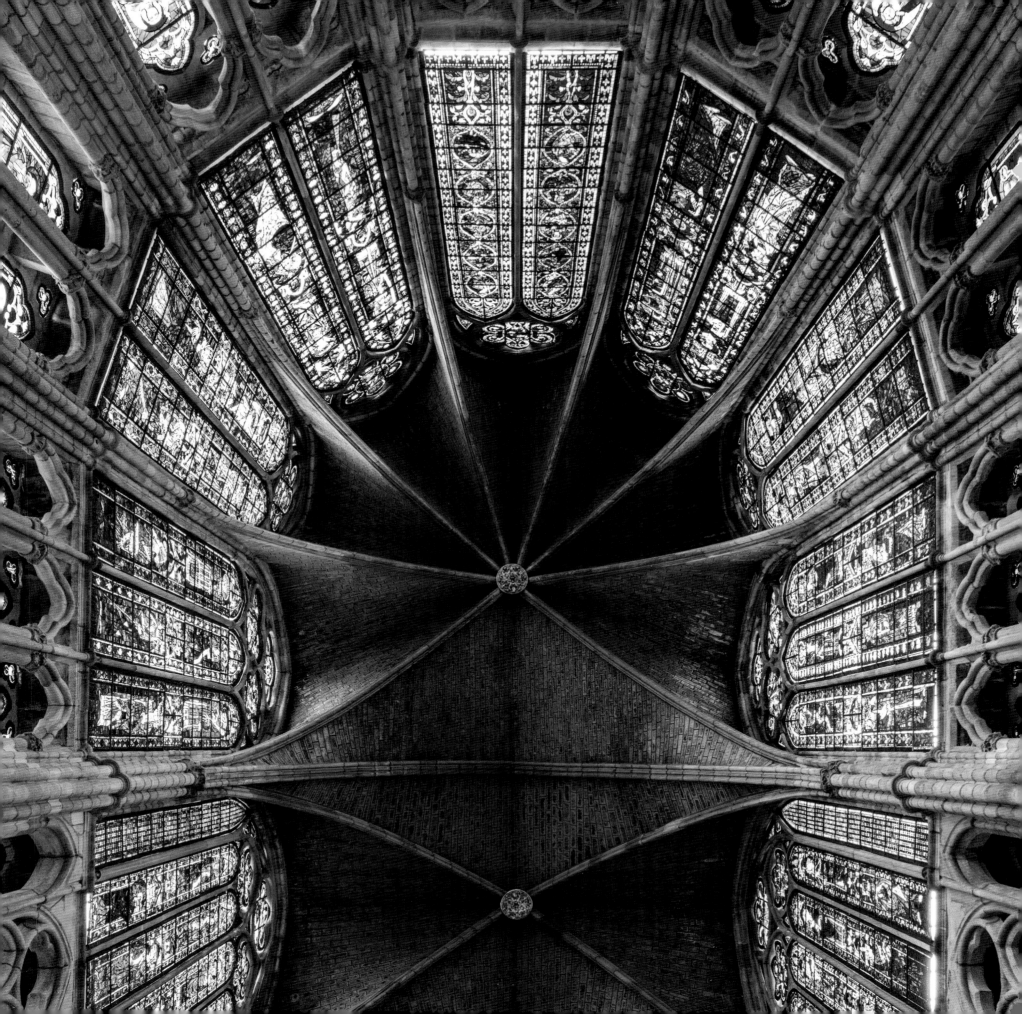

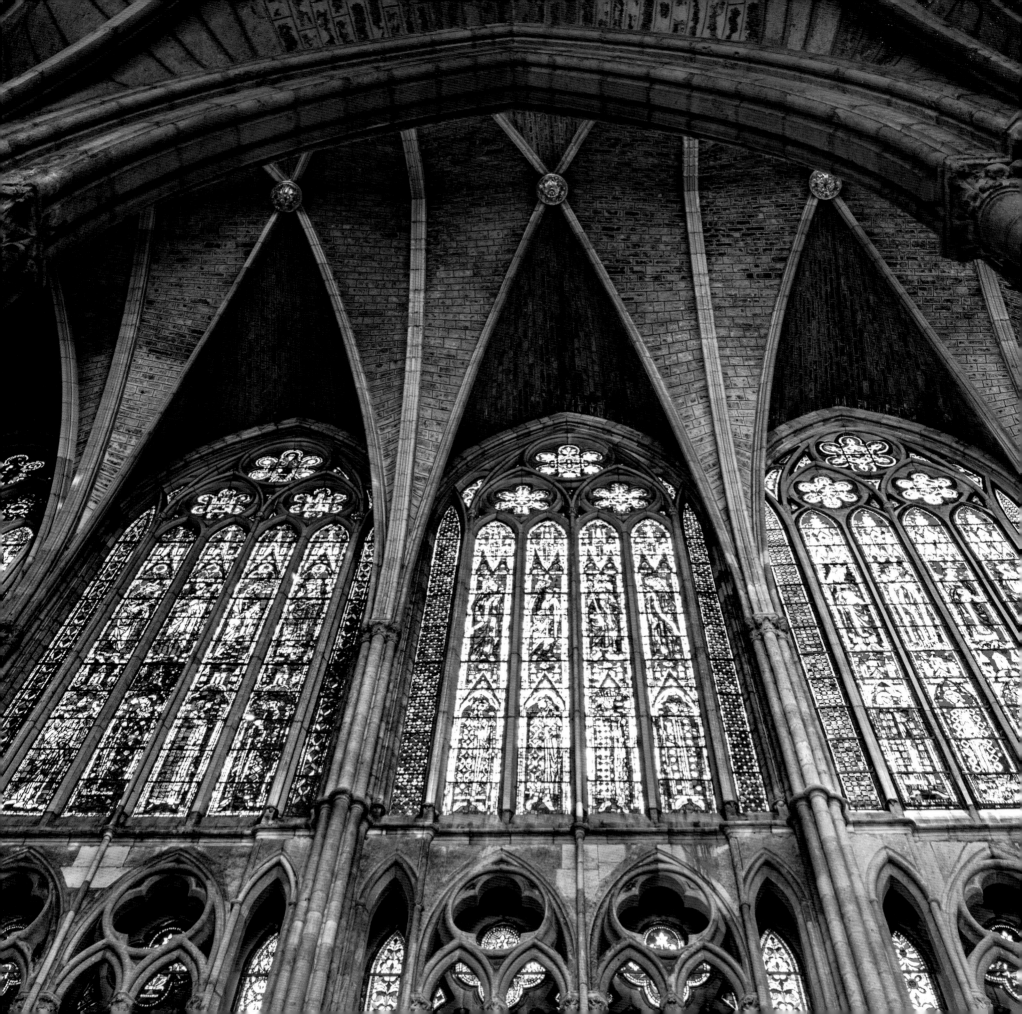

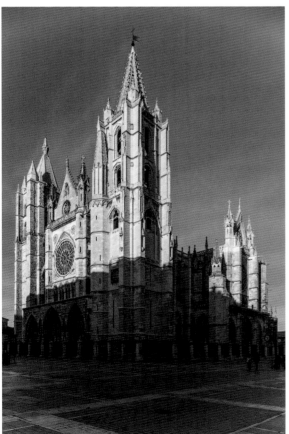

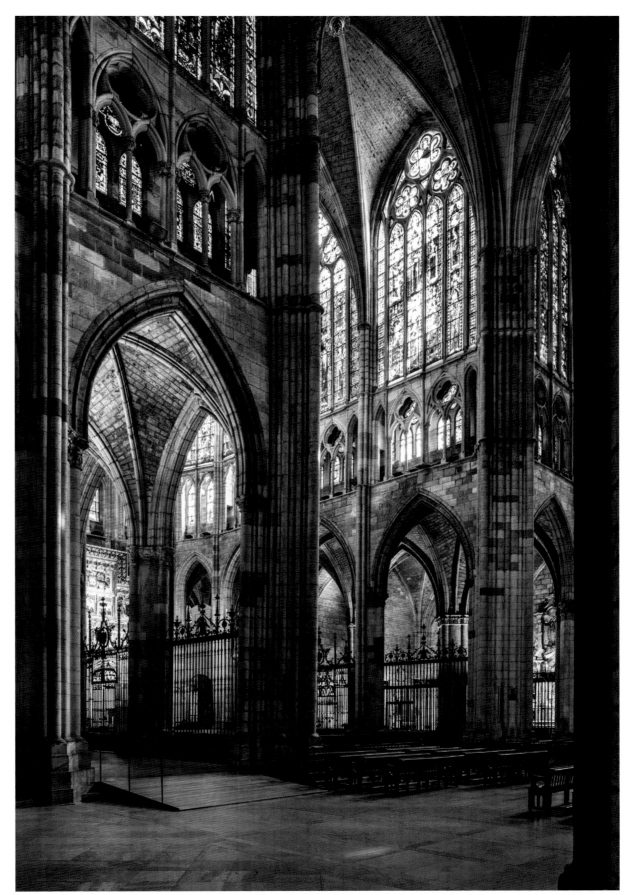

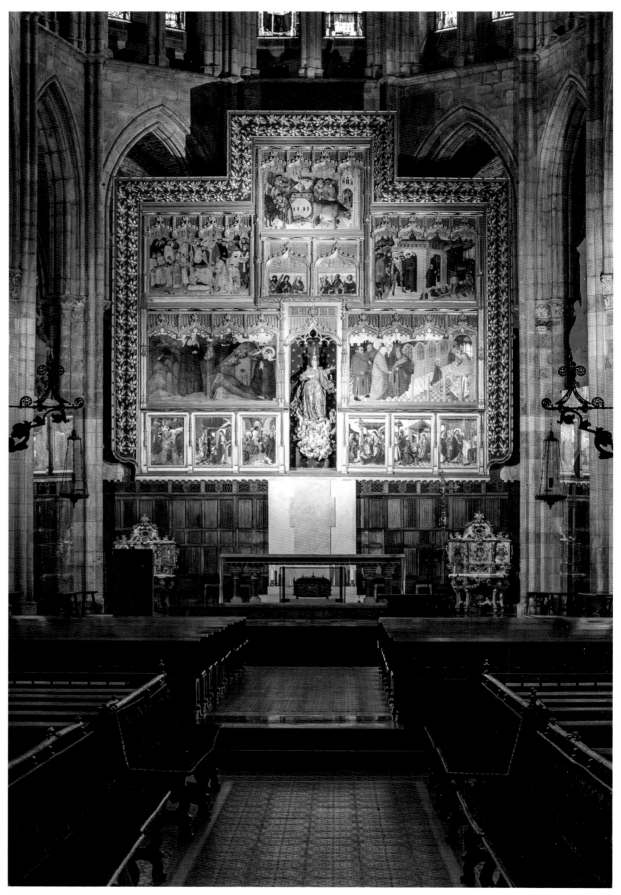

SANTA MARIA DE LEÓN CATHEDRAL

The building was reinforced as best as it could be, but that added weight to the weakened foundations. Then, in the seventeenth century, Juan Naveda (1590–1638), Philip IV's (1605–1665) architect, proposed that a cupola be placed on the transept, an unfortunate initiative that both clashed with the Gothic style and architectural concept and seriously enfeebled the central vault. In 1755, the vault was further weakened by an earthquake, and stones began to fall from the structure around 1830. The cathedral was eventually awarded considerable funding; major reinforcement and reconstruction began under Demetrio de los Ríos (1827–1892), who, being a champion of Viollet-le-Duc's theories, reestablished the Gothic character of the building we see today. Unfortunately, recent studies have revealed that the stone has been blighted; many sculptures have already needed to be replaced with copies.

Such recurring setbacks, past and future, must not make us forget that we are dealing with the finest Gothic cathedral in Spain; some even call it a "Reims replica"

because of its close resemblance to French Gothic cathedrals. Its originality—and one of the reasons it is so fragile—is tied to the great number of stained glass windows. They cover some 19,000 square feet (1,800 sq. m) and include twenty-five panels and fifty-seven medallions executed from the thirteenth to the twentieth century. At the end of a winter's day, when the setting sun strikes horizontally, it illuminates the naves, floors, elaborate pillars, and fine vault ribs with a lavish blaze of color. The cathedral is a shrine of light.

The interior is richly decorated, primarily in the Renaissance style. Its impressive altarpiece from the fifteenth century executed by Nicolás Francés (1400–1468), a local painter perhaps originally from Burgundy, exemplifies the International Gothic style and incorporates a touch of Hispanic Flemish influence. The piece, which remains spectacular, was partially reconstructed in the twentieth century.

In 1895, the architect Demetrio de los Ríos wrote: "Every cathedral in the world can be considered a legacy to future generations, inevitably doomed to permanent restoration. León's was subject to that inescapable law more than any other." León residents have shown great perseverance through the centuries to meet the challenge of conserving such an exceptional testament to the ambition of the cathedral's builders.

PAGE 90 TOP LEFT: *Virgen de la Esperanza* (thirteenth century) in polychrome stone. ✚ PAGE 90 BOTTOM LEFT: Medieval wrought iron gate to the choir. ✚ PAGE 90 RIGHT: The extraordinary altarpiece (1434) dedicated to Mary by Nicolás Francés (1400–1468), a painter perhaps originally from Burgundy. Dismantled in the eighteenth century, it initially included eighteen large panels and four hundred small ones.

SEVILLE CATHEDRAL

SEVILLE ▫ SPAIN

Let us build a church that is so vast that future generations will think we were mad," a member of the Seville chapter is said to have proposed in 1401. It took over a century, but the challenge was met in full. With its nave measuring some 138 feet (42 m) high, some 430 feet (132 m) long, and 275 feet (84 m) wide, there are those who believe it rivals St. Peter's in Rome. For Seville, which is the wealthy economic capital of southern Spain, erecting such a building was more a proclamation of the city's power than an act of faith.

The romantic description penned by Théophile Gautier in 1842 is still convincing today: "The most extravagant and most monstrously prodigious Hindoo pagodas are not to be mentioned in the same century as the Cathedral of Seville. It is a mountain scooped out, a valley turned topsy-turvy; Notre-Dame at Paris might walk erect in the middle nave, which is of frightful height; pillars as large round as towers, and which appear so slender that they make you shudder, rise out of the ground or descend from the vaulted roof, like stalactites in a giant's grotto."

The cathedral stands at the site of an Almohad mosque built when Seville was called Isbiliya. Only one element from that building remains, the famous Giralda tower. The mosque was transformed into a church after the Reconquista of Andalusia in 1248; then, in 1401, it was realized that an earthquake in 1356 had seriously weakened the sanctuary. Reconstruction began immediately, but the project was not completed until 1506 and would last in the chapels until 1575. In the meantime, a pillar would collapse in 1511, leading to the fall of the dome in 1588. The building was also damaged by the Lisbon earthquake in 1755 and a third one in 1888.

An example of late Gothic style, it was the last of the large Gothic cathedrals to be built in Spain. Several architects and project supervisors intervened, including

PAGE 92: This altarpiece (1482–1564), the largest in Spain, measures more than twenty-six-hundred square feet (246 sq. m) and was made by Fleming Pieter Dancart, who worked on it for forty-four years. With its gilded gold and many colors, it is a masterpiece of late European Gothic art.

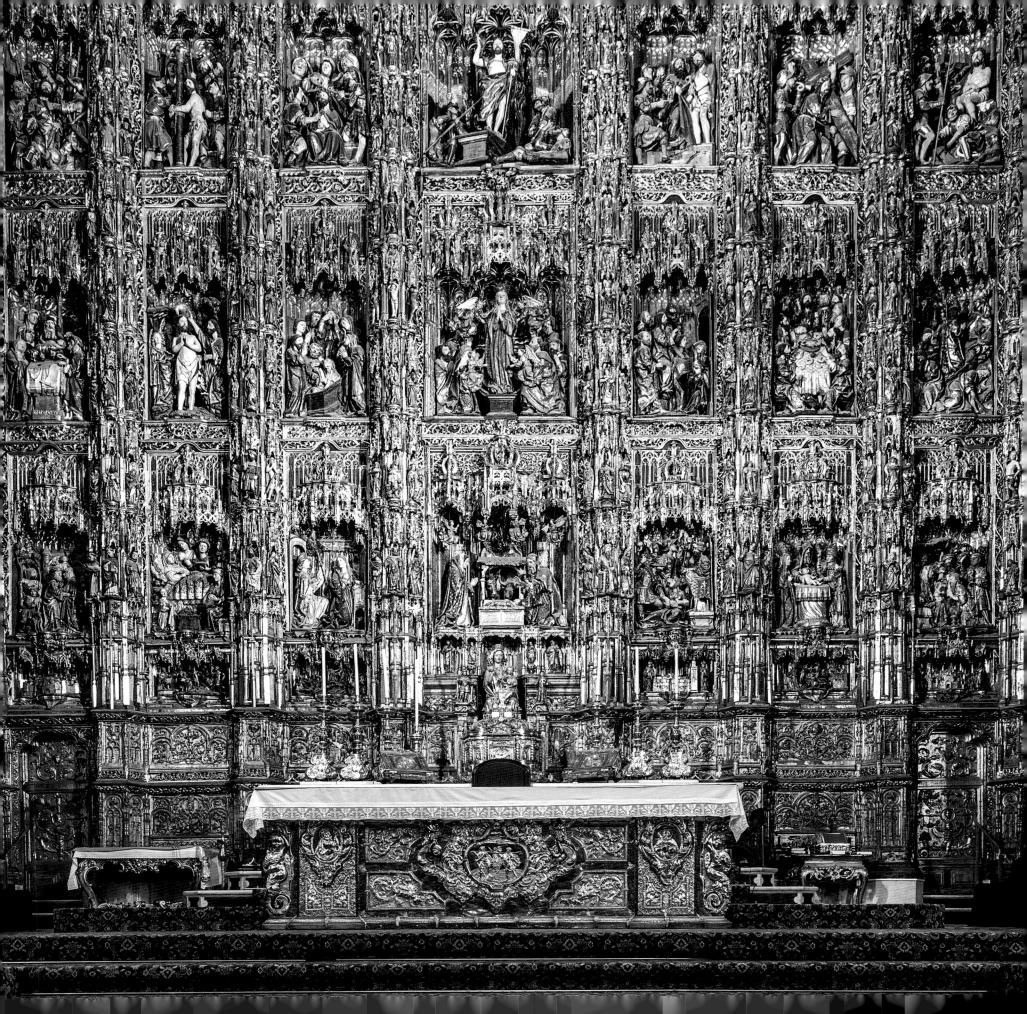

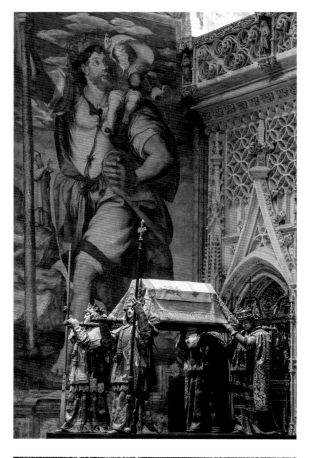

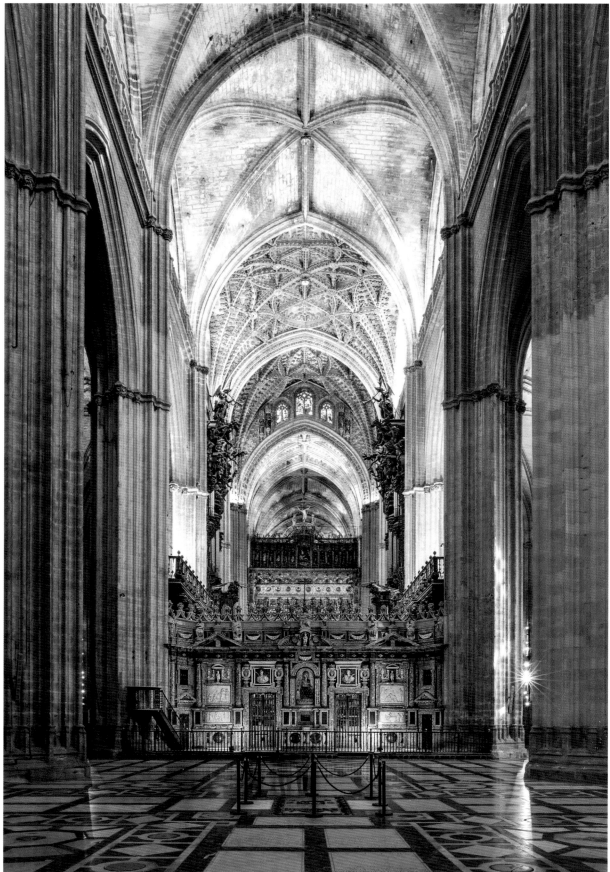

Alonso Martinez and Charles Galter, a Frenchman who had worked in Normandy and in Barcelona.

From the exterior, it is not immediately clear how extraordinary the structure truly is. Somewhat obscured from view, it is partially surrounded by low buildings and a courtyard of orange trees (a vestige of the former mosque). Additionally, the facades are a variation from the French Gothic style. The austere decorative splendor of the doors, for example, depicting the Baptism and the Assumption, in no way foretells the visual shock one experiences upon entering the immense nave.

Inside, everything seems out of proportion, enormous, crushing, as if the Seville chapter had continually wanted to break records: a silver altar is dominated by a gigantic monstrance, a silver lectern is monumental in size, paintings by Francisco de Zurbarán (1598–1664), Bartolomé Esteban Murillo (1617–1682), and other great

names of Spanish painting cover entire walls, and, in the main chapel there rises the most excessive, lavish altarpiece ever imagined. Mostly the work of Flemish sculptor Pieter Dancart, it stands like a ninety-eight-foot (30 m) wall of gold and includes, in its forty-five carved scenes, more than one thousand sculptures of biblical figures. Stained glass windows based on designs by Peter Paul Rubens (1577–1640), Raphaël (1483–1520), and Michelangelo were executed around 1535 by one of the most famous master glassmakers of the time, Arnao de Flandes the Younger (d. 1544).

There is also Christopher Columbus's tomb, made in 1899 by the sculptor Arturo Mélida (1849–1902): Four figures symbolizing the four kingdoms of Castile, León, Aragon, and Navarre shoulder the coffin containing the bones of the famous navigator, which had spent time in a monastery in Valladolid, in the Dominican Republic, in Cuba, and finally here, the great traveler's last stop.

The enormous cathedral is dominated by an equally impressive belfry. The Giralda, which measures no less than 340 feet (104 m), is the minaret (tower) of the former mosque (1172–1198) and was considerably enhanced and modernized in the Renaissance and early Baroque style between 1558 and 1568.

Registered as a World Heritage Site by UNESCO in 1987, the cathedral is newly restored. The grandiose gloom of its naves and dark chapels, which until recently

PAGE 94 *TOP LEFT*: Catafalque of Christopher Columbus (1899), by the sculptor Arturo Mélida (1849–1902). It is carried by figures symbolizing the four kingdoms of Castile, León, Aragon, and Navarre. ✝ PAGE 94 *BOTTOM LEFT*: Detail of the lock on the *Puerta del Perdón* (Door of Forgiveness), former Almohad door from the mosque (late twelfth century–early thirteenth century). ✝ PAGE 94 *RIGHT*: The composite Renaissance rood screen and the dark nave, measuring some 140 feet (42 m) high and some 430 feet (132 m) long.

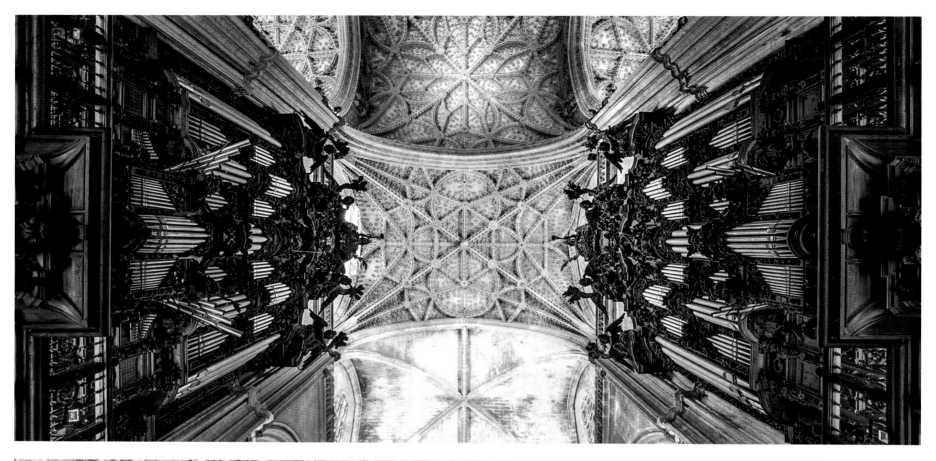

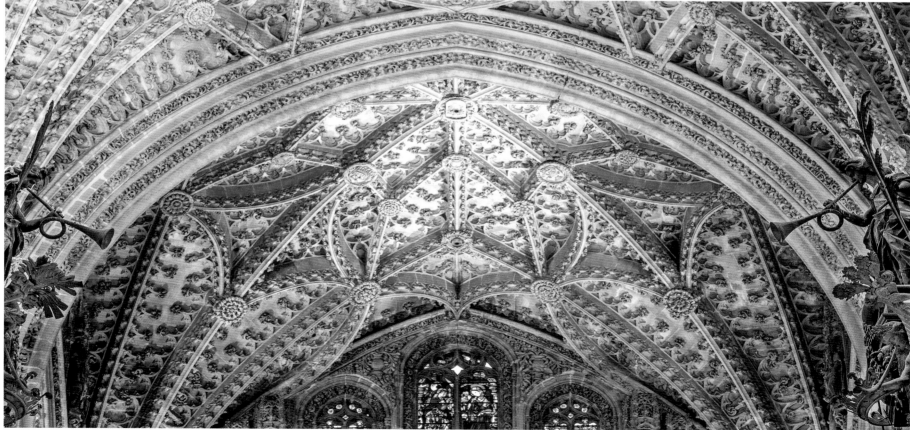

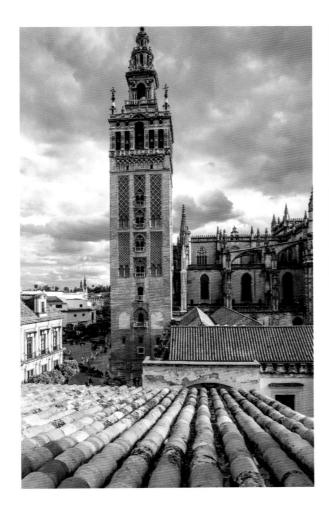

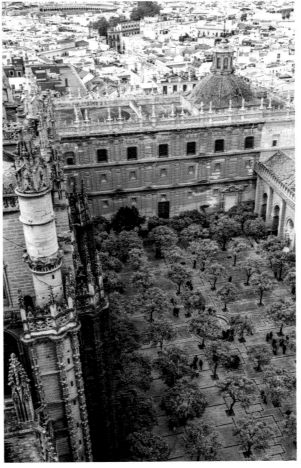

was pierced only by the shimmer of the gold altarpieces, has been mitigated; subtle lighting allows visitors to better admire the lacelike stone vaults and works of art that, at every moment, catch one's eye.

Today, fewer masses are celebrated in the cathedral—there were five hundred per day in eighty chapels during the nineteenth century!—and visitors are mostly tourists who have paid to enter. But a certain silence still reigns within, a silence of respect for the work of those men from a distant past who hoped to be taken for madmen.

PAGE 96 *TOP*: The two-part organ. ✝ PAGE 96 *BOTTOM*: Fifteenth-century vaults. Some were restored at the end of the nineteenth century. Their decoration, among the most sumptuous of the late Gothic period, remained hidden until the interior was restored and modern lighting installed. ✝ PAGE 97 *LEFT*: The Giralda bell tower, the former minaret from the thirteenth century. It was raised to accommodate the bells in the sixteenth century. ✝ PAGE 97 *RIGHT*: The orange tree courtyard, the former mosque's courtyard of ablutions.

BASILICA DE LA SAGRADA FAMÍLIA

BARCELONA ▫ SPAIN

Antoni Gaudí i Cornet (1852–1926) was only thirty-one when the Spiritual Association of Devotees of St. Joseph commissioned him to create an "expiatory temple dedicated to the holy family." He did not yet know that he would dedicate his life to the project. While relatively unknown in 1881, he quickly became the architect of choice of a few important and sophisticated families in the upper class of Barcelona, a city open to the world and to European culture, thriving on its industries and its port. For them, he would erect estates, villas, and buildings that would amaze his contemporaries.

Gaudí's style was always extremely personal. After being trained in the neo-Gothic spirit then in fashion, he quickly turned toward a type of expression that was essentially organic, Catalan modernism. It was inspired in part by Art Nouveau, Jugendstil, and experiments coming out of Vienna and Brussels, but was also strongly influenced by regionalism. It was a new architectural and decorative language in which each project was conceived of as a total work of art. Gaudí, who wrote little, would have practically no disciples, aside from his brilliant assistant, Josep Maria Jujol (1879–1949), who monitored the construction of La Sagrada Família until his death. Gaudí has seven works classified as World Heritage sites by UNESCO.

Gaudí concretely observed nature in all its most curious forms—mountains, cliffs, caves, exotic plants—and wanted his architecture to reflect its structures. He did not defy nature but, to the contrary, sought to reproduce its laws. A fabulous technician, he drew on studied geometric forms, for example, hyperbolic paraboloids, hyperboloids, helicoids, conoids, catenary arches—all structures soon to be rejected by European modernism in favor of the right angle. Eighty years later, architects like Zaha Hadid (1950–2016) would turn to them again, but armed with computers. Gaudí calculated everything himself, drew with a pencil, and built models with weights and bits of string.

PAGE 99: The transept crossing. The vaults are supported by pillars with oval nodes and tree columns.

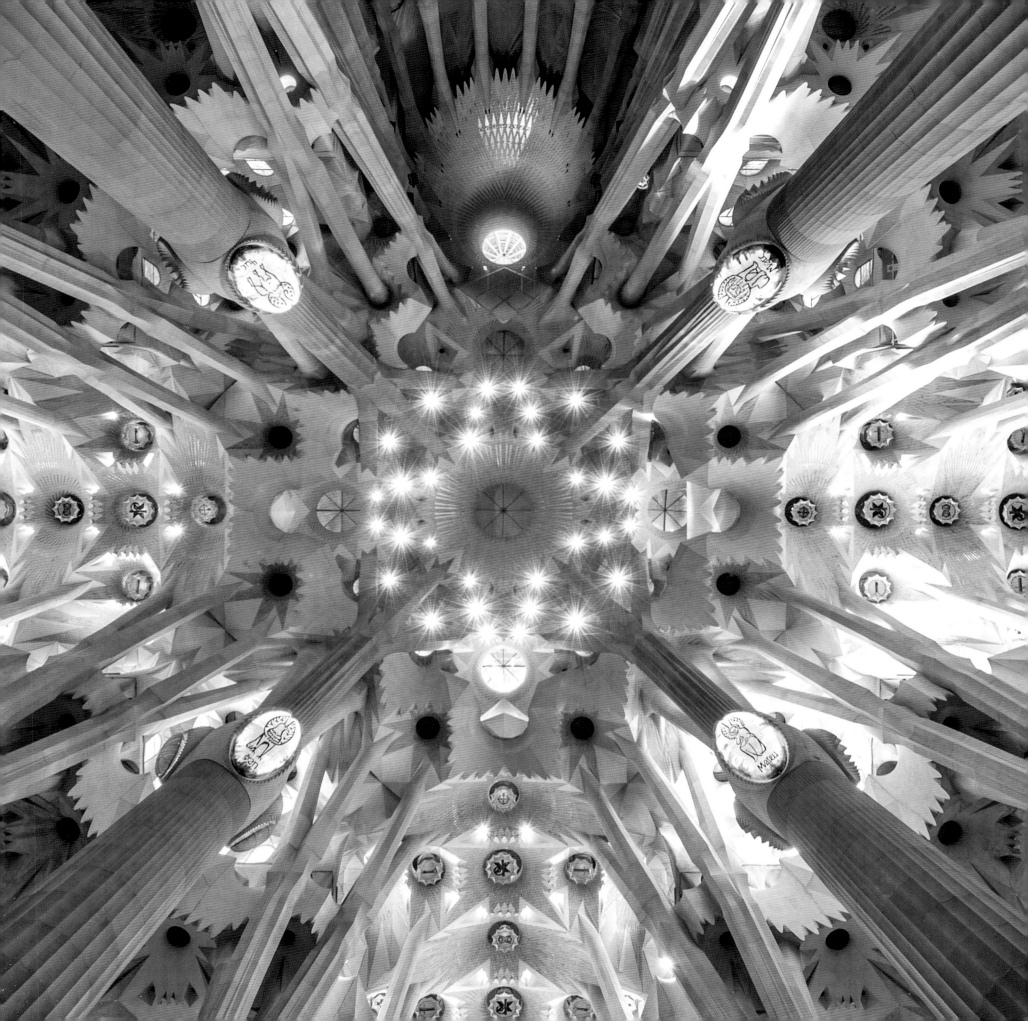

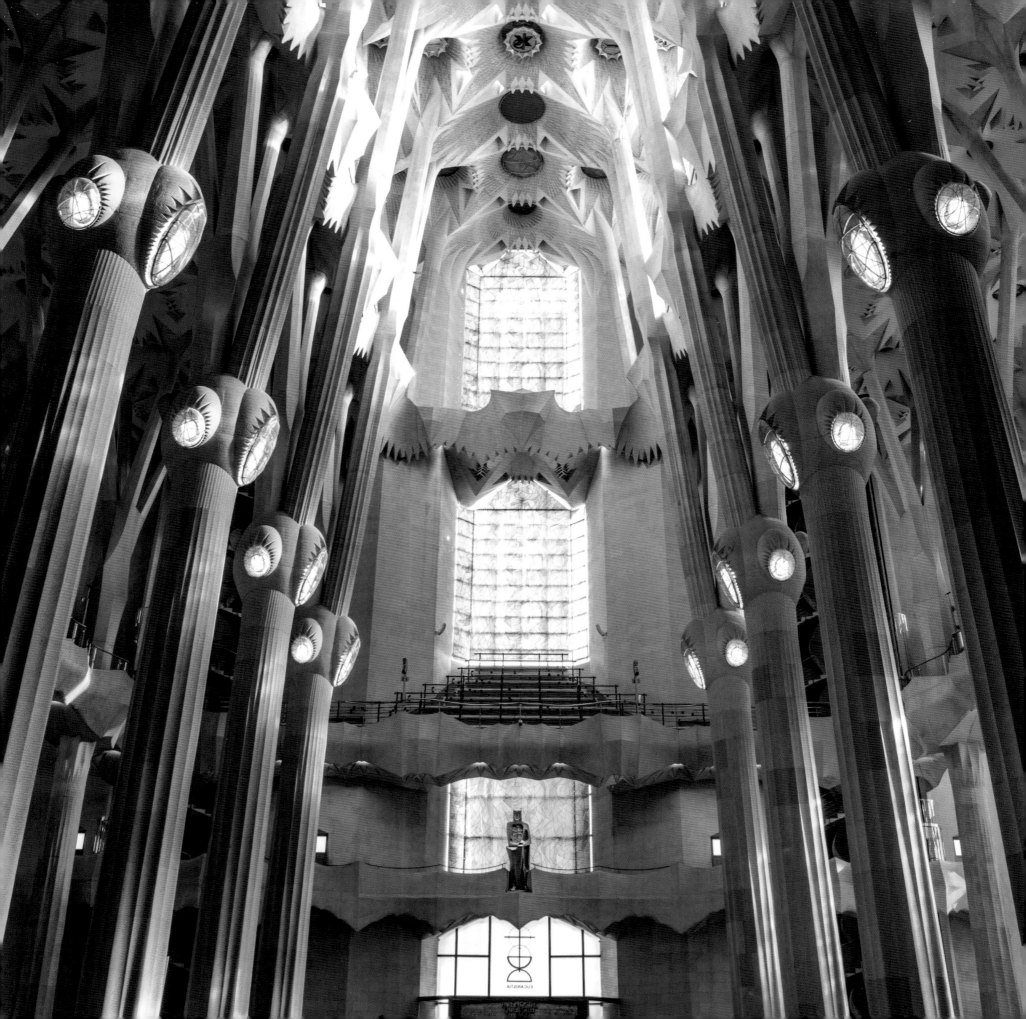

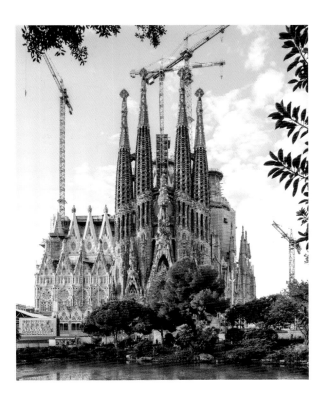 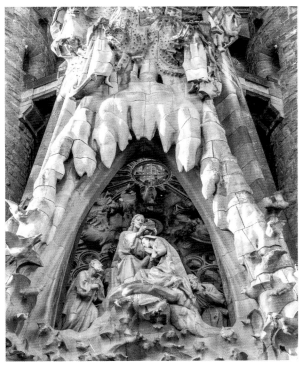

He was part craftsman, part alchemist. Generous with his time and his money, he died poor and would be forgotten for decades.

There is nothing in the world like La Sagrada Família. Its slender exterior facades are astounding for their many towers and for their gables adorned with rich narrative sculptures, similar to those found on medieval cathedrals. The interior enchants with its imperious play of tree-like pillars that rise to the vaulted canopy dotted with openings

PAGE 100: Interior view of the principal facade. The nave is almost two hundred feet (60 m) high. ‡ PAGE 101 *LEFT*: As with most large cathedrals, construction has lasted for decades—in this case more than one hundred and thirty years. In theory, it will be completed in 2026. ‡ PAGE 101 *RIGHT*: Detail of the Passion facade, about which Antoni Gaudí (1852–1926) wrote, "I wanted it to inspire fear."

that look out onto the Catalan sky. Light, captured by stained glass or clear windows, enlivens the structural mass. Rarely in the history of Christianity has such a captivating evocation of the mythical vision of the heavenly Jerusalem come into being. Gaudí was proposing not only to build a place of worship but also to compose a poem to the glory of the triumphant church, the unique and glorious path to God. The expressive wealth of abounding symbols continues to speak to us: for example, the east-west transept, conceived as a passage between one facade celebrating the Nativity and another illustrating the Passion; or the towers crowned with fruit and Episcopal emblems; or the forest of pillars, reminiscent of Eden.

The construction of La Sagrada Família has lasted more than one hundred and thirty years, as long as that of many medieval cathedrals. But still no one can tell when

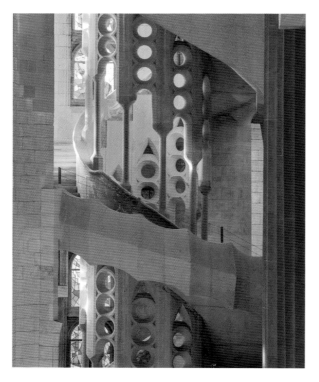

it will be completed and especially if its openwork tower, some 566 feet (173 m) high, dedicated to Christ, will crown the project. Combining helicopter footage with 3-D animation, a video created by the Sagrada Família Foundation, which can be seen on YouTube, reveals how the final

version could take shape. The basilica and its future eighteen towers look like the setting of an epic science fiction movie, a major temple in a faraway kingdom.

Very early on, Gaudí knew that he would never see his dream fully realized. He himself had doubts, changed his plans, and redesigned them. He wrote: "I have decided to leave it only scheduled so that another generation will collaborate on the Temple, as is repeatedly seen in the history of cathedrals."

He was run over by a trolley car while crossing the street and died from his injuries. Exalted by his project and having become very pious, he is now being considered for sainthood. To accelerate the process, some are looking for a miracle the architect may have performed. Is the miracle not before our eyes, in his basilica that reflects such fervent faith?

PAGE 102 *LEFT*: Detail of a staircase in one of the eighteen towers. ‡ PAGE 102 *RIGHT*: Staircase at the transept crossing. ‡ PAGE 103: The ciborium, or hanging baldachin, over the altar, supporting the cross and fifty oil lamps. ‡ PAGE 104: Gaudí conducted extensive studies on light, both natural and artificial, which he considered part of his architecture. ‡ PAGE 105 *LEFT*: View of a vault with oblique columns (catenary arch). ‡ PAGE 105 *TOP RIGHT*: The golden mosaics amplifying the natural light falling from the keystone openings. ‡ PAGE 105 *BOTTOM RIGHT*: Stained glass creates multiple intangible effects.

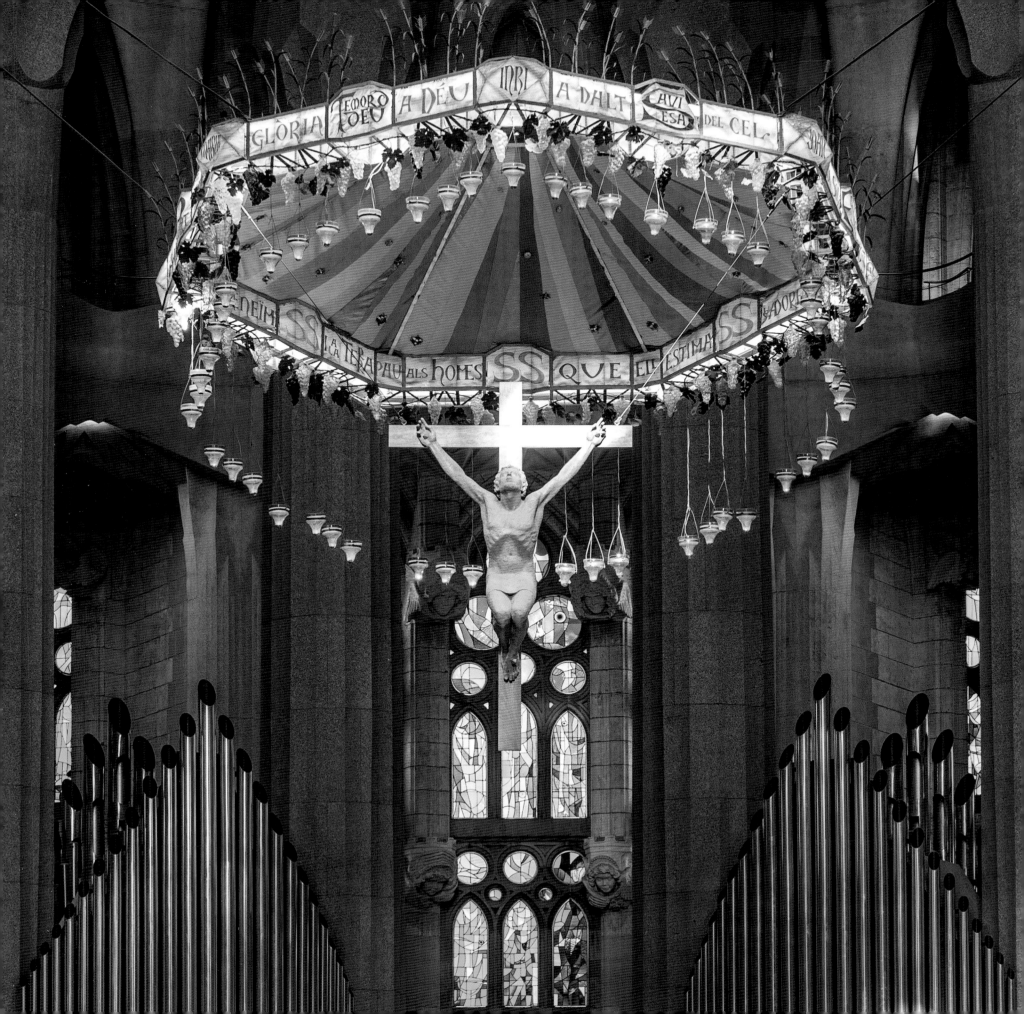

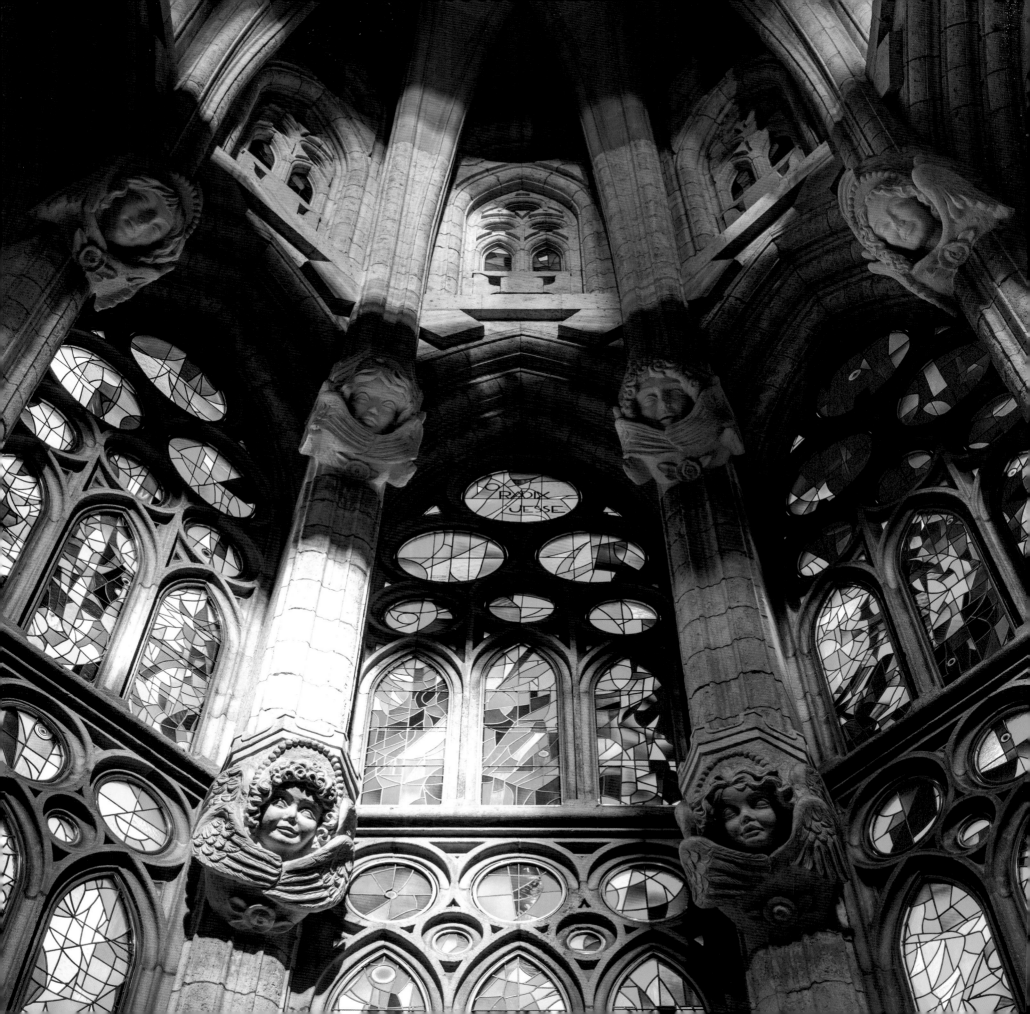

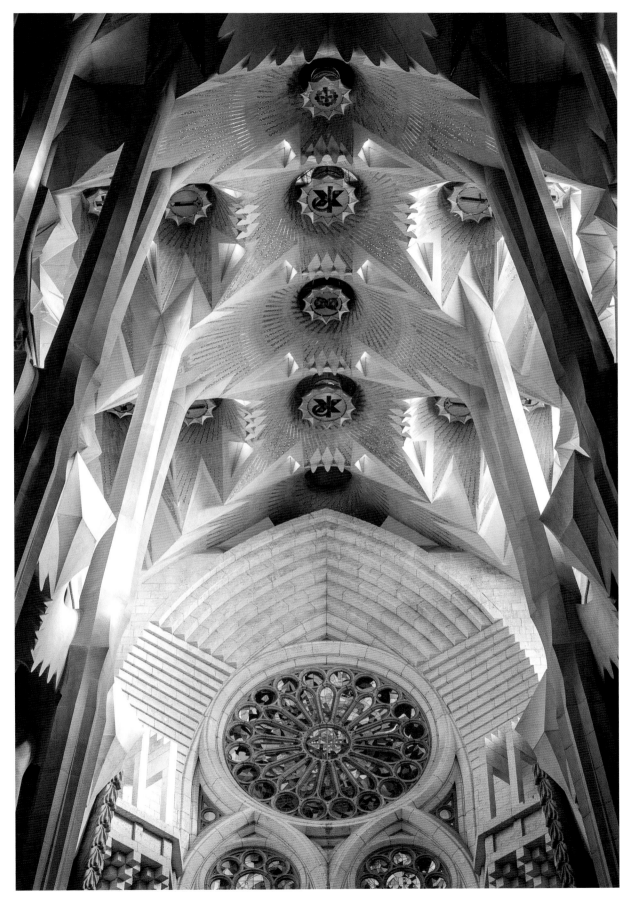

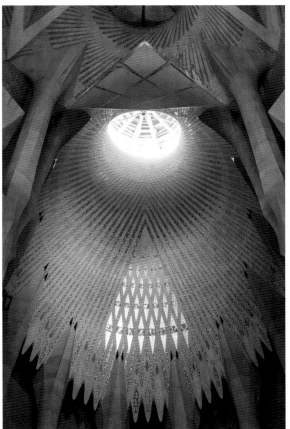

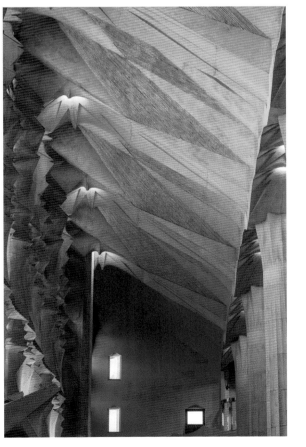

IGREJA DE SÃO FRANCISCO

PORTO ▫ PORTUGAL

How a sanctuary belonging to a mendicant religious order, the Franciscans, ended up becoming the most lavish church in Portugal, to the point that it had to be closed for a few years to quell public anger, is one of the paradoxical anecdotes punctuating the triumphalism of the Catholic Church.

In 1210, Francis of Assisi (1181–1226) founded the Franciscan order, its brothers committing to poverty and depending on public charity. As early as 1233, a related religious community was established in Portugal, and the city of Porto offered them a small plot of land on which to build a church and convent. The bishop of Porto was not pleased and protested the ownership of the premises. It took decades and the pope's intervention to resolve the somber dispute. Nevertheless, the order continued to be appreciated by the residents of Porto, who could finally see monks living in as much poverty as they were. A new, larger church was agreed upon and construction began in 1383.

The mendicant orders had little means and built accordingly, adhering to the building style of the time.

Although there was a Cistercian style, there was never a Franciscan one, and it would not be until the Jesuits and the sixteenth century that a religious order produced its own vision of sacred architecture. Some writers have invented a concept of mendicant Gothic, but it is a minor category, if it is one at all, of the Gothic style. Today's church, completed in 1410, is therefore Gothic in spirit overall—an impoverished gothic if you will—save for a few elements such as the main Baroque porch with Solomonic columns or the ceiling of the St. John the Baptist chapel in the Manueline style. The outside is plain, without ostentation, gray, and somewhat sad amid the gusts of rain coming off the Atlantic.

The classic interior includes three naves and a trefoil (three-lobed) apse. The arms of the prominent transept

PAGE 107: Construction of the church began in 1383 and was completed in 1410. The fan trumpet, typical of Iberian Baroque organs.
‡ PAGE 108: The nave. The great families of Porto and its region competed for the right to cover this once-modest church in gold.
‡ PAGE 109: Baroque angel in the middle of the broken pediment of the lateral chapel's altar.

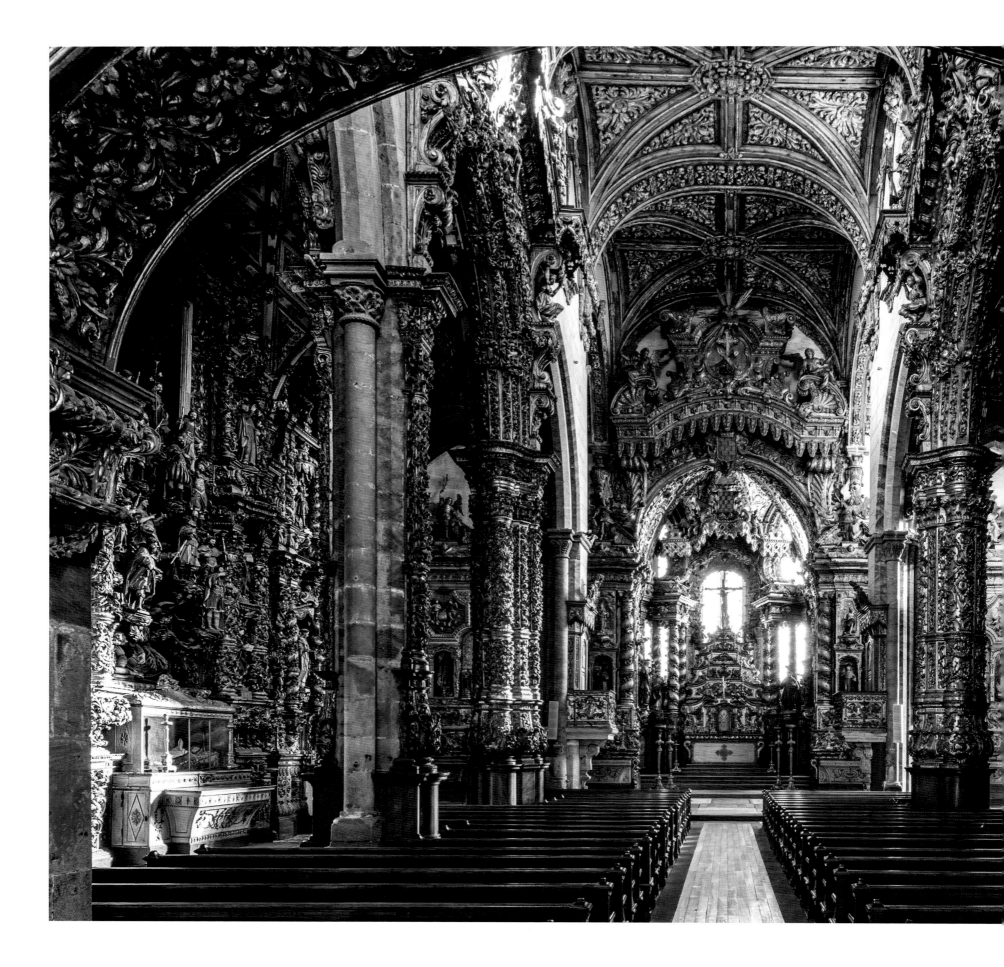

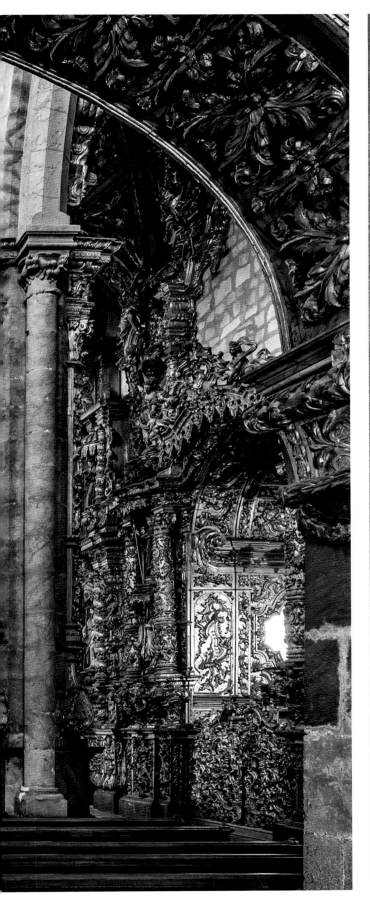
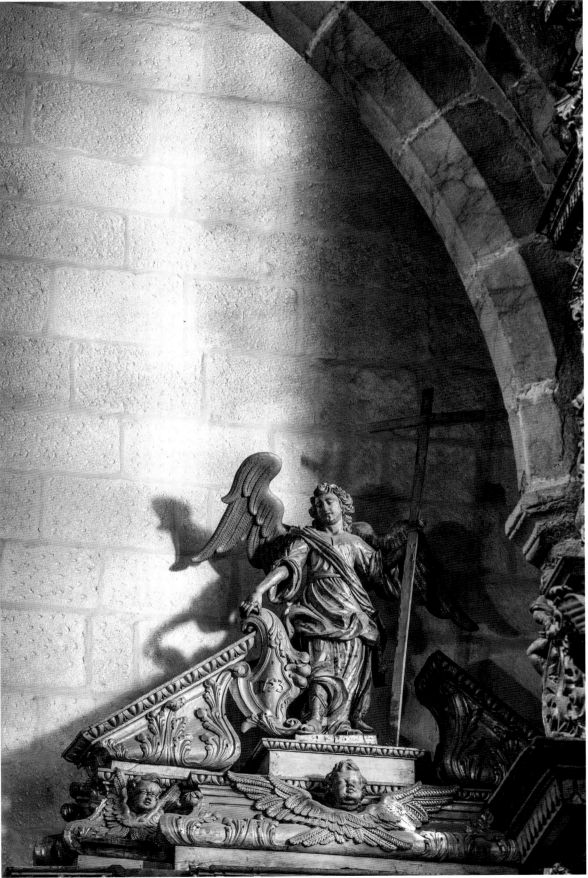

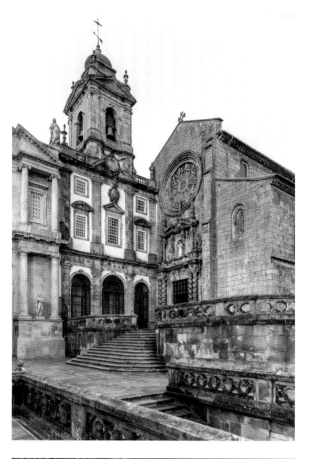

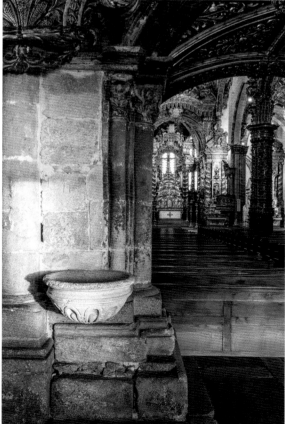

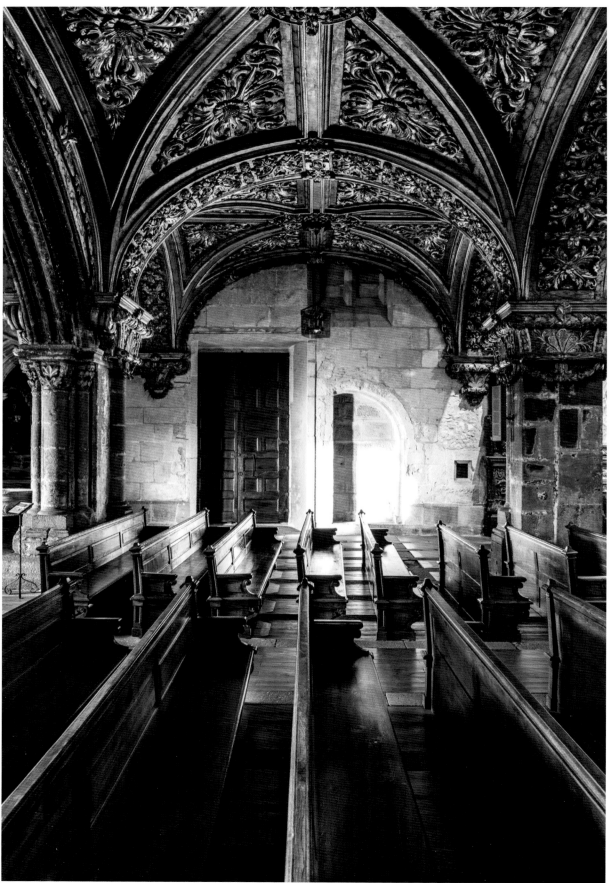

are very short and almost nonexistent on the side that in all likelihood originally led to the convent cloister. It was destroyed in a fire and in 1832 the Palácio da Bolsa (Stock Exchange Palace) was built in its place. That pushed the church toward the apse, and the main facade was seemingly reduced by about a third.

The inside makes a wholly different impression. In the nineteenth century, Count Athanasius Raczyński (1788–1874), ambassador to the King of Prussia, spoke of a "church made of gold . . . that surpassed everything he had seen in Portugal and in the world." A "church made of gold" was not just a turn of phrase. Between nine and thirteen hundred pounds of pure gold from Brazil were needed

to gild the boiserie (sculptured panels), altars, altarpieces, statues, and other decorative elements in *talha dourada* (gilded sculpture) during the seventeenth and eighteenth centuries. The Franciscans were not to blame; their sanctity had inspired the charity of rich local families who, starting in the sixteenth century, decided to fund chapels where they would be buried. The Matosinhos, Brandam, Carneiro, Brandão, and Pereira families competed with each other in excessive generosity as a way to prove their piety; hence, the feeling of entering a precious shrine.

The many shining gold forms, the sparkle and splendor of every relief, the overabundance of blossoms, cherubs, birds, acanthus, columns and colonettes, statues and statuettes, as if the whole church were dipped in a bath of liquid gold, make it difficult to take in the succession of chapels, altars, and altarpieces. In the mad contest for visual attention, one astounding work nevertheless stands out: the Tree of Jesse, an altarpiece located in the northern aisle. Dating from 1718 and produced by two Portuguese artists, Filipe da Silva and António Gomes, it depicts the genealogy of Christ, a popular theme since the Middle Ages. Taken literally, the piece is particularly striking

PAGE 110 *TOP LEFT:* The part Baroque, part Gothic facade of the modest Franciscan church built in a narrow plot and wedged between a staircase, the convent entrance to the convent, and the giant Stock Exchange Palace. ✚ **PAGE 110** *BOTTOM LEFT:* The narthex before the nave. In the back, the high altar. ✚ **PAGE 110** *RIGHT:* The start of the nave. Only the ceiling, decorated after, announces the flamboyance of the choirs, lateral altars, and three chapels. ✚ **PAGE 111:** A rich collection of statues, made mainly from wood, populates the altarpieces.

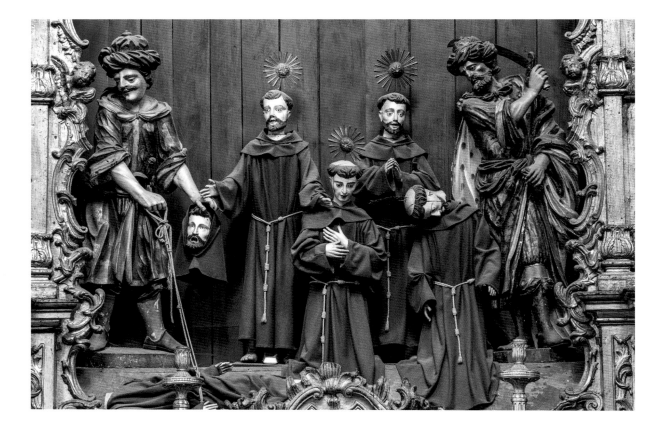

because it involves high-relief sculpture; it isn't painted or made of stained glass. A "real" tree emerges from Jesse's body and unfurls over several yards, its branches carrying brash polychrome statues of Christ's ancestors. Elsewhere, the oldest fresco in the church, from the fifteenth century, was painted by António Florentino, *Senhora da Rosa* (Lady of the Rose). The Renaissance-style composition, the soft colors, somewhat faded by time, and the expression of tender maternal happiness seem almost out of place among the gilded columns, niches, and sculptures.

The Franciscans disappeared and their convent was destroyed, but their church still survives, a vestige of the incredible wealth of a Portugal smitten with the mirage of Brazilian gold that was soon to tarnish.

PAGE 112: Altarpiece depicting the five Franciscan martyrs of Morocco (1750), the first martyrs of the order, decapitated in 1220. ✠ PAGE 113 *TOP LEFT*: The Tree of Jesse in sculpted wood, which illustrates the genealogy of Christ. It is the church's most famous altarpiece. Although certain elements date from the sixteenth century, it was reworked and embellished between 1718 and 1721 by the sculptors Filipe da Silva and António Gomes. ✠ PAGE 113 *BOTTOM LEFT*: The Holy Spirit in gilded wood (fifteenth century) on the baldachin canopy above the high altar. ✠ PAGE 113 *RIGHT*: The altar in the Chapel of St. John the Baptist, an example of the Mannerist sophistication of the church's Manueline style (sixteenth century). The altarpiece is Flemish in origin.

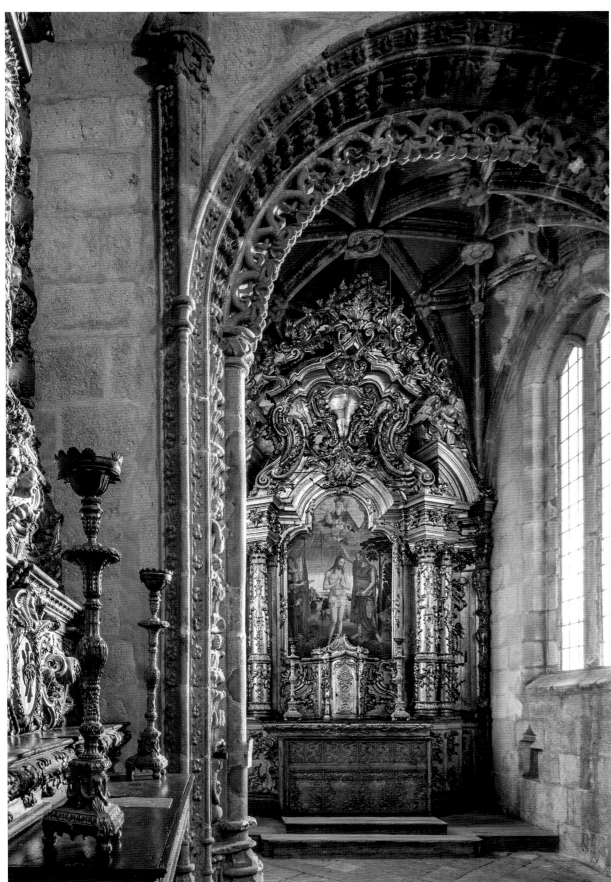

JERÓNIMOS MONASTERY

LISBON ▫ PORTUGAL

The year was 1500. The kingdom of Portugal was at its peak. Throughout the fifteenth century, its adventurous navigators explored the coasts of Africa, created outposts, brought back spices and gold, and traded slaves, and Vasco da Gama (1460–1524) had just found the route to India through the Cape of Good Hope. The kingdom was poised to become one of the first maritime and colonial powers of Europe, reinforced by the discovery of Brazil that same year. Not long before, in 1496, Manuel I (1469–1521), an enlightened king, had decided to found a monastery to allow sailors to reflect before their journeys. He entrusted it to the Spanish Order of St. Jerome as a way to please the Castile court and curry their favor. The future monastery would therefore be both a religious and a political gesture, a symbol of the growing power of the small kingdom saved from its agricultural destiny by the call of the sea.

The first stone was set in 1502 near the Tagus River, where caravel (small ship) and royal carrack (large merchant ship) expeditions embarked and returned. But what then? What would be the building's style? At the beginning of the sixteenth century, Gothic architecture had reached its final phase and was on the brink of being replaced by the Renaissance approach. While Portugal had its own architectural traditions, which were influenced by the Visigothic and Islamic arts, there was not yet a national style for religious edifices. The rapidly growing wealth of the country, the involvement of experienced architects and sculptors of international renown, and the influence of the Plateresque style that was in fashion in Spain all led to the emergence of what would be called the Manueline style. The monumental Hieronymite complex is its most remarkable expression.

PAGE 115: Painted wood crucifix, facing the upper choir reserved for monks above the nave. The sculpted floor-to-ceiling pillars and the tierceron and lierne vaults are characteristic of the Manueline style. Construction of the Santa Maria de Belém Church and of the monastery started in 1502 and lasted a century. In the back, one can see the choir.

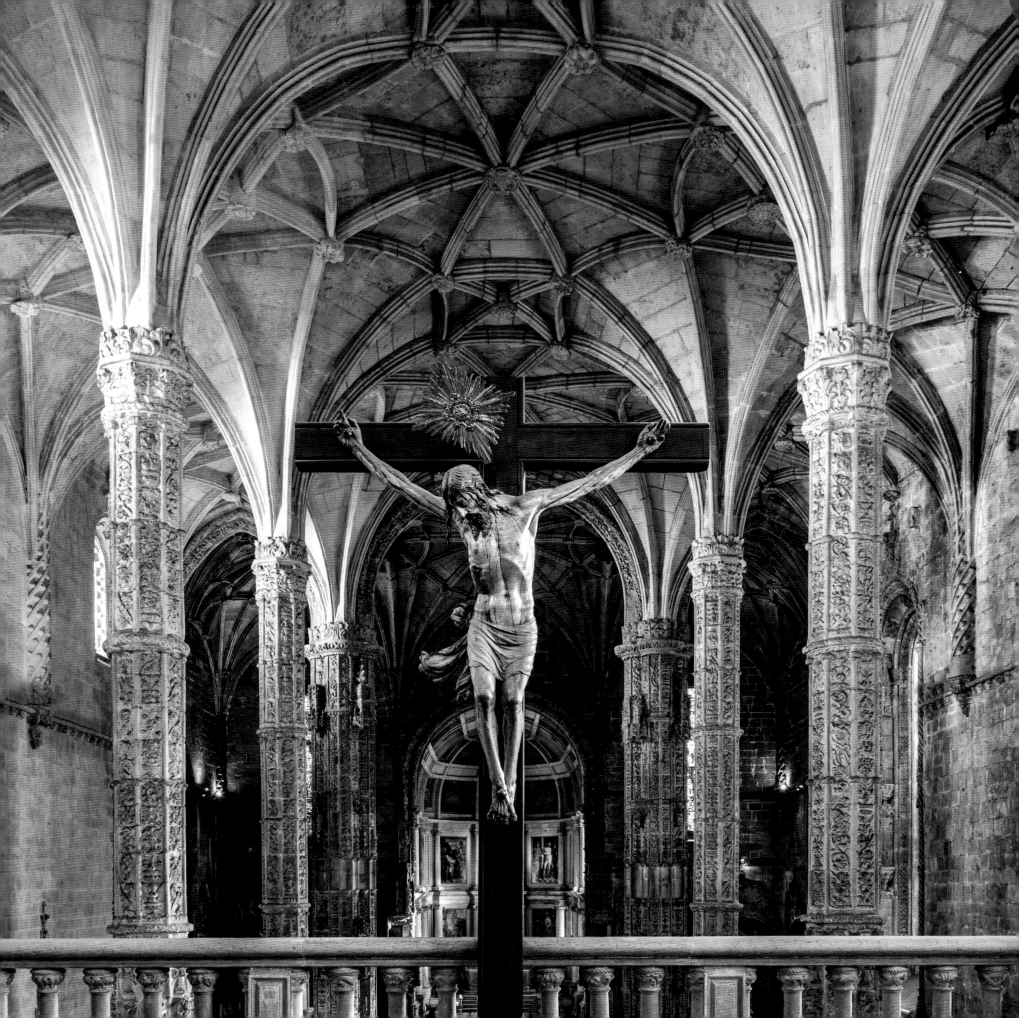

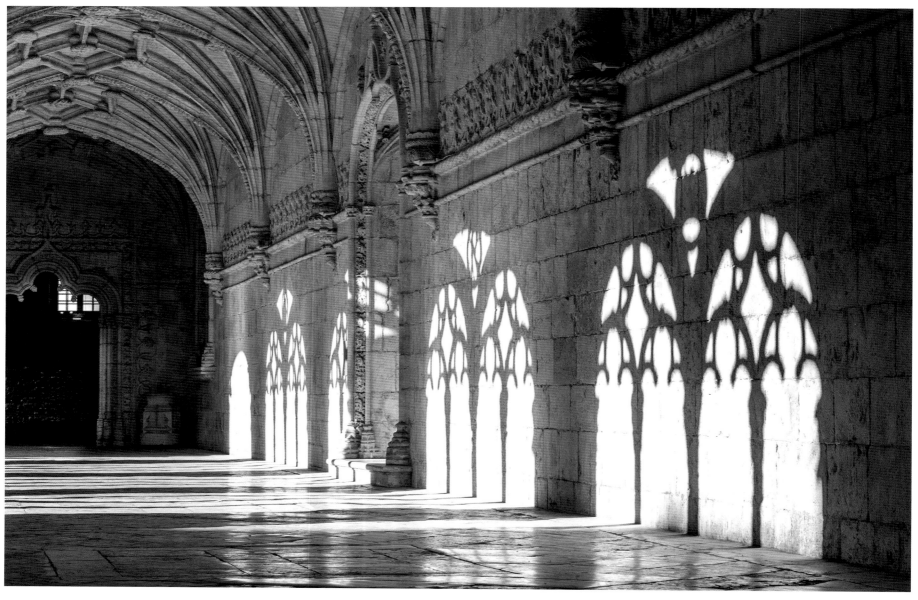

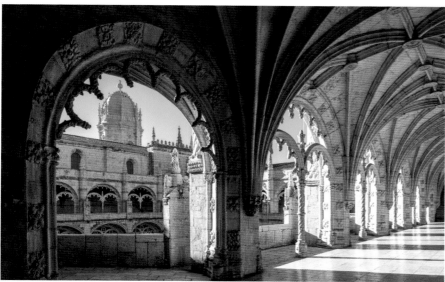

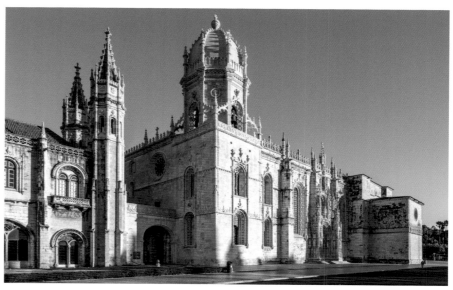

JERÓNIMOS MONASTERY

The style comes neither from the North nor from the Mediterranean: It is Atlantic. Although it did not introduce any structural innovations, its decoration and ornamentation are notable. In addition to presenting holy figures, various stylizations, and depictions of heaven and hell in the Gothic style, it opened a window onto the imagination of the new empire: ocean waves, flowers and exotic fruit, twists, ropes, armillary spheres (models of the celestial globe), and even elephants. That iconography reflected the spirit of discovery and colonial conquest accomplished in the name of God with the pope's blessings. At the far end of Europe, at Atlantic outposts, the Hieronymites paradoxically offered a vision of a new world in a monument that revolved around prayer.

Several architects would take the helm of the century-long project, including Diogo de Boitaca (1460–1528) and João de Castilho (1490–1552), who were assisted by numerous teams of sculptors from Portugal, Spain, and France.

PAGE 116 *TOP*: Play of shadows on the bright white stone of the cloister (sixteenth century). ✝ PAGE 116 *BOTTOM LEFT*: The square cloister, with a length of 180 feet (55 m) on each side. Architect Diogo de Boitaca (1460–1528) began the construction and then was succeeded by João de Castilho (1490–1552). ✝ PAGE 116 *BOTTOM RIGHT*: View of the church and its cupola. Between the two buildings, one can see the bridge leading to the monk's tribune.

Santa Maria de Belém, the monastery's church, has the simple rectangular plan of a hall church, where the nave and aisles are of approximately equal height. The nave and two aisles are each some 80 feet (24 m) high and 230 feet (70 m) long. It has no real articulations, no flying buttresses, just one massive, practically solid south transept branch; the other branch to the north is incorporated into the monastic buildings. A cupola rising some 150 feet (45 m) surmounts its octagonal bell tower. One enters the sanctuary via the monumental western portal; its frieze (horizontal band of sculpture on a wall near the ceiling) depicts the birth of Christ in high relief. Inside, the church boasts a series of vaults, the multiple ribs of which form a stunning geometric pattern. The choir was renovated in the Renaissance style in 1571. The church has another unique feature, an upper choir facing the main choir at the other end of the large nave. Some thirty-three feet (10 m) off the floor, the upper choir was reserved for monks who entered it by crossing a stone bridge from the massive monastic buildings.

The interior volume is punctuated by a sequence of eight, sixty-foot (18 m) pillars, masterpieces of Manueline art. Faceted and decorated from top to bottom with a jumble of lavish sculptural motifs, they seem unbelievably delicate. Nevertheless, they survived the big earthquake of 1755. The monastery was built on a sandy soil that absorbed the seismic wave.

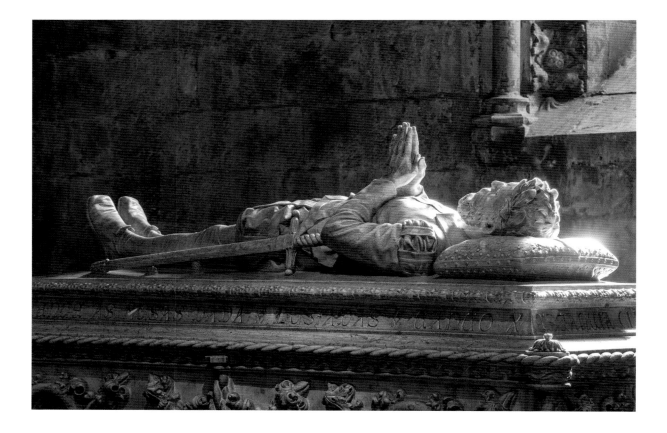

Extending from the north side of the church, the splendid octagonal, two-story cloister is a kind of open-air theater of unique sculptural luxury. It is composed of intricately carved twisting columns and colonettes (thin columns), with sea creatures, flowers, coats of arms, and more sculpted in bright white stone. In one corner, a slab indicates the tomb of Fernando Pessoa (1888–1935), one of the great European poets of the twentieth century. The church also contains the tomb of Luís de Camões (c. 1524/1525–1580), the legendary bard, as well as the tombs of Vasco da Gama (1460–1524) and Portuguese kings whose sarcophagi stand on marble elephants.

PAGE 118: Inside the church, the tomb of Luís de Camões (c. 1524/1525–1580), the Portuguese national poet and bard of great adventures, installed in 1880. ‡ PAGE 119 *TOP LEFT*: Pillar and window frame exemplifying the decorative wealth of the Manueline style. ‡ PAGE 119 *BOTTOM LEFT*: Lion fountain in a corner of the cloister. ‡ PAGE 119 *RIGHT*: View of the nave and the Manueline vaults, looking from the altar toward the monastery's tribune.

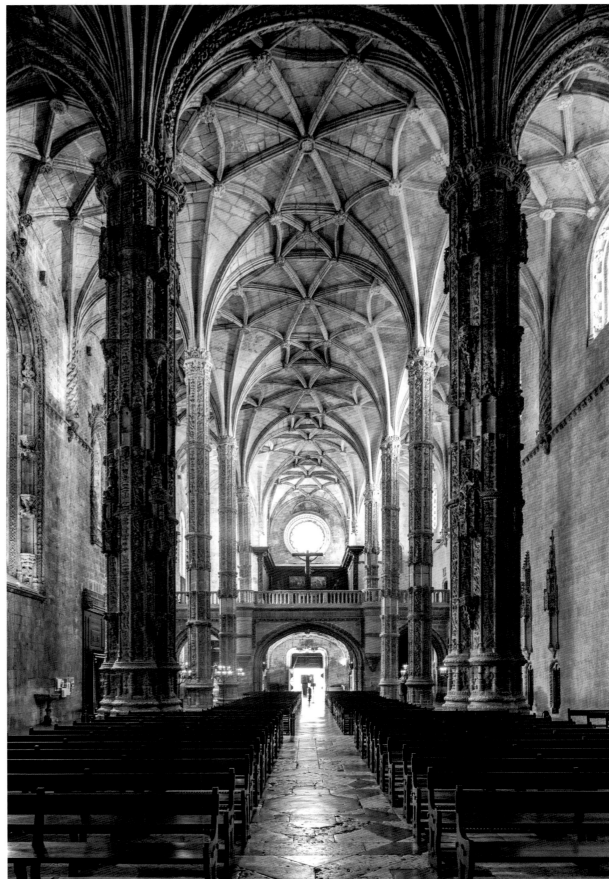

IGREJA DA MISERICÓRDIA

CHAVES ▫ PORTUGAL

Chaves is a city in the region of Trás-os-Montes, in northern Portugal, not far from the Spanish border. In its historic center, on Praça Luís de Camões, there stands an unusual and elegant granite facade. It could have been a provincial theater, but it is in fact the Igreja da Misericórdia, which may have been the chapel to the Duke of Braganza's palace, located nearby. Surprisingly, local archives offer few words about this small sanctuary, and scholarly texts are rare. Nothing seems certain, even after the request to register the church as a historic monument in 2016 temporarily opened the way for a review.

In all likelihood, there was originally a fifteenth-century inn and chapel at the site. Between 1532 and 1601, a large church was built; on the brink of collapse, it underwent major renovation between 1720 and 1724, which was partly funded by the king of Portugal, from the House of Braganza.

Rather curiously, the facade combines exuberant Baroque elements—for example, eight Solomonic columns and wooden balustrades—with plainly articulated openings. A porch allows the faithful to take cover from the rain without entering the building. Five different Baroque roof ornaments—one no longer exists—were added to enliven the circumference of the pediment, which includes a sculpture of *Mater Omnium*, Mother of All.

The interior is of the utmost simplicity: a single rectangular nave with a gallery on one side and a magnificent altarpiece of gilded wood on the other. In the Baroque style of King John V (1689–1750), the altarpiece fills the entire western wall behind the main altar and the two lateral ones that are aligned with it. A wood ceiling panel depicts the *Visitação de Nossa Senhora a Santa Isabel* (Visitation of Our Lady to St. Elizabeth) painted by Jerónimo da Rocha Braga (1871–1948). But it is essentially its murals that have earned this church its acclaim. The walls are entirely

PAGE 121: The walls of the church (eighteenth century) entirely covered in Azulejo tiles, likely made by the Oliveira Bernardes family. The specialist craftsmen were renowned throughout Portugal.

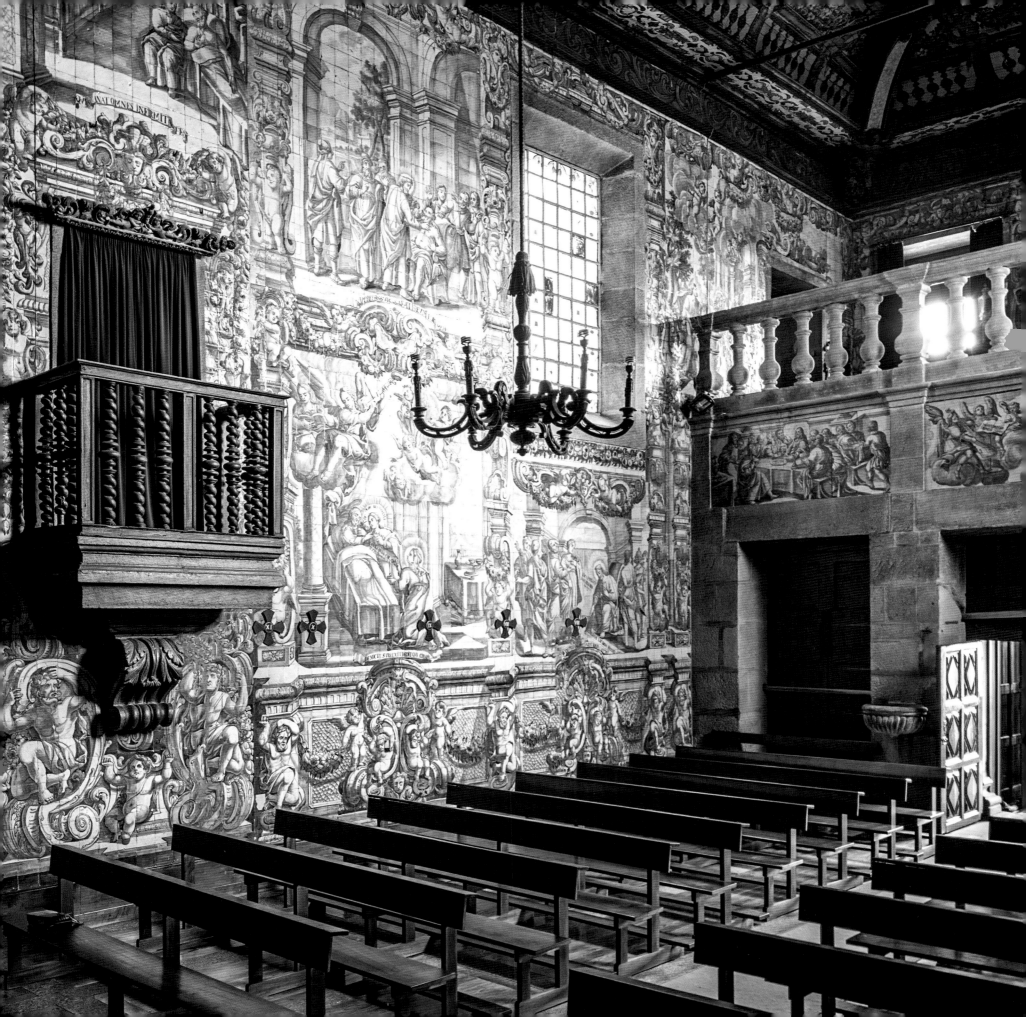

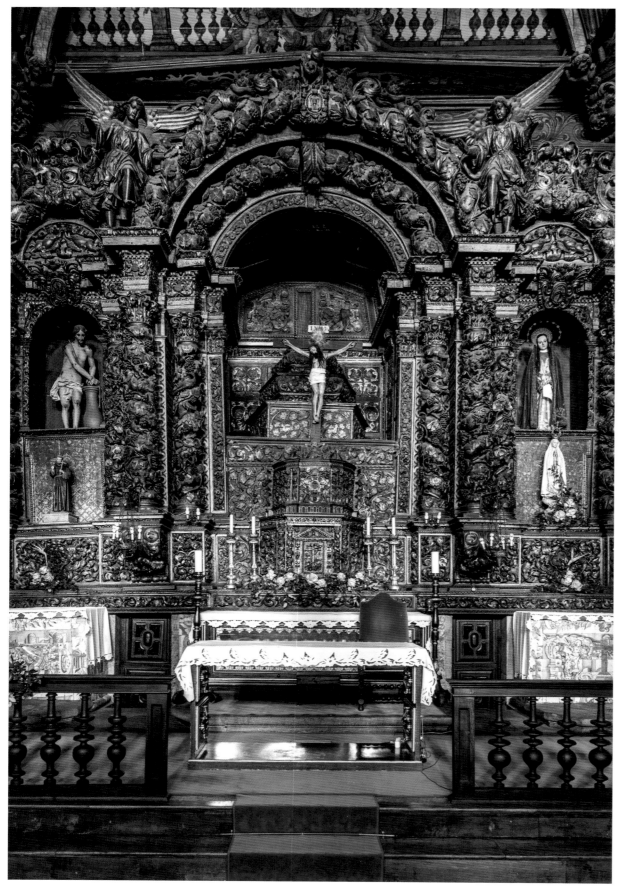

covered by twenty-two enormous Azulejo tile panels, illustrating themes drawn from the Old and New Testaments.

The Portuguese Azulejo tradition stems from Arabic tin-glazed ceramics. Later, Andalusians were among the first to use the technique for figurative compositions. One finds Portuguese Azulejo tiles as early as 1584, when they became widely popular throughout the country. Panels showcasing this technique were commissioned for homes, churches, palaces, and public buildings. In addition to

PAGE 122 *LEFT*: The main altar and, on the same level, its two lateral altars in painted and gilded wood. ‡ PAGE 122 *TOP RIGHT*: In the tribune, *Ecce Homo* was made by a local artist. ‡ PAGE 122 *BOTTOM RIGHT*: One of the twenty-two Azulejo tile panels in the Portuguese Baroque style (starting in the eighteenth century) titled *The Arrest of Jesus.* ‡ PAGE 123: Detail of a tile panel (*right*) and the painted ceiling (1743) (*left*).

their beauty, the tiles had the advantage of reverberating candlelight and retaining cool air in the summer. The characteristic blue color is influenced by Chinese porcelain and also by Delft pottery, to which it is related. At the end of the seventeenth century and for decades to come, compositions on panels were even commissioned to Dutch artists. The Misericórdia Azulejos, which date from no later than 1722, are thought to be the work of the renowned Oliveira Bernardes family of craftsmen, their production a response to Dutch imports. Royal patronage perhaps explains how these well-known artists came to intervene in such a modest church. Perfectly conserved, the extremely fresh colors, the subtle rendering of the figures, the exuberance of the frames similar to the borders of tapestries, and the generosity of the compositions qualify the work as one of the under-recognized masterpieces of an art that has become so very Portuguese.

ULM MINSTER

ULM ▫ GERMANY

Although Ulm Minster is not a cathedral, it is nevertheless the tallest Protestant church in Germany and boasts the highest tower on a church building in the world: 530 feet (162 m).

Today, a large project such as a shipyard can last five years, even when everything goes according to plan. In 1377, as they laid the first stone of their future parish church, the bourgeoisie and clergy of Ulm knew that construction would last decades and that they would not see it completed in their lifetimes. A sense of duty, civic pride, and the certainty that their descendants would carry out the project prevailed.

During that tumultuous period, Ulm, an imperial city of two thousand residents along the Danube, had a large church, but it was unfortunately located outside the city walls, which presented danger due to frequent warfare. It was decided that the church would be rebuilt in the center, despite the extensive demolition involved. The people of Ulm were rich and ambitious; and the cost did not scare them; they even planned for the new building to be able to accommodate twenty thousand congregants.

They chose one of the great architects of the time, Heinrich II Parler, who proposed a Hallenkirche (hall church) plan with a single nave. In 1383, construction began with the choir, as was customary. In 1387, Parler's son, Henry III, succeeded his father as head of construction. Four years later, when Henry III assumed an appointment in Milan, a new architect, Ulrich von Ensingen (c. 1365–1419), took over the project; he changed the plan to a basilica with three naves. Progress was slow, to the point that, around 1480, the choir was already being modernized. The two towers were then 105 feet (32 m) tall and the entrance, some 130 feet (40 m). By 1519, construction stopped . . . until 1885. The church was vast and luminous, but the stub of the tower was ugly. In the nineteenth century, even the poet Eduard Mörike (1804–1875) spoke of the "horrible block."

PAGE 125: Choir stalls (1469–1474) by Jörg Syrlin the Elder (1425–1491). The busts depict the great figures of humanism, including philosophers and scholars of antiquity. In the foreground, Pythagoras (c. 570–490 BCE), the mathematician and philosopher.

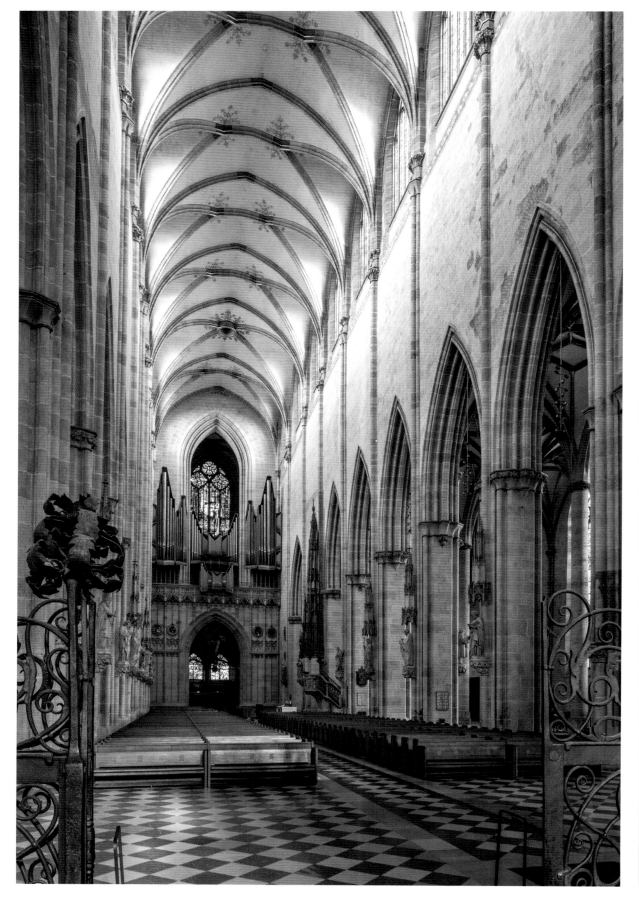
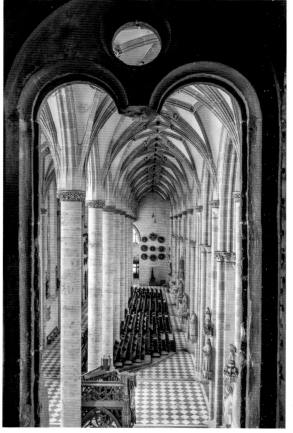
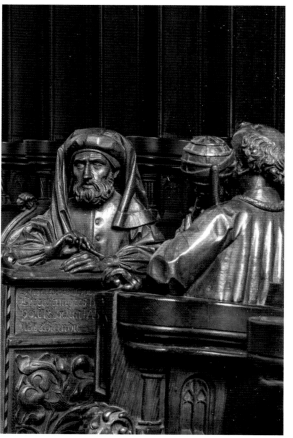

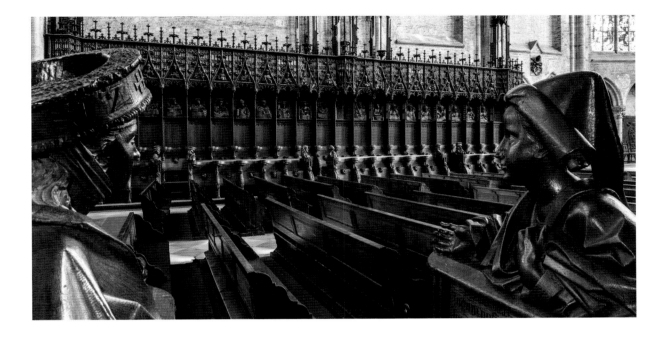

In 1530, the majority of Ulm residents voted to become Protestant. The families who remained Catholic removed the altars and artworks they had donated, and sixteenth-century sectarians vandalized the inside of the church. It would not be until the nineteenth century and the revival of the Gothic style in Germany, in particular in religious buildings, that construction resumed. In 1841, a

PAGE 126 *LEFT*: The nave, viewed from the altar. It is the tallest Protestant church in Germany. ✝ PAGE 126 *TOP RIGHT*: The north aisle. The color on the capitals is original. ✝ PAGE 126 *BOTTOM RIGHT*: Jörg Syrlin the Elder (1425–1491) lined the choir with intricately decorated wooden stalls. Eighty-nine seats are arranged in two rows on the north and south sides. ✝ PAGE 127: The stalls also present the Sibyls, or female oracles, recognized by the church. Here, on the right, the Libyan sibyl.

scholarly association "for art and antiquity" was founded in Ulm and spearheaded the continuation of the project.

The architect Ferdinand Thrän (1811–1870) then built elegant flying buttresses (nonexistent until that point) to reinforce the structure as a whole; they also created a better visual dynamic. Ludwig Scheu (1830–1880) raised the choir towers to 282 feet (86 m) and replaced the wooden framework with iron for safety reasons. Finally, August von Beyer (1834–1899) brought the main tower to 530 feet (162 m) using Matthäus Böblinger's (1450–1505) marvelous plans and technical drawings from the end of the fifteenth century, which had been carefully preserved. From that moment on, the way the church looked totally changed, transforming the image of the city. During the terrible bombings of 1944, it miraculously survived the near total destruction of the town's center.

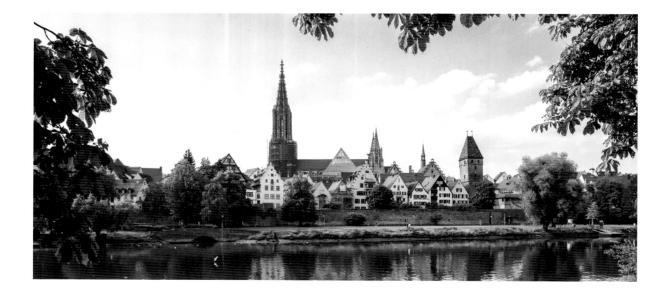

While the interior calls to mind the austerity of Protestant temples, it nevertheless contains many artistic treasures, most dating from the Catholic period. Jörg Syrlin the Elder's (1425–1491) choir stalls, built between 1469 and 1474, are, in their rigor and precision, among the finest works of sculpture of the late Middle Ages. The original altarpiece was destroyed in 1531 during the iconoclastic period and was replaced in 1808 by another one sculpted and painted by Laux Hutz (d. 1520) at the end of the fifteenth century. It was saved from Protestant fury and its vivid color is dazzling. The tabernacle is a complementary masterpiece, soaring to the phenomenal height of almost ninety-eight feet (30 m). Carved in a lacelike pattern, it is animated by statues of prophets and church fathers painted in bright colors. Much of the fifteenth-century stained glass, presenting original compositions (*Bessererkapelle*), has been conserved, and the ones added in the twentieth century attest to the creativity of contemporary sacred art in Germany.

The surrounding Münsterplatz, or town square, has been rebuilt and is now closed to traffic and very lively. Among the buildings encircling it is a landmark (Ulm Stadhaus Exhibition and Assembly Building) by the American architect Richard Meier (b. 1934). Like a rampart, these buildings accentuate and seem to protect the enormous church, which has found a distinctive urban setting after the appalling destruction of the war.

PAGE 128: In the heart of the old city, which was rebuilt after World War II, the church has the highest spire in the world at 530 feet (162 m). ✝ PAGE 129 *TOP LEFT*: Above the choir's entrance arch, a fresco depicting the Last Judgment (1471) by Hans Schüchlin (1440–1505). It was painted over during the Reformation and remained covered for a long time. ✝ PAGE 129 *BOTTOM LEFT*: Stairway leading to the monumental tabernacle, eighty-five feet (26 m) high (1467–1491). ✝ PAGE 129 *RIGHT*: The pulpit. Its baldachin (c. 1510) is a masterpiece of woodwork by Jörg Syrlin the Younger (1455–1521).

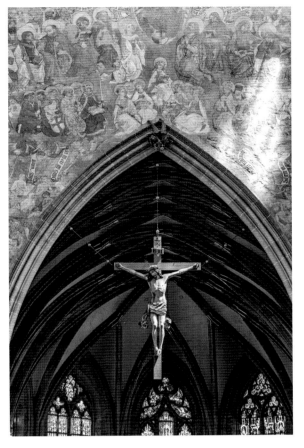

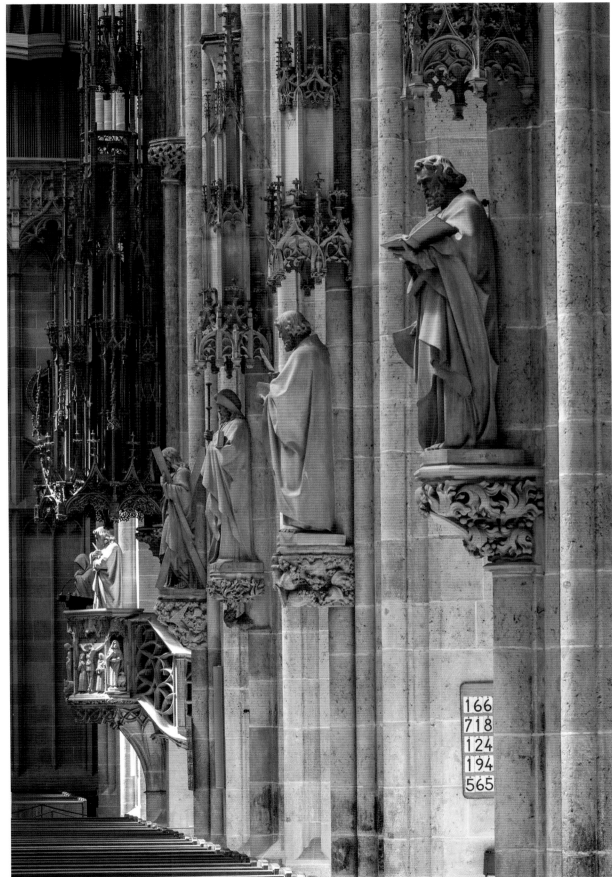

166
718
124
194
565

OTTOBEUREN ABBEY

OTTOBEUREN ▫ GERMANY

In the distance, at the heart of the verdant, pre-Alpine landscapes of the Allgäu region, there emerges the massive Benedictine abbey of Ottobeuren, dominating the village that crouches at its feet. There is a drastic contrast between the charming vernacular architecture of the town and the haughty, cold elegance of the imposing vessel of monastic buildings of which the immense church is the prow.

Ottobeuren is the largest abbey in Bavarian Swabia and one of the only ones still pursuing its mission after more than 1,250 years in existence. Founded in 764, under Pepin III (714–768), it was reconstructed in 1089 and declared an imperial abbey in 1299—and therefore independent of the Augsburg diocese. In total decline during the fourteenth and fifteenth centuries, it was rebuilt but pillaged during the Thirty Years' War. It rose again from its ruins and, starting in the eighteenth century, enjoyed prosperity and was uniquely influential. Secularized in 1802, its property annexed to Bavaria, the abbey was reestablished in 1834 and regained its independence in 1918. In 1926, Pope Pius XI (1922–1939) promoted the church to the rank of minor basilica. At its height, its domain was seventy-two thousand acres (twenty-nine thousand hectares) and included twenty-seven villages and ten thousand residents.

Its history was marked by a notable figure, Abbot Rupert Ness II, who managed the abbey from 1710 to 1740 and developed its current buildings. A cultivated man, in the emperor's favor, and a brilliant administrator, he nurtured relationships with the best artists of his time. Seven plans were drawn up for the monastery's reconstruction at an unprecedented scale; Father Christoph Vogt's (1648–1725) plan was used. Shortly before his death, Abbot Rupert commissioned Simpert Kraemer (1679–1753) for the

PAGE 131: Altar vault with depiction of St. Alexander (d. 251), St. Theodore (d. 130), and St. Sebastian (d. 288). The fresco is the *Damnation of Saint Felicity and her Seven Sons* (c. 1756) by the Austrian cousins Johann Jakob Zeiller (1708–1783) and Franz Anton Zeiller (1716–1794). ‡ PAGE 132: The nave, an explosion of light and color. ‡ PAGE 133 TOP: Central cupola, *The Glorification of the Holy Spirit*, a fresco by the Zeiller cousins. ‡ PAGE 133 BOTTOM: One of the church's three organs (1766).

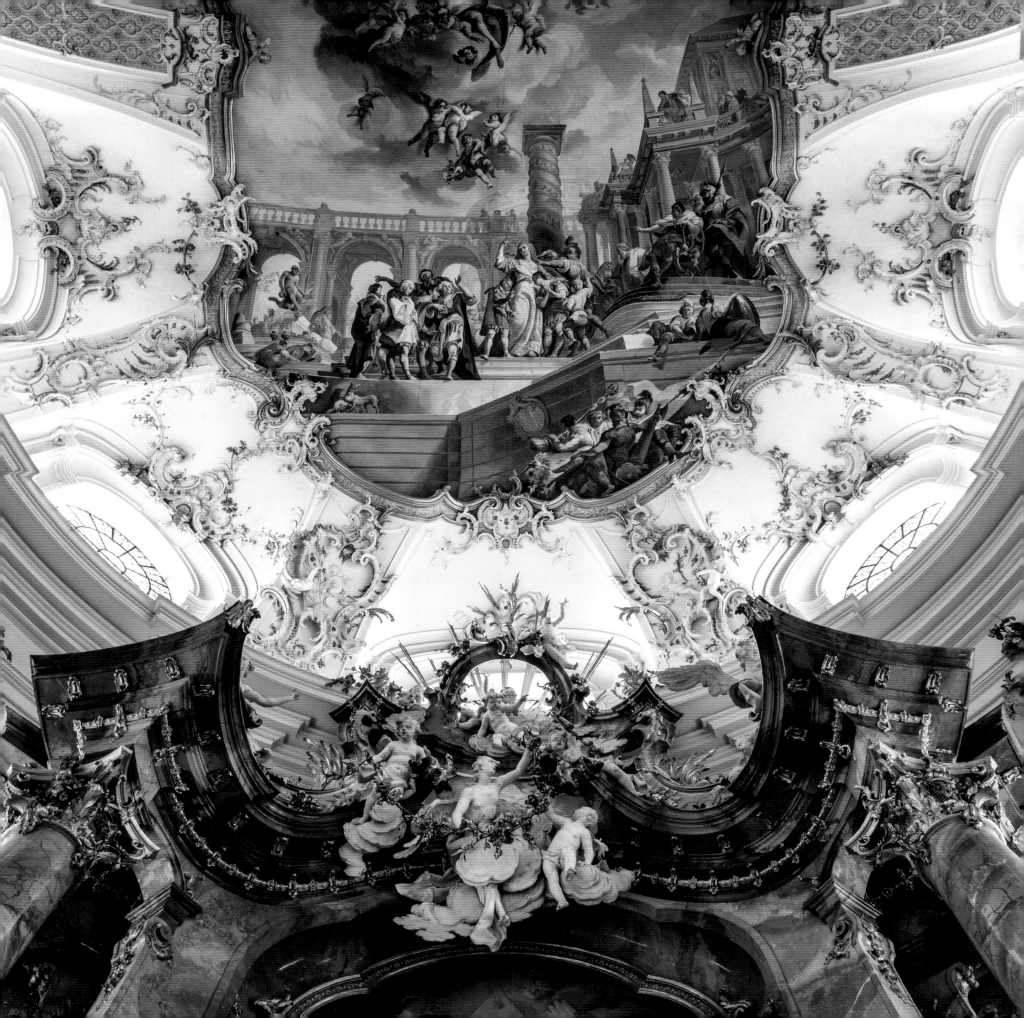

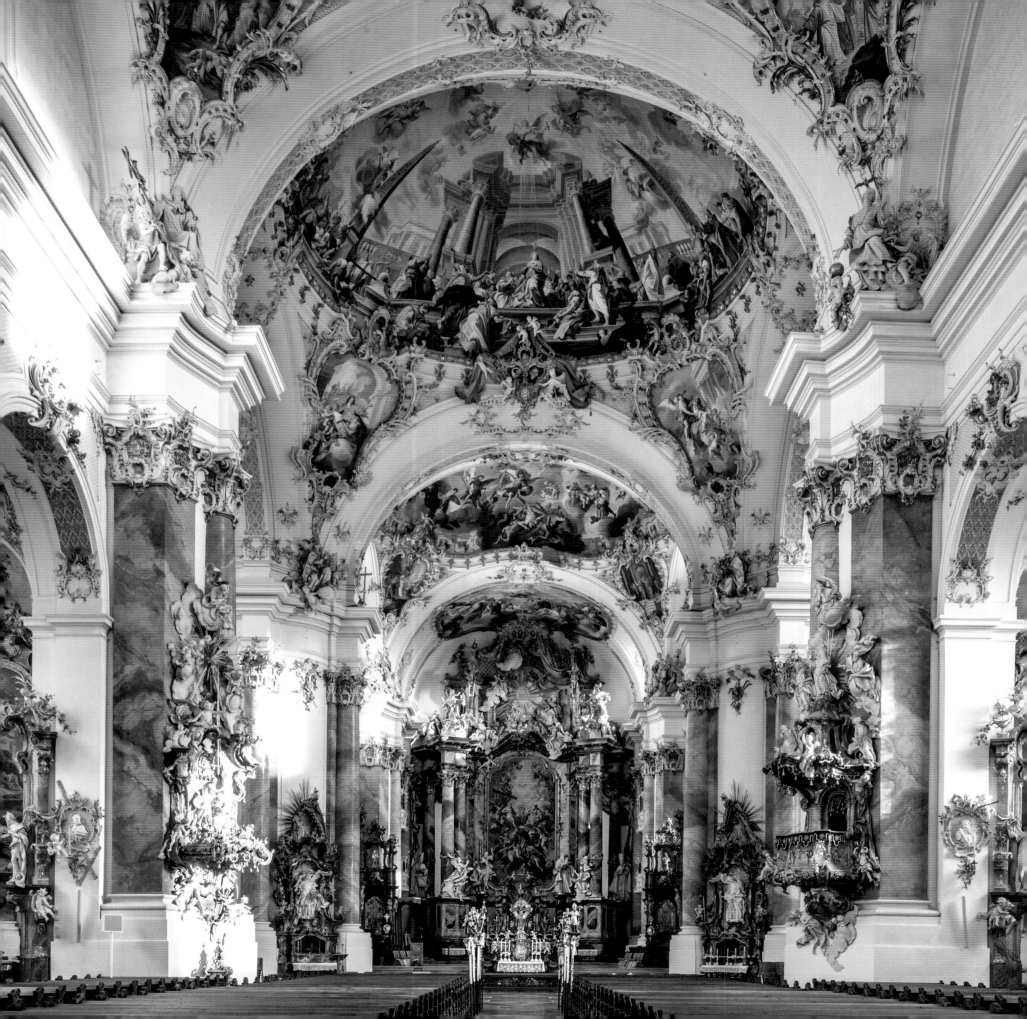

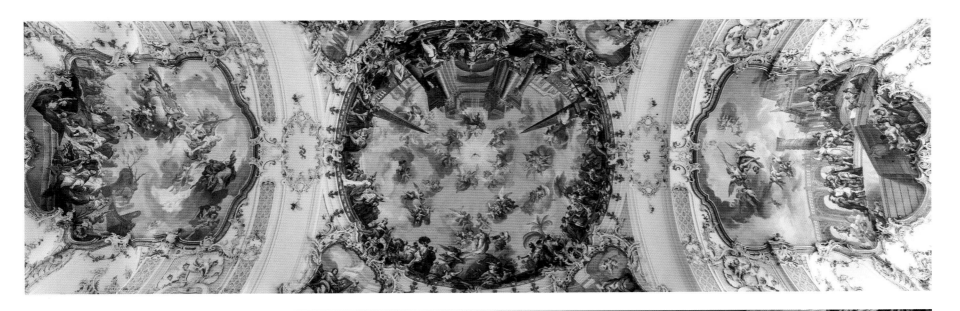

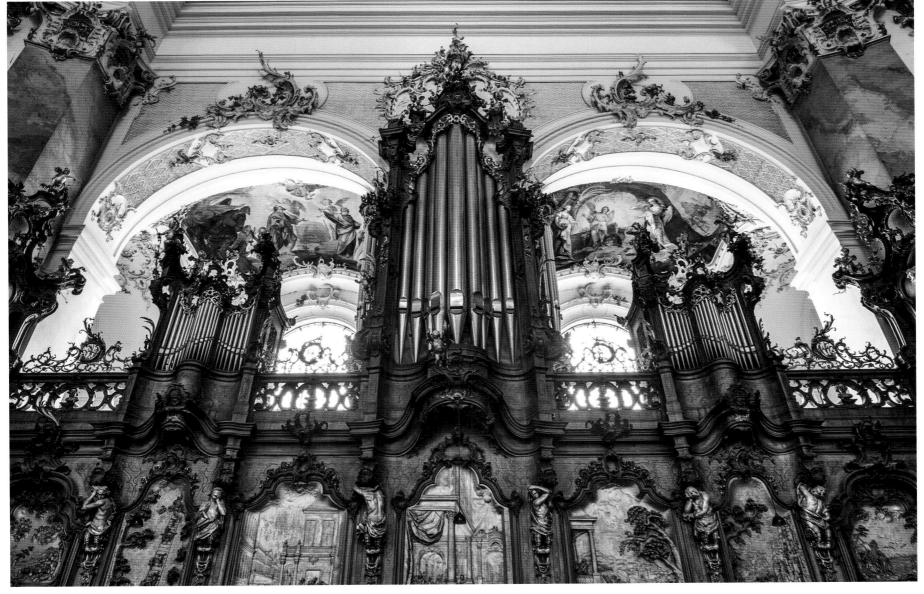

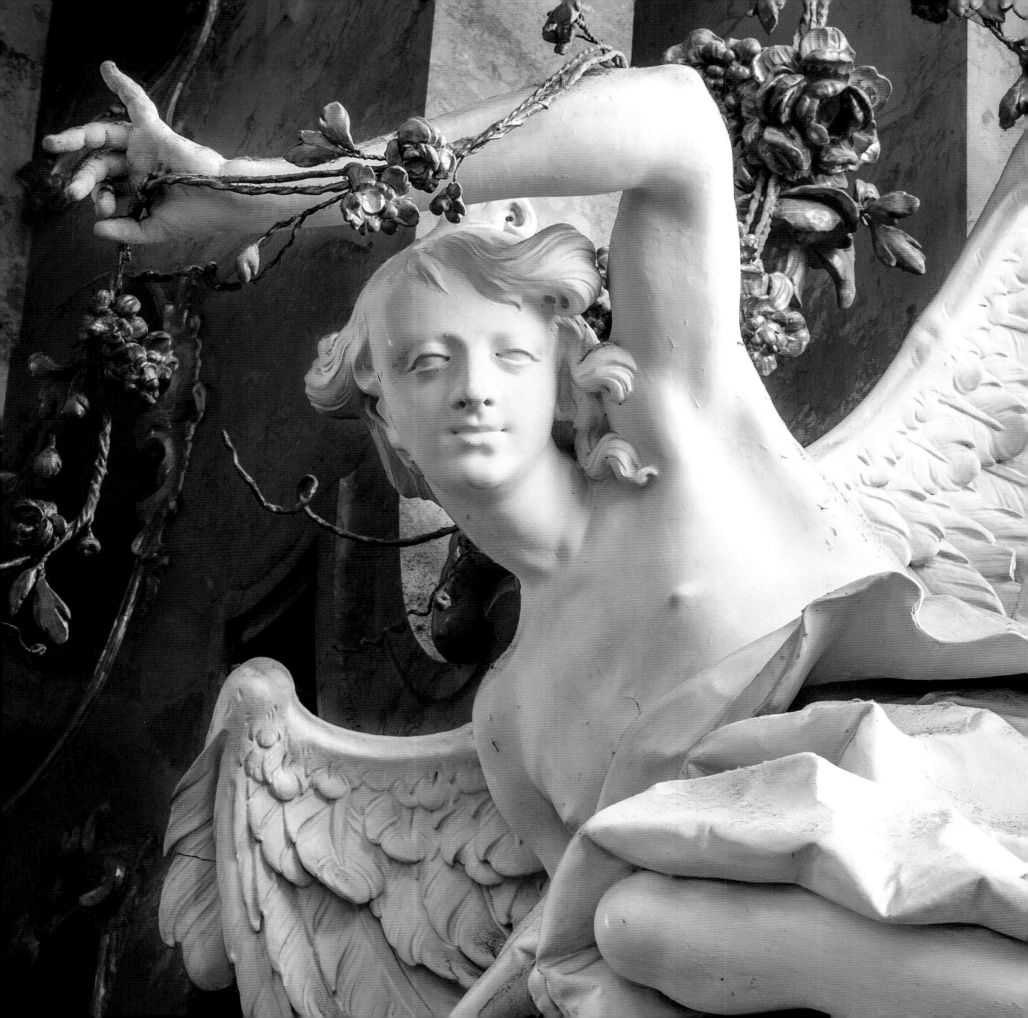

construction, but in 1743, Rupert's successor transferred the responsibility to Johann Michael Fischer (1692–1766), one of the most prolific architects of the late Baroque and Bavarian Rococo period. He was entrusted with the construction of the church. Fischer used what was already in place—the walls surrounding the church, the transept structure, and the facade foundations—as a base for the enormous but elegant abbey church.

The monastery's majestic and slender facade, with two 270-foot (82 m) towers, is punctuated by four enormous columns that are echoed by the tower's overlapping pilasters (rectangular columns that project from a wall). It has three enormous bay windows and an almost modest entrance; the monks enter separately at the back of the choir. Intriguingly, the outside walls integrate impressive trompe-l'oeil decorations that make them striking when

PAGES 134 AND 135: Two stucco angels and gilded metal garlands. Most of the statues were made by the stucco artist Johann Michael Feichtmayr the Younger (1709–1772). Born into a family of artists, he worked with Johann Michael Fischer (1692–1766), Ottobeuren's architect. He contributed to countless churches in Bavaria and Baden-Württemberg.

seen from afar. The economical technique was common at the time in Bavaria and Austria, where the art of imitation (faux marble, faux wood, faux stone, faux drapery, the effect of perspective and volume) was taken to great heights.

Contrary to tradition, the church was built on a north-south axis, which meant that the course of the sun freely interacts with its interior decor. No stained glass filters the light falling from the massive clear windows in the enormous space, which is 118 feet (36 m) high by 292 feet (89 m) wide. The visitor's first impression is of entering a bubble of dazzling light. After the short vestibule, the space seems to abruptly dissolve into a milky brightness that transforms the frescoes and abundantly gilded decorative elements. That is one of the triumphs of the Rococo style: Its ornamental and iconographic complexity proposes to magnify the glory of God and the Holy Trinity through a theater that speaks to the senses.

The single nave lined with lateral chapels opening beneath semicircular arches, the short and rounded wings of the central transept, the four enormous pairs of pillars that uphold the central cupola, the choir as large as the area for congregants, the whitewashed walls: All direct the eye

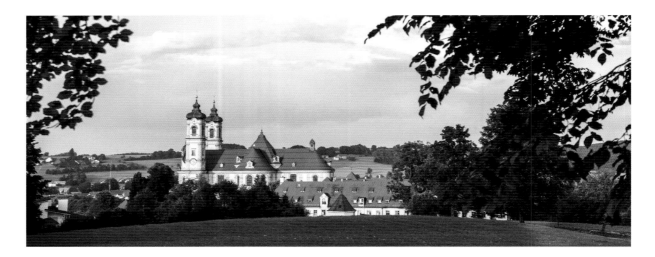

toward the cupola's frescoes and the splendid main altar. Brought together are all the elements of the architectural drama of the Counter-Reformation. "Money, prudence and patience," as invoked by Abbott Rupert at the start, in a few decades culminated in the creation of southern Germany's church archetype, which combines a relatively modest exterior with the boundless luxury of interior decoration.

The sculptors Josef Weinmüller and Johann Michaël Feichtmayr the Younger (1709–1772) executed most of the large statuary, using their own stucco techniques. Above the pulpit, which is suspended like an opera box, there is a stucco statue of Jesus surrounded by Moses and Elijah with God the Father overlooking; alongside, Judas kills himself on the right, and Paul, the convert, appears on the left. Symmetrically, on the other side of the nave, there is a sculpted representation of Christ's baptism. The large altar is an explosion of gold and stucco around a painting by Johann Jakob Zeiller (1708–1783) on the theme of the Trinity and the redemption of humanity. Angels intervene everywhere. They bustle about, observe, apologize, and rejoice amid clouds, cartouches (rounded, convex surfaces surrounded with scrollwork), and garlands. Four altars

on the themes of bravery, wisdom, moderation, and justice are located between the pillars supporting the main cupola. Beneath the statues, visitors might be astonished, even horrified, to find in glass reliquaries the mummified corpses of four saints exhumed from Roman catacombs, dressed in lavish finery and loaded with jewels. The cupola frescoes, painted by the Zeiller cousins, draw attention toward the glorious heavens.

Beneath this theatrical vision there stretches a long low crypt from east to west. Dark and humid, it is there where the bodies of the Ottobeuren abbots rest, forever kept apart from the basilica's ostentatious splendors, an emblem of triumphant Catholicism.

PAGE 136: View of the basilica overlooking the small town of Ottobeuren. ‡ PAGE 137 *TOP LEFT*: Facing the pulpit, *Baptism of Christ* (1763–1764), by sculptors Feichtmayr the Younger and Johann Joseph Christian (1706–1777). ‡ PAGE 137 *BOTTOM LEFT*: At the four corners of the transept intersection are shrines to the evangelists. Each includes the mummified body of a saint from the Roman catacombs. ‡ PAGE 137 *RIGHT*: Lateral chapel of St. Nicholas of Myra, a remarkable example of the Rococo style of southern Germany.

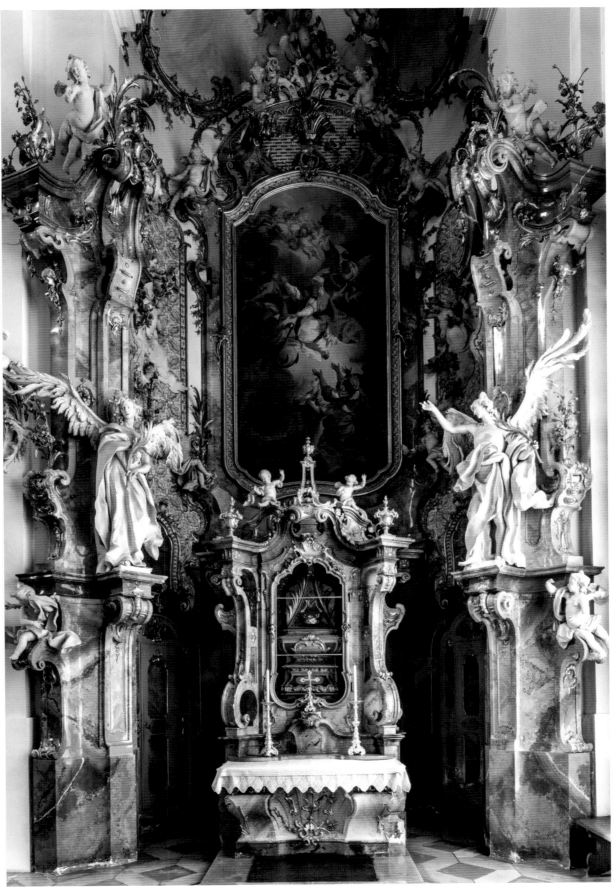

ASAMKIRCHE

MUNICH ▫ GERMANY

Sendlinger Strasse has always been one of Munich's main commercial streets. It is there, in 1732, amid boutiques, businesses, stalls, and carts, that Egid Quirin Asam (1692–1750) and his brother Cosmas Damian Asam (1686–1739) decided to build a church to St. John of Nepomuk. At the time, the heart of the Bavarian capital held almost five hundred religious establishments for its thirty thousand residents. Cosmas was a reputed painter, and Egid a sculptor and architect who hailed from a family of artists. They had spent time in Rome, earned an excellent reputation, and contributed to the construction of churches and monasteries in Bavaria, Austria, and Switzerland. In 1729, the martyr John Nepomucene (Johannes Nepomuk) (c. 1345–1393) had just been canonized and a relic was being offered to those who would build a church to house it. Deeply religious, the Asam brothers would devote their lives and fortune to the project.

Egid bought three adjoining houses, reserved the house on the left for future priests, the one on the right for himself and his family, and the middle house for the church he and his brother would build. Construction lasted more than ten years and was only truly completed after the death of both brothers.

The project presented a tricky problem in terms of architecture. How to insert a church between two existing houses and still draw in enough light? Egid developed his plans around options for capturing light. That is why the facade is distinguished by a large, mostly glass portal topped by an immense convex bay and a giant oculus. The nave is inserted between the two houses, and its second part is illuminated by enormous oval openings that look out onto inner courtyards; in the back, two discreet windows provide light to the choir and a third concealed one creates a halo of golden light above the upper altar. The

PAGE 139: Above the organ, the eagle, which is part of the coat of arms of the emperor and king of Bavaria Charles VII (1697–1745). The wings protect the joyful grace of the Asamkirche's Rococo decoration. The church was built, starting in 1733, by Egid Quirin Asam (1692–1750), the Bavarian painter, sculptor, and architect, and his brother, the painter Cosmas Damian Asam (1686–1739).

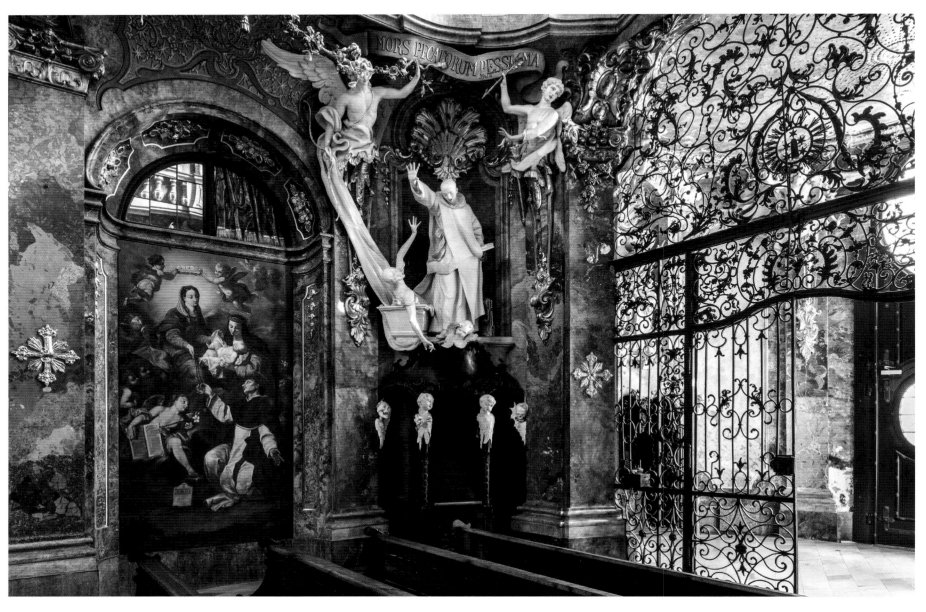

MORS PECATORUM PESSIMA

yellow oval oculus that draws attention to the altar is a controversial addition dating from when the church was restored after the 1944 bombardment. It distorts Egid's vision of the choir.

The interior plan consists of a small luminous vestibule, a large rectangular nave, and an oval choir. There are four altars: the main altar, in the axis of the nave, two lateral altars, and an upper altar in a gallery. Seven confessionals integrated into the walls and rendered as small, sculpted monuments respond to the ardent need congregants felt at the time to go regularly to confession. Like a prince, Egid Asam could access his church's tribune directly from his apartments.

The dimensions of the church are modest, seventy-two feet (22 m) long by twenty-six feet (8 m) wide, but the effect of the iconographic program and the late Rococo

Baroque style is striking, even if, to the contemporary eye, it might seem excessive as a whole. It is a controlled excess, full of charm, especially the colors, where muted reds, beiges, greens, and metallic effects abound.

Most of the frescoes on the walls and vault are devoted to the life of St. John of Nepomuk, who was tortured and sent to the Moldau region in the fourteenth century by King Wenceslaus IV of Bohemia (1361–1419) after taking part in a plan to prevent the king from choosing a new abbot. Egid entrusted his brother Cosmas with the execution of dynamic frescoes combining the effects of distant perspective and trompe l'oeil with the vaporous atmosphere of sacred exaltation. The architect himself tackled a few bas-reliefs in stucco covered in silver, several statues of saints and the church fathers made from stuccoed wood, and a profusion of angels and cherubs. None of those sculptures will leave viewers indifferent. Above a confessional, for example, there is a larger-than-life depiction of a scene from *Cenodoxus*, a play written by a Jesuit in 1602, in which a priest calls out to Cenodoxus, who is deceased but comes back to life three times to proclaim himself a sinner. Elsewhere, near the organs, a cherub beats time while another, wrapped in sheets of music, strikes his drum. Asam's vision of the small army of young children is surprising and humorous. Among the cherubs are two with skulls for heads. Farther away, an angel whose body dissolves into a faux marble pedestal holds a real votive offering in his hands. God the Father, wearing

PAGE 140 TOP: Gate separating the vestibule from the nave. In the middle is a confessional surmounted by the sculpture *Cenodoxus*, by Asam. ✝ PAGE 140 BOTTOM LEFT: Bottom of the nave. The confessional is surmounted by a sculpture by Asam depicting a believer entering eternal life. ✝ PAGE 140 BOTTOM RIGHT: A view of the vault with its exquisite Rococo decoration—cherubs, cartouches, gilded garlands, and faux drapery in stucco. ✝ PAGE 142: The unique nave. Most of the paintings were executed by Cosmas Damian Asam. The decoration is in wood and stucco. ✝ PAGE 143: *St. John the Evangelist,* between the twisting columns of the main altar.

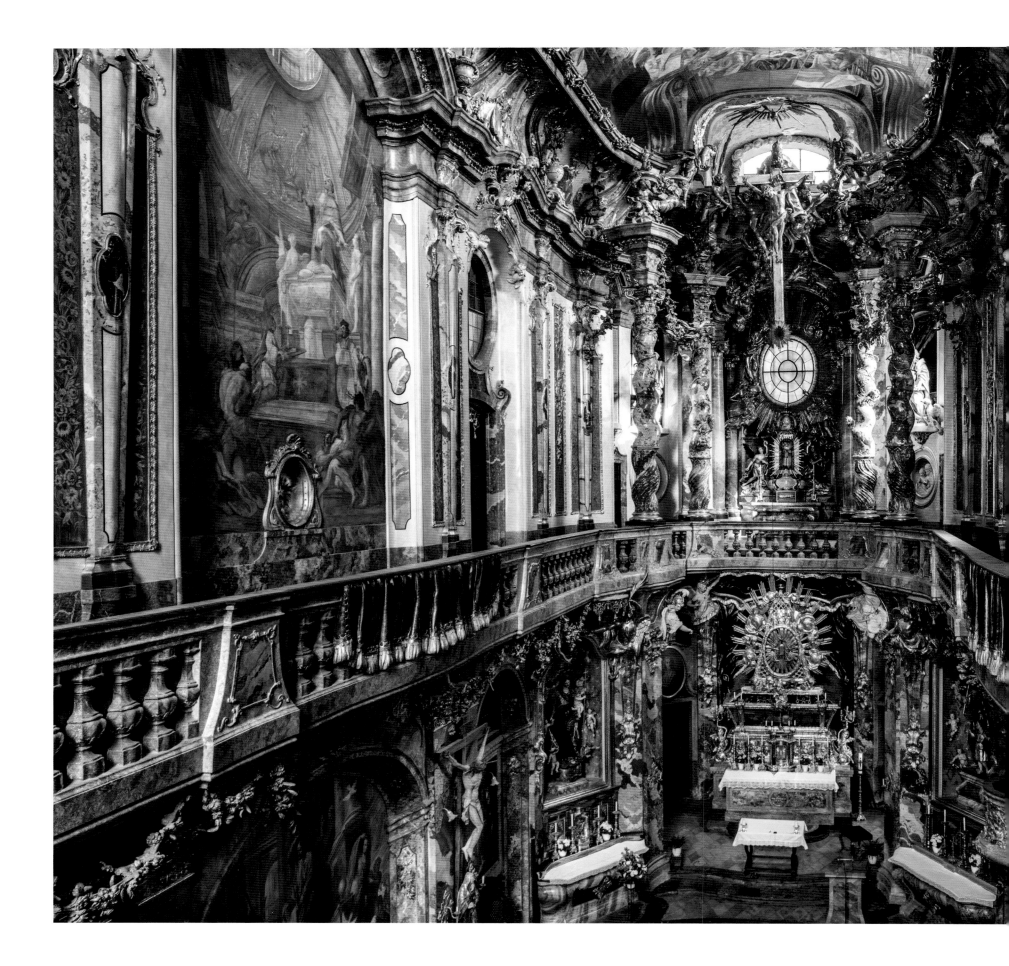

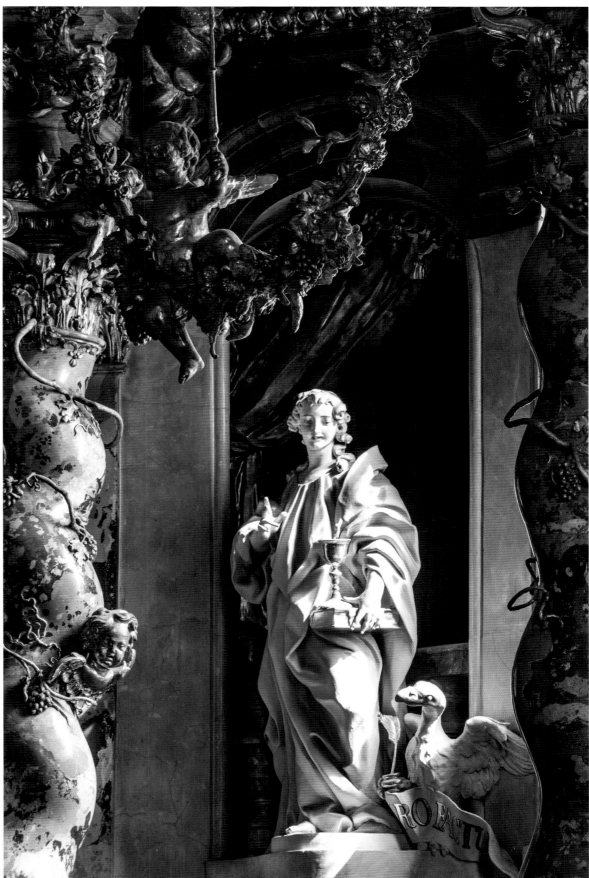

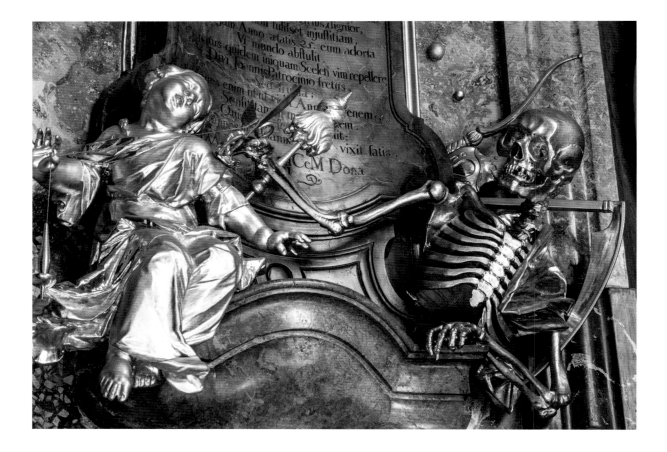

the papal tiara, appears above the gilded cross on which a silver Christ is dying; he hangs from a kind of baldachin with Solomonic columns. Everyone involved in the astonishing spectacle seems to be in action, to be flying, soaring. A figure lifts his leg over an entablature, another lands atop a column, a third brandishes a flute, and a fourth holds up a panel of a wall hanging. A statue cries, and the little world is laughing, is moved, sings. It is the great parade of Baroque heaven, crowded with an army of the servants of God.

Egid was not able to carry the project to completion. The stones that frame the entrance on the street were meant to be fountains honoring John of Nepomuk, patron saint of boatmen. But for his efforts, for his masterpiece, the architect received a piece of what was thought to be the saint's tongue as a relic (an analysis done in 1973 showed that it was in fact part of his brain).

PAGE 144: Macabre detail of the monument to Baron Johann Nepomuk Joseph Zech, a relative of St. John Nepomucene, by Ignaz Günther (1725–1775), one of the greatest sculptors of the era. ✚
PAGE 145: Above a confessional decorated with stucco seraphs, *The Washing of the Feet of the Apostles* by Cosmas Damian Asam, one of the scenes illustrating the life of Christ on the walls of the church.

ST. MORITZ CHURCH

AUGSBURG ▫ GERMANY

The parish church of St. Moritz stands in the heart of Augsburg, amid pedestrian streets, tramlines, cafes, and boutiques. The Romanesque sanctuary dating from 1019 was damaged by fire in 1084, collapsed in 1299, and in 1714, it was replaced by a Gothic church that was given luxurious Baroque accents. On February 24 and 25, 1944, Allied bombing left St. Moritz with only some of its walls and its bell tower standing. Dominikus Böhm (1880–1955), an architect of churches and convents, was put in charge of its reconstruction in 1946–1947. In 2007, the very active parish community decided to undertake more comprehensive restoration and called upon the English architect John Pawson (b. 1949).

Pawson is a unique figure in the world of contemporary architecture. A devout minimalist and proudly so, he takes on only a small number of projects, which he completes with a small team, from in-depth study through development and execution. In the field of religious architecture, he has made a name for himself through his inspired overhaul of the Trappist monastery of Nový Dvůr in Bohemia, in the Czech Republic; and through the restoration of the Archabbey of Pannonhalma, in Hungary. It was those two notable projects that drew the attention of Augsburg residents.

For the parish community, its priest, Helmut Haug, and the diocese, the undertaking was a matter not simply of décor, but also of implementing and staging the church's new role in the heart of a neighborhood that is very active commercially but has relatively few residents. St. Moritz was meant to become a center where a congregant, or simply a passerby, could enter and find a serene place for prayer, meditation, spiritual retreat, and sacred art in our time. No one could be further from the lyrical flights of the Baroque than Pawson; a great admirer of Cistercian architecture. He could not turn down such an opportunity.

While modern and contemporary sacred architecture successfully express the purity of faith and the simplicity

PAGE 147: Lateral nave. Only a few Baroque statues saved from the ruins of the church after the bombings in 1944 have been restored. At the foot of each statue sits a minimalist candlestick.

of dialogue between the believer and his or her god, rarely have these qualities been as intensely articulated as they are here, with the exception of perhaps Le Corbusier's Convent of La Tourette (see page 72). Pushed to this extent, minimalism almost erases the material presence of architecture. The inside of St. Moritz church is uniformly white. It is the purest white one can imagine, to the point that, in the choir brightened by three laminated onyx windows, the light at certain times turns into a silvery and luminous fine mist. The visitor's eye, passing through the handsome bronze doors, is drawn to the apse and stops not at a crucifix but at an extraordinary wooden statue, *Christus Salvator* (Christ the Savior), made by one of the greatest Baroque sculptors of the seventeenth century, Georg Petel (1601/1602–1634). The Christ extends his arms, calling, welcoming. He announces the hope of redemption, not the sacrifice.

PAGE 148: St. Maurice has existed in various forms in the center of Augsburg for a millennium. ‡ PAGE 149 *TOP LEFT*: *Christ the Savior* by Georg Petel (1601/1602–1635). After spending time in Rome, he became one of the precursors of the Baroque style in Germany. ‡ PAGE 149 *BOTTOM LEFT*: Baptismal fonts, simple cylinders of carved limestone. ‡ PAGE 149 *RIGHT*: The main nave transformed by John Pawson (2013). Five bays and five oculi in translucent onyx open the apse. The apse's former altar was replaced by Petel's sculpture. The new altar is now in the foreground.

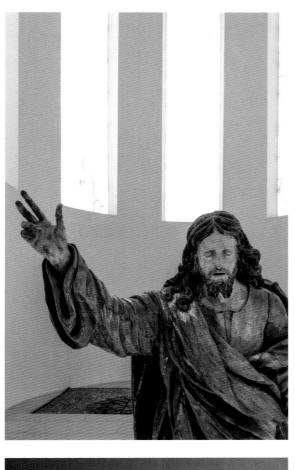

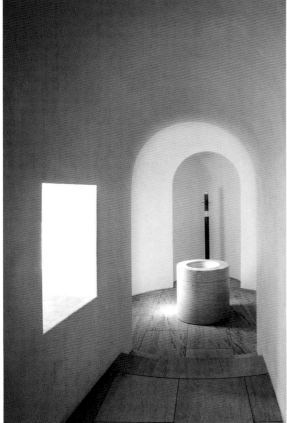

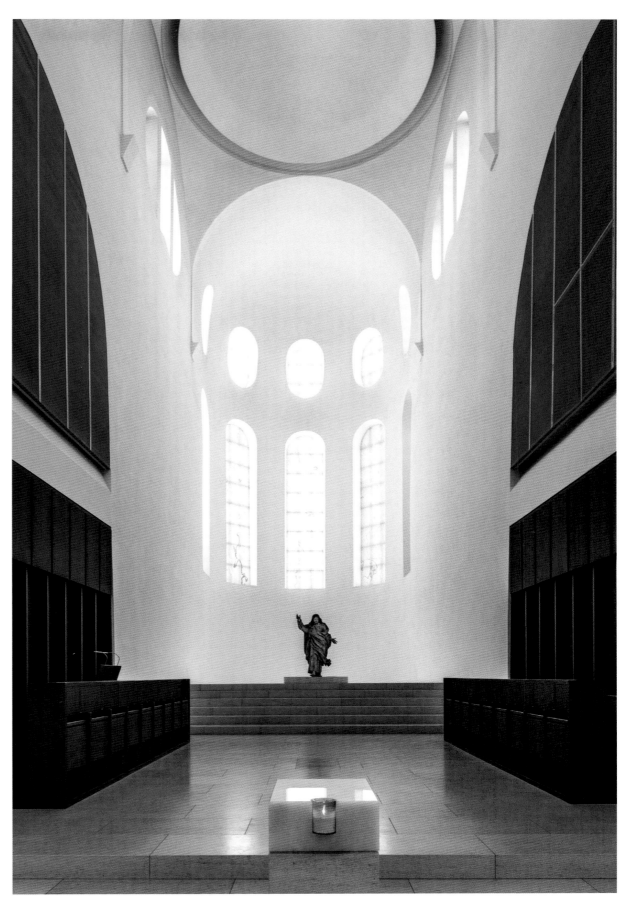

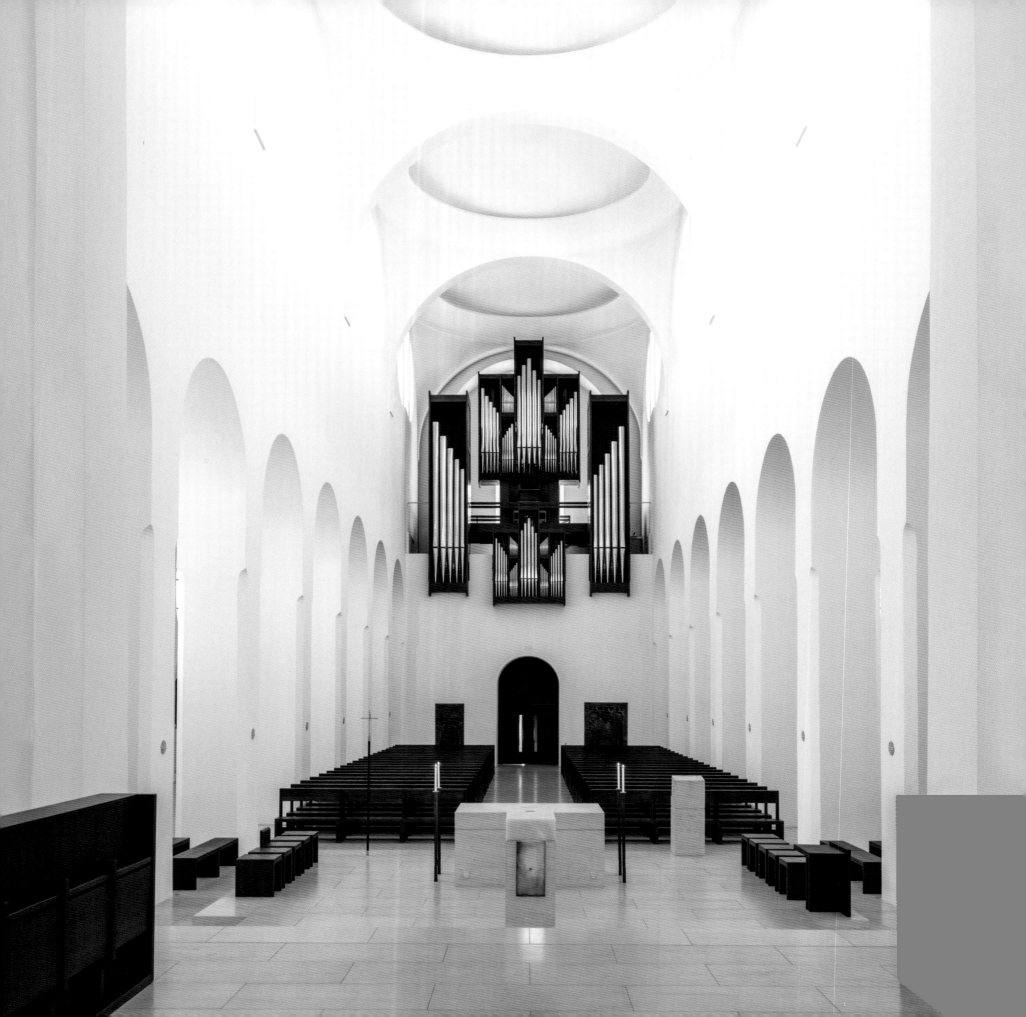

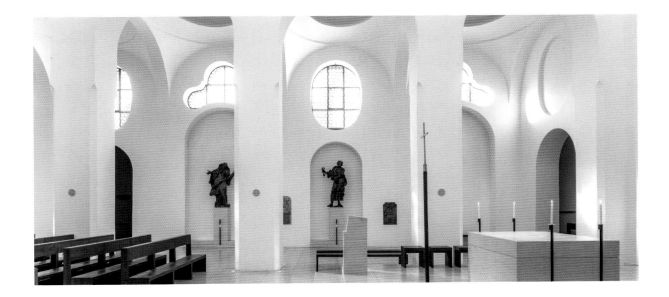

In the choir, the altar, an enormous block of Sicilian marble, rises before the faithful, complemented by a tribune carved in the same material, which is also used for the floor. The heavy (and comfortable) pews of darkened wood sit directly on the polished marble floor. Aside from fourteen small crosses placed on the pillars to recall the Stations of the Cross, no decoration disrupts the minimalism of the nave brightened by Baroque bay windows and, at night, by concealed LED lights along the cupolas

PAGE 150: The main nave, in immaculate white, viewed from the apse. In the foreground are the altar and ambo (pulpit) made from Portuguese limestone. The marble floor contrasts with the furniture, which is in dark, almost black, oak; note also the modern organ. The choir organ is set into the walls. The architectural purity and rigor, and the light falling from the high windows, create a paradoxically tactile feeling of spirituality. ✠
PAGE 151: The main altar, pulpit, and Baroque-style windows in clear glass.

and floor. Nothing here distracts the eye; no painted or sculpted image offers an example, an anecdote, an edifying narrative; no relic is presented for devotion. Martyrs, archangels, angels, seraphs, and putti have flown to other skies. Nevertheless, attesting to history, a few fine Baroque sculptures of saints and the coats of arms of local families are on display in the aisles.

What is perhaps most striking about St. Moritz is just how much Pawson's intervention is both invisible and omnipresent. It is invisible because here the architecture, stripped of its finery and decorative frippery, finds its primary function: protection. It is neither intrusive nor emphasized nor suggested. It is there only to allow for and facilitate an exchange with God. Every detail was considered in the spirit of unity, such as the rusted metal candlesticks in the aisles, the tribune, the baptismal fonts, and the functional and careful design of the vestibule. Through the restoration, John Pawson aims to bring those seeking God a little closer to him.

CHURCH OF
ST. LEOPOLD

VIENNA ▫ AUSTRIA

In Vienna, one can sometimes see in the distance the golden dome of the Church of St. Leopold at the top of Galitzinberg; in the past, residents of the city even called it "lemon hill." The sanctuary—the largest and most modern of its time—prevails over the 356 acres (144 hectares) of the psychiatric hospital of which it is a part. After winning a design competition for Vienna's renovation program, Otto Wagner (1841–1918) built the church, which exemplifies the principles outlined in his famous book *Moderne Architektur* (1895).

Born into a wealthy family, well-educated, and hardworking, Wagner was the most brilliant representative of the new architecture that emerged in Austria in the 1890s in reaction to the official historicism that had not moved beyond the Baroque, the Italian Renaissance, and the Gothic. For a long time he was involved with the Vienna Secession and Austrian Art Nouveau, and fell in with artists like Gustav Klimt (1862–1918) and Koloman Moser (1868–1918), collecting their work and often commissioning them for his projects. The fundamental support he lent

was not revolutionary, strictly speaking, but it served as the historical link between Beaux-Arts and the modernist architecture that would make its mark after World War I. He was among the first architects to openly draw on the possibilities of new materials, while appreciating ornamentation, wrought iron, mosaics, stained glass, and sculpture. He considered most of his projects to be *Gesamtkunstwerk* or "total works of art," a concept he resolutely put into practice at St. Leopold.

Built at the highest point of the hospital complex, the church plan is essentially in the shape of a Greek cross, with a slightly longer branch forming the nave. Built in brick over a stone base, it is covered with a veneer of Carrara marble held in place by big copper bolts so as to clearly indicate that it is decorative. In the middle of the main facade, which is distinguished by two low spires topped

PAGE 153: The baldachin of the high altar mirrors the shape of a cupola with gilded copper openwork. Two marble columns uphold the structure.

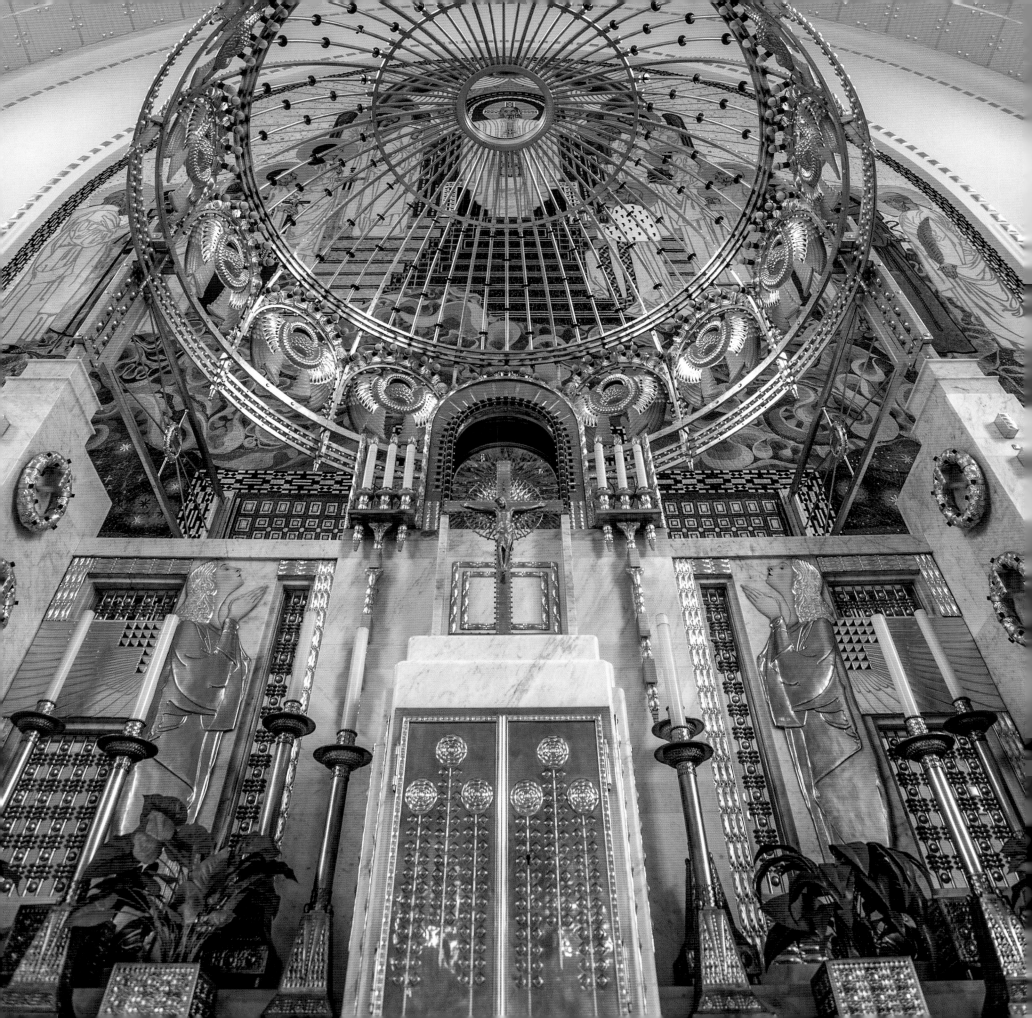

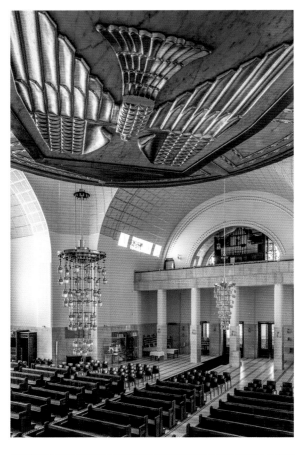

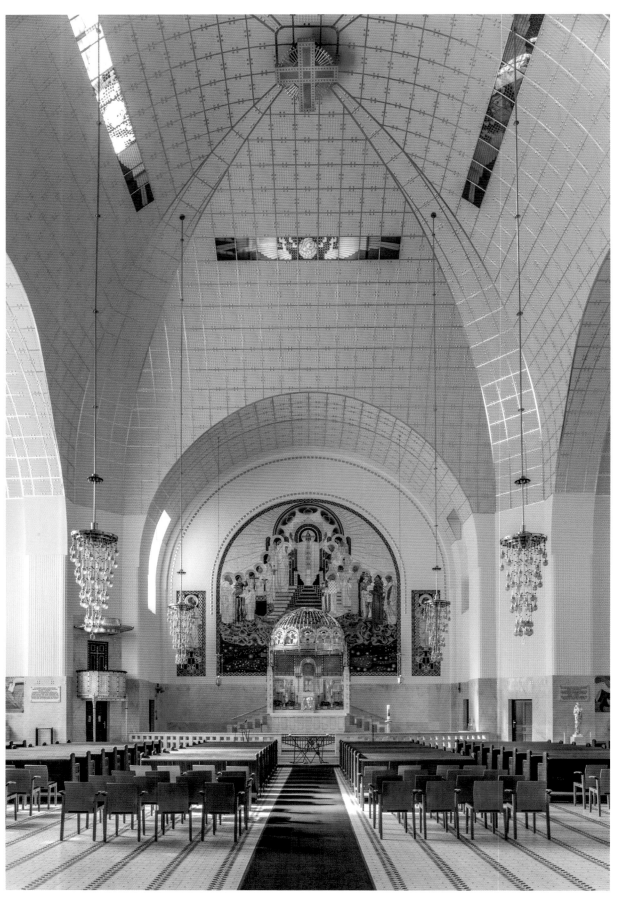

by statues of St. Leopold and a seated St. Severin, both by Richard Luksch (1872–1936), is a monumental porch with four bronze angels in prayer by Othmar Schimkowitz (1864–1947). Light enters through enormous stained glass windows and shines onto multiple ornaments, furnishings, ceiling moldings, and gilded mosaics. The architectural inspiration is tangible, even if the dazzling light, the rich illustrative decoration, and the formal splendor do not inspire religious fervor. The iconic stylization of the figures, the sophisticated luxury of details, and the affirmation of a unique and strong creative will are undoubtedly the reason. Wagner wrote, "Only that which is practical can be beautiful," and indeed, everything is practical and functional in this lavish church: There were separate entrances for male patients and female patients and rounded pews so they wouldn't hurt themselves, with enough room between for caretakers to quickly intervene; holy water flows at all times through a spout so as not to contaminate the fonts; and there are even bathrooms.

Archduke Franz Ferdinand (1863–1914), who attended the consecration of the sanctuary in 1907, did not even mention Wagner in his speech. He publicly declared that the "Maria Theresian style was nevertheless more beautiful" and made sure that Wagner received almost no more official commissions. During World War II, the hospital,

only a few yards from the church, served as a center for eugenics for patients who weren't sent to concentration camps. Today, following many years of restoration, it has been given the name Otto Wagner Hospital and the Church of St. Leopold. It shines once more, dazzling evidence of the final creative flames of the Austro-Hungarian Empire's sophisticated architecture and art.

PAGE 154 *TOP LEFT*: The church can welcome up to eight hundred congregants. ‡ PAGE 154 *BOTTOM LEFT*: Detail of the mosaic, ceramic, and marble altarpiece by Leopold Forstner (1878–1936). ‡ PAGE 154 *RIGHT*: The nave beneath the spangled cupola, with four narrow bays decorated with stained glass by Koloman Moser (1868–1918), one of the principal figures of the Vienna Secession. ‡ PAGE 156 *TOP LEFT, CENTER, AND RIGHT*: Portico angels by Othmar Schimkowitz (1864–1947), who regularly worked with Otto Wagner (1841–1918). The main facade overlooks the valley. At the top of the bell towers are sculptures of St. Leopold (1050–1136) and St. Severin by Richard Luksch (1872–1936). ‡ PAGE 156 *BOTTOM LEFT AND RIGHT*: Stained glass by Koloman Moser (1868–1918) depicting various male and female saints. ‡ PAGE 156 *BOTTOM CENTER*: The church is a "total work of art" or *Gesamtkunstwerk*. Every detail was studied, and often designed, by Wagner, including the tiled floor. ‡ PAGE 157: Detail of the high altar with praying angel designed by Wagner.

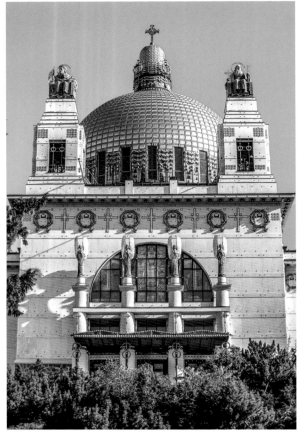

CHAPEL OF ST. MARY OF THE ANGELS

MONTE TAMARO ▫ SWITZERLAND

Europe is studded with secluded chapels; they are hidden in the depths of a valley, forgotten along the edge of a spring, or isolated in a clearing or atop a hill. Built as testaments, in gratitude, as symbols, in commemoration and honor, like crosses and wayside shrines, they are manifestations of the dense network of the Catholic presence.

Egidio Cattaneo (1925–2002) wanted to build a chapel in memory of his deceased wife. As the owner of Monte Tamaro's ski lifts—atop one of the peaks of Ticino, which rises to some 6,437 feet (1,962 m)—he had both the taste and daring to not only choose an extraordinary site but also to call upon Mario Botta (b. 1943), one of the greatest architects in Switzerland.

Like an outcrop surging from the side of the mountain or the starting point of a viaduct into eternity, the chapel points straight toward the wide-open valley. Built in reinforced concrete but covered in thick porphyry, it was designed to defy time and the elements, to commemorate forever.

It took four years, from 1992 to 1996, to build and decorate it. Botta believes that much of contemporary culture and architecture will not last, that we have entered

PAGE 159: A narrow footbridge leads, via a double staircase, to the chapel and toward the sublime view of Rose Mountain, in Bellinzona, Ticino. ‡ PAGE 160: The footbridge and chapel entrance made from concrete and red porphyry. Mario Botta (b. 1943), a Swiss architect of great visual and conceptual originality, was born in Ticino. He built St. Mary of the Angels at an altitude of almost 6,500 feet (2,000 m) between 1992 and 1996. ‡ PAGE 161: The bell hangs in open space.

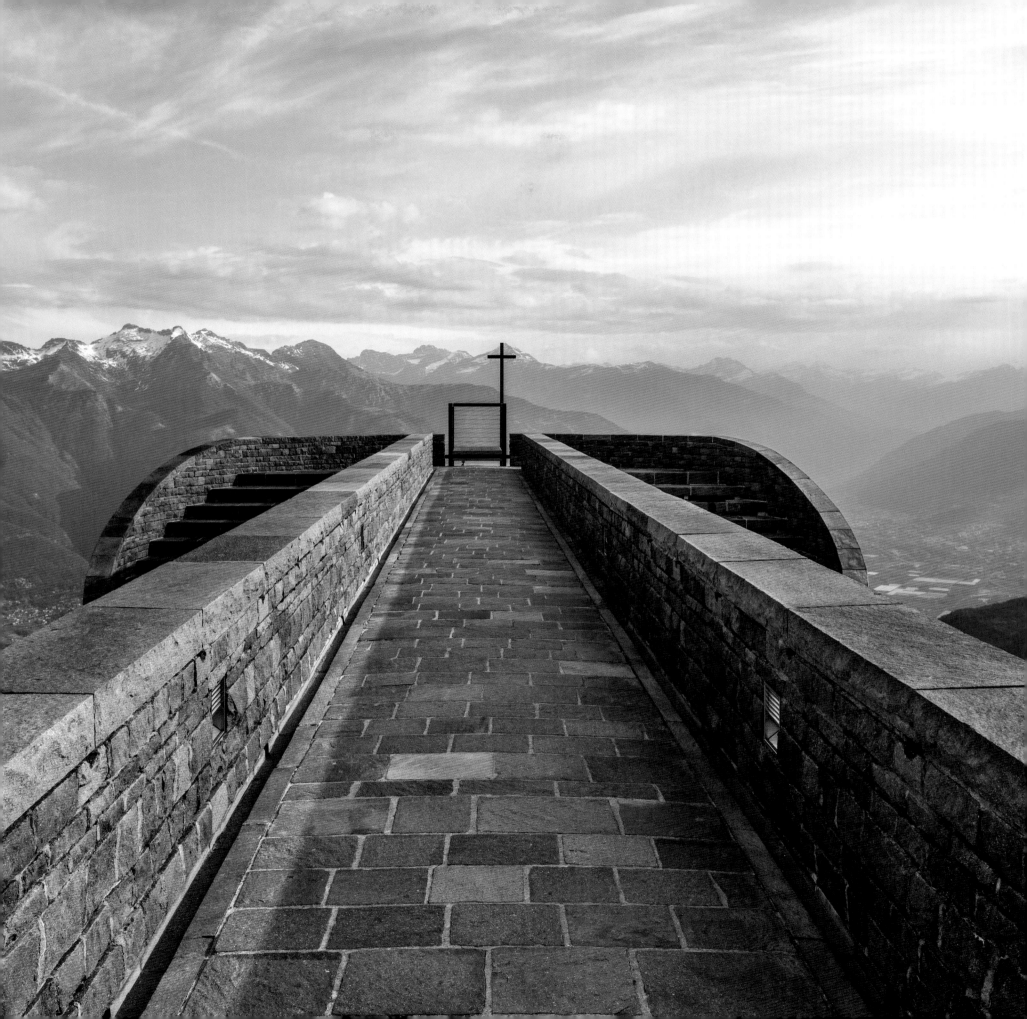

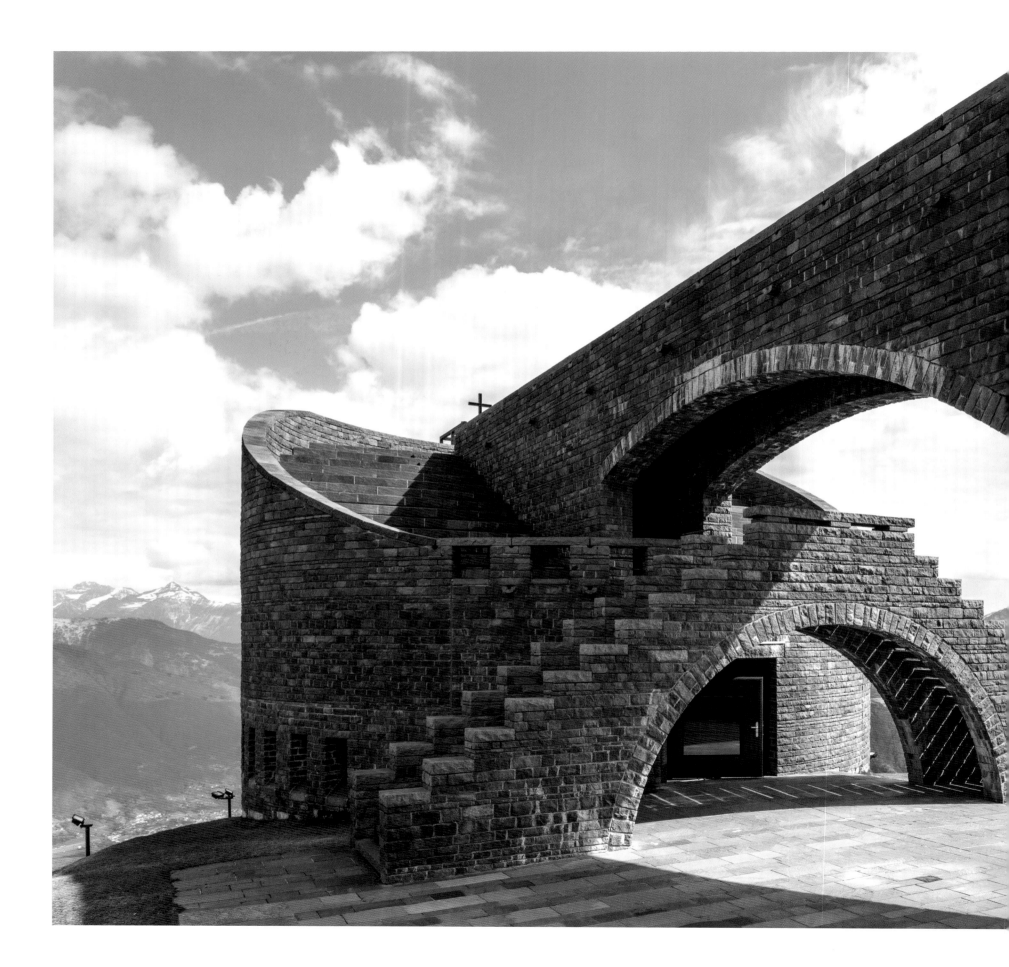

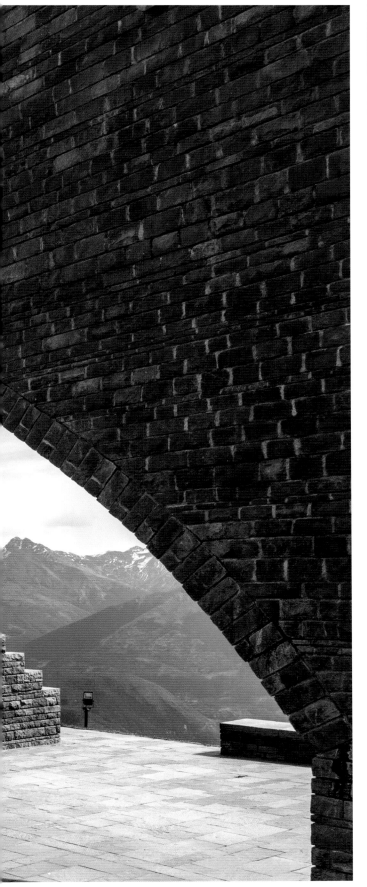

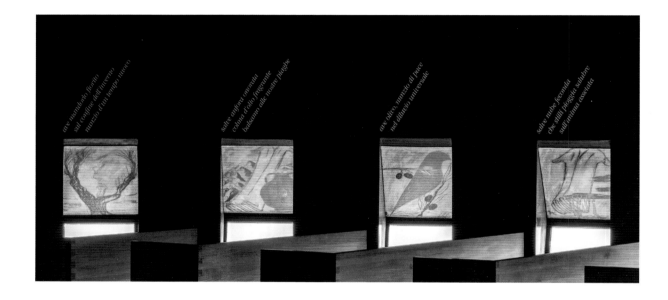

a phase of rapid construction and demolition that is ever more apparent. Since his start, the architect, who learned his profession on construction sites, has built many churches, private homes, museums, and libraries in a decisively personal style, though it sometimes reminds us of Louis Kahn (1901–1974). Botta is behind the most recent cathedral built in France, in Évry, in 1995, and his interventions are notable at once for their uncompromising originality, the power of their presence, and their architectural and urbanistic quality.

Enzo Cucchi (b. 1949), one of the principal members of the Italian Transavanguardia, was given free rein to develop his poetic approach to the painting and image of the chapel. For example, a long black streak draws the eye to the altar, and the altarpiece depicts two hands cupped in offering against an electric blue background. On the sides

are pews and modest windows at eye level illustrating natural elements—birds, landscapes—and presenting prayers.

In such stillness and solitude, swept by the wind, the contemplative visitor can climb stairs to the edge of the roof to admire the spectacular landscape of mountains, valleys, and clouds—all the majesty of divine creation.

PAGE 162: The Italian artist from the Transavantgarde movement, Enzo Cucchi (b. 1949), created these stained glass windows. They are based on twenty-two litanies composed by a Capuchin friar and are installed at the eye level of seated congregants. The lower, transparent part looks out onto the valley. ✚ PAGE 163 TOP: The chapel's nave, viewed from the altar, surmounted by a concrete vault adorned with a fresco by Cucchi. ✚ PAGE 163 BOTTOM LEFT: The altar in front of an altarpiece by Cucchi, lighted naturally. ✚ PAGE 163 BOTTOM RIGHT: View of the fresco and stained glass.

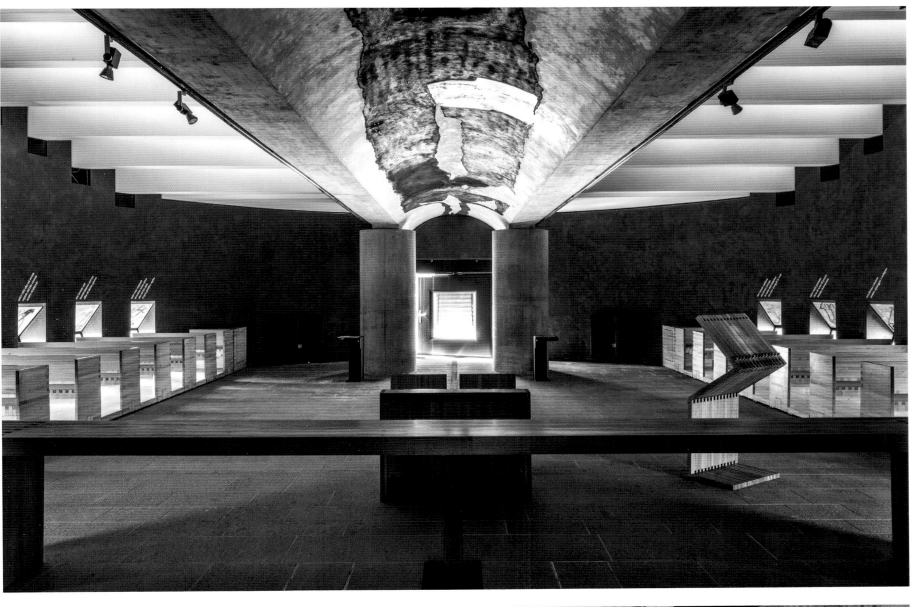
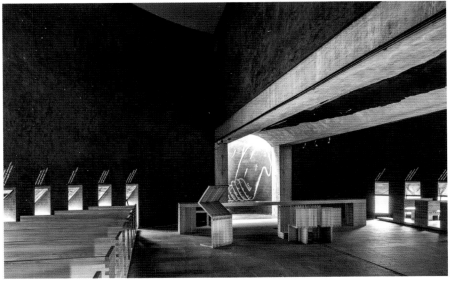
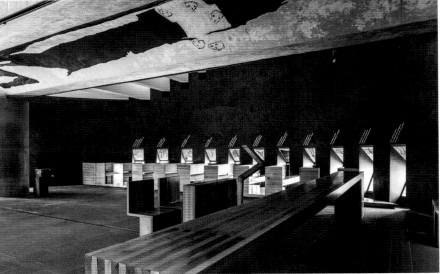

ELY CATHEDRAL

ELY ▫ UNITED KINGDOM

In a region of fog, sleet, rain, and ponds, of marshes, canals, and drenched soil, the ferns of East Anglia are made more appealing by a humble hill which was once an island. It is there, in Ely, that in 673 the queen and future St. Etheldreda (636–679) founded a double monastery. It was taken over in 970 by the Benedictines, who built a new church and turned it into one of the wealthiest communities of England. In 1080, following the Norman Conquest and the great movement it triggered to rebuild cathedrals and abbeys, the decision was made to build a cathedral. Construction would last more than a century and over time would draw on the Norman style, early Gothic, and eventually Decorated Gothic. Despite the evolution, the cathedral, which can be seen for more than twelve miles, remains a sophisticated testament to Norman art.

Its plan is rather complex, as is the case with many English cathedrals from that period that are linked to an abbey. The main facade, which is Norman, was preceded, in all likelihood after 1215, by a galilee, an intricately decorated monumental porch. It allowed monks to greet penitents and to speak with the women they served, because the latter were not allowed to enter the abbey. Once through the entrance, one finds the Norman nave with its powerful semicircular arches and wood ceiling, which was repainted in the Victorian era. The wealth of decoration highlighted with gold and resembling illuminations (Ely was well-known for book production) contrasts elegantly with the whiteness of the stone.

The transept was reengineered after a catastrophe in 1322 in which the octagonal tower suddenly collapsed, in all likelihood undermined by the construction of the Lady Chapel or insufficiently supported by its own foundations. Like many others during the Middle Ages, the Ely community was undiscouraged and rebuilt a more beautiful and higher octagonal tower, 140 feet (43 m) tall and as spectacular on the outside as it was on the inside. To the influential German art historian Nikolaus Pevsner (1902–1983), it was a work of genius. Its architect, Alan de Walsingham

PAGE 165: Above the transept rises the famous octagonal tower, 140 feet (43 m) high, by Alan of Walsingham (d. c. 1364). It was built after a previous version collapsed. Extraordinarily elegant for the period (c. 1330), it was fully restored between 1860 and 1890.

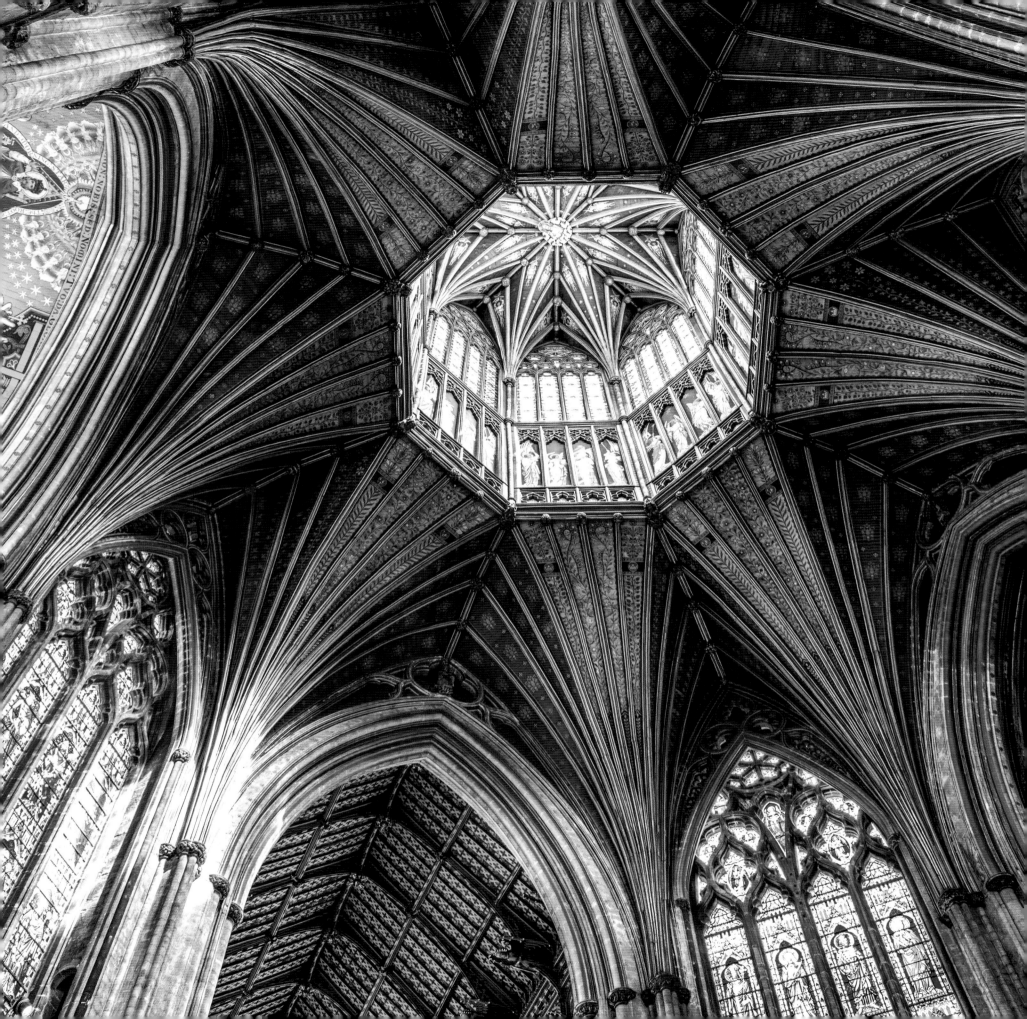

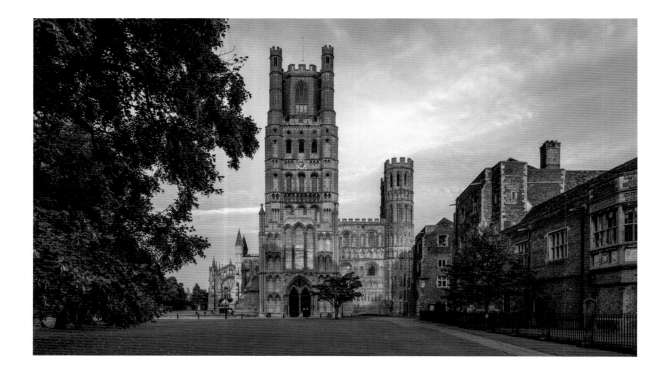

(d. 1364), designed an extraordinarily elaborate octagon, resting on eight arches opening onto the nave, the choir, the two arms of the transept, and four bay windows. Eight wooden structures fan out from there and support a second octagon, also wooden. The structures form a skylight composed of a base decorated with paintings of angelic musicians and includes eight luminous windows. The effect is exhilarating. At night, seen from the outside, the skylight sparkles from all its stained glass.

The choir, which in all likelihood was damaged at the time of the collapse in 1322, was restored around 1330 in the Decorated Gothic style. Its vault is brilliantly crafted and retains all its power. Several chapels were added over the century, including those for St. Etheldreda and John Alcock (1430–1500), the wealthy bishop buried amid an abundance of statues and beneath a stone fan vaulted ceiling. From the choir, one enters Lady Chapel, a luminous room of stone and clear glass built in the middle of the fourteenth century. In times past, statues of bishops and kings were painted along with walls, and windows were fitted with stained glass; those did not survive Elizabeth I (1533–1603) and Oliver Cromwell's (1599–1658) iconoclastic furor.

PAGE 166: The cathedral's main western facade. To the right are the two Norman towers; to the left, in back, the Lady Chapel. ‡ PAGE 167 *LEFT*: The nave seen from the altar. The fourteenth-century stalls were embellished with new sculptures during the Victorian era. ‡ PAGE 167 *TOP RIGHT*: Detail of the octagonal lantern painted by Thomas Parry (1816–1888), who had invented a new technique of fresco painting. ‡ PAGE 167 *BOTTOM RIGHT*: View of the nave (538 feet [164 m] long) in the Norman style.

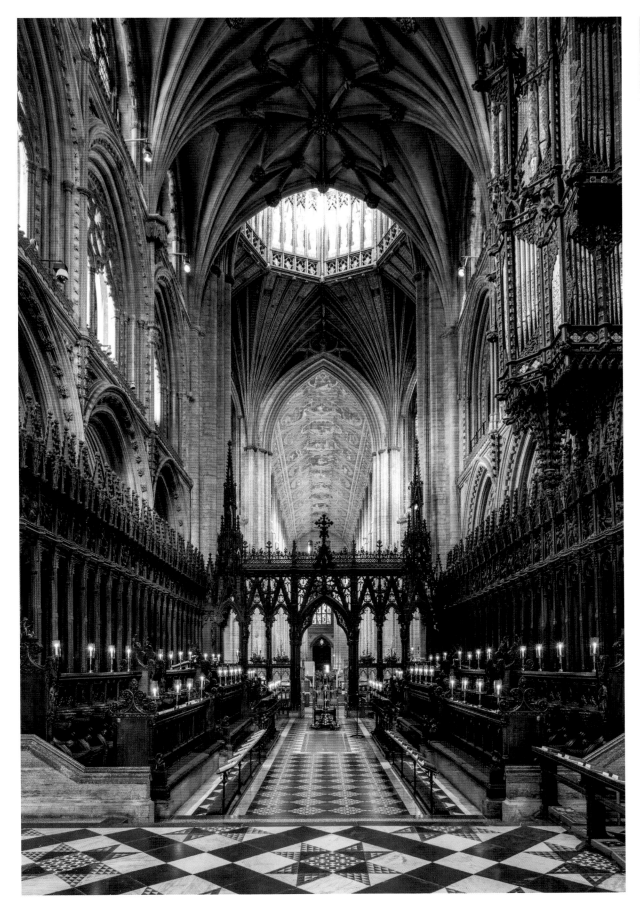
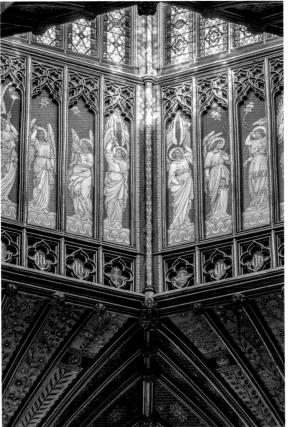
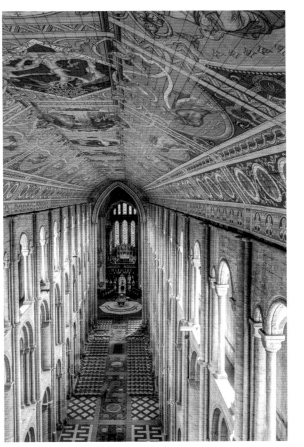

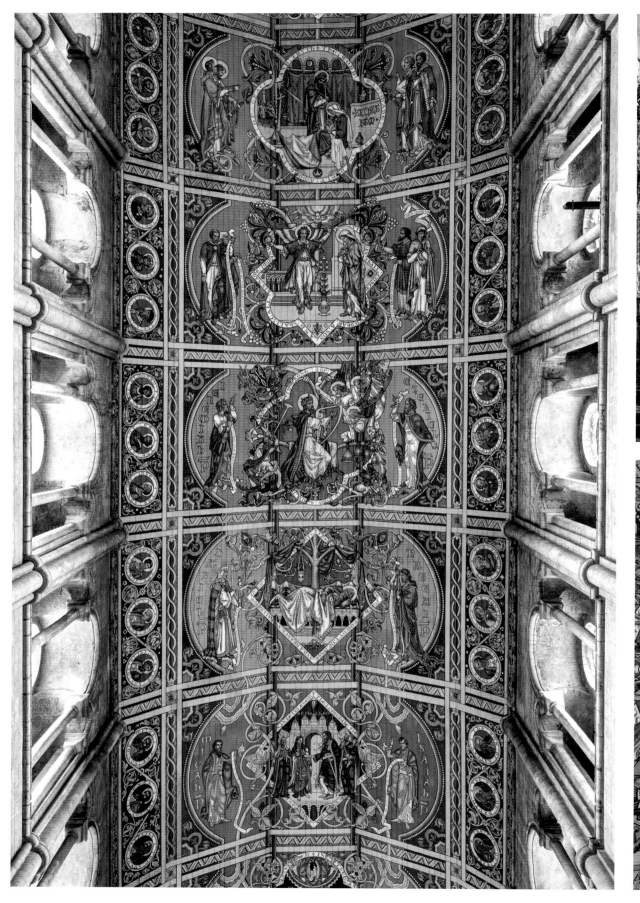

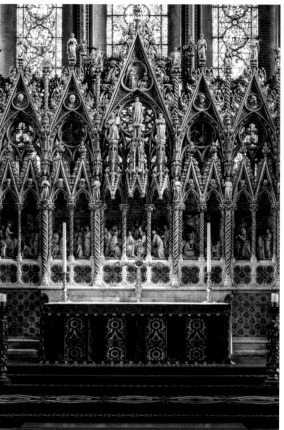

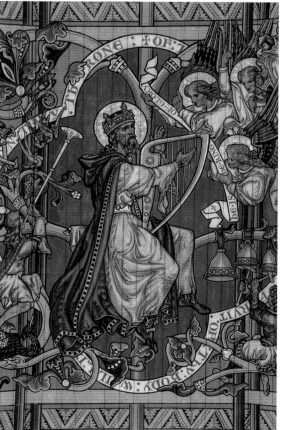

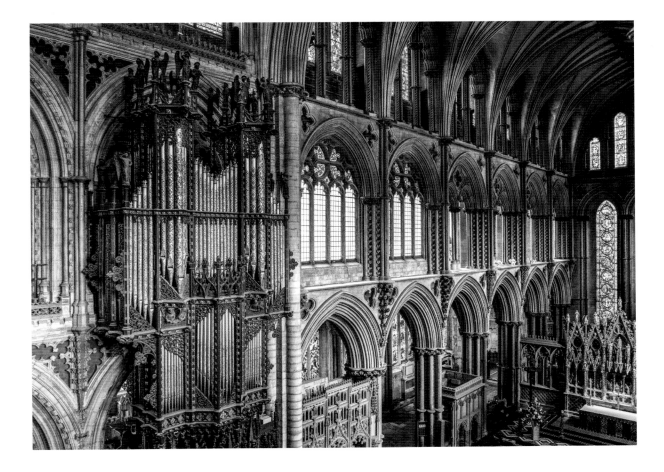

During the Victorian era, Ely required substantial restoration. The project was first entrusted to two enthusiastic amateur architects who removed the coating from the walls, repainted the choir, and changed the floors. They were replaced by the famous George Gilbert Scott (1811–1878), an ardent champion of the Gothic Revival, which focused on the octagon in particular. He repainted the angels bearing instruments in the skylight. The English art critic John Ruskin (1819–1900) commented: "They've ruined the Octagon, it's like the decoration for a music hall."

Two famous watercolors by J. M. W. Turner (1775–1851) present Ely more poetically, as it might have appeared around 1800: a cathedral of light standing on an isle amid a landscape of marshes.

PAGE 168 *LEFT*: The extraordinary ceiling, dating from the Victorian era, was inspired by illuminations and the style of medieval Psalters. It illustrates the genealogy of Christ. ✠ PAGE 168 *TOP RIGHT*: The high altar and its altarpiece by George Gilbert Scott (1811–1878), the prolific architect who restored the Ely cathedral during the Victorian period. ✠ PAGE 168 *BOTTOM RIGHT*: King David, ceiling detail. ✠ PAGE 169: The choir organ. George Gilbert Scott was inspired by the instrument at the Strasbourg Cathedral.

WELLS CATHEDRAL

WELLS ▫ UNITED KINGDOM

Although cathedrals have a reputation for being erected *ad majorem Dei gloriam* (to the greater glory of God), other interests may have come into play, for example, prestige and civic pride, power, the spirit of competition, the economy, and, of course, need. Wells Cathedral's history began with a dispute about territory.

The first church was built in 705 on a quiet site at the foot of the Mendip Hills in Somerset, famous for its wells. The site, fittingly called Wells, served as a diocese starting in 909, but a Norman bishop, John of Tours (d. 1122), moved it to nearby Bath, to the great displeasure of the city's chapter. Then it was decided that the diocese could have two headquarters, one in each town. Finally, upon order of the pope, the cathedral was definitively granted to Wells in 1245, with the dignitary holding the title of bishop of Bath and Wells. The dispute had lasted more than one hundred and fifty years. Without waiting for it to be settled, the bishop Reginald Fitzjocelin (1140–1191) began to restore and expand the cathedral to replace the existing building, which was in a sorry state. He launched the project around

1185, and it was completed with the consecration of the altar in 1239, although construction continued until 1350.

Wells is a charming town that has been excellently preserved; it is practically a film set for a Trollope novel. At one end of Market Place are two large fortified medieval portals: one leads to the cathedral; the other, to the vast bishop's palace surrounded by moats and a crenellated (with battlements) wall.

The cathedral, which rises from the center of a grassy area surrounded by fine homes, seems heavy, stocky, even slightly primitive when viewed from the front. The towers appear truncated, because spires were meant to surmount them but were never built. The incredible wealth of sculpture on the facade remains astonishing. Financed by Jocelin of Wells (d. 1242), the powerful bishop, its 148 feet (45 m) of height are filled with almost three hundred statues of all

PAGE 171: Although construction of the cathedral started in 1105, the three famous scissor arches, which compensated for the transept's structural problems, were not added until between 1338 and 1348. The architect William Joy (1329–1348) turned a flaw into a virtue.

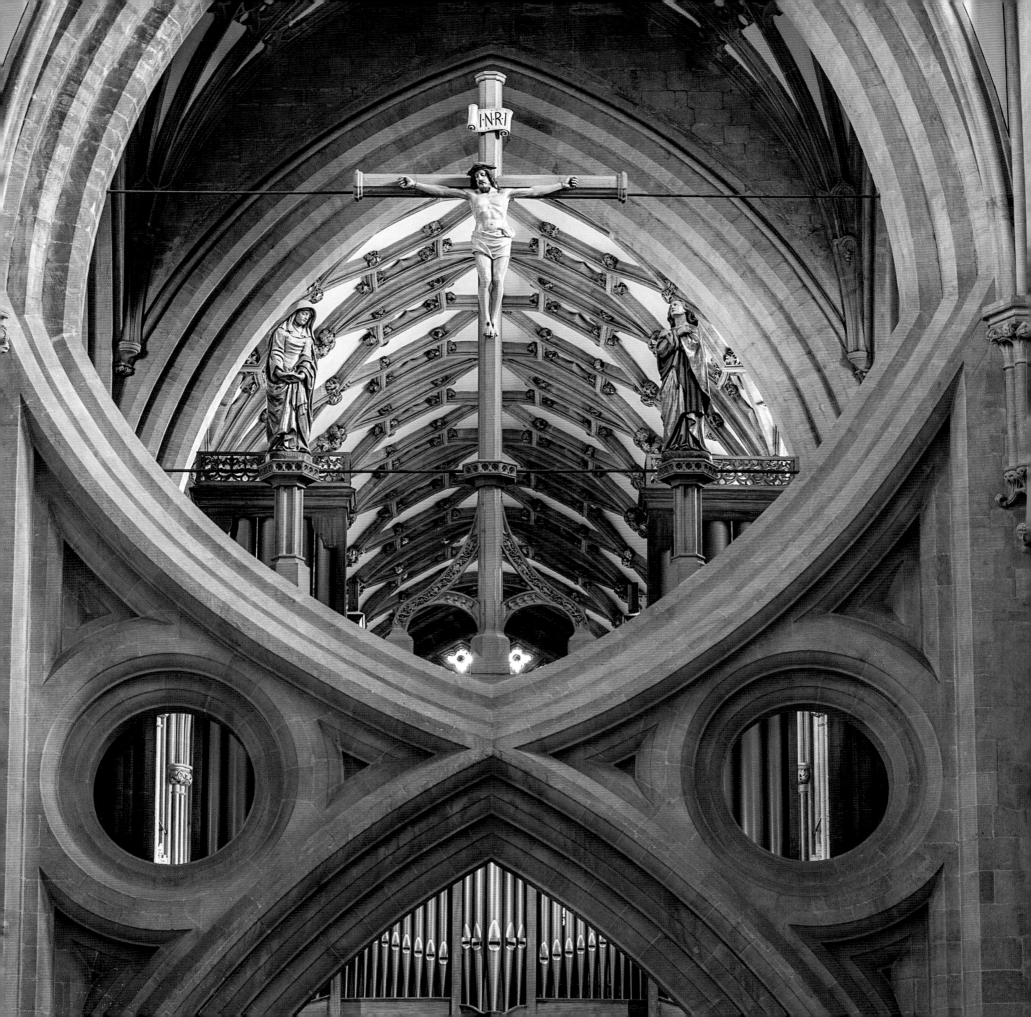

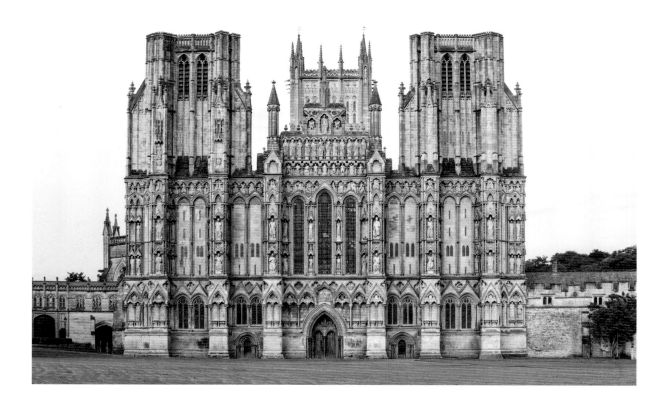

sizes (there were four hundred originally) aligned in subtle hierarchical order and depicting kings, bishops, and saints. There are clear allusions to the signing of the Magna Carta, which took place on the advice of the bishop of Wells. The inclusion reflects the influence of the church on the temporal, and celebrates its triumph and union with the state.

The slope of the terrain prevents an immediate view of the plan's complexity as a whole, and of the enormous square tower that dominates the transept. The choir, which was built last, was reinforced by flying buttresses. In fact, although entirely Gothic, the cathedral was initially built using Norman—in other words, Romanesque—techniques that involved thick walls that precluded outside supports. It was only during the drawn-out construction process that larger and larger bays were added, leading to the huge

stained glass Jesse Window; it encloses the choir and fills two-thirds of the wall's height, making Wells a brilliant example of the Early English Gothic style and its transition into Decorated Gothic.

Such technical changes had their problems. Around 1336, it was realized that the transept was not properly supporting the enormous, 180-foot-square (55-m-square) tower that had been added twenty-three years earlier. Turning a

PAGE 172: The western facade (c. 1230) adorned with almost three hundred statues illustrating the glory of the Church of England and its bishops. ‡ PAGE 173 *TOP LEFT*: The central bell tower as seen from the garden. ‡ PAGE 173 *BOTTOM LEFT*: The cloister (fifteenth century) surrounds the old cemetery. ‡ PAGE 173 *RIGHT*: View of the nave with the quadripartite vaults and scissor arches.

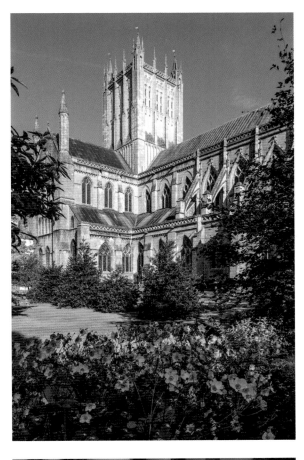

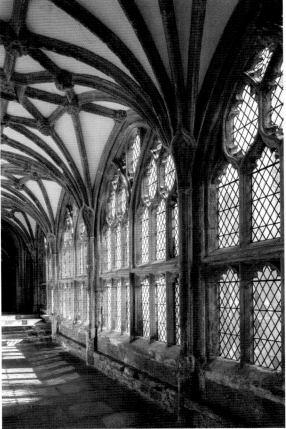

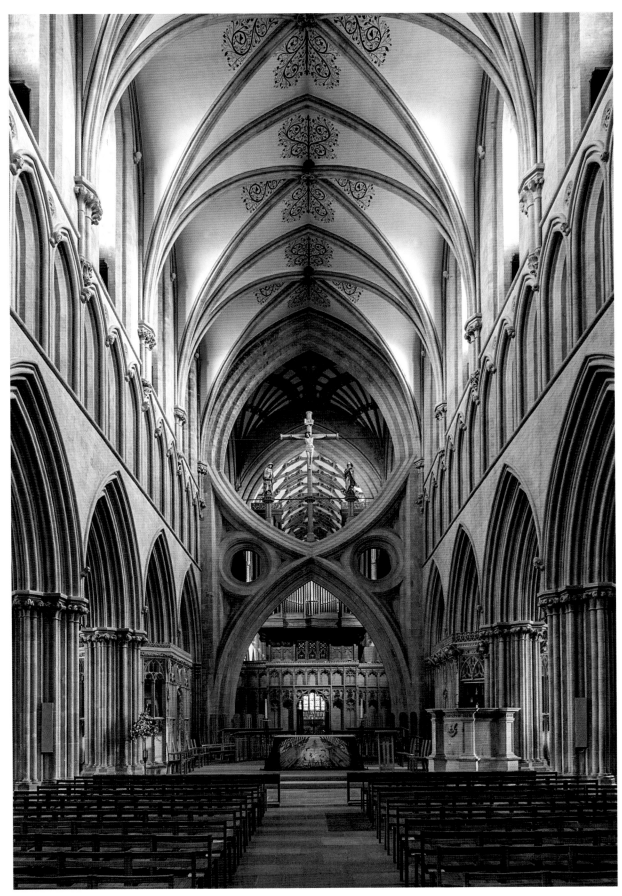

construction vice into a virtue, the architect William Joy (1329–1348) (in all likelihood) had the idea to create three arches in the shape of St. Andrew's Cross—scissor arches—which, erected between 1338 and 1348, reinforced the transept while giving Wells an iconic masterpiece of elegance and architectural intelligence.

Curiously, perhaps because it has been recently restored, the inside of the cathedral belies the impression of heaviness one has looking at the outside. The initial view of the large nave of white, warm stone, which culminates in the majestic scissor arches of the transept, is astoundingly beautiful. The choir proceeds beyond the dark wood rood screen and leads to the monumental window, among the most beautiful in England. It is one of the first triumphs of English art, which had begun to distinguish itself from its continental influences. Miraculously, the stained glass windows were spared from Elizabeth I's iconoclastic resolution and were only partially vandalized by Cromwell's troops.

The cathedral holds a few surprises. As visitors proceed through, they will discover a monumental clock, the second oldest in Europe; an enormous brass lectern from 1660; the chapter house with a spectacularly elaborate palm vault that rests on a single central pillar; a staircase with a cascade of beautifully worn steps; a library from the seventeenth century untouched by time; and a big ginger cat, the site's mascot, stretched out in front of the radiators and charged with limiting frolicking rodents, as a long line of tomcats have done before him.

PAGE 174 *RIGHT AND LEFT*: The stalls are made more comfortable with cushions upholstered during the Victorian era. ✚ **PAGE 175** *TOP*: The choir, almost as long as the nave, extends beneath the Jesse Window (c. 1340). Depicting the genealogy of Jesus, it is one of the most splendid examples of the art of Gothic stained glass in Europe. It was spared from Oliver Cromwell's (1599–1658) troops and Elizabeth I (1533–1603), who were determined to eliminate all of England's stained glass. ✚ **PAGE 175** *BOTTOM LEFT*: Corner of the choir. ✚ **PAGE 175** *BOTTOM RIGHT*: The modern organ installed on top of the rood screen. ✚ **PAGE 176 AND 177**: The stairway to the chapter house (1306), the chapter house vault, and the central palm pillar.

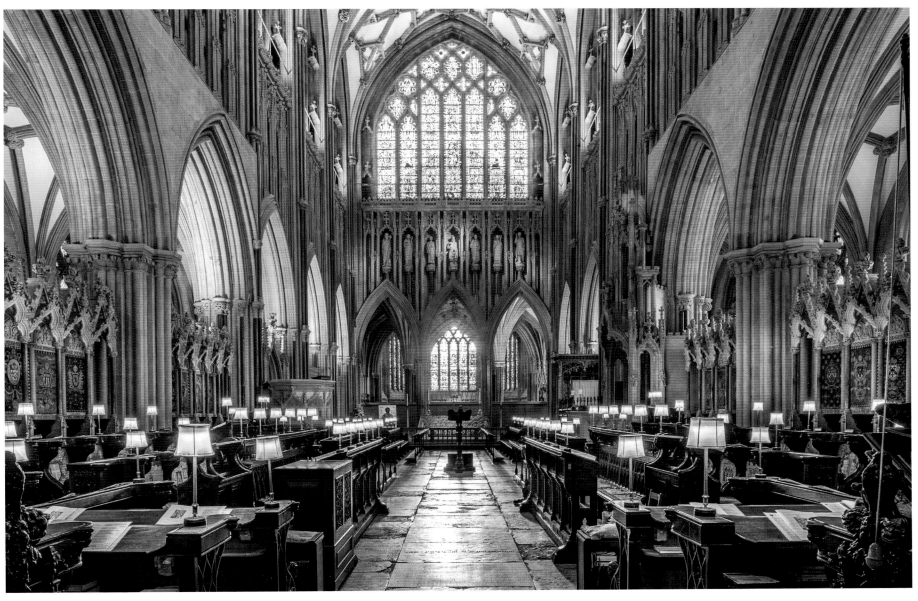

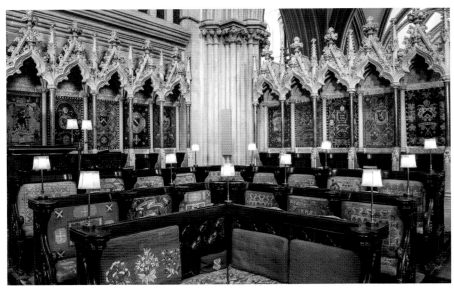

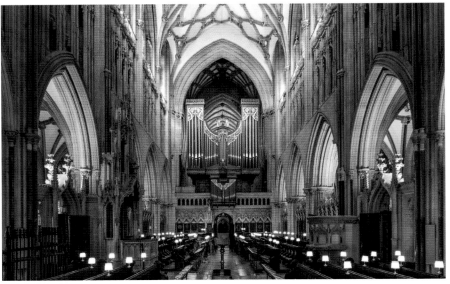

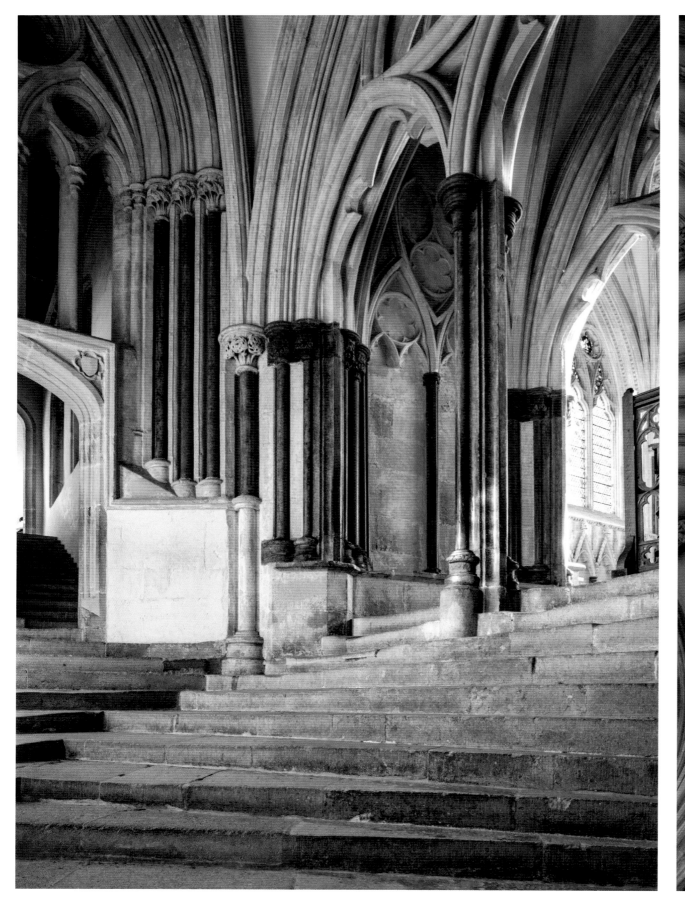
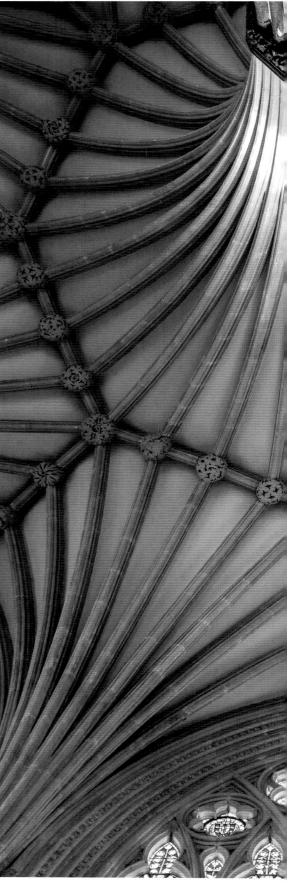

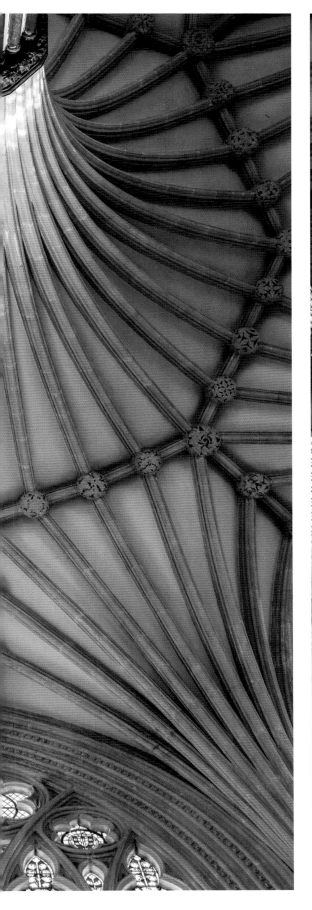
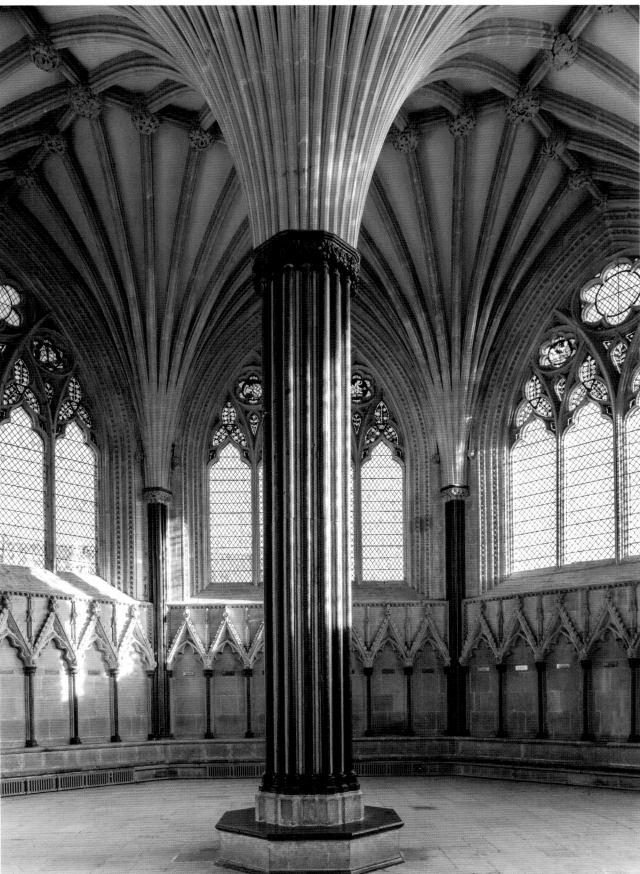

KING'S COLLEGE CHAPEL

CAMBRIDGE ▫ UNITED KINGDOM

The tourist arriving at King's College will see the chapel almost as it stood at the end of the fifteenth century. Occupying one side of a roughly square courtyard, this masterpiece of Perpendicular Gothic proudly exhibits the austere engineering of its facade. While its finest view is of the River Cam, the view from the other side of the courtyard better expresses the quasi-industrial unfurling of such infallible architecture. It is about the repetition of bays and buttresses but also the hypnotic rhythm of the sculpted decor and fan vaults inside.

The building has always been well maintained. Visitors can still experience its original vision: a vast, single nave as large as a cathedral, incredible light, the splendor of execution of hundreds of sculptures that tirelessly replicate the royal emblems of the rose, the crown, and the fleur-de-lys. In its purity, the king's chapel concentrates the almost physical pleasure of mathematics, geometry, and architecture, so similar to music. Hearing, for instance, Purcell's *Funeral Music for Queen Mary* sung there by the King's College Choir at night, when the stalls are illuminated by dozens of candles, is one of the most exhilarating experiences of high European culture.

The long nave is interrupted by an elegant, dark oak rood screen with powerful and unusual sculptures in the English Renaissance, perhaps even Mannerist, style. They were executed under Henry VIII (1491–1547) by a sculptor whose name and nationality are unknown. A slender gilded organ topped by two angels with gold trumpets lends unexpected dynamism.

Several architects worked on the construction of the building, which progressed at a brisk pace between 1446 and 1515; but history has especially remembered the name of John Wastell (1460–1518), the master mason from Bury,

PAGE 179: King's College Chapel stands along the River Cam. It was built between 1446 and 1515 by four successive kings of England. Two hundred and eighty-eight feet (88 m) long and eighty feet (24 m) high, it is a brilliant example of the Perpendicular Gothic style.

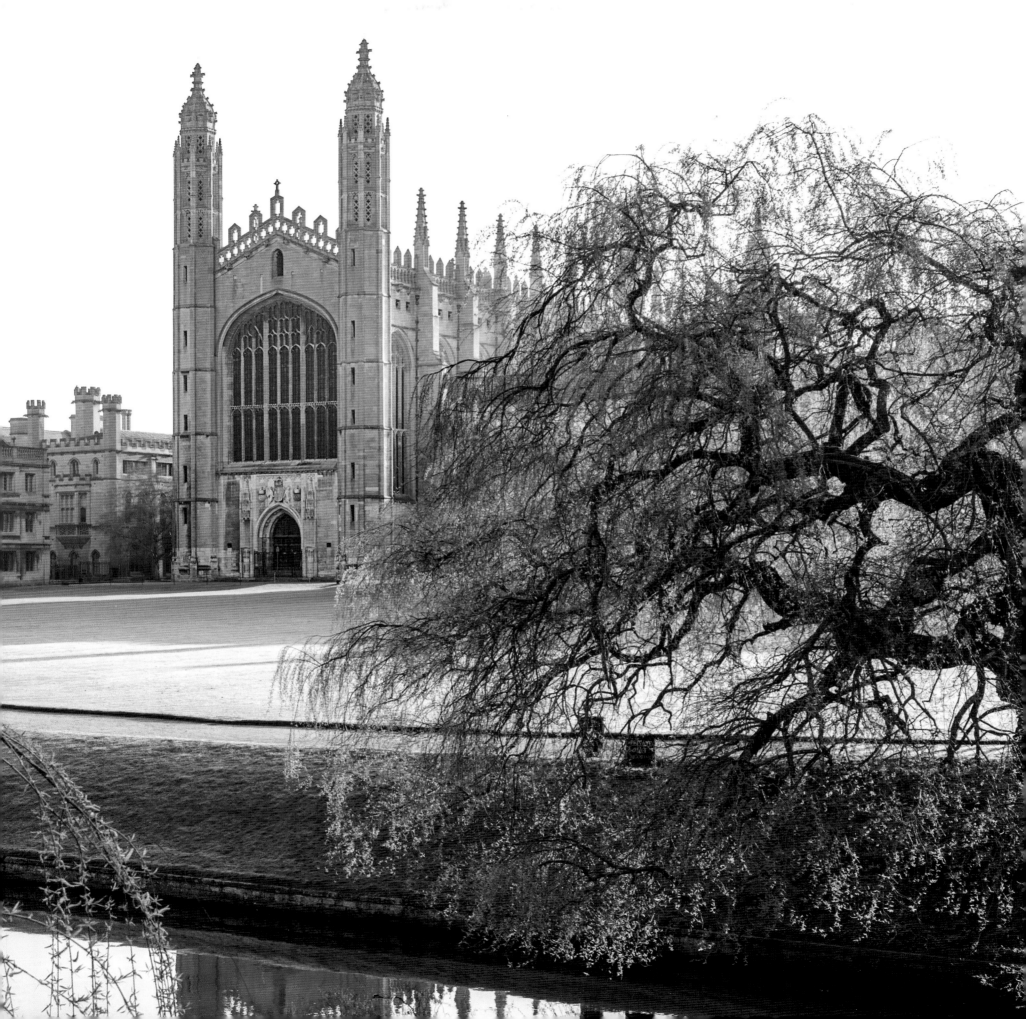

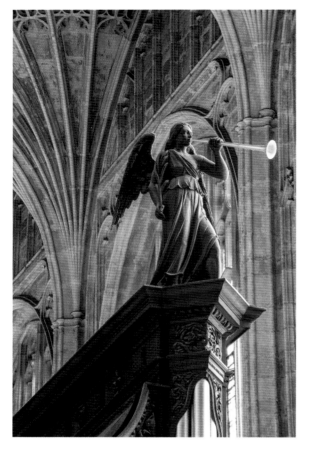

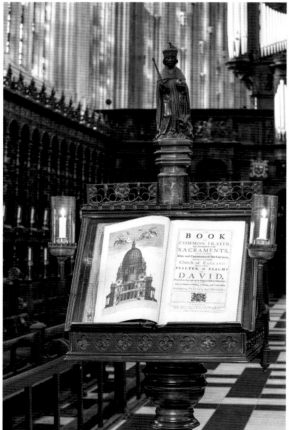

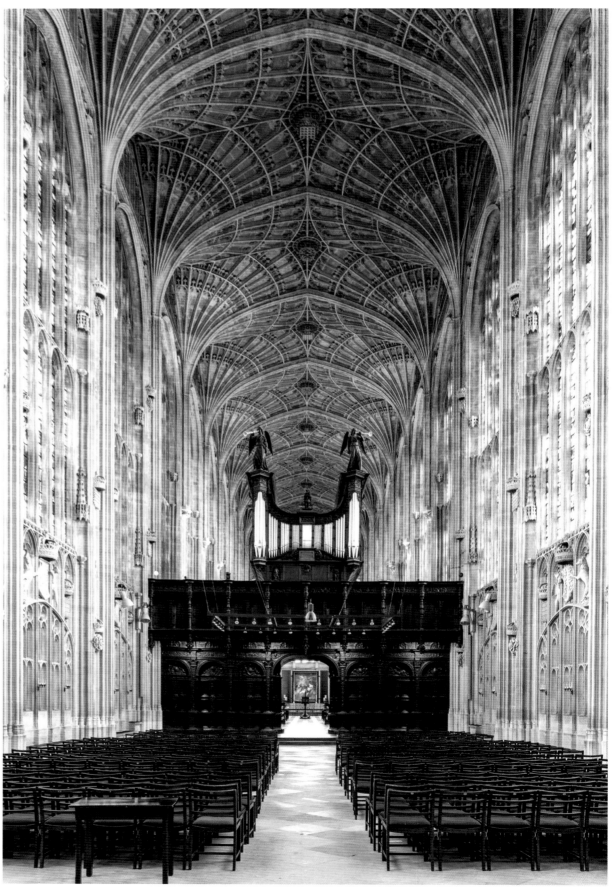

in Greater Manchester, who executed the astounding fan vaults. It is believed that those vaults, at least the first ones, were assembled on the floor, their stone carefully carved, and then erected in place over the walls. The calculations made at the time, including the ones for such thin vaults, remain a mystery. In certain areas, some of the ribs are no more than four inches thick. The repetition, an economical solution, and the Perpendicular style itself, can be explained in part by the kingdom's serious financial difficulties at the time, which, despite generous royal patronage, were a burden to many religious building projects.

At the beginning of the seventeenth century, the chapel served as a cathedral, in part because it was the only college church where women were allowed. Prominent visitors from abroad were quick to come—Cosimo de' Medici III (1642–1723) arrived in 1669—and climbed to the roof to admire the panorama from the highest point in the city; one could even see the towers of Ely Cathedral. Very early on, concerts of sacred music were performed, as were plays, including several for Elizabeth I (1533–1603) in 1564. The musical program has always been highly developed; one pious student in 1923 lamented that he was often under the impression of attending a concert rather than a mass. The Choir of King's College remains one of the best choral groups in the United Kingdom.

The tiny side chapels—they're almost small sitting rooms—have more secular functions; one, for example, is a museum of the building's history. In 1968 a large painting by Peter Paul Rubens (1577–1640), *Adoration of the Magi*, was installed above the altar; the floor was lowered to accommodate it. The controversy over the choice of this papist work for a high place of Anglican faith remains heated—what's more, the painting was executed after the building was constructed in a style that clashes with the choir's superb stained glass windows that date from the sixteenth century.

PAGE 180 *TOP LEFT*: Musician angel at the top of the rood screen organ case. ✙ PAGE 180 *BOTTOM LEFT*: The *Book of Common Prayer*, the foundational text of the Anglican religion, on a lectern decorated with a statue of Henry VI (1421–1471). ✙ PAGE 180 *RIGHT*: The nave and rood screen, a gift of Henry VIII (1491–1547). The extraordinary fan vaults above were executed between 1512 and 1515 and were based on plans by the architect John Wastell (1460–1518). ✙ PAGE 182: One of the many large stained glass windows. They were made primarily by Flemish craftsmen and were installed between 1515 and 1531. ✙ PAGE 183 *TOP*: The dark oak choir culminating in the altar. The altarpiece is Peter Paul Rubens's *Adoration of the Magi* (1634). The large stained glass window depicts Christ on the cross. ✙ PAGE 183 *BOTTOM LEFT*: Detail of the choir's wrought iron gate. ✙ PAGE 183 *BOTTOM RIGHT*: Corner of the choir with oak sculpture and dark patina, a mix of the Gothic and Renaissance styles.

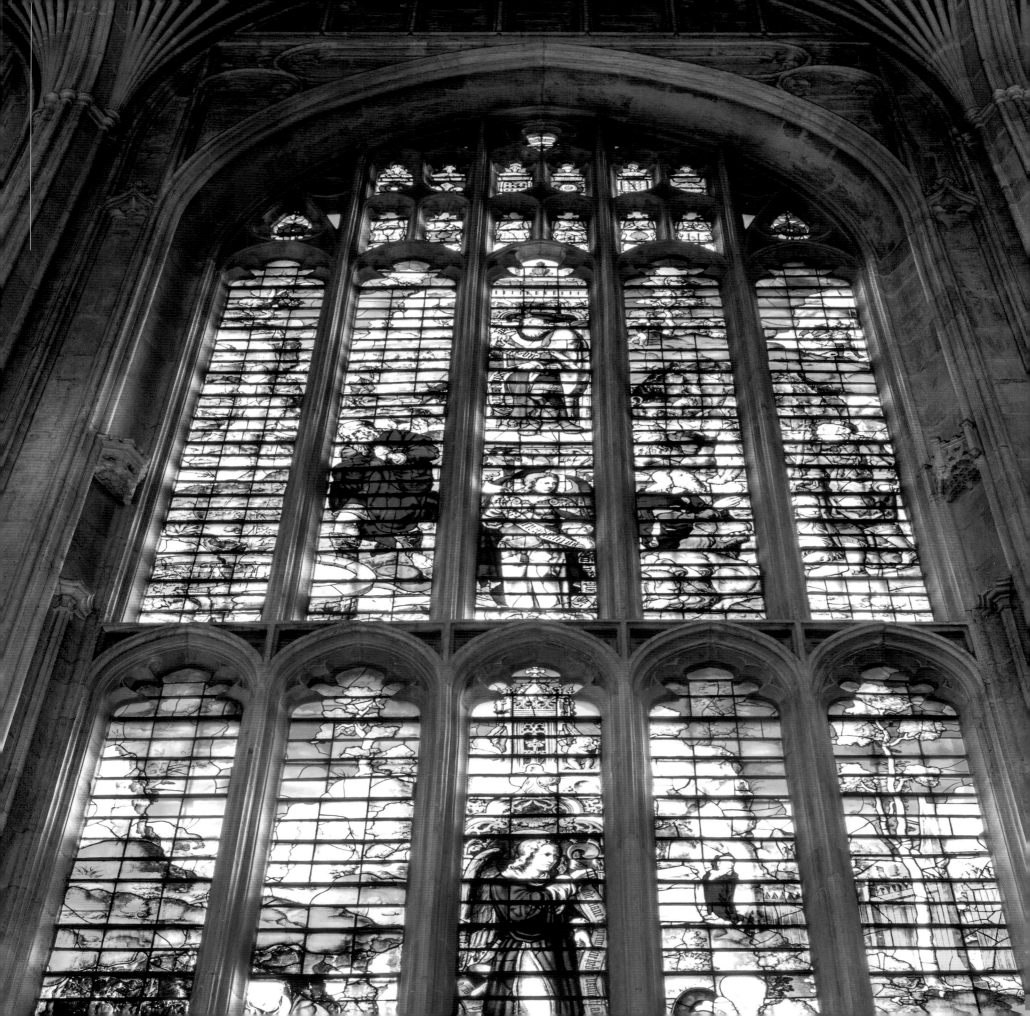

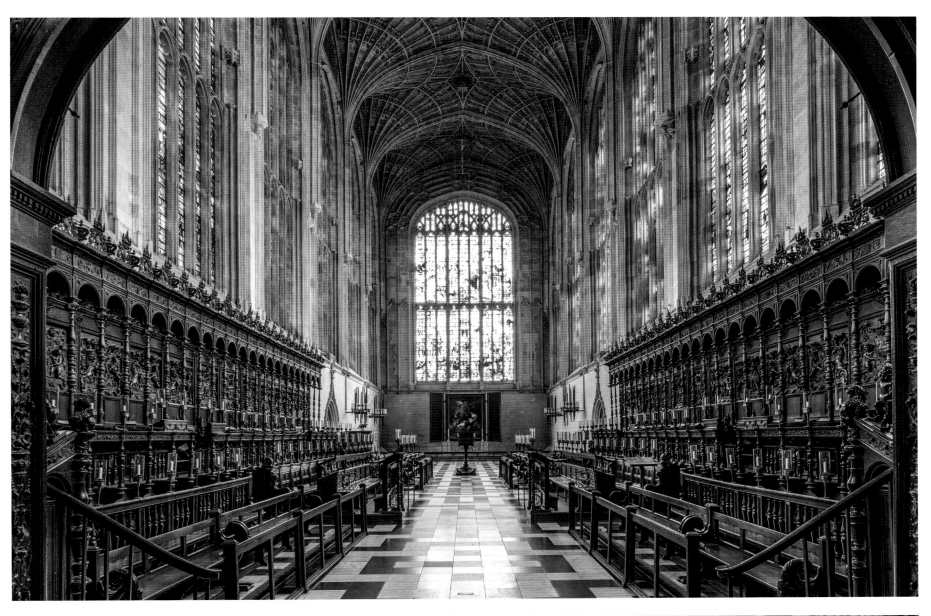

ST. PAUL'S CATHEDRAL

LONDON ▫ UNITED KINGDOM

Sir Christopher Wren (1632–1723) was outlining the transept on the grounds of a future cathedral when he was brought a piece of a tombstone to mark its center. He turned it over and discovered part of an inscription: *Resurgam* (I shall rise again). Twenty years later, for the pediment of the transept's southern wing, the architect included a sculpted phoenix perched on a cartouche on which is engraved: *Resurgam*.

That simple word encapsulated the already long history of St. Paul's Cathedral. A church was built at the site as early as 604; it was followed by two others and then by a Norman Gothic cathedral that was gutted during the Great Fire of London, in 1666. That catastrophe, which ravaged the city, gave Wren the opportunity to become the king's architect. A young man of talent, he was a brilliant student at Oxford, where he took an interest in astronomy; he even became a professor in the subject at age twenty-five. A true scholar, he taught, wrote, experimented, and drew the attention of the court. At the time, just as in the Middle Ages, builders and master masons served as architects, and architecture, strictly speaking, was still a matter of mathematics. Wren was consulted to resolve a few structural problems posed by large royal building plans and, because he was an excellent draftsman, he was put in charge of projects at Oxford. After the Great Fire, the king entrusted him with rebuilding several churches. He ultimately built fifty-one over forty years.

The former cathedral had been severely damaged in the fire. At first there was an attempt to rebuild it, but eventually the decision was made to erect a new building, one that expressed the now established power of the Anglican Church. St. Paul's Cathedral was was thought of as a challenge to St. Peter's Basilica in Rome, even as its northern equivalent.

PAGE 185: The chapel dedicated to the order of St. Michael and St. George honors British service overseas. There is a plaque and coat of arms for each saint.

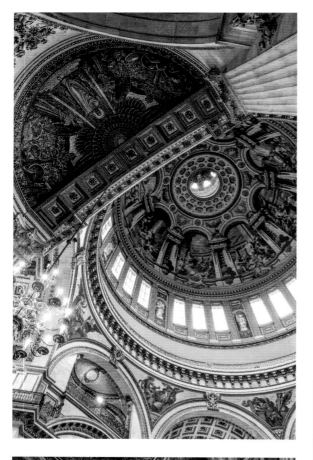

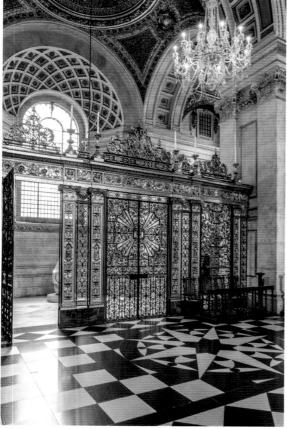

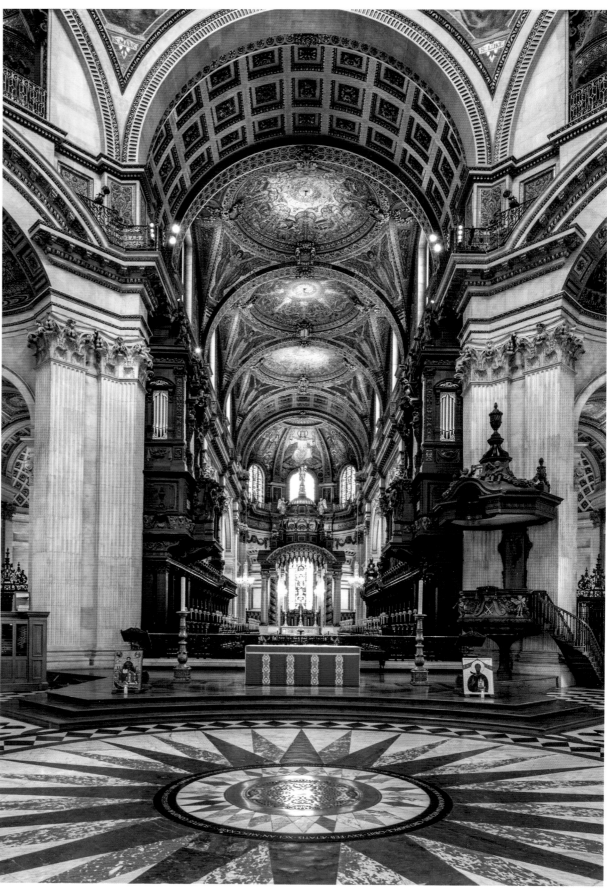

Construction lasted more than thirty-five years and cost an astonishing sum, totaling approximately 184 million dollars in today's money. Despite the enormous expenditures involved in rebuilding, the necessary funding was raised, even if it meant imposing financial hardship on the community in the form of coal import taxes.

Wren proposed several plans and models, including his favorite solution, a cathedral in the shape of a Greek cross with concave walls, which was not met favorably. The royals decided on a plan that was still relatively vague, and that included a provision giving the architect permission to modify the project as he wished; and he did, both because of personal taste and funding, timing, foundation, and material problems.

Construction began in 1675, even though the perilous demolition of the former cathedral was still in progress. The first mass was celebrated on December 2, 1697. A Te Deum was sung in honor of the signing of the Treaty of Ryswick, which marked victory over Louis XIV; it was held in the new cathedral where only the choir was mostly finished and covered. Ten more years would be needed to complete the nave and roofs, and ten more after that to complete the interior decor.

Today, St. Paul's is no longer as prominent in London's urban landscape, which has been entirely overhauled over the past twenty years. Rather low buildings once surrounded the vast square, but that is no longer the case. Although German bombing spared the cathedral, the neighborhood around it was annihilated, and has subsequently been rebuilt. The area's most recent project is a huge shopping center designed by Jean Nouvel (b. 1945); its dark mass seems as if it could swallow up everything around it.

The term "architectural object" must therefore be brought into the conversation here. In the implacable perfection of its volumes and details, the cathedral might almost make one think of an enormous model. It's not so much a gesture as it is a perfect geometric composition, frozen, almost platonic. Disliked, it doesn't speak to the senses; Queen Victoria herself stated that she found it "cold and boring."

The interior seems to be another story though, as is often the case with Baroque architecture. Inside the immense volume, some 490 feet (150 m) long and 118 feet (36 m) wide, bathed in warm light as Wren hoped it would be, one can still experience a kind of religious emotion, even if the building has become somewhat of a museum. As one of the first London tour guides would say in 1755, there emanates from the building a powerful "feeling of dignity" and of elegance. The enormous nave, interrupted by the majestic transept and surmounted by the large

PAGE 186 *TOP LEFT*: The transept cupola, Christopher Wren's (1632–1723) technical masterpiece, rivals Rome's. It is decorated with a fresco by James Thornhill (1675–1734) depicting the life of St. Paul (1720). ‡ PAGE 186 *BOTTOM LEFT*: High altar grille by the Huguenot ironworker Jean Tijou (c. 1650–c. 1712). ‡ PAGE 186 *RIGHT*: The choir, the first phase of the construction project, was completed in 1697. The cupola mosaics date from the end of the nineteenth century. At that time, the rood screen was removed.

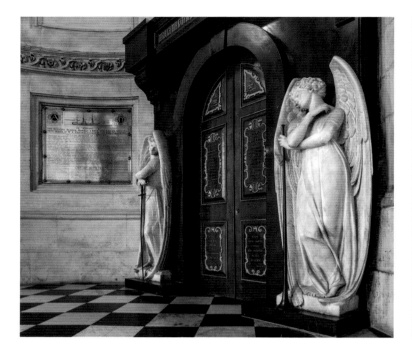

dome, is extended by a choir that is almost as long; until the nineteenth century, it was kept separate by a sculpted wooden rood screen topped by a monumental organ. There are no paintings or sculptures here as this is a Protestant church, but there are frescoes depicting St. Paul's life on the inside of the dome and later mosaics in the choir.

The dome, with its spire rising to 495 feet (151 m), is a tour de force. It is made up of three stacked cupolas. The first, almost a hemisphere, is made of brick. It is surmounted by a second one in the shape of a ninety-five-foot-tall (29 m) cone, which holds the skylight, covered by a third wooden cupola clad with lead. The extraordinary structure has survived time, sinking ground, and the shock of bombs. It stands on strong pillars that form the four main barrel vaults that define the transept and the four oblique arches that direct perspectives and effects of light.

Many of England's most notable figures are interred at Westminster, but St. Paul's enormous crypt has housed several official tombs since the beginning of the nineteenth century, including the Duke of Wellington's (1769–1852) and Admiral Nelson's (1758–1805). In the cathedral itself, above Wren's tomb, there is a modest plaque with an inscription that ends with *Lector, si monumentum requiris, circumspice*: "Reader, if you seek his [Wren's] monument, look around you."

PAGE 188 *LEFT AND RIGHT*: The tomb of William Lamb (1779–1848), the prime minister, and his brother, a diplomat. ✚ PAGE 189 *TOP*: The choir and the high altar. ✚ PAGE 189 *BOTTOM LEFT*: Commemorative statue to John Howard (1726–1790), the philanthropist, by the Neoclassical sculptor John Bacon the Elder (1740–1799). ✚ PAGE 189 *BOTTOM RIGHT*: Sarcophagus of Admiral Nelson (1758–1805).

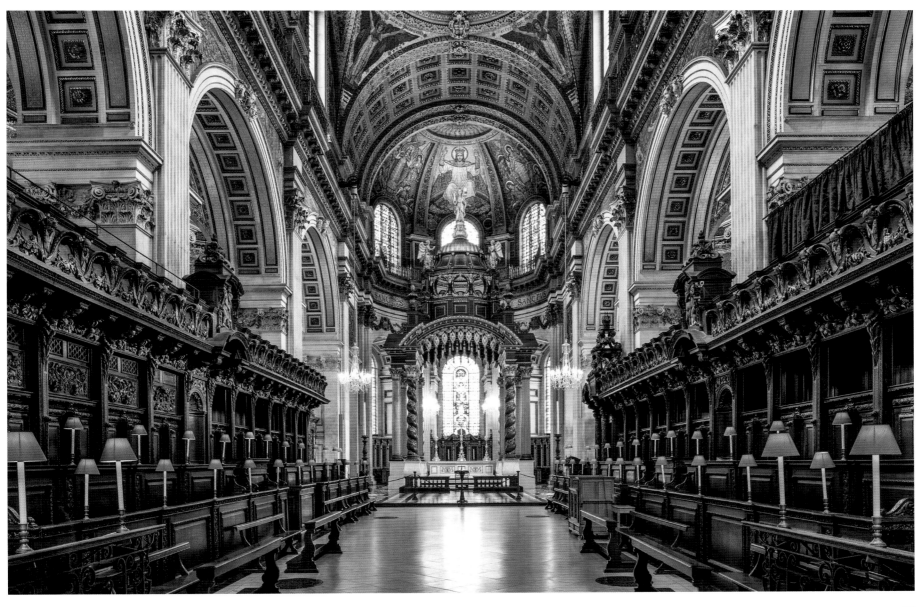

ST. MICHAEL THE ARCHANGEL CHURCH

BINAROWA ▫ POLAND

In the idyllic (summertime) countryside of southern Lesser Poland, the Church of St. Michael the Archangel stands on a hillside, almost hidden by large trees.

Located in Binarowa, near Tarnów, the church was built around 1500, which is very old for this border region, as it has been ravaged by so much war over the centuries. Although wooden, it seems to have escaped fire, flood, and the material's slow and natural deterioration. In fact, from the end of the sixteenth century to our day, it has undergone multiple restorations and was completely restored in the 1990s, when an ugly tin roof was replaced with wooden shingles, which are more faithful to the original. It was also given back its *soboty*, which had been destroyed at some point. A soboty is a porch typical of local churches under which pilgrims took shelter, and where they slept when they visited for major ceremonies. The tower and entrance, built to expand the church, date from 1596. In 1602, a separate brick and stone bell tower was built next to the church to stabilize the structure.

This small country church and five others are stops along the tourist Wooden Architecture Trail and represent, despite their modesty, one of the defenses put forward by Catholicism against Lutheranism and the push toward orthodoxy in the frontier region. Generally sponsored by noble families seeking to manifest their faith and prestige, they also marked their territory during a period of brutal religious wars.

The outside of the church is remarkable for its austerity and the rustic simplicity of its architecture. The

PAGE 191: The small Church of St. Michael the Archangel (founded c. 1500, but under seemingly perpetual restoration) is one of the six wooden churches in Southern Lesser Poland. It appears on UNESCO's World Heritage List as part of the Malopolska Region's Wooden Architecture Trail.

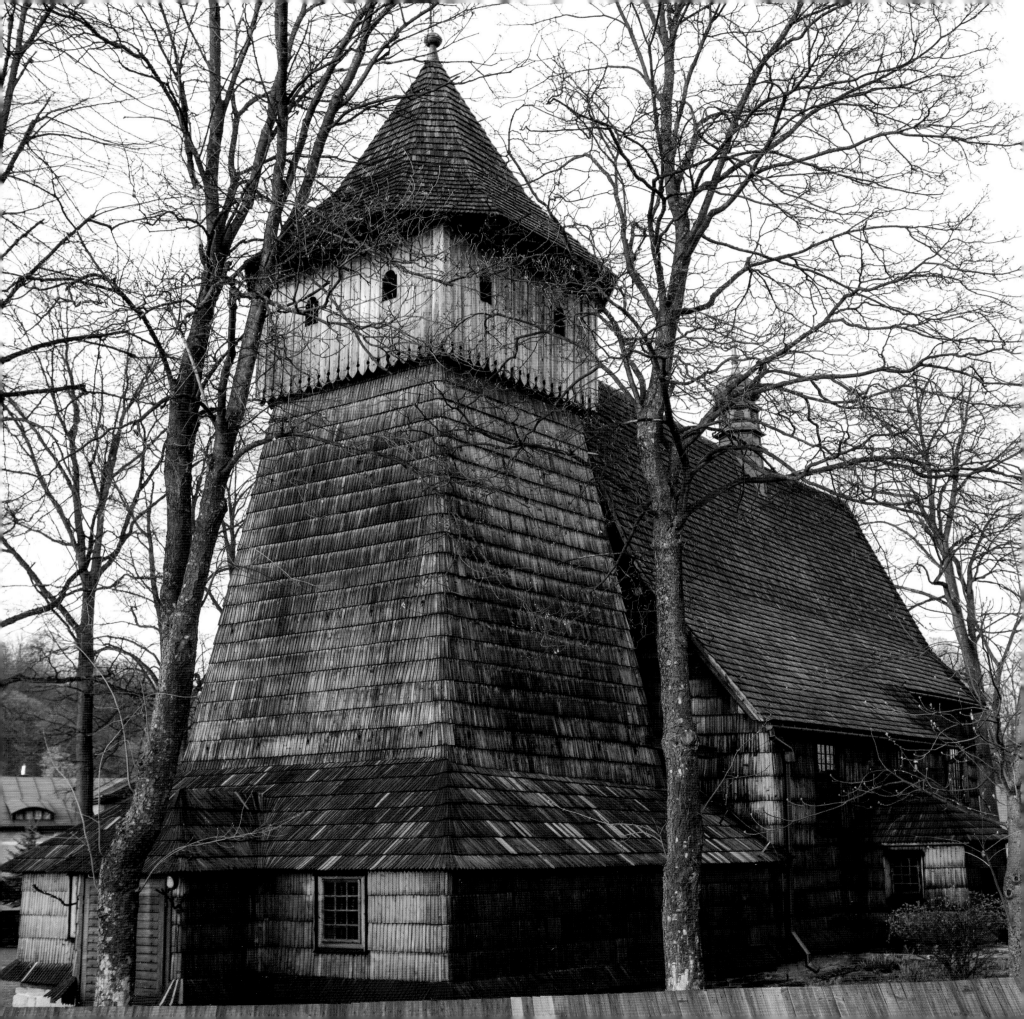

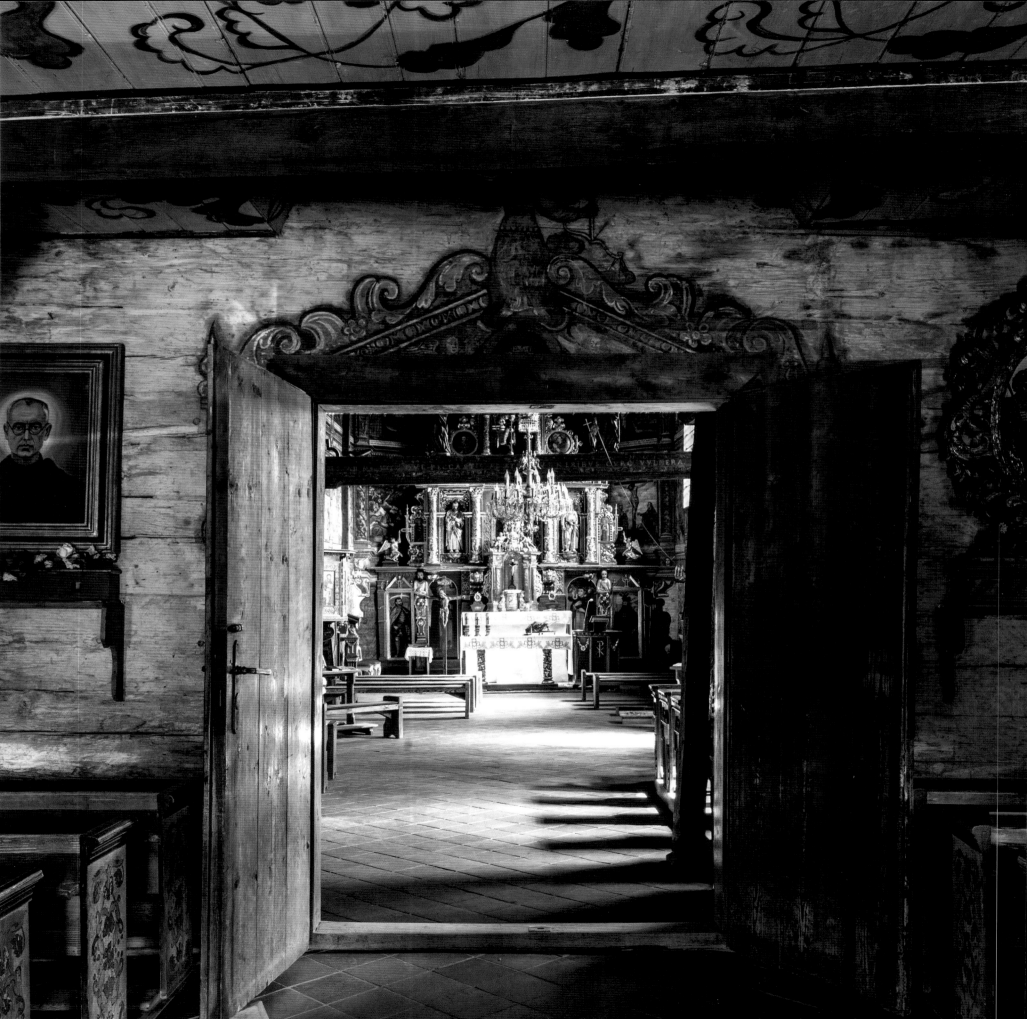

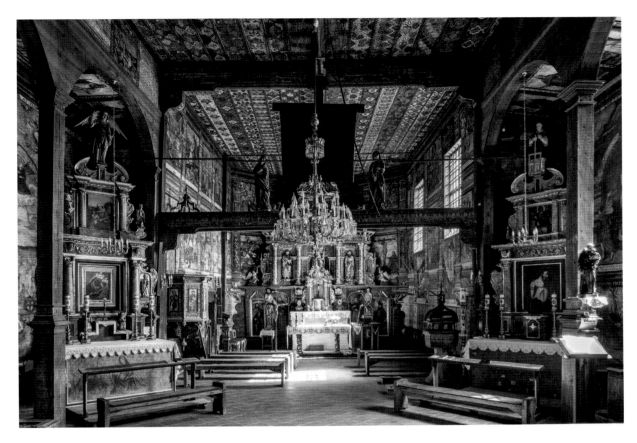

interior is a striking contrast, a true gallery of Polish religious art from the fifteenth and sixteenth centuries. The painted decoration on the ceiling depicting biblical scenes dates for the most part from after construction, and on the walls, from 1650 and after. The altars are from the seventeenth century and certain sculptures are still Gothic in style. For example, a *Madonna and Child* is undoubtedly from the former church. The painted mural panels, some in grisaille, (oil painting in monochromatic shades of gray) are detailed, figurative paintings that merit extensive study. The altars, pulpits, and sculptures are decorated with natural, slightly faded hues; their rich original palette has survived and is accentuated by the omnipresence of silver and gold. The effect is breathtaking, luxurious, and

intimate and is suggestive of both prayer and celebration. Today, pushing open the wooden door of this small country church still means entering another world.

PAGE 192: The inside of the church with divided nave. ‡ PAGE 193: The vast choir with two Baroque lateral altars and rood beam. ‡ PAGE 194 *LEFT*: The pulpit, with staircase decorated with *Jacob's Ladder*, and one of the twenty-one panels, part grisaille, depicting the Passion of Christ (mid-sixteenth century). ‡ PAGE 194 *TOP RIGHT*: Small statue of St. Vincent (c. 1650). ‡ PAGE 194 *BOTTOM RIGHT*: A fresco on wood, *Learning to Die Well*. ‡ PAGE 195 *TOP*: The polychrome ceiling motifs are drawn from embroidery. ‡ PAGE 195 *BOTTOM*: View from the choir. The *matroneum* (gallery), which was transformed into the tribune when it was rebuilt around 1650, and the old organ.

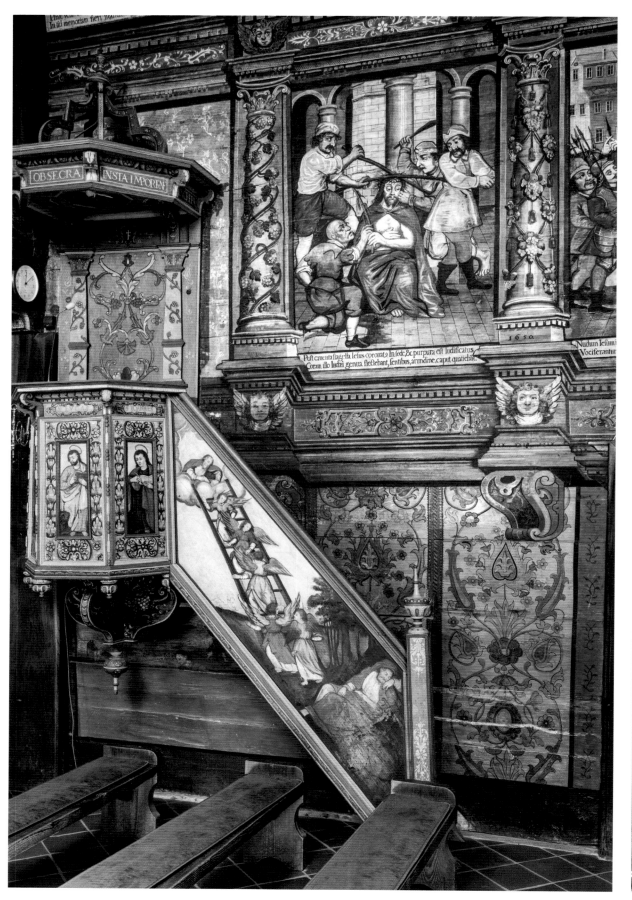

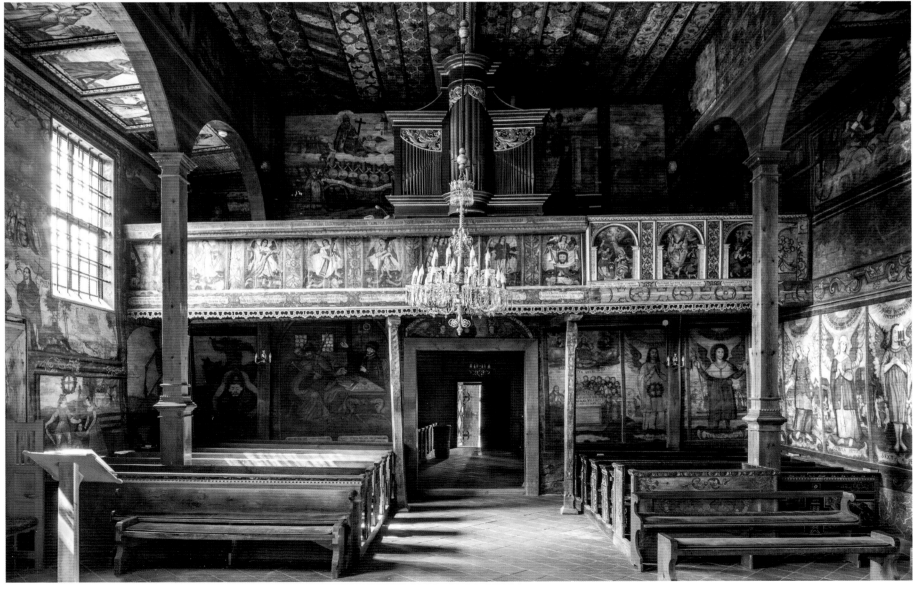

CHURCHES OF PEACE

JAWOR AND ŚWIDNICA ▫ POLAND

It is unusual for churches to so deserve their names. These two "churches of peace," located in Jawor and Świdnica, at the foot of the Sudetes in southern Poland, were built after the Peace of Westphalia treaties were signed in 1648, marking the end of the Thirty Years' War. That abominable war of religion had bloodied and devastated a large part of the Germanic Holy Roman Empire. Realizing that a gesture of tolerance could consolidate his power, Ferdinand III of Habsburg (1608–1657) agreed to allow three Lutheran churches to be built on his Silesian territory, which is today Poland. His conditions were nevertheless very strict: They had to be wooden structures outside city walls, they were to have no nails, steeple, or bell, and their construction was to last no more than a year. His restrictions were an incredible challenge for the architect appointed by the local Protestant communities, Albrecht von Saebisch (1610–1688).

This forgotten architect is one of the great engineers in the history of architecture, alongside figures like Joseph Paxton (1803–1865), Auguste Perret (1874–1954), and Santiago Calatrava (b. 1951). To build, in one year, a Hallenkirche with a complex and stable wooden structure, using loam and straw, and especially one that could accommodate six thousand (Jawor) or seventy-five hundred (Świdnica) congregants was a practically impossible feat at the time. That capacity is still considered enormous today considering that Notre-Dame Cathedral, in Paris, for example, holds nine thousand congregants. Not only was the goal accomplished, but both churches have survived the onslaught of time. Parts of the framework have sometimes needed to be replaced and the roof was renovated, but this

PAGE 197: The church of peace in Świdnica, built in one year (1656–1657) by Albrecht von Saebisch (1610–1688). It could welcome up to seven thousand congregants. ✠ PAGES 198 AND 199: The inside of the church. The altar (depicting the baptism of Jesus) and the pulpit, which dates from 1752, are by August Gottfried Hoffmann.

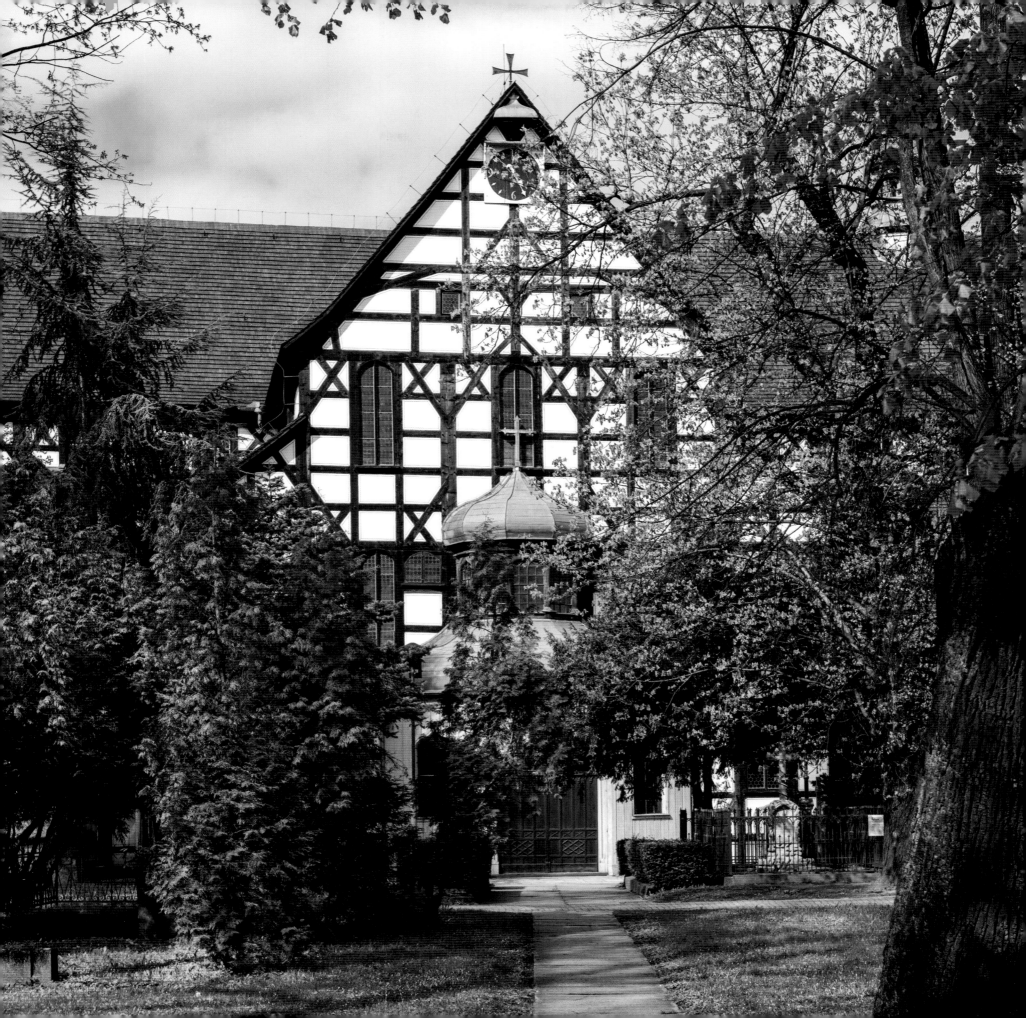

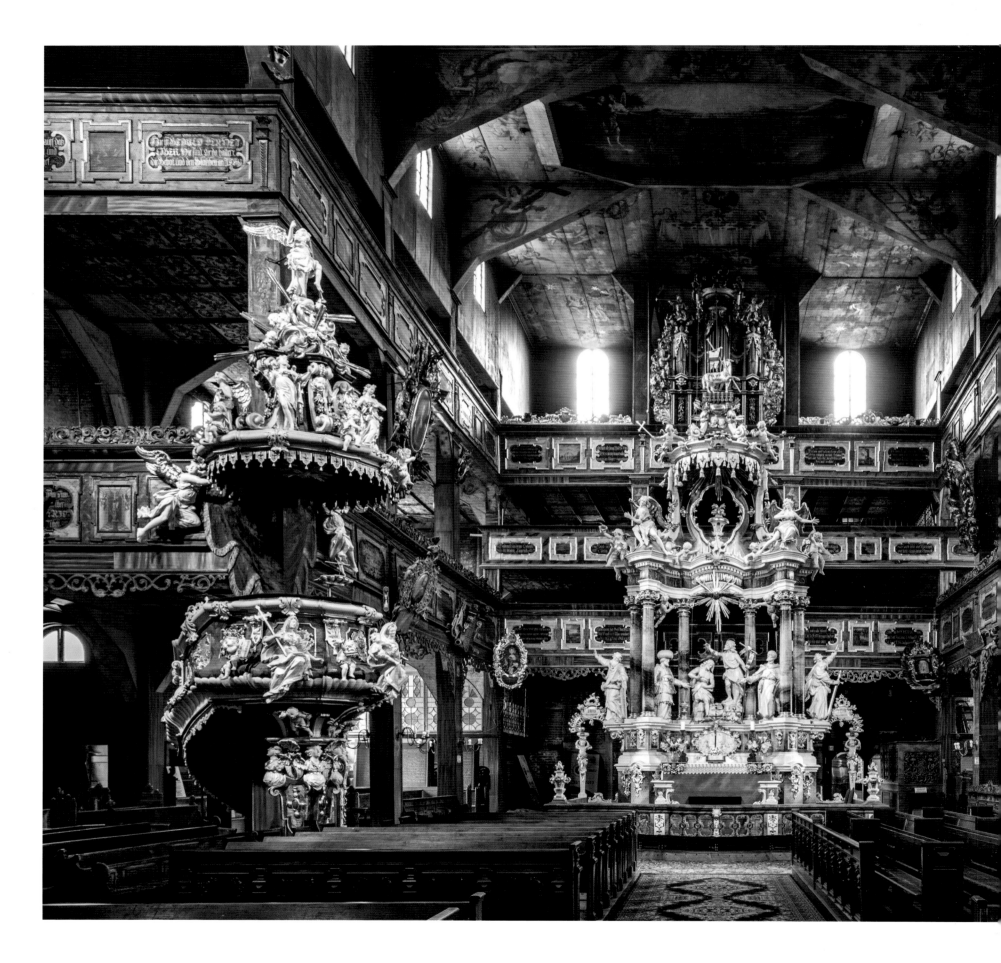

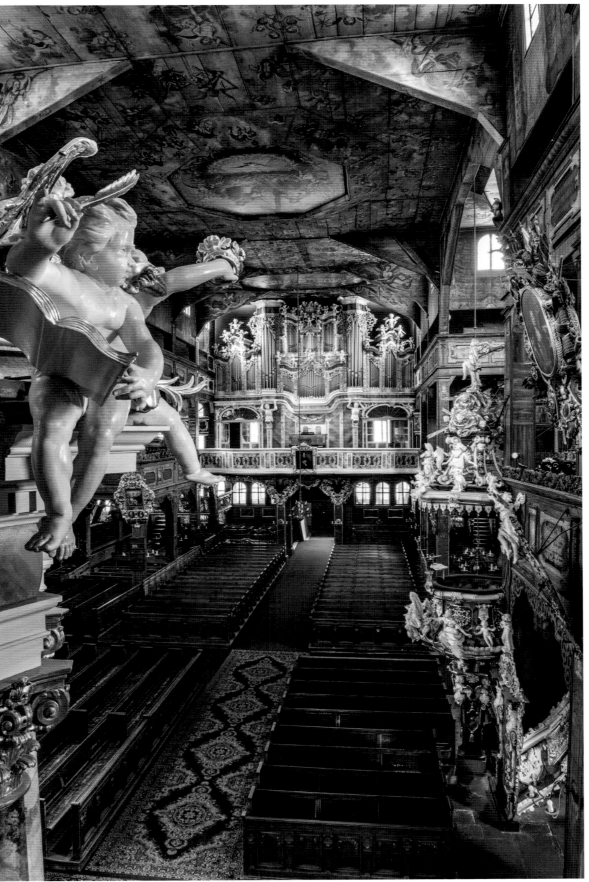

but this is normal for this type of structure. The Jawor church was built in 1654–1655, and the Świdnica church in 1656–1657. A third, in Glogów, was built in 1652, but did not survive past the eighteenth century.

The exteriors are relatively discrete, as obligated by imperial order, but the interiors are dazzling. Oddly enough for that period, which followed the triumph of the Counter-Reformation, Silesian Protestants chose to vie with the wealth of Catholic churches. A far cry from the austerity of churches in northern Europe, these two churches are distinguished by the inventiveness, profusion, and beauty of their decor. During the eighteenth century, noble families and guilds even had private boxes built for their use—like at the theater—within the galleries they sponsored. The four stories of galleries that surround the nave on three sides further the comparison with a theater. The painted decor dates for the most part from the end of the seventeenth century and from the beginning of the eighteenth century; the altars came later. In Jawor, there are no less than 143 fine paintings depicting biblical scenes with ribbons of elegant inscriptions. The names of some of the artists are known, for example, Georg Flegel (1566–1638) and Christian Süssenbach, for whom the Swiss-born German engraver Matthäus Merian (1593–1650), famous at the time, was a source of inspiration.

These wooden structures are the only ones of their kind to have survived until our time. Added to UNESCO's World Heritage List in 2001, the two churches continue to hold religious services. The Protestant community that built these churches for thousands of congregants has today been reduced to a few hundred. But their houses of worship continue to attest to the glory of their past.

PAGE 200 TOP LEFT: In Świdnica, a statue of St. Paul, a gift for the church's bicentennial. ✠ PAGE 200 BOTTOM LEFT: One of the loges reserved for noble families. ✠ PAGE 200 RIGHT: Świdnica's organ and tribunes. ✠ PAGE 202: Jawor church interior, hall of the Holy Ghost (1654–1655) also by Albrecht von Saebisch. Not one nail was used to build the structure, which is made entirely of wood. The altar and pulpit of this church were built later. ✠ PAGE 203 TOP FROM LEFT TO RIGHT: Macabre detail of Jawor's funerary monument, lateral entrance to the Świdnica church, and detail of the staircase of Jawor's pulpit. ✠ PAGE 203 BOTTOM FROM LEFT TO RIGHT: In Jawor, the tribune's painted panels depicting biblical themes, one Moses, and baptismal fonts.

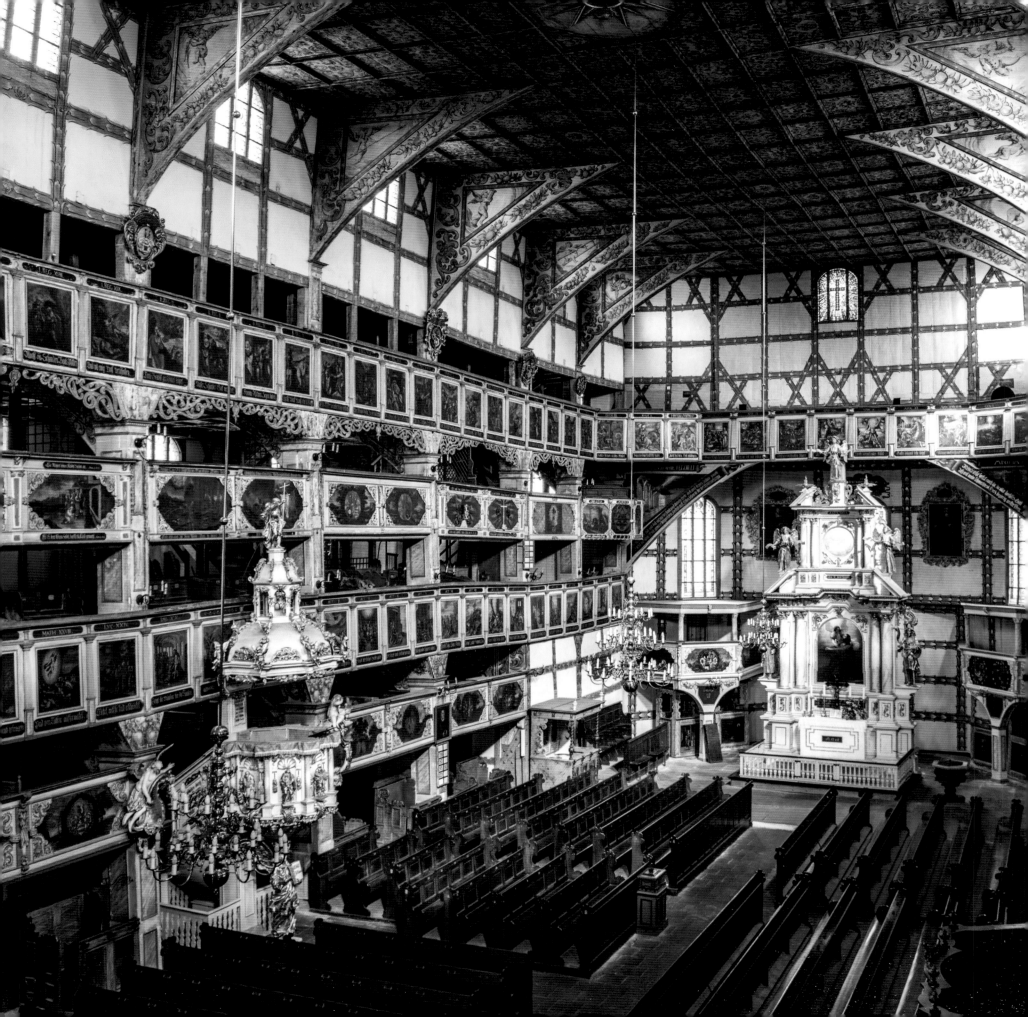

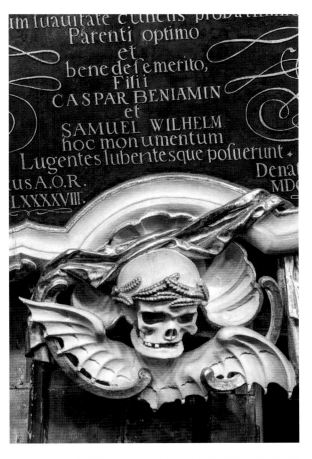

CHURCHES OF
MOLDAVIA

ARBORE, MOLDOVITA, AND SUCEVITA ▫ ROMANIA

Now divided between Romania, the Republic of Moldova, and Ukraine, Moldavia is one of those eastern regions that has been cruelly tossed about by history. It was controlled by Rome, then by local feudal princes, then by the Ottomans, and then Poland, Austria, and Russia. A unified rural community with deep traditions, for a long time it was protected, but also isolated, by mountains. It is therefore not surprising that it developed a particular architectural style for its churches.

Eight churches built during the fifteenth and sixteenth centuries, classified as World Heritage sites by UNESCO as early as 1993, are stirring manifestations of the vitality of the Orthodox faith in the face of threats from feudal Catholics, Protestants, and Muslim Turks. Small in scale, the structures can be found in rustic settings, often outside villages; Sucevita was built as part of a small, fortified monastery.

Their architecture is similar in style. There are Romanesque and Gothic forms adapted to the Orthodox religion, with clear Byzantine influences in the decor. Generally, the plan consists of an almost square pronaos (vestibule), reserved for catechumens and women, a naos, which, strictly speaking, is the nave, and a trefoil apse, meaning it is composed of three rounded elements. Sometimes, one also finds an exonarthex for the tombs of founders and patrons. The limited space is divided by a series of walls or partitions that create a feeling of seclusion, typical in Orthodox churches.

These sanctuaries, built with stone and bound with mortar, are distinguished by small bell towers and elegant

PAGE 205: Passage between the first and second room at the Arbore monastery church. Its interior plan, typical of the region, is clearly divided in two. The frescoes, which are of Byzantine influence, were executed around 1541 under the direction of Dragos Coman.

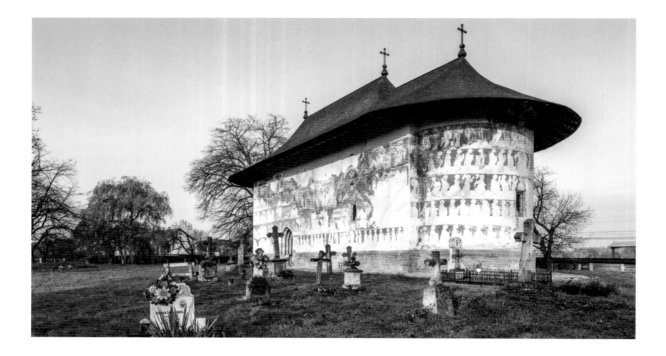

roofs, with large eaves to protect the painted outside walls and also to shelter pilgrims. In addition to their originality and formal charm, they are extremely interesting for their frescoes inside and out. In winter, when the sun shines on the snow, they look like shrines in the celestial city, with light emanating from within though walls that are sometimes three feet (1 m) thick. The outside frescoes are rooted in age-old eastern traditions, such as those on the Sumela Monastery from the ancient Empire of Trebizond (present-day Turkey), but they also stem from local traditions; the same kind of decor can be found on the facades of wealthy homes in Transylvania from the same period.

The paintings draw for the most part on fresco techniques, becoming part of the wall. Lime is used in great quantity, lending a mineral shine to certain colors, and so are pigments such as iron oxide, mercury sulfide, minium,

and especially lapis lazuli, which is the source of the magnificent blue in Voroneț, another Moldavian church. The vast amounts of lapis lazuli used is particularly amazing considering how expensive it was to obtain; even wealthy Florentines at that time used the pigment sparingly. In all likelihood, there were more affordable sources for obtaining it in the region.

The iconography is similar in all these churches. The great themes of the Orthodox faith are depicted,

PAGE 206: The Arbore monastery church, completed in 1503. The outdoor frescoes, including the famous *Last Judgment*, are by the painter Dragos Coman. ‡ PAGE 207 *TOP*: Ceiling fresco depicting Christ Pantocrator. ‡ PAGE 207 *BOTTOM*: Second room. The top fresco illustrates festivities in Constantinople. The family of boyars that built the church wanted to be associated with the former imperial power.

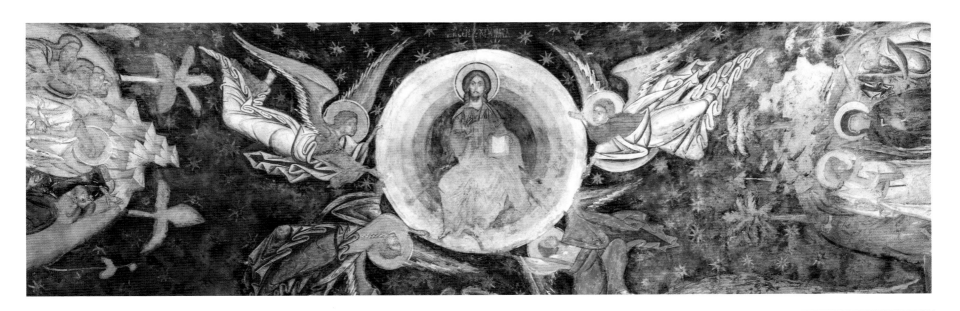

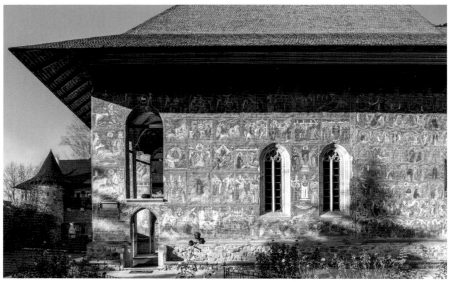

such as the triumph of Christ Pantocrator (represented in the narthex cupola), the Last Judgment, and the Resurrection; but inside, there are also portraits of founders and patrons. While the same themes are found in Arbore (1503), Moldovita (1532), and Sucevita (1582–1601), each site is original and spectacular. Consider, for example, the splendid *Ladder of the Divine Ascent* in Sucevita, with its blue background and thirty rungs corresponding to the virtues and practices required to reach heaven. The fathers of the Orthodox Church are always represented, usually toward the entrance, but one also finds secular scenes like the Ottomans seizing Constantinople. The artists are sometimes known—Toma of Suceava, Grigorie Rosca (d. 1570), and Dragos Coman (Arbore) and

PAGE 208 *TOP LEFT*: The Moldovita Monastery, built in 1532 by the vaivode Petru Rareş (c. 1483–1546). ‡ PAGE 208 *TOP RIGHT*: The twin Gothic windows on the facade show a Germanic influence. ‡ PAGE 208 *BOTTOM LEFT*: Fresco depicting the siege of Constantinople by the Ottomans. ‡ PAGE 208 *BOTTOM RIGHT*: Detail of facade frescoes, characterized by a luminous blue-green background. ‡ PAGE 209 *LEFT*: Interior frescoes by the painter Toma of Suceava (1537) depicting the fathers of the church, saints, and philosophers from antiquity. ‡ PAGE 209 *RIGHT*: Detail of the Moldovita altar: Christ Pantocrator presenting the New Testament on a throne adorned with the lion and the ox, symbols of St. Mark and St. Luke. ‡ PAGES 210 AND 211: At the back, the Moldovita iconostasis, the richly decorated screen, separating the nave from the sanctuary.

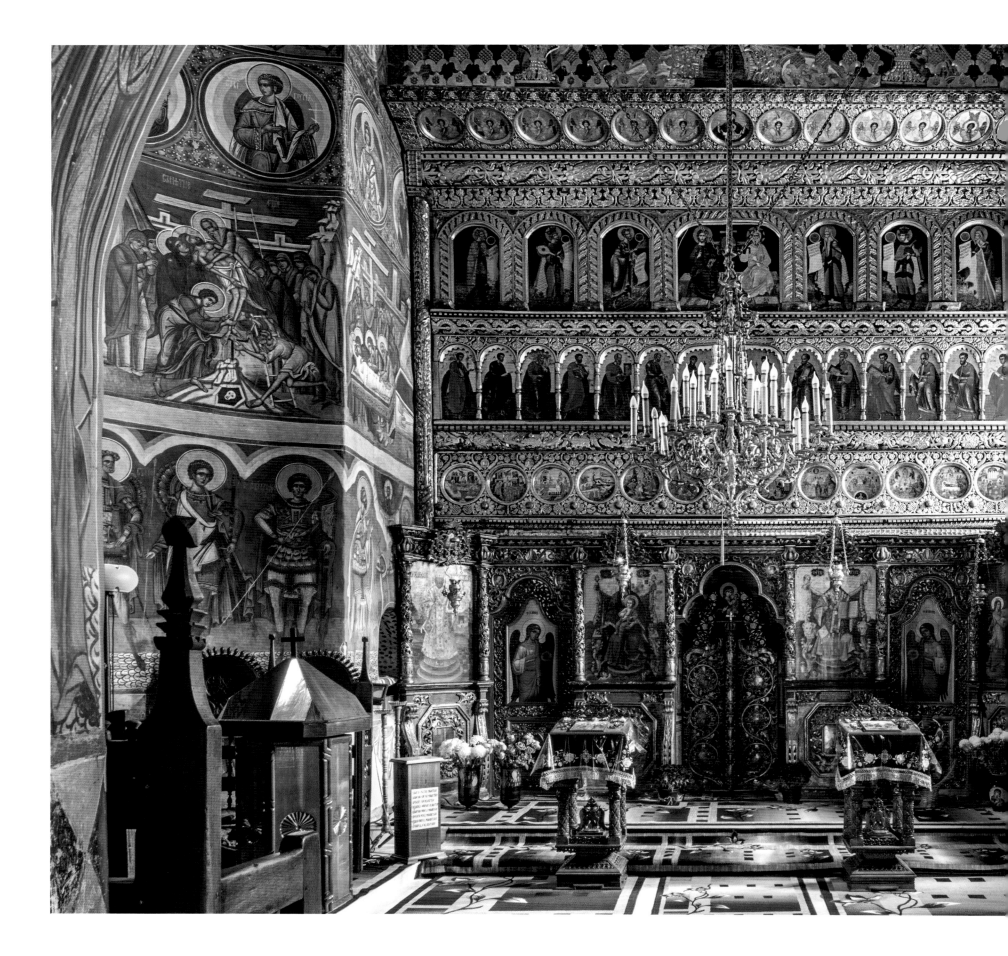

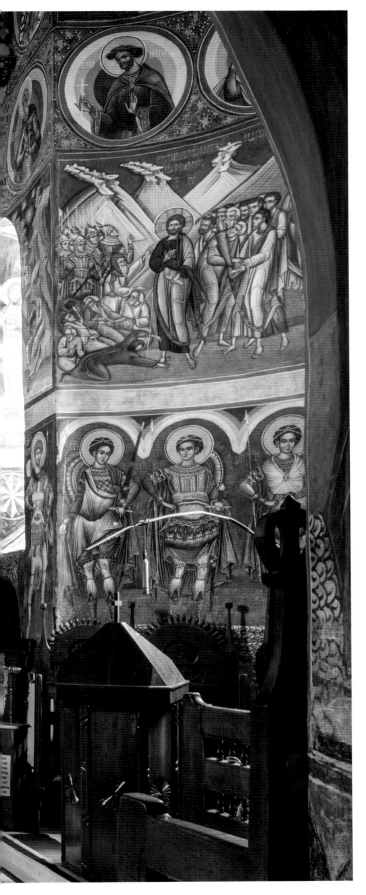

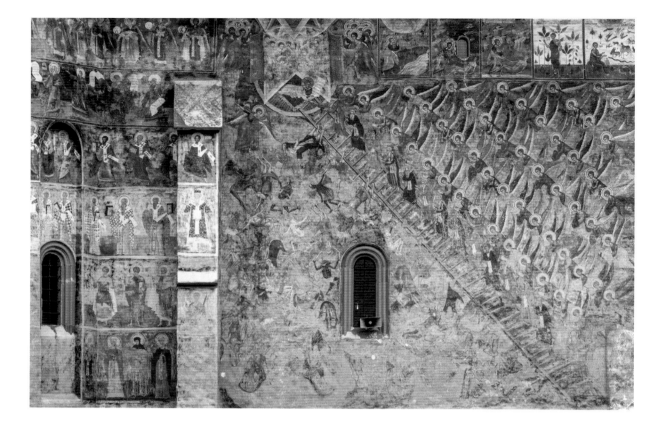

their assistants—but for the most part, they are anonymous. The influence is clearly Byzantine, with perhaps a detour through Kiev and Moscow.

The paintings inside are on the whole rather degraded, masked by centuries of residue from oil lamps, candles, and incense in small spaces; the ones outside are partly damaged by weather, especially those on the northern facades, which are exposed to rain. Others are miraculously still fresh, evidence of the high-quality craftsmanship of the forgotten painters. At each site, delicate restoration projects have been undertaken or are being planned.

These painted churches, in their spirit and sophistication, so unexpected for such remote regions, are reminiscent of mountain churches and chapels in Savoie and in the Pyrenees of France and Spain. It is as if these isolated, often poor communities wanted to manifest through architecture and art their wish to remain connected with that paradise, that divine city that their religion promised them.

PAGE 212: Sucevita's exterior frescoes are among the best conserved of the Moldavian churches. Here, the *Ladder of Divine Ascent* (1595) by Ioan Zugravul. ✚ **PAGE 213** *TOP LEFT*: Interior of Sucevita, detail of an angel. ✚ **PAGE 213** *BOTTOM LEFT*: The Church of the Resurrection at the Sucevita monastery was built between 1584 and 1601 by the Movilă family, who ascended to the throne of Moldavia in 1595. ✚ **PAGE 213** *RIGHT*: The entrance's astoundingly well-preserved frescoes, with multiple compartments and cartouches.

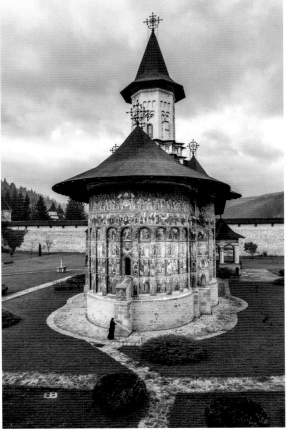

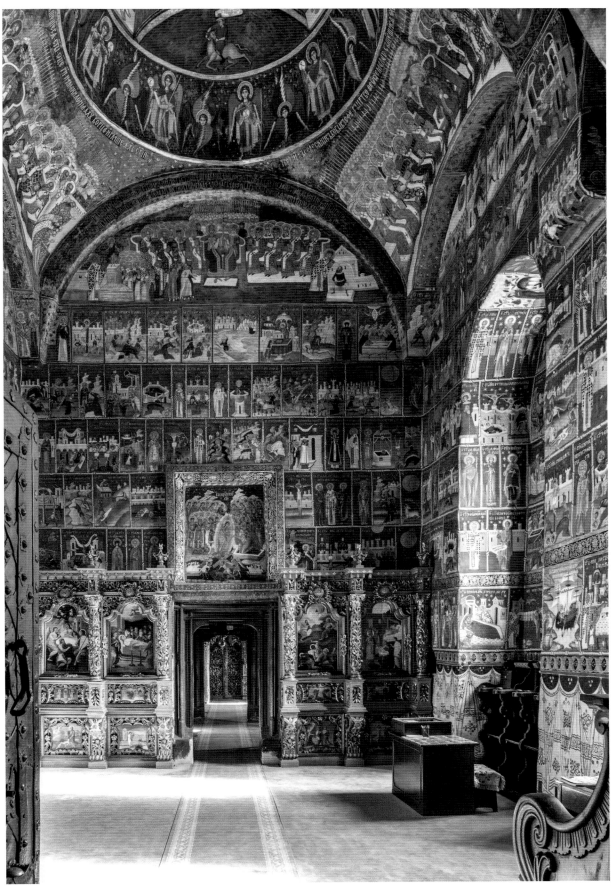

SEDLEC OSSUARY

KUTNÁ HORA ▫ CZECH REPUBLIC

Europe is rich with ossuaries and catacombs. The tradition is ancient and was epitomized by the Etruscans, the first Christians of Rome, the Celts, and rich Neapolitan and Palermitan families in various forms: small tombs, niches, bone heaps, stagings of the dead dressed as they were when alive. In Paris, the catacombs are not tied to the church but rather to public health initiatives; starting in the eighteenth century, many of the city's cemeteries were eliminated and the remains were piled in former quarries.

The Church of All Saints, in Sedlec is an exceptional, extravagant ossuary. Although it has few champions among art historians, it nevertheless welcomes two hundred thousand visitors per year.

Its origins date back to the thirteenth century, when the abbot of the Cistercian monastery of Sedlec, upon his return from the Holy Land, scattered some earth from Golgotha in the cemetery. Many members of Bohemia's aristocracy and wealthy class then wanted to be buried there. After that, in 1318, the plague struck the region and took more than thirty thousand lives; many of the dead were buried in Sedlec. Around 1400, a two-story Gothic structure was built. The lower part was home to the ossuary; the upper part, not as big, was the chapel and symbolized, by its position, Christ's victory over death. The Hussite Wars brought more cadavers, but starting in 1511, a monk developed a technique for preparing human remains and organized dignified, rational heaps, most often into pyramids. The Thirty Years' War again provided thousands of dead. The chapel was restored between 1703 and 1710, and then the macabre establishment was practically forgotten.

PAGE 215: The Sedlec Ossuary sits beneath the Cemetery Church of All Saints. The building, which dates from the very beginning of the eighteenth century, was entirely redecorated in 1870 by the local sculptor and woodcarver František Rint. ╪ PAGE 216 AND 217: The remains of tens of thousands of people rest in the ossuary. Hundreds of them served to create this macabre decor. In the middle, the chandelier is said to be made with at least one of every bone in the human body.

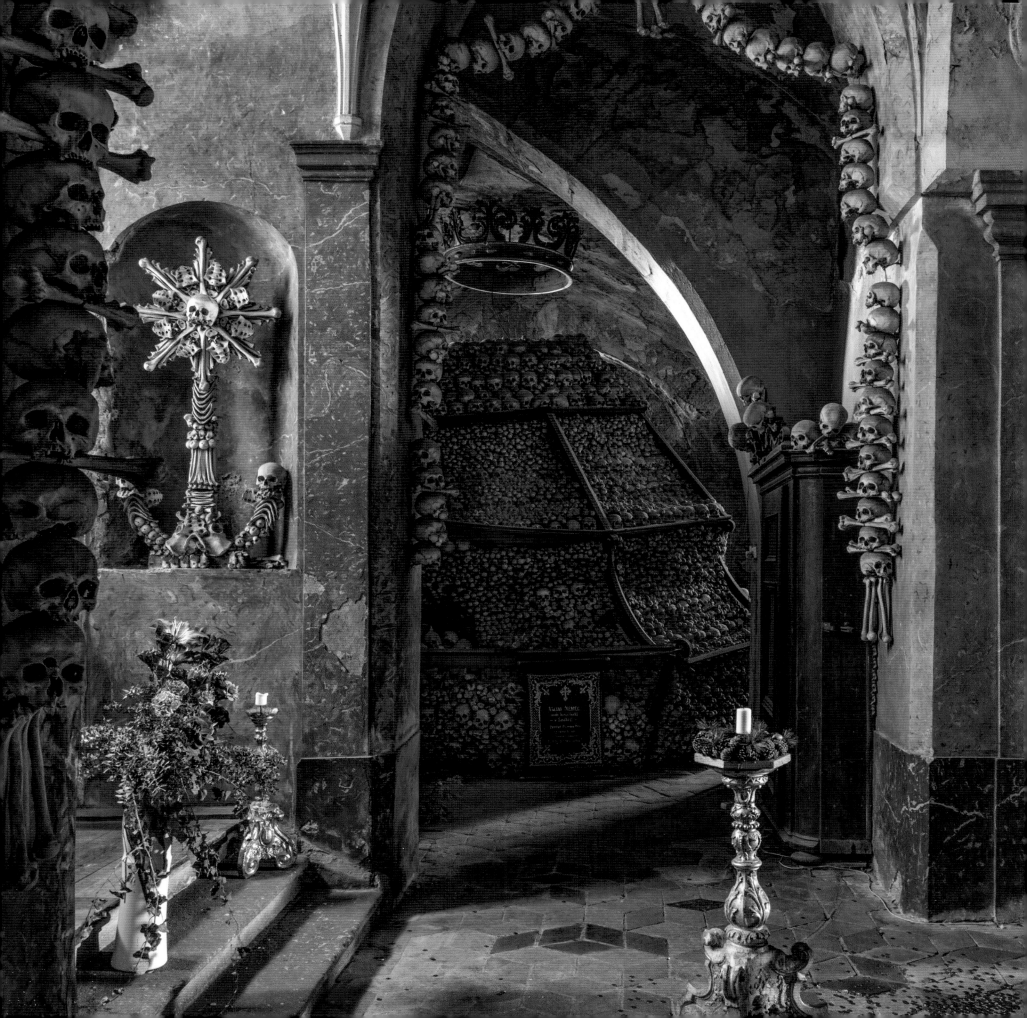

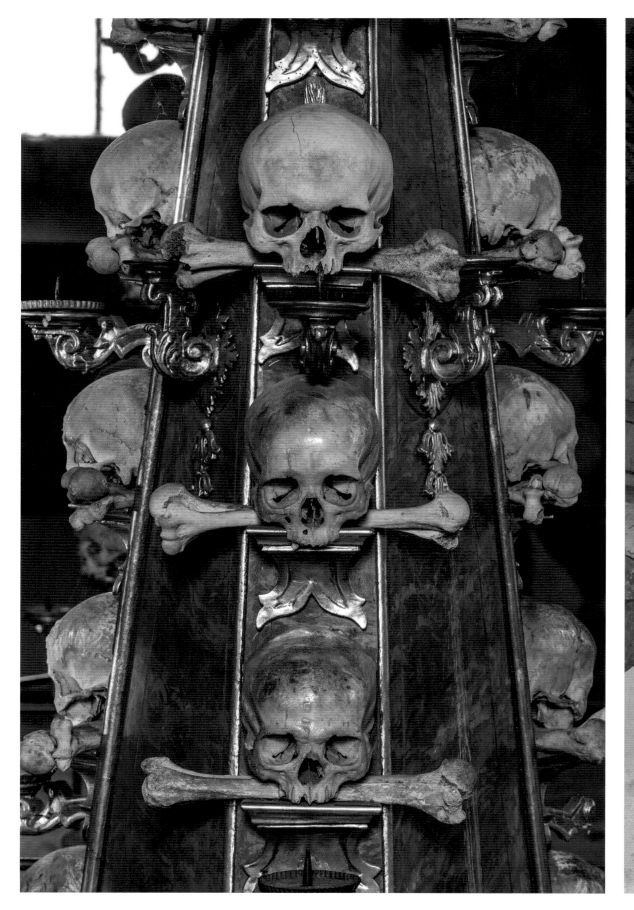
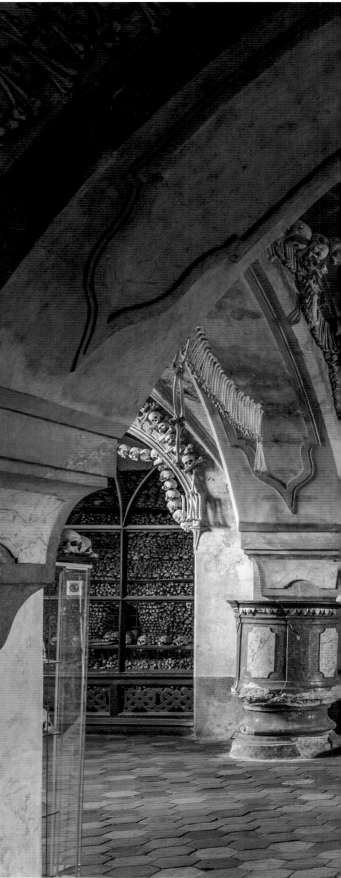

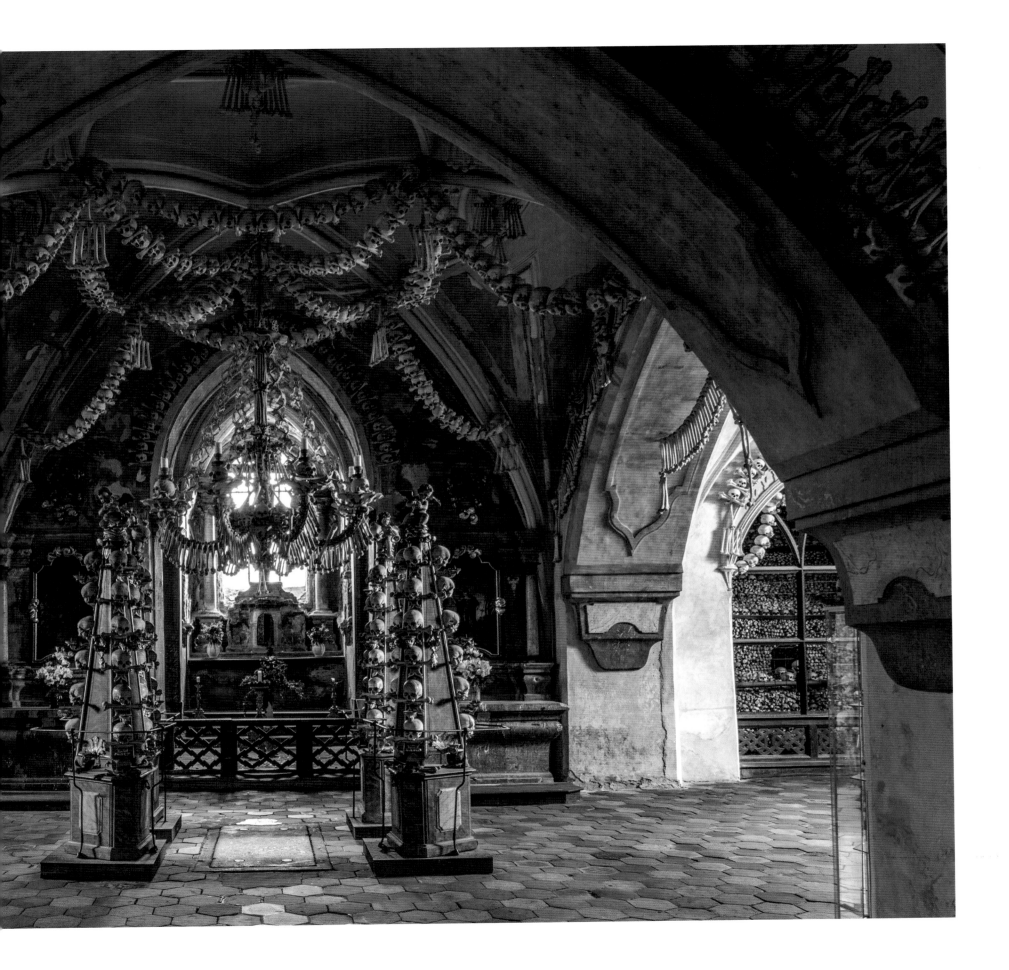

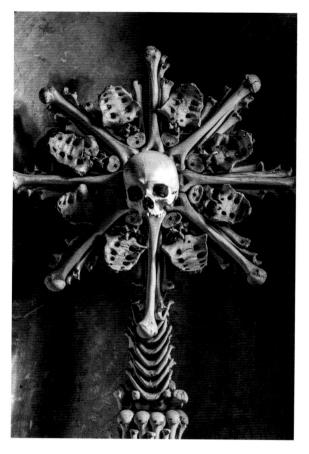

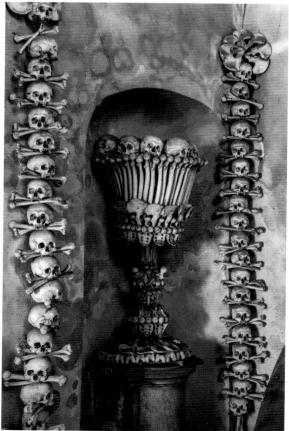

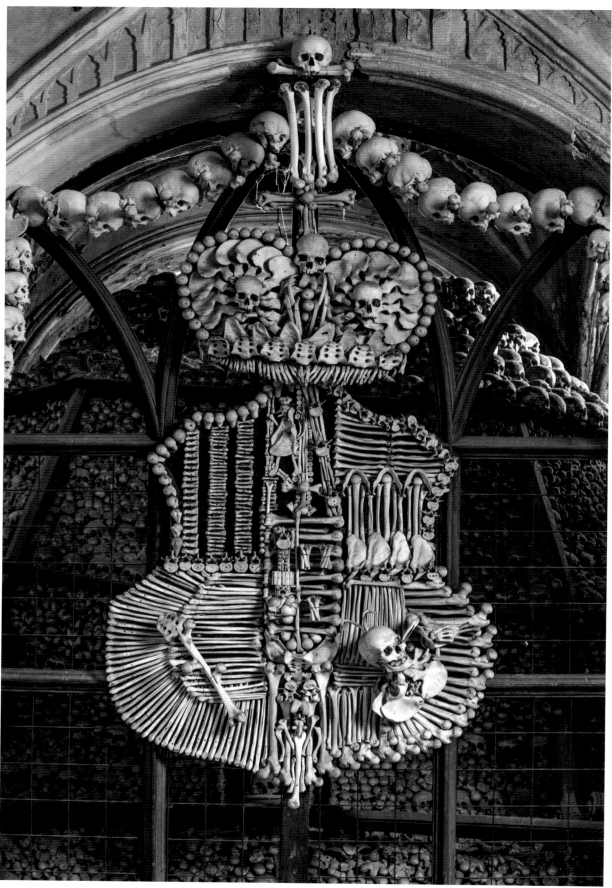

The powerful Schwarzenberg family bought the monastery in 1784 and transformed it into a tobacco factory. It was not before 1870, however, that they decided to renovate the sanctuary and hired a woodcarver, František Rint, who devoted his life, one might say, to the task. He retained four of the existing heaps and let his imagination run wild with the bones of the last two. He made an enormous chandelier using at least one bone from each part of the body. He also made chalices, monstrances, candlesticks, the coat of arms of his patrons, and his signature, all from bones.

Apparently, no one at the time was offended by what might have been considered an unfortunate fantasy, even an affront to human dignity. In its defense, one must remember that skeletons and bones played an important role in religious iconography, in the decor of houses of worship during the Middle Ages and Renaissance, and even

PAGE 218 *TOP LEFT*: Rint's imagination was staggering. This recurring decorative motif serves as an example. ✝ PAGE 218 *BOTTOM LEFT*: Small columns and basins made from skulls and tibias. ✝ PAGE 218 *RIGHT*: The Schwarzenberg coat of arms. The family owned the property and commissioned the sculpture.

in Baroque art. One need only think of the many frescoes of Danse Macabre, of the jovial skeletons in Bavarian churches, and of the vanitas (painting symbolic of the inevitability of death) in Northern Europe. For the Christian religion, which offers a meaning to life beyond death, the latter was for a long time a major artistic theme, prompting viewers to reflect on existence and mortality. In Europe, its representation in art was symbolic, even though there was a certain amount of realism during the medieval period. But in Sedlec, at the end of the nineteenth century, we have a supposedly artistic and decorative arrangement of the bones of between thirty and seventy thousand human beings. The heaps inevitably will make one think of the skeletons found in Khmer Rouge prisons or the piles of body parts in Nazi concentration camps. In Europe, there are no more recent examples of the ancient and morbid sensibility in a house of worship.

The Sedlec Ossuary, therefore, in its brutal way, puts us in touch with our fascination with death and perhaps with a certain kind of voyeurism. Nevertheless, redemption and resurrection seem to be a far cry from a chandelier made of tibias, hips, skulls, ribs, and vertebrae strung like beads on rusty wire.

SAINT-SOPHIA CATHEDRAL

KIEV ▫ UKRAINE

In response to a question from the newspaper *Le Monde* about which book had most influenced him, André Grabar (1896–1990), the great Ukrainian historian of Byzantine art, answered that it was Saint-Sophia in Kiev. The white cathedral with green roofs and thirteen gold cupolas rising in the heart of the Ukrainian capital is among the largest monuments in Kiev. It is also a marvelous "book" on the history of the federation of Kievan Rus, the establishment of Christianity in Slavic territory, and Orthodox sacred art, from the Byzantine to the Baroque.

Construction began in 1037 and was remarkably fast for the time: some fifteen years. That speed can undoubtedly be explained by the fact that it was one of Yaroslav the Wise's (980–1054) major projects. A son of Vladimir the Great (956–1015) and a ruler who promoted the spread of Christianity, the young grand prince of Kiev wanted to manifest his ties to the church with a prestigious monument and thereby imply his desire to be independent of the Empire.

On the outside, the cathedral we see today does not look like Yaroslav's. It was expanded and transformed in the early eighteenth century in a generous Ukrainian Baroque style, with gilding and onion domes, as was typical.

The initial cathedral, which was much plainer, in simple brick, was Byzantine in spirit but nevertheless unique. In fact, it still exists and is for the most part conserved at the center of the current building, in terms of both its architecture and its decor. The expansion involved adding parallel lateral galleries, a covered entrance, and two towers with staircases inside. The heart of the sanctuary is therefore the original inscribed-cross church (incorporated into the plan as a whole) with five naves. Congregants would gather within the Greek cross plan in the main nave, around the ambon (a raised platform from which scriptures were read), while the officiating priests would stand in front of the sanctuary's altar, the bema, which occupied the central apse. The bema was open; later

PAGE 221: Detail of the iconostasis (eighteenth century).

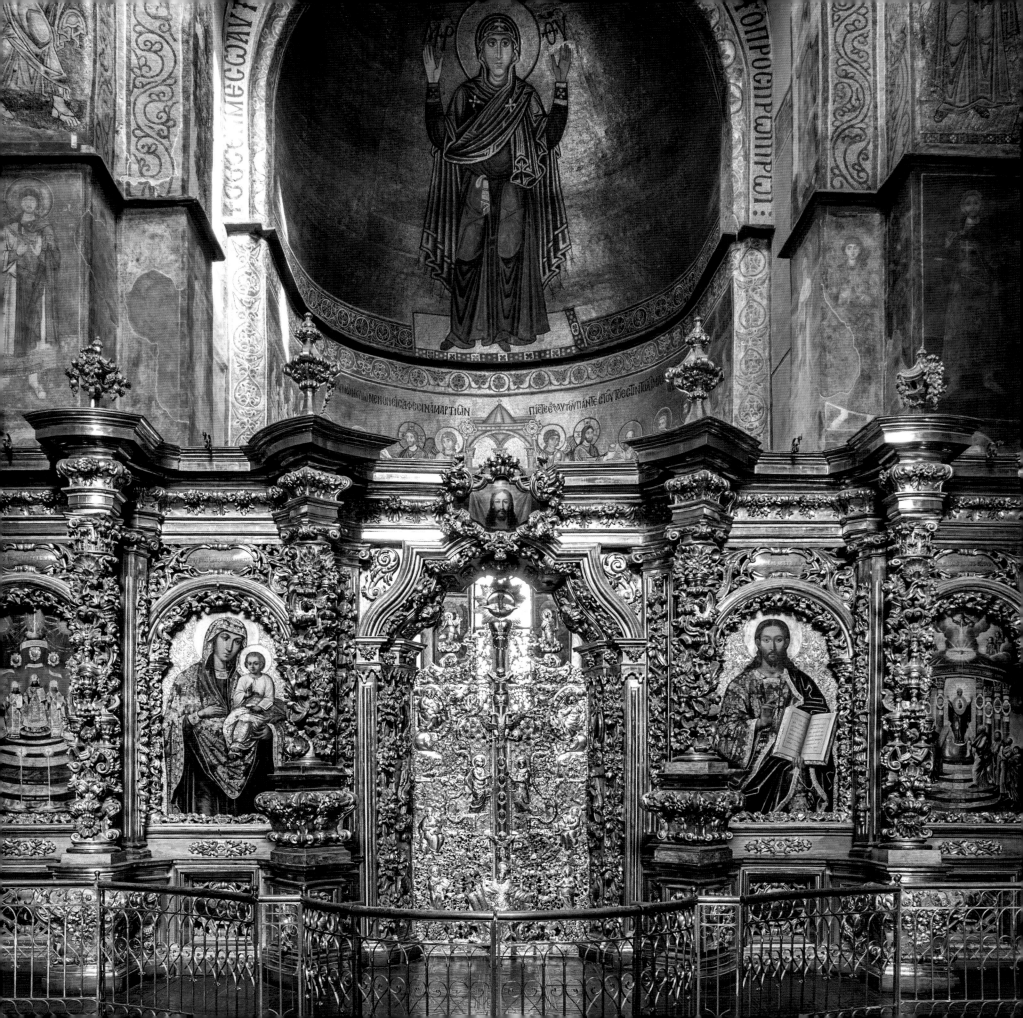

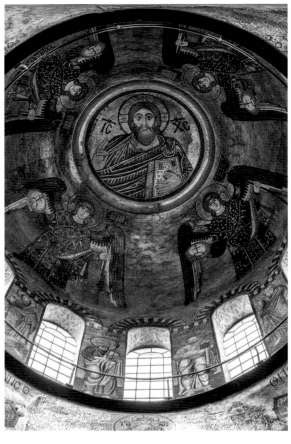

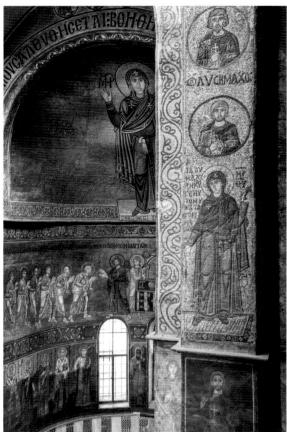

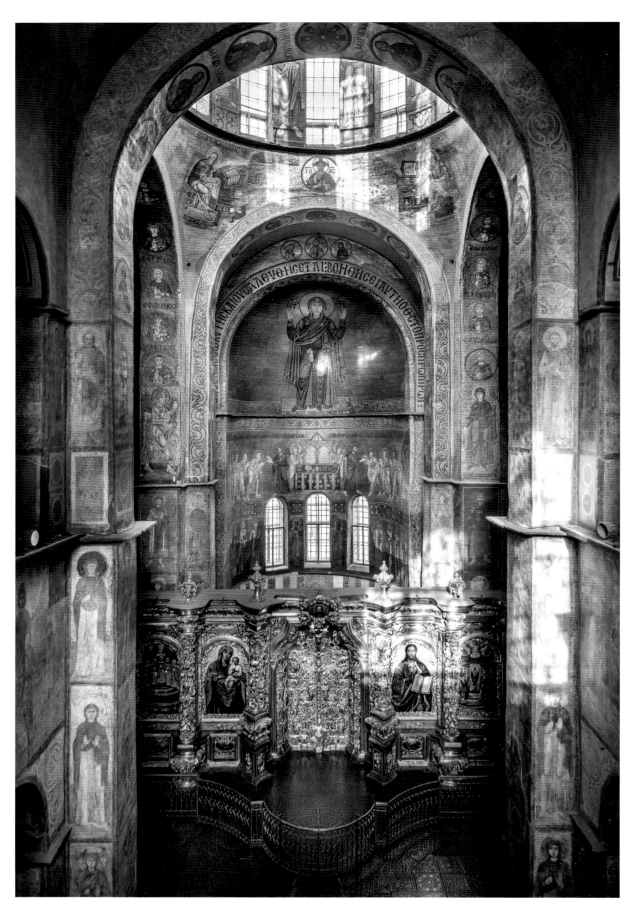

it was separated by a balustrade, drapes, hanging icons, and finally a low partition that gradually took the form of the iconostasis, similar to a rood screen, which totally separated the priests from the faithful.

Saint-Sophia's extraordinary iconostasis dates from the eighteenth century. While the transept is lighted by bay windows that illuminate the mosaics of the main cupola, the aisles are extremely dark, which, for Western Christians, adds even greater mystery to the Orthodox theophanic liturgy.

The decor is exceptional in quality considering the distant and troubled times from which it comes. It constitutes the largest collection of mosaics and frescoes from the period; their splendor is so evident that eighteenth-century restorers left them alone for the most part. Because there are no archives, one can only surmise that the

mosaics and frescoes were executed by artists from Constantinople, assisted by local craftsmen. The iconography is directly inspired by the sacred art of Byzantium. The main cupola is decorated with a huge mosaic with a gold background; Christ Pantocrator is surrounded by archangels

PAGE 222 *TOP LEFT*: The central cupola was decorated with mosaics by local artists and artists from Constantinople between 1043 and 1046. In the middle, Christ Pantocrator surrounded by archangels and apostles. There are more than one hundred and sixty nuances of color. ‡ **PAGE 222** *BOTTOM LEFT*: The *Virgin Orans*. The silver and gold Byzantine mosaic dates from the eleventh century. ‡ **PAGE 222** *RIGHT*: The nave, the iconostasis, and the apse decorated with the monumental *Virgin Orans*. The decoration echoes the adornment of Byzantine churches. ‡ **PAGE 223**: View of the cathedral with its thirteen cupolas. It stands on a hill along the Dnieper River.

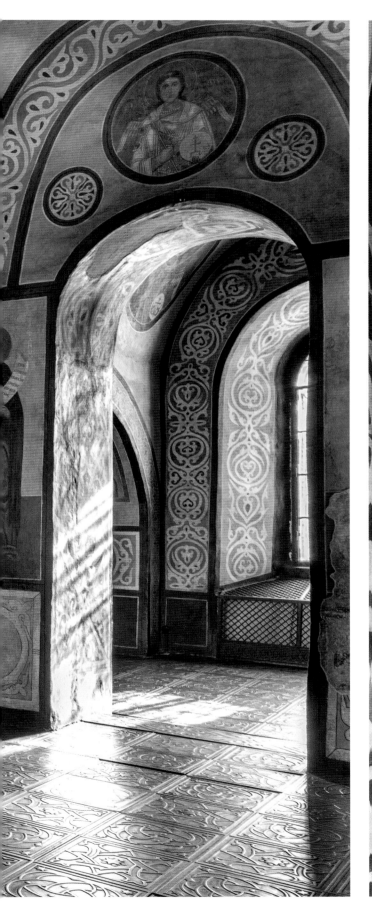

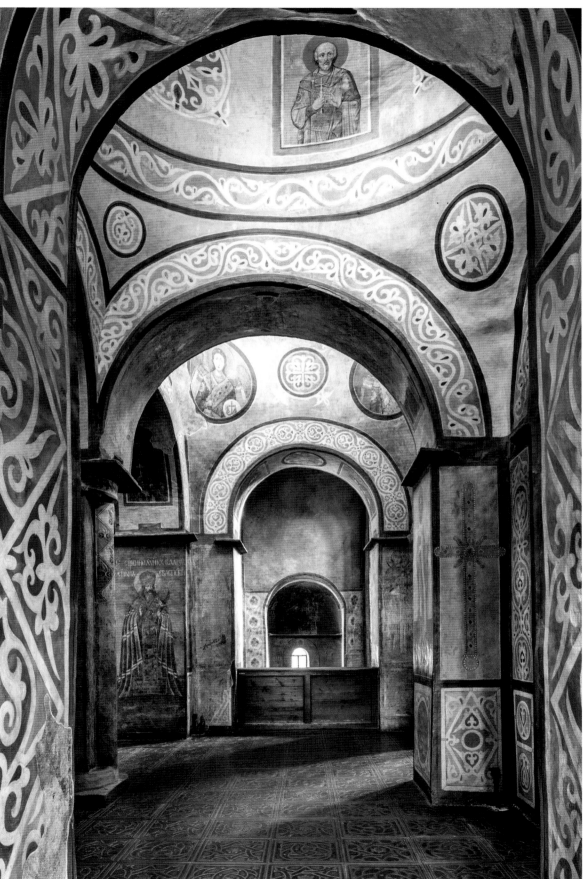

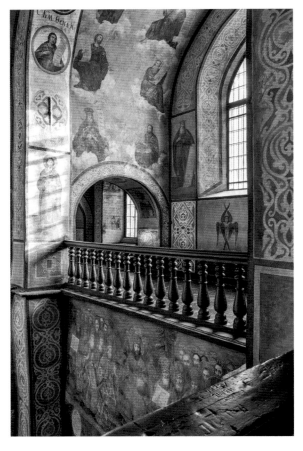

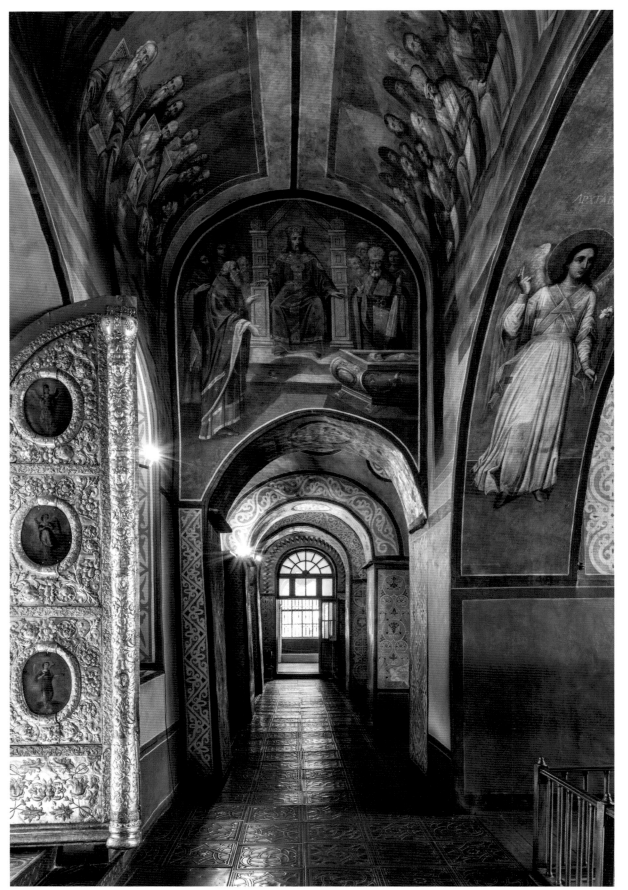

and apostles. Mother of God (Orante) is depicted in the central apse, under which are represented the Communion of the Apostles, the fathers of the Eastern Church, and St. Stephen and St. Laurentius. In the galleries, on the walls and pillars, frescoes in poorer condition present scenes from the Bible, the lives of the saints, and also the patron, Yaroslav, and his wife and sons. Surprisingly, one fresco depicts scenes from games played in Constantinople's famous hippodrome, a theme normally prohibited

PAGE 224 AND 225: View of the two levels of galleries surrounding the choir. ✦ PAGE 226 TOP LEFT: View of a tribune in the nave. ✦ PAGE 226 BOTTOM LEFT: Cast iron floor, behind the iconostasis. ✦ PAGE 226 RIGHT: Gallery surrounding the choir. The gilded door leads to the sanctuary. ✦ PAGE 227 LEFT AND RIGHT: St. Nicholas of Myra and St. Martin (316–397) (eleventh century) are among the thousands of fresco figures on the cathedral's walls, pillars, ceilings, doorways, and paneling.

in Orthodox churches. André Grabar has explained that, because everything related to the emperor was divine, those images were profane only in appearance. The grand prince of Kiev was thought to have wanted to establish a connection between his power and the emperor's.

The Kiev cathedral as well as the buildings surrounding it—the metropolitan palace, belfry, seminary, consistory, and monk quarters built in the seventeenth and eighteenth centuries—were added to UNESCO's World Heritage List in 1990. A high place of the Orthodox faith, it survived the wars and unremitting tumult endured by the Rus region, from which emerged Russia, and it also withstood the terrible battles of 1943. To put an end to the seemingly endless conflicts between local Orthodox churches, the cathedral was recently transformed into a museum of Christianity. Now tourists are able to admire Yaroslav the Wise's masterpiece and his tomb, which remains intact.

STAVE CHURCHES

BORGUND, HEDDAL, AND UVDAL ▫ NORWAY

Of more than a thousand wooden sanctuaries known as *stavkirker* built during the Middle Ages in Sweden and Norway, only twenty-eight remain in good condition. Humidity, rain, snow, fire, termites, and evolving lifestyles almost completely decimated this type of architecture as early as the eighteenth century.

The structures date from the twelfth century, when Norwegian kings, including Olaf II Haraldsson (995–1030), who later became St. Olaf, could impose Christianity on their subjects. The people resisted for a long time, preferring instead their ancestral religion founded on a mother goddess and polytheist myths. During that time, Norwegians lived on scattered farms. Small in size, their houses of worship were for the most part built in solitary locations, in the middle of a cemetery surrounded by dry-stone walls. Their construction was utterly simple. Standing on a stone foundation (to protect the structure from the ground's moisture), a solid wooden platform supported a framework of posts and beams outlining a nave, which was often square in shape. The space was extended by a small nave or apse, built in a similar way, for the altar. One or sometimes two additional levels, decreasing in size, were built on top of the base to create the necessary height and volume as well as the sought-after monumental effect. The heart of the church was in most cases surrounded by a low, covered gallery. The formula explains the spectacular terracing of the roofs, their eaves protecting against the rain and snow. Walls were made of wooden planks installed vertically, hence the name given to these sanctuaries, "stave churches."

Their decor is completely unique. It expresses the transition from the pagan art of the Vikings to Westernized

PAGE 229: The Borgund stave church (c. 1180), with its gables, lanterns, and dragonheads, almost looks like a Japanese pagoda and shares its architectural logic.

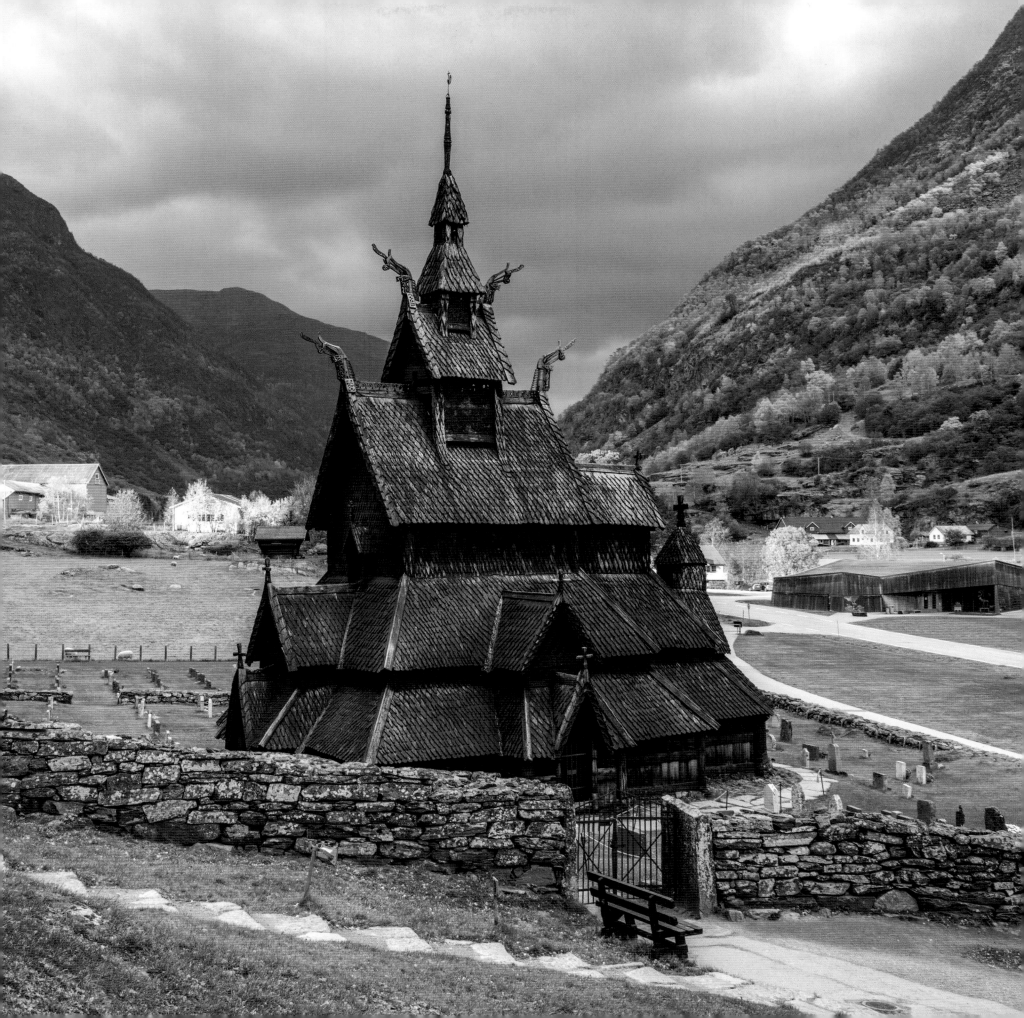

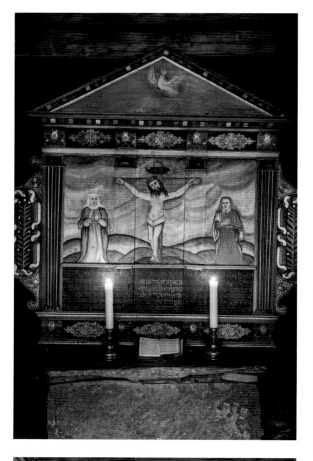

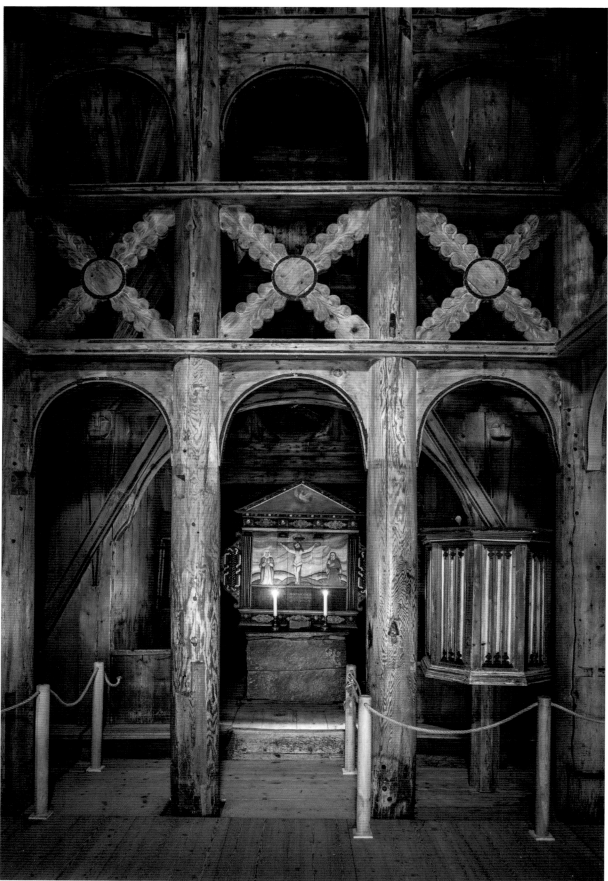

art influenced by interactions with countries such as Roman France and England, as well as with the Baltic states, Poland, and the fringes of the Byzantine Empire.

The more uncommon painted decor, executed later, sometimes even dating to the seventeenth century, is inventive, generous, and graphic in spirit, with endless repetitions of plant motifs. The surviving handful of representations of Christ and his apostles reflect faraway Norman, English, and even Byzantine influences.

The decorative art of the period is expressed mostly through wooden sculpture. On portals, pillars, capitals, beams, and furnishings, there is a wild and fantastic bestiary of serpents, dragons, "clawed creatures," and dogs, rendered as part of impressively intricate interlacing. We find ourselves at the threshold between religion and ancient magical beliefs; these animals symbolize fertility and the evil or protective spirits of nature. Thus, the stylized dragons seen on the roofs are meant to ward off "real" dragons deterred only by their own image. The serpent, the companion of the mother goddess, is omnipresent; its small head, sometimes endowed with a duck beak and prominent eyes, appears sometimes incongruously amid geometric interlacing. Such patterns, which are reminiscent of Celtic knots, fill doorframes as well as outside walls, for example, at the Urnes church. Sometimes there are also fantastic animals chewing their tails. In fact, there is practically no iconography that is strictly Christian. The ancient Norwegians invented a decorative iconography for their churches that, in spirit, ensured continuity with the religion of their ancestors. As the church did everywhere, for centuries the

Church of Norway chased out ancient superstitions and attempted to prohibit celebrations considered to be too pagan while still allowing some of them.

The Uvdal church dates from the end of the twelfth century. Particularly picturesque, we do not know what it originally looked like because it was expanded and modified several times, especially during the Reformation and until the eighteenth century. Its cross-shaped plan is relatively unusual and the large pillar in the middle of the transept must have once supported a spire. The two abundantly sculpted portals illustrate the theme of the vine from which sometimes emerge imaginary animals. There is also a depiction of Gunnar (Gunther in the Nibelungenlied) in a snake pit that echoes the image of Daniel in the lions' den.

The Borgund church, one of the best-conserved wooden churches of Norway, dates from around 1180. The proliferation of roofs over six levels and of turrets, gables,

PAGE 230 *TOP LEFT AND RIGHT*: Borgund's tiny choir, the altar with modest altarpiece, and the impressive church pulpit (sixteenth century). The open central structure with crosspieces ensures the overall stability of the building. ✚ PAGE 230 *BOTTOM LEFT*: Borgund's western portal with sculpted interlacing of plants and fantastical animals. ✚ PAGE 232: The Heddal Stave Church (mid-thirteenth century), the largest wooden church in Norway. It is eighty-five feet (26 m) high and sixty-five feet (20 m) long. ✚ PAGE 233: The nave of the Heddal Stave Church. The painted floral decoration is thought to date from the seventeenth century.

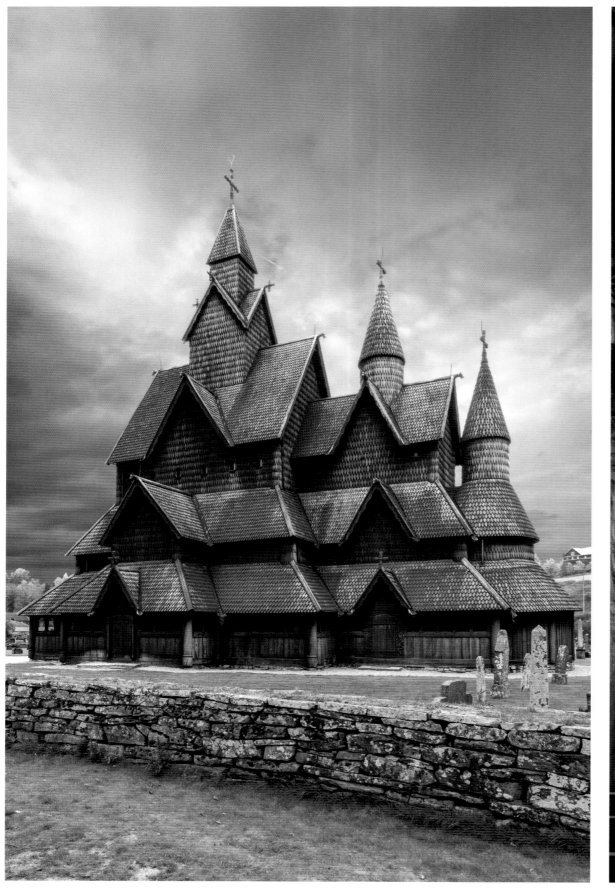

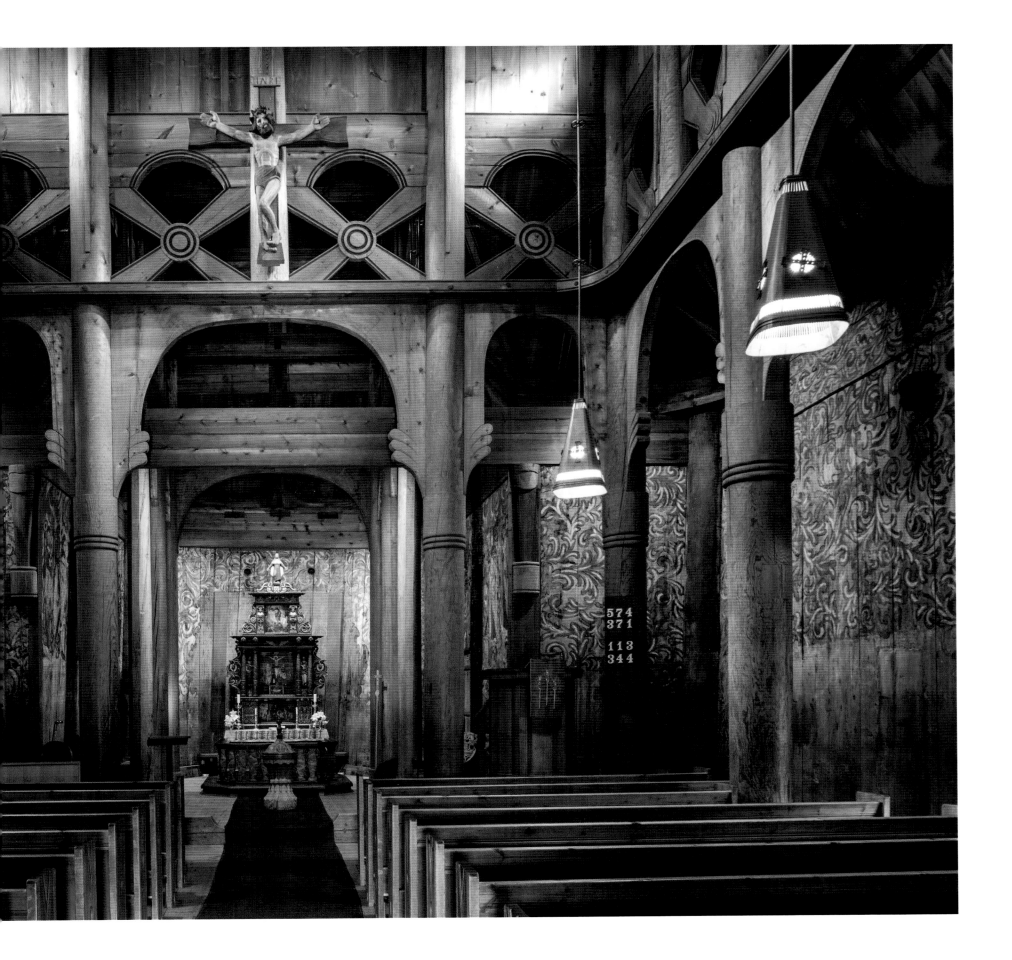

and ridgepoles decorated with dragons are almost reminiscent of a Japanese pagoda. Although its portals are highly adorned, the inside, barely lighted by a single window, is practically without decor; there are only capitals made of human masks and the heads of mythical animals. One's eye then wanders freely through the joists, the timber trusses, the turrets, and the beams of the amazing framework.

The Heddal church dates from the thirteenth century. Eighty-five feet (26 m) high and sixty-five feet (20 m) long, and expanded several times, it is the largest of the surviving wooden churches. It was extensively restored in the middle of the nineteenth century as well as more recently to fix the first restoration. Surmounted by three towers, the stunning terracing of its roofs has made it the

tourist archetype of this kind of sanctuary. The sculpted knots on the portals, the battling fantastical animals, the snake heads emerging from leaves, and the various reliefs are markers of what is known as the Viking style.

PAGE 234 *LEFT AND RIGHT*: The Baroque altar in Heddal and a detail, perhaps of St. Elizabeth of Hungary (1207–1231). ☦ PAGE 235: Interior of Heddal Stave Church with its covered gallery on all sides. ☦ PAGE 236 *TOP LEFT*: Uvdal Stave Church (late twelfth century). ☦ PAGE 236 *TOP RIGHT*: Uvdal altarpiece, *The Last Supper*. ☦ PAGE 236 *BOTTOM AND* 237: Uvdal interior with its rich painted decoration (seventeenth–eighteenth century) inspired by motifs from local folk art. Some panels imitate stained glass.

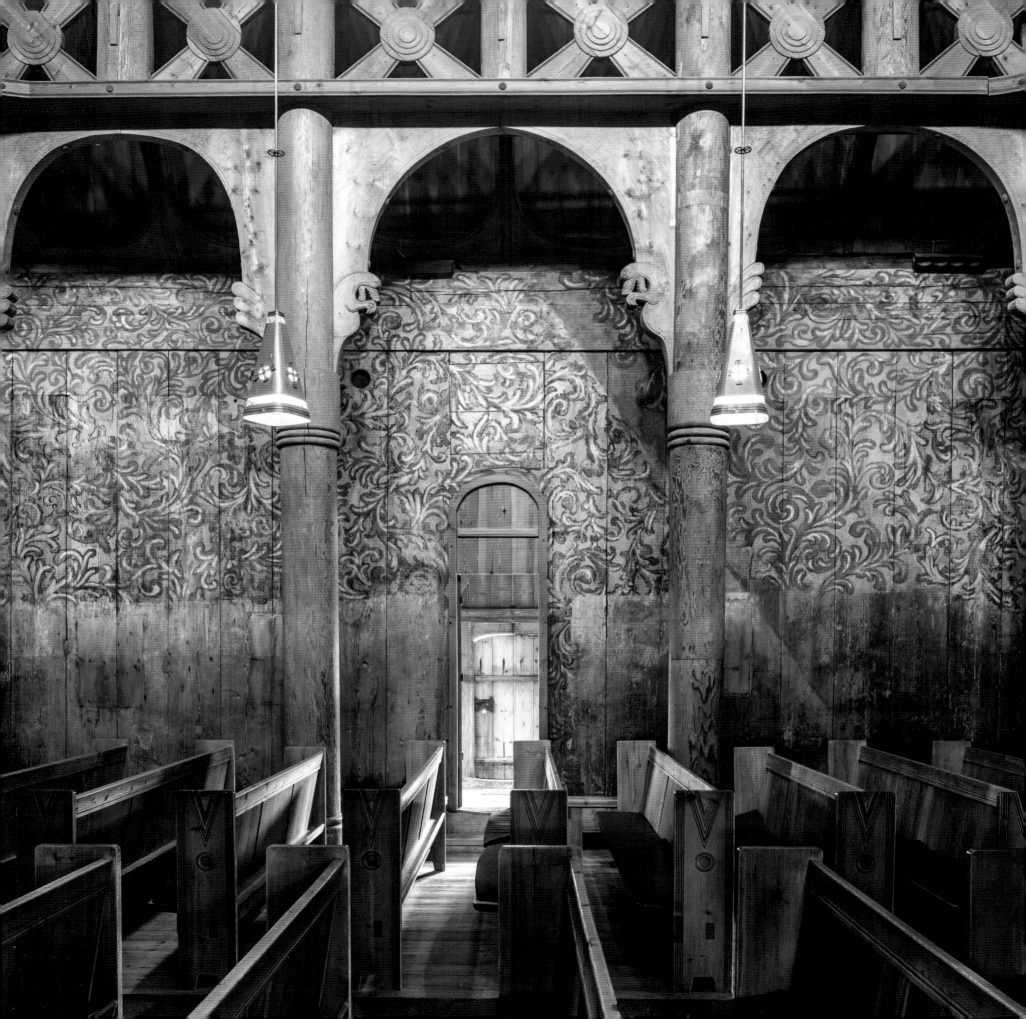

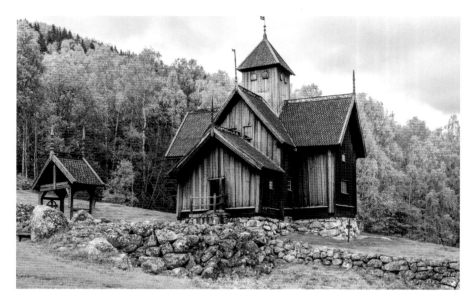

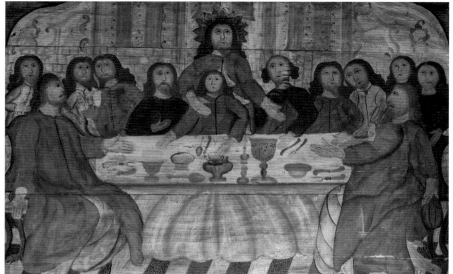

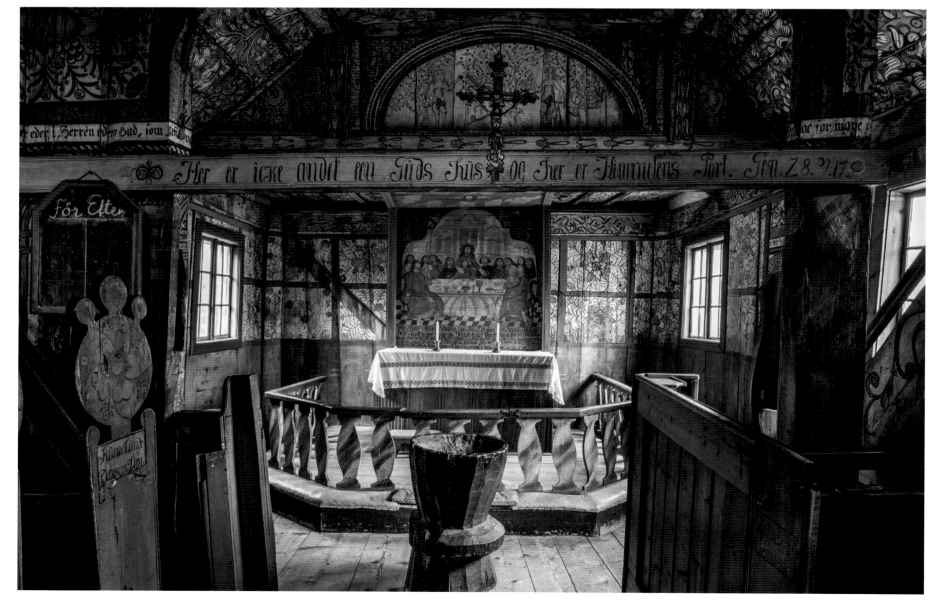

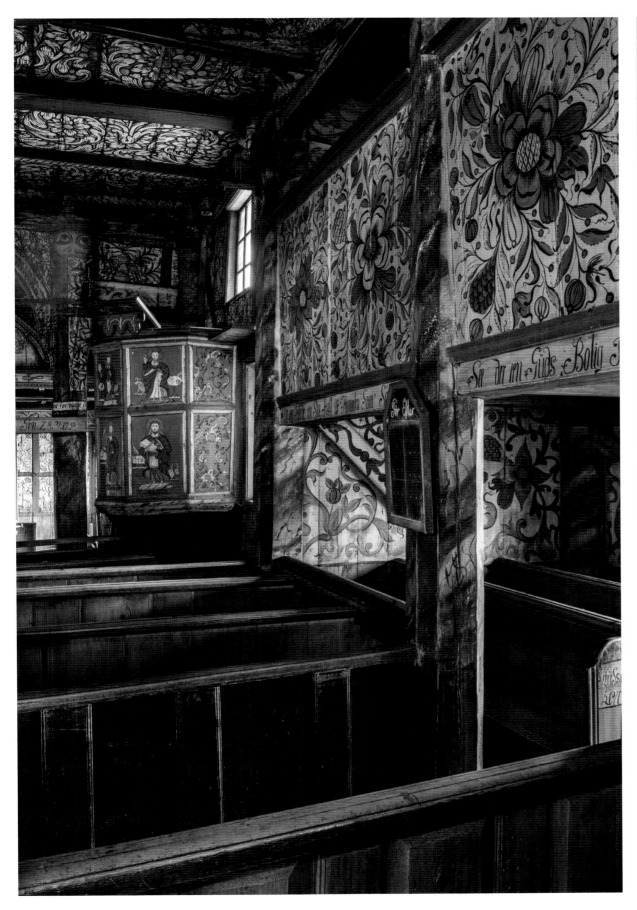
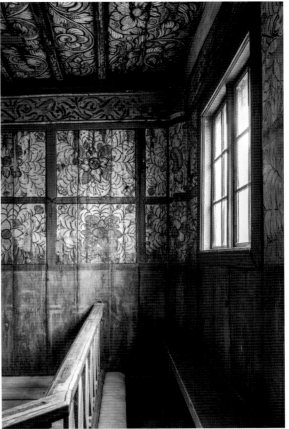

AFTERWORD

For me, entering a church to find light means to strip everything down to only what is essential. Working with this light, the original photographer's obsession, is always a new challenge. Each of these churches was created following the race of the day over many seasons. Each is animated with a clean voice, like a unique signature of shadows and light. It remains to be seen if that will show in the images . . .

I sometimes had to wait several months before having the privilege of opening the doors to these places of worship outside of visiting hours or prayers. Having obtained ninety minutes, not one more, to find myself entirely alone inside St. Peter's of Rome justified all the efforts made to finish this book.

I so loved listening to the dialogue of a spring sun discovering at its own pace the copper arches of Thoronet.

I was touched by the emotion of Father Helmut Haug, Francophile priest of St. Moritz in Augsburg, recounting his church being radically refined by John Pawson after a thousand years. I admired the availability of all these volunteers, deeply attached to "their" church, in Vienna, Milan, Binarowa, Chaves, Palermo, Ulm, Cambridge, Kiev.

At the Sucevita monastery, I tasted the flavor of Moldovan morels, as if fallen from the sky, with the joyful complicity of the nuns. I will never forget the fjord crossings in search of Norwegian stave churches, the faded perfumes of incense and resin in Swidnica, and the astonishing appearance of Gothic bikers tattooed with skulls who came to admire, almost fearfully, the ossuary of Sedlec and his forty thousand skulls.

—Guillaume de Laubier

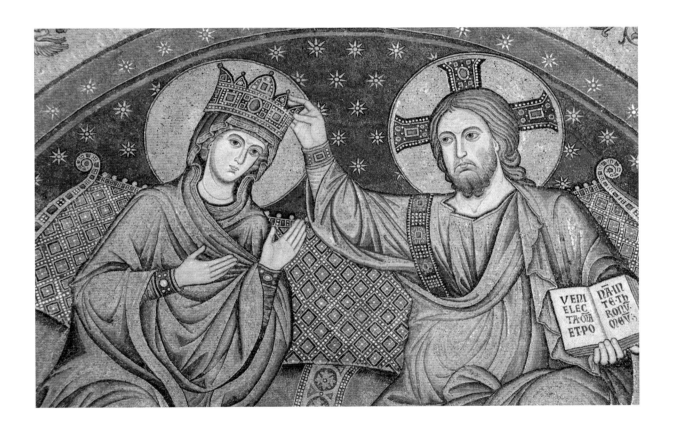

ACKNOWLEDGMENTS

The authors first thank the sanctuaries, their priests and pastors, administrators and conservators, who opened their doors to this project often with great kindness.

The trust of the teams at Éditions de La Martinière, which has been relied on many times, did not disappoint. Isabelle Dartois initiated the project and Aude Mantoux finalized it—both vigilant and enthusiastic editorial leaders. Laurence Alvado was particularly valuable in looking for the right contacts for each of the churches selected (sometimes negotiating at length when the conditions proposed were not satisfactory), and was helped by Claudia Tamburro for the Italian part, far from being the simplest to manage, and participated to the end to read and correct text.

Éléonore Gerbier reset the book twenty times—she often had to skillfully arbitrate in the vast harvest of images to lay out the thirty-nine wonders of this book.